Adobe Photoshop Elements 10

Unleash the hidden performance of Elements

Mark Galer
Dr. Abhijit Chattaraj

ELSEVIER

AMSTERDAM • BOSTON • HEIDELBERG • LONDON • NEW YORK • OXFORD
PARIS • SAN DIEGO • SAN FRANCISCO • SINGAPORE • SYDNEY • TOKYO
Focal Press is an imprint of Elsevier

Focal Press is an imprint of Elsevier
The Boulevard, Langford Lane, Kidlington, Oxford OX5 1GB, UK
225 Wyman Street, Waltham, MA 02451, USA

First edition 2012

Notices

Knowledge and best practice in this field are constantly changing. As new research and
experience broaden our understanding, changes in research methods, professional practices,
or medical treatment may become necessary.

Practitioners and researchers must always rely on their own experience and knowledge in
evaluating and using any information, methods, compounds, or experiments described herein.
In using such information or methods they should be mindful of their own safety and the safety
of others, including parties for whom they have a professional responsibility.

To the fullest extent of the law, neither the Publisher nor the authors, contributors, or editors,
assume any liability for any injury and/or damage to persons or property as a matter of
products liability, negligence or otherwise, or from any use or operation of any methods,
products, instructions, or ideas contained in the material herein.

British Library Cataloguing in Publication Data
A catalogue record for this book is available from the British Library

Library of Congress Control Number: 2011939002

ISBN: 978-0-240-52379-8

For more information on all Focal Press publications
visit our website at: www.focalpress.com

Printed and bound in Canada

12 13 14 15 10 9 8 7 6 5 4 3 2 1

for Dorothy and Cathy

Picture Credits

Dorothy Connop, www.iStockphoto.com,
Shane Monopoli, Ed Purnomo, Victoria Verdon-Roe.

All other images by the authors.

Cover Design: Namrata Chattaraj, www.wagdesign.net

Contents - part 1

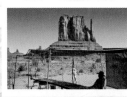

1

optimize

Contents - part 2

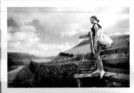

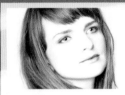

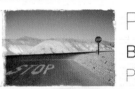
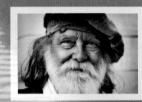

2

enhance

Contents - part 3

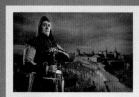

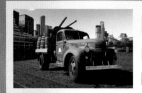

3

composites

Contents - website

The supporting website www.markgaler.com has HD movies for every project covered in this book. For a small fee you can either subscribe to the movie channel or download the movies to your computer. The movies are an invaluable resource, allowing you to start, stop and rewind so that the skills can be quickly and easily acquired at your own pace. The supporting website also has a link to a resource pack of image files that were used in the tutorial projects outlined in this book. Just download the supporting image files to your computer (see 'Getting Started'- page xvi). The resource pack of image files contains master Raw files, JPEGs with saved selections to fast-track some projects and multilayered files (PSDs) of the completed projects.

HD movies are available to watch online

THE WEBSITE PROVIDES EXTENSIVE SUPPORT IN THE FORM OF:

- Over eight hours of movie tutorials recorded using Photoshop Elements. These will support you through all of the projects in this book. You may need to install the QuickTime movie player by following the link on the supporting website.

- High-resolution, high-quality JPEG images to support the imaging projects.

- Saved selections for users interested in completing the projects in the least amount of time while achieving maximum quality.

- Camera Raw files.

- Multilayered Photoshop documents (PSD files) of completed projects.

- Adobe actions and presets (layer styles and gradients) to enhance the performance capabilities of your Adobe Photoshop Elements software.

- Printable PDF file of keyboard shortcuts to act as a quick and handy reference guide to speed up your image-editing tasks.

website

www.markgaler.com

Preface

The creative projects in *Adobe Photoshop Elements 10 Maximum Performance* are designed to provide you with the essential techniques for professional quality editing – without the need to upgrade to the full version of Photoshop. The projects are designed to unleash the hidden potential of the budget software through a series of workarounds, advanced techniques and loadable presets. Each creative project is supported by a QuickTime movie tutorial and high-resolution images – all available from the supporting website (www.markgaler.com). This website contains all of the project images together with full and comprehensive movie support. Each project is designed to build the skills required so that any photographer can attain the status of 'imaging guru'. The magic is deconstructed using a series of easy-to-follow step-by-step projects using large clear screen grabs and jargon-free explanations. Completed multilayered project files are also available from the supporting website for those users who like to have access to the completed project for comparison and analysis.

This book will act as your guide to some of Elements' less well-known and more powerful post-production editing techniques. It will enable you to attain the same high-quality images as professionals using the full version of Photoshop. This book makes Elements a viable alternative to the full version of Photoshop for imaging professionals and enthusiasts looking to extract the maximum performance from their software.

This book is primarily concerned with the post-production stage of the creative process and demonstrates how this part of the creative process can optimize and enhance the original capture or create an entirely new image out of several images (the creation of a composite photograph or photomontage). Where appropriate the book will discuss measures that can be taken by the photographer in pre-production or production to enable the highest-quality outcome as a result of the post-production stage. To ensure the best quality image from our sophisticated and professional post-production techniques we should make certain that we access quality raw materials whenever possible – 'quality in, quality out'. The vast majority of the JPEG images from the supporting website were processed from either Camera Raw files or high-quality 16 Bits/Channel scans. Many of the images featured in this book were captured using budget digital SLR and fixed-lens digital cameras, affordable cameras used to capture information-rich images.

The techniques used in this book promote a non-destructive approach to image editing wherever possible. The term 'non-destructive image editing' refers to the process of editing an image whilst retaining as much of the original information as possible and editing in such a way that any modifications can usually be undone or modified. Editing on the base layer of the image can often mean that modifications to the pixel information cannot be undone easily or at all, e.g. sharpening an image file cannot be undone once the file has been saved and flattened. It is, however, possible to sharpen non-destructively in post-production so that the amount of sharpening can be altered when the file is opened at a later date. This latter approach would be termed 'non-destructive'. When capturing images with a digital camera many users do not realize that if the JPEG file format is used image processing starts in the camera. Color correction, contrast adjustment, saturation levels and sharpening all take place in the camera. If maximum quality is to be realized the Raw format should be chosen in preference to the JPEG format, if possible. The post-production decisions can then be left to the Adobe software, allowing the user many more options.

Photoshop Elements replaced 'Photoshop LE' (limited edition – as in limited function and not availability); both of these software packages share something in common – they offer limited elements of the full version of Photoshop. Adobe limits the access to some of the features that would be the first port of call for some professional image editors and photographers, but this does not mean that the same level of control cannot be achieved when using the budget software. Professional post-production image editing does NOT have to be compromised by using Photoshop Elements. When editing images there is usually more than a single way to reach the destination or required outcome. With a good roadmap the Elements user can reach the same destination by taking a slightly different course. These roads are often poorly signposted, so are often inaccessible to the casual user of the software. This book will act as your guide to enable you to attain a broad range of sophisticated post-production image-editing skills through a series of creative projects designed to circumnavigate the missing features.

Photoshop Elements IS a viable alternative to the full version of Photoshop for most professional image-editing tasks. Many professionals may disagree with this statement, as a quick glance at the Elements package may result in a long list of the elements that are missing rather than taking a long hard look at the elements that remain (a case of 'the glass is half empty' rather than 'the glass is half full'). After more than a decade of professional image editing I have learnt that there is more than one way to create an image. There is no 'one way'. In short, it is possible to take a high-quality image file and work non-destructively to create an image which is indistinguishable from one that has been optimized using the full version of Photoshop. This book does not aim to outline every tool in your kit (a paintbrush doesn't really require an owner's manual and some of the automated features are sometimes more trouble than they are worth). It just deals with how to adapt the tools you do have to perform the tasks you didn't think you were able to. It aims to show you that Elements is better equipped than you were led to believe. Photoshop Elements really is the proverbial wolf in sheep's clothes.

mark galer

Location image by Dorothy Connop

Getting Started

Most users of this book will have some experience of digital imaging and Photoshop Elements, but just check the following to make sure all is in order before you start.

Note > The screen grabs in this book may vary in appearance depending on whether you are using a Mac or a PC.

Following orders

The commands in Photoshop Elements allow the user to modify digital files and are accessed via menus and submenus. The commands used in the projects are listed as a hierarchy, with the main menu indicated first and the submenu or command second, e.g. Main Menu > Command. For example, the command for applying a Levels adjustment would be indicated as follows: Enhance > Adjust Lighting > Levels. If you get stuck or are unclear, watch the movie from the supporting website and follow my mouse cursor to help you find what you are looking for.

Calibrate your monitor

If your images are going to look good everywhere – not just on your own monitor – it is advised that you calibrate your monitor (set the optimum color, brightness and contrast). I recommend that you use a 'Hardware White Point' or 'Color Temperature' of 6500 °K (daylight) and a gamma of 2.2.

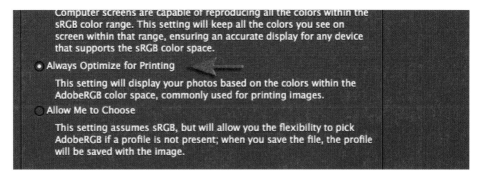

Color settings

The colors are kept consistent between devices such as cameras, computers and printers through the use of color profiles. If you intend to print your images you would be advised to go to Edit > Color Settings and then click on the radio button that says 'Always Optimize for Printing'. Elements will now use the larger Adobe RGB profile instead of the smaller sRGB profile.

Memory

You will be working on images in excess of six megapixels (the supporting website provides high-resolution images for ALL of the creative projects in this book). This professional level of image editing can place a strain on a computer's working memory or RAM. It is advised that you install at least two gigabytes of RAM (four gigabytes or more is not considered excessive when editing very large image files) so that the image editing you are about to undertake does not begin to crawl. Shut down any other applications that you are not using so that all of the available memory is made available to Photoshop Elements. Photoshop Elements keeps a memory of your image-editing process that it calls the 'History States'. The default setting in the General Preferences (Edit > Preferences > General) is 50 History States. Allowing the user to track back 50 commands, or clicks of the mouse, can again place an enormous strain on the working memory. I would recommend that you lower this figure to 20 for most editing work. This can be readjusted without restarting the software should you wish to increase Photoshop's memory for your editing actions. Just remember that the more memory you dedicate to what you have just done, the less you have available for what you are about to do. In Preferences > Performance you will see the Available RAM and the Ideal Range that can be assigned to Photoshop Elements. Adjust the slider so that you are using the top of the suggested range. Photoshop Elements will also be using your 'scratch disk' or hard drive in the image-editing process so be sure to keep plenty of gigabytes of free space available.

Give yourself some elbow room

I recommend that you keep the Photo Bin and Panel Bin closed until you need them (go to Window > Panel Bin). This will maximize the area on your screen for viewing the image you are editing. Only the Layers panel is used all of the time in advanced image editing. In the default mode it is stacked with the other panels in the Panel Bin. Locate the Layers panel and drag it out into the working area before closing the Bins. Similarly the Tools panel on the left side of the screen can be dragged to new locations so that it can be close to the action. I prefer to view the image in a window rather than in Maximize mode. This allows me to see the additional information that is displayed in the title bar together with the magnification. I like to view my images at 50% or 100% (Actual Pixels) to gain a more accurate idea of the image quality. This information is also available in the Navigator panel but, as I use keyboard shortcuts for moving and zooming in and out of images, I usually keep this panel closed as well.

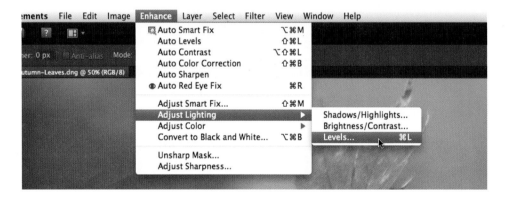

Keyboard shortcuts

Many commands that can be accessed via the menus and submenus can also be accessed via keyboard shortcuts. A shortcut is the action of pressing keys on the keyboard to carry out a command (rather than clicking a command or option in a menu). Shortcuts speed up digital image processing enormously and it is worth learning the examples given in the study guides. If in doubt use the menu (the shortcut will be indicated next to the command) until you become more familiar with the key combinations. See the 'Shortcuts' sections at the end of the book for a list of the most frequently used shortcuts.

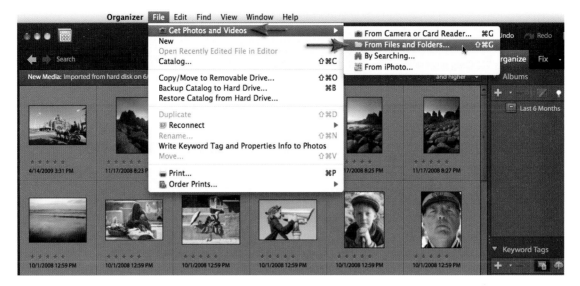

Accessing the support images and movies

Purchase and download the images and movies for the projects by going to www.markgaler.com and then clicking on the Book Resources link. Place your downloaded images and movies into a new folder on your computer. Then go to File > Get Photos and Videos in the Organizer workspace (the little camera icon) and choose the From Files and Folders option. Then locate the files you have downloaded and would like to import.

Note: **You may need to install the QuickTime movie player that is available from the link on the supporting website before watching the movies in the Organizer workspace.**

When the Get Photos and Videos dialog box opens make sure the Automatically Fix Red Eyes option is not checked (unless you need it) and then click on the Get Media button. Checking the Red Eyes option will slow down the import even if your images do not have red eye. Your images or movies will be imported and organized. Click on the Folder Location option from the Display menu in the Organizer window (top right-hand corner) to see the images as a collection. Use the keyboard shortcut Ctrl/Command + I to open any image in the Editor workspace. Double-click on any movie icon to watch the movie within the Organizer workspace.

part

1

optimize

Project 1

Adobe Camera Raw

Adobe Camera Raw (ACR) is the gateway for opening Raw images into the main editing space of Photoshop Elements, but ACR is also a great space for optimizing images quickly and easily. Many of the basic tasks such as straightening and cropping images, correcting exposure and color balance can all be achieved faster and more easily than by performing these same tasks in the main editing space of Photoshop Elements.

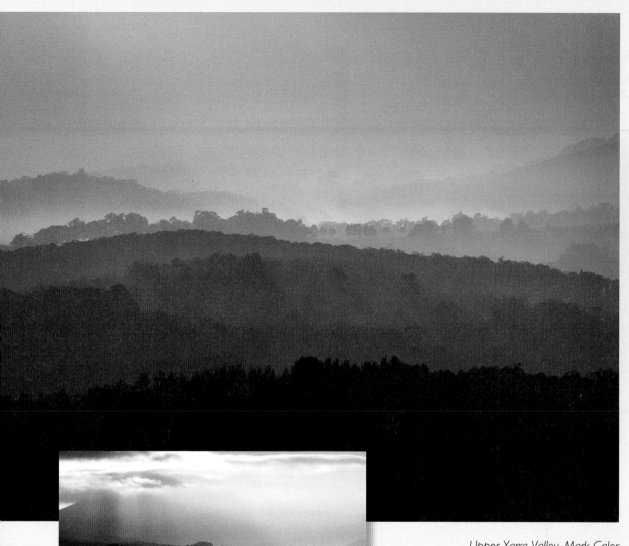

Upper Yarra Valley. Mark Galer

For maximum quality choose to optimize your images in Adobe Camera Raw

One of the best-kept secrets of Photoshop Elements is that you can also open JPEGs into the ACR editing space to access these user-friendly editing tools. If you have not yet explored the ACR interface, or are having trouble breaking old habits, then the following project is designed to make you think again.

Important Note > It is advisable to study this project thoroughly before working on the subsequent projects in this part of the book.

The Raw advantage

Most professional photographers capture images in the Raw format rather than the JPEG format. The Raw format offers greater flexibility in achieving different visual outcomes while ensuring a high-quality finished result. The JPEG file format can offer great quality so long as only minor editing is required after the image has been captured. A JPEG captured in-camera should be considered as a print-ready file while a Camera Raw file is unprocessed data that can be edited extensively in Photoshop Elements. Most professional photographers have switched from JPEG capture to using the Camera Raw format for the following reasons:

1. Extended dynamic range (great for combating the photographer's worst enemy – subjects where the lighting contrast is high).
2. Higher bit depth: having access to 12, 14 or even 16 bits per channel instead of 8 results in higher quality if you have to 'fix' the image after capture.
3. Flexible editing (why worry about the correct camera settings before you shoot when you can set them after?). The processing that is normally done by the camera (white balance, saturation, sharpening, etc.) can be carried out in Photoshop Elements after you have returned from your shoot.

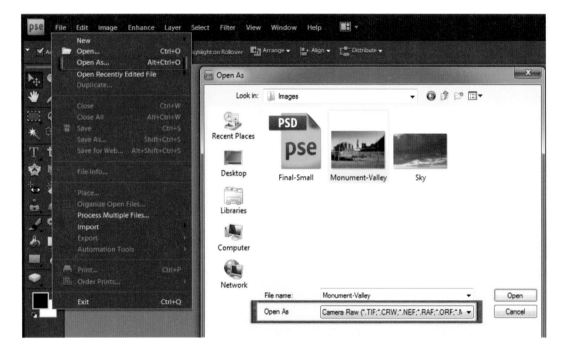

Editing JPEGs in Adobe Camera Raw

For photographers who are choosing to work with JPEG images rather than using Raw images, the Adobe Camera Raw (ACR) space still offers an advantage over the main editing space of Photoshop Elements for quick and easy editing. Adobe Camera Raw can be considered as the 'Quick Fix' space for professionals and keen amateur photographers alike. You can open JPEG images in ACR from the Edit space of Photoshop Elements to take advantage of the powerful tools in this editing space. Just go to File > Open As (Windows) or File > Open (Mac). Browse to the JPEG you want to open and then in the Open As menu choose the Camera Raw option.

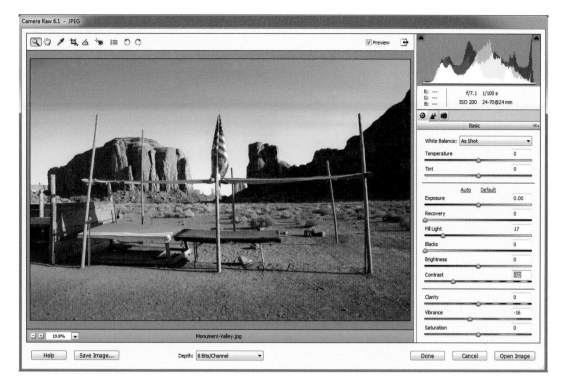

When the JPEG opens in Camera Raw you can utilize simple controls to optimize and enhance the color and tonality of your images. It is important to remember, however, that JPEGs are saved by the camera at a lower 'bit depth' to Raw images so they are less able to withstand extreme adjustments before the quality becomes compromised. JPEG files also offer the photographer less chance of being able to recover highlights that were slightly overexposed in-camera.

Adobe Camera Raw – A non-destructive workspace

Adobe Camera Raw is a completely non-destructive workspace. Any changes that you make to your image in ACR can be completely undone, allowing the file you are working on to be returned to its original state (as recorded by the camera). Even if you crop your image in ACR, the pixels are never discarded – just temporarily hidden from view. Photoshop Elements simply records any change made in ACR as a list of processing instructions (XMP metadata) that is used to modify the preview. Every time a Raw image is displayed in ACR these processing instructions are applied to the image. Changes can only be permanently made to the actual pixels of the image file if the images are saved from the main editing space or processed (File > Process Multiple Files). When the user clicks 'Done' in the main editing space, Photoshop Elements will remember the changes you have made to the image. The changes are stored in a 'central cache' or memory bank that is, in turn, saved on your computer's hard drive. Adobe Camera Raw refers to this central cache to remember how you last processed the Raw file the next time you open it. If you want another computer running Photoshop Elements to be able to preview these changes you can hit the Save Image button in the ACR dialog and save your Raw file as a DNG file. Any changes you made in ACR will now be written directly to the file as well as the central cache.

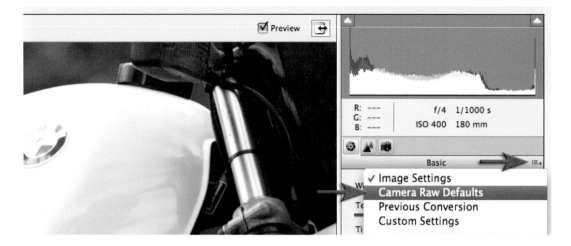

Important Note: The images used in this project are not provided in the online image resource pack. They are intended as examples to demonstrate basic adjustments that can be made using all Raw files.

Camera Raw defaults and image settings

You can choose to return to the Default preview (the original preview) at any time by clicking on the button in the top right-hand corner of the Basic tab in the ACR dialog and selecting Camera Raw Defaults from the drop-down menu. If you choose Image Settings in this menu the preview will revert to the version that started the current editing session. This will include any changes you made to the image the last time the Raw file was opened in ACR.

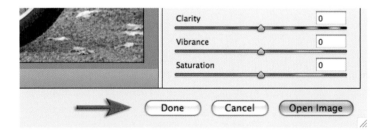

Done, Cancel or Open Image

Choosing Done in the bottom right-hand corner of the ACR dialog will save any changes you have made to either the file (JPEGs and DNGs) or an .xmp file (Propriety Raw file) and close or 'dismiss' the ACR dialog. If you choose Cancel the ACR space will close without modifying the previews, while choosing Open Image will open the selected image or images, with all of the changes you made in ACR, into the Edit space of Photoshop Elements. In addition to opening the image in the Edit space, this action also saves the ACR processing instructions to the central cache, so that the next time you open one of these images in ACR it looks just like it did when you clicked the Open Image button. Opening images into the Full Edit space will allow you to access all of the familiar features of the Edit workspace to continue the editing process.

File Naming

Example: Autumn_Leaves01.dng

| Autumn_Leaves | ▾ | + | 2 Digit Serial Number | ▾ | + |

| | ▾ | + | | ▾ | + |

Begin Numbering: 01

File Extension: .dng ▾

Format: Digital Negative

☑ Compressed (lossless) JPEG Preview: Medium Size ▾
☐ Convert to Linear Image
☐ Embed Original Raw File

PERFORMANCE TIP

Adobe has created a universal Raw file format called 'DNG' (Digital Negative) in an attempt to ensure that all Camera Raw files (whichever camera they originate from) will be accessible in the future. The Save option in the Camera Raw dialog box gives you access to convert your camera's Raw file to the Adobe Digital Negative format with no loss of quality. The conversion will ensure that your files are archived in a format that will be understood in the future. Expect to see future models of many digital cameras using this DNG format as standard. One thing is for sure – Raw files are a valuable source of the rich visual data that many of us value, and so the format will be around for many years to come.

Thumbnails and previews of DNG files when not using Photoshop Elements

When using Photoshop Elements Organizer (Windows) or Bridge (Mac) you will probably not be surprised to find that you can see thumbnails and previews of all of your DNG Raw files before you open them in Photoshop Elements. If, however, you are using the Windows or Macintosh operating systems you may not see any thumbnail views or previews for these Raw files. Windows Vista users can download and install a 'DNG Codec' from the Adobe Labs website (http://labs.adobe.com) if they wish to view thumbnails when using the computer operating system to navigate and choose images instead of their Adobe software. Macintosh users are advised to keep their Preview and iPhoto Applications up to date if they are experiencing any problems viewing thumbnails and previews. Users of Windows XP will need to install the Microsoft RAW Image Thumbnailer and Viewer before they can view Raw images outside of the Adobe Photoshop Elements software.

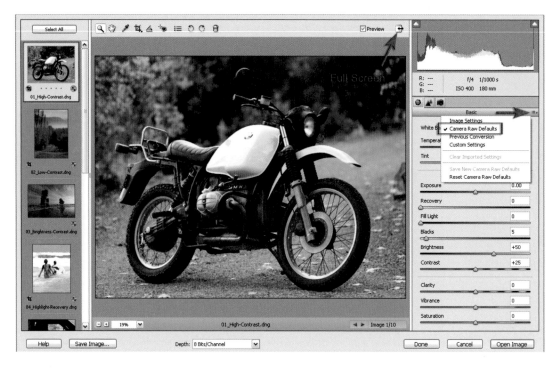

A fast and efficient workspace for editing multiple Raw files

It is possible to open multiple images into the ACR dialog at the same time (just shift-click a range of Raw images in the Organizer workspace and choose 'Edit with Photoshop Elements Editor' or Open As > Camera Raw as outlined on page 4). If your computer's operating system does not recognize the Raw file format then drag the images on to the Photoshop Elements shortcut.

Note > Opening multiple images in ACR is less draining on your computer's working memory than opening the same number of images in the Edit workspace. Your computer just has to deal with the pixels that are on the screen rather than multiple megapixels of the files.

Managing your screen real-estate

Thumbnails of all the open files are displayed on the left side of the dialog – just click one of the thumbnails to display a large preview of the image. This column of thumbnails can be temporarily hidden from view by dragging the central divider to the left to increase the working area in the middle of the dialog. In the top-right corner of the dialog you can see a histogram that relates to the color and tone of the image you are viewing. This histogram is like the one you can access on the LCD screen of most good-quality cameras. This histogram has useful information about the color and tonality of your image. The beauty of the ACR space is that this is by far and away the best place to optimize the histogram to make each and every photograph you edit appear at its absolute best so that the world recognizes you for the wonderful photographer that you are. Click on the tiny icon just to the left of this histogram so that the ACR dialog goes full-screen. Professional photographers spend a lot of time in this dialog so make the most of this feature and give yourself some elbow room!

Checking exposure in Adobe Camera Raw

Above the histogram there are two triangles. These are the Shadow and Highlight clipping warning controls. The term 'clipping' is used by Adobe when the pixels in the red, green or blue channels, the three channels that make up an RGB image, are registering either level 0 or level 255 in one or more of the three channels. When there are pixels in the image that are registering level 0 in all three channels then the pixels in the image preview will appear as absolute black and the Shadow clipping warning triangle (the one on the left) will turn white. When there are pixels in the image that are registering level 255 in all three channels then the pixels in the image preview will appear as absolute white. The Highlight clipping warning triangle on the right will again appear white when this happens. When a shadow or highlight in the image is made up of pixels that are all level 0 or 255 then the surfaces will not have any detail. Shadows or highlights that do not have any surface texture or detail are referred to as being 'clipped' and this is usually regarded as a flaw by photographers, whose goal is generally to preserve as much detail as possible. Clipping may occur due to overexposure or underexposure in-camera or due to excessive contrast in the scene that was photographed. It is not uncommon for wedding photographers, for instance, to experience problems of clipping when photographing the bride and groom in sunny locations. They may review their images only to find that neither the bride's white dress nor the groom's dark suit has any detail. I often refer to level 0 and level 255 as the goal posts between which photographers must aim to squeeze all of their tonal information.

Activating the clipping warning in the image preview

If staring at the color of tiny triangles does not give you a lot of feedback about what is actually happening with the shadows and highlights within your image then try clicking the clipping warning triangles. Notice how the shadows or highlights in your image preview that are clipped are replaced with the color blue (for clipped shadows) or red (for clipped highlights). Click on either triangle to leave the warning on so that you can move your mouse cursor away and still retain warnings within the preview image.

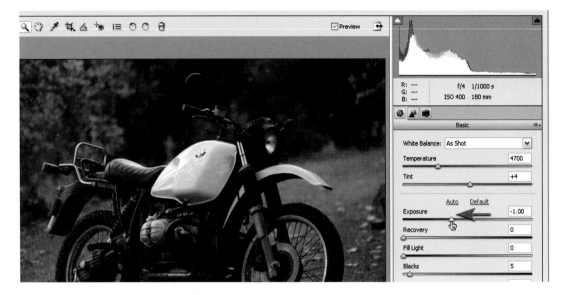

1. Adjusting exposure in Adobe Camera Raw

In the Basic tabbed panel (below the histogram) is an Exposure slider. This slider can be used to control the brightest pixels in the image file. Moving the slider to the left will lower the exposure and quite often pixels in the image that were shown to be clipping can be brought back behind the 255 goal post so that the highlight tones are now filled with tone and texture. Notice in the image above how with a one stop (-1.00) lowering of exposure the fuel tank on the motorcycle is no longer clipped and the clipping warning triangle turns black. The highlights have effectively been restored to this image. This is usually only possible with files that were captured using the Raw file format or processed as a JPEG in-camera using a dynamic range optimizer setting if available. It may not always be possible to save overexposed highlights but Raw shooters may have one or two extra stops of highlight headroom compared to JPEG shooters. The image is now a little dark due to the one stop exposure adjustment but this can be fixed later using the Brightness slider.

Auto and Default

Click on the underlined blue Default option directly above the Exposure slider to return all the adjustments in the Basic tabbed panel back to their default settings or double-click on the slider control to return this single Exposure slider back to its default setting of 0.0. If you click on the Auto setting for the image above you will see that ACR tries to recover some (but not all) of the overexposed highlights using the Recovery slider instead (the one below the Exposure slider). We will look at this alternative approach to recovering highlight detail later in this project.

Set the white point using the Exposure slider

Use the Exposure slider in ACR as a White Point slider. If you are used to using Levels in the main editing space of Photoshop Elements then this slider can be likened to the one under the extreme right-hand side of the histogram. It is used to ensure the brightest pixels in the image are touching, but not pushed beyond, the level 255 goal post.

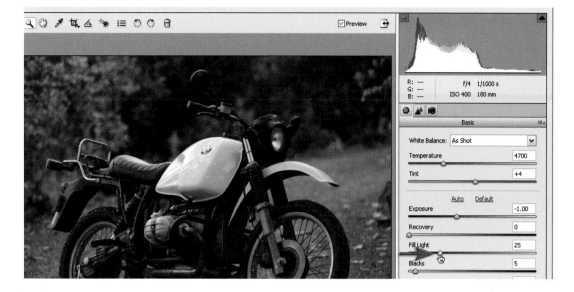

Set the black point using the Blacks and/or Fill Light slider

We can restore the shadow detail in this image using the Fill Light and Blacks sliders (below the Exposure and Recovery sliders). Technically it is the Blacks slider that controls the black point in the image. We could drag this left so that the darkest tones do not clip to black. This approach, however, often leads to blacks with detail but that appear weak and without depth. If you move the Fill Light slider to the right to recover the shadow detail, instead of moving the Blacks slider to the left, the shadows will usually appear to have a lot more depth.

Note > You will notice that no matter how far you move the Fill Light slider to the right you will never be able to make the Shadow clipping warning triangle turn black. The clipping warning will remain blue from the time the slider is moved beyond +20, indicating that the blue channel will remain clipped no matter how far the slider is moved. You will, however, notice that there is no blue clipping warning in the preview image itself. The blue channel is not being clipped because of how dark the shadow tones are but because of how saturated or vibrant some of the leaves are in the background behind the motorcycle.

PERFORMANCE TIP

Excessive adjustment using the Fill Light slider can lighten the shadow but can also reveal the greater amounts of noise that lurk in the shadows. My advice would be to keep the Fill Light value below 35 and keep the camera's ISO setting low to avoid this problem. Keeping the camera's ISO low also keeps the noise in the image file low and the dynamic range of the sensor (the ability to record a range of brightness values) high.

PERFORMANCE TIP

Hold down the Alt key (PC) or Option key (Mac) while clicking on the Blacks or Exposure sliders to give you a 'threshold' view in the preview window in order to obtain a more precise clipping warning. The threshold view will render the image preview entirely black or white except for where there is clipping. Instead of the regular blue and red clipping warnings you are now presented with a broader range of clipping colors to alert you to luminance clipping (all three channels) or whether the clipping is a result of very vibrant or saturated colors clipping. The issue of color saturation and clipping is dealt with later in this project.

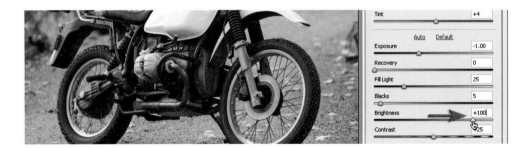

Gamma adjustments

After setting the white and black points using the Exposure and Fill Light sliders you can then dial in your preferred brightness or 'gamma' value for the image. The Brightness and Contrast sliders will usually leave the black and white points where they are and so these adjustments can be considered non-destructive tonal controls, i.e. they are slow to clip tonality after first setting white and black points. If you see any highlight clipping warnings after raising the brightness, return to either the Exposure or Recovery slider to fine-tune the white point.

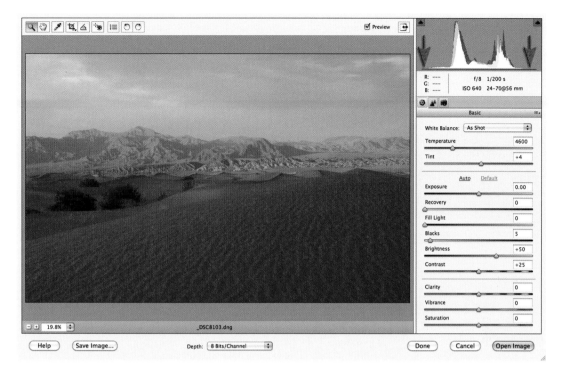

2. Correcting a low-contrast image

This image has the opposite tonal problems to the previous one. If you see a yellow warning triangle in the image preview window it is telling you that ACR is building a better preview from the data found in the Raw file. This time instead of having to recover shadow and highlight detail we have to expand the subject brightness range (SBR) or contrast. The original contrast was lost due to a combination of using a telephoto lens and the early morning mist.

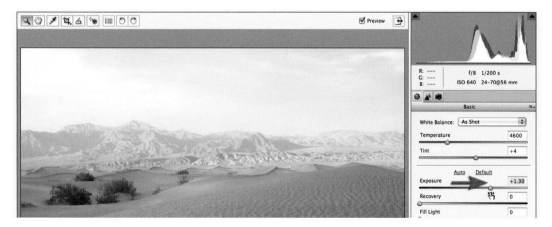

Re-establish a white point by dragging the Exposure slider to a point just before the highlight clipping warning indicates that you have overcooked or clipped the brightest tones in the image (up to 1.5 stops brighter than the original in-camera exposure used to capture this image).

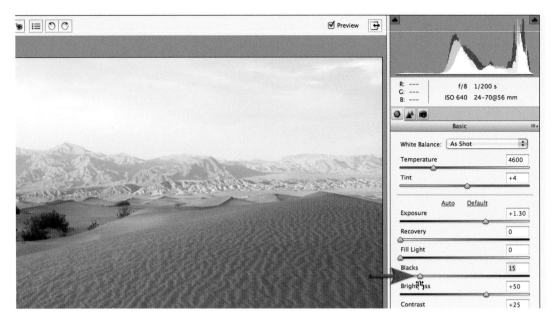

Re-establish a black point by dragging the Blacks slider to a point just before clipping occurs. You have now effectively expanded or stretched the histogram of the file to touch level 0 and level 255. The higher bit depth of the camera's sensor makes this possible without lowering the quality of the outcome (JPEGs are less forgiving).

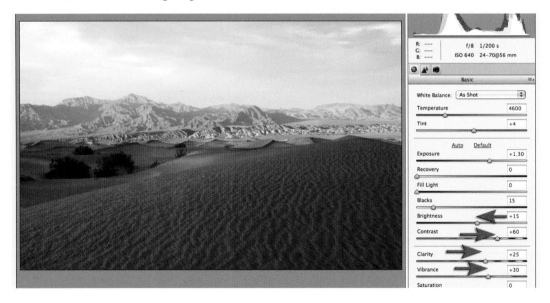

It is now possible to lower the Brightness slider and raise the Contrast slider without upsetting the black or white points of the image. Raise the Clarity slider to improve detail and depth and raise the Vibrance slider to the right to increase the saturation of the colors. The Vibrance slider is less likely to cause saturation clipping compared to using the Saturation slider for this task. Compare the use of the Vibrance slider to the Saturation slider while observing the clipping warnings.

PERFORMANCE TIP

Is saturation clipping a bad thing? If we hold down the Alt key (PC) or Option key (Mac) and then click on the Blacks slider we can see the yellow colors are clipped. The reality is that when colors clip in one or two channels they will have slightly less texture than if they were processed to have information in all three channels. If, however, we value a vibrant appearance more than texture we must sacrifice texture for color. This is a subtle difference, so many viewers will fail to notice that the clipped colors they are looking at are slightly 'flat' (without a lot of texture) when compared to less vibrant colors that were not clipped. If we are printing to high-end print service providers or using high-quality inkjet printers then it is important to go to Edit > Color Settings in the main Edit space of Photoshop Elements before we open and process images in ACR. Choose Always Optimize for Printing in the Color Settings dialog. This informs ACR that you want to open files in the larger Adobe RGB color gamut rather than the smaller sRGB color gamut that is more suitable for most computer monitors and the cheap-and-cheerful print service providers (consult your own print service provider if you are not sure which yours fits into). If you choose to use the larger Adobe RGB color gamut you will have the advantage of being able to use more vibrant colors that clip less easily, i.e. you can enjoy vibrant colors with good detail and texture.

Note > If you choose the larger Adobe RGB color gamut then you must always remember to convert your images to the smaller sRGB color gamut (Image > Convert Color Profile) when uploading the files to web galleries and sharing the files with people who do not use Photoshop Elements to view their images. If you forget to convert your colors to sRGB the colors will appear less saturated.

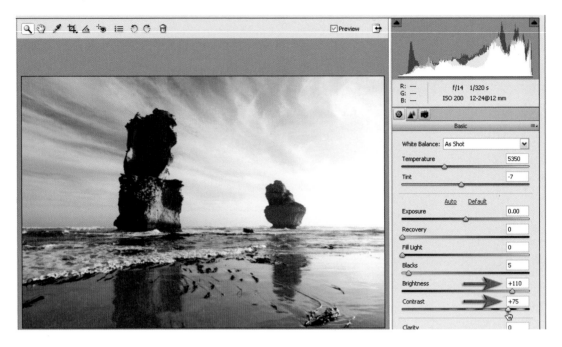

3. Brightness and contrast

The Brightness-Contrast image can be optimized without the need to set a black or white point. The brightness range of the subject captured by the camera matches the dynamic range of the image sensor. In order to avoid overexposing the highlights in-camera, the exposure was reduced at the time of capture. This has led to an image that is slightly dark and also lacking in contrast and vibrancy. To correct these shortcomings the Brightness and Contrast sliders can be dragged to the right to bring this image back to life. These adjustments are largely 'subjective', i.e. there is no right or wrong.

The Vibrance slider in this instance does not cause any saturation clipping when used to achieve the desired effect. If you require a brighter, more saturated outcome than the one shown you will need to raise the Recovery slider slightly to ensure you don't lose some of the subtle highlight tones in the sky.

4. Straightening an image

Straightening an image in ACR is very easy. Select the Straighten tool at the top of the ACR dialog and then find any horizontal line in the image (such as the horizon line as pictured in the illustration above). If you don't have a horizontal line in an image you are straightening you can select a vertical line so long as it is at, or near, the center of the image (so that you avoid using a vertical that is subject to perspective convergence). Then click and drag along the line while holding the mouse button down. When you let go of the mouse button the image is immediately rendered straight using the minimum amount of cropping.

Click on the Zoom or Hand tool to escape from the crop view so that you can see the image straightened in the ACR dialog. The cropped pixels that are hidden from view can be reclaimed at any time by going to the Crop tool and then selecting Clear Crop from the drop-down menu (this action also undoes the straightening effect, putting things back the way they were). You can also press the Enter key to escape from the crop view.

5. Highlight recovery

As discussed previously there are two workflows that can be employed for recovering highlight detail. The first option we looked at, where we lowered the exposure and increased the brightness, usually gives superior results to the single Recovery slider option. As we can observe in the examples above, the first option gives slightly better midtone contrast with slightly improved highlight detail. This workflow, however, is usually only superior when working with images that have the detail from the dynamic range headroom that Raw files possess. The Recovery slider really comes into its own when one or more channels are truly clipped, as would be the case with overexposed JPEGs.

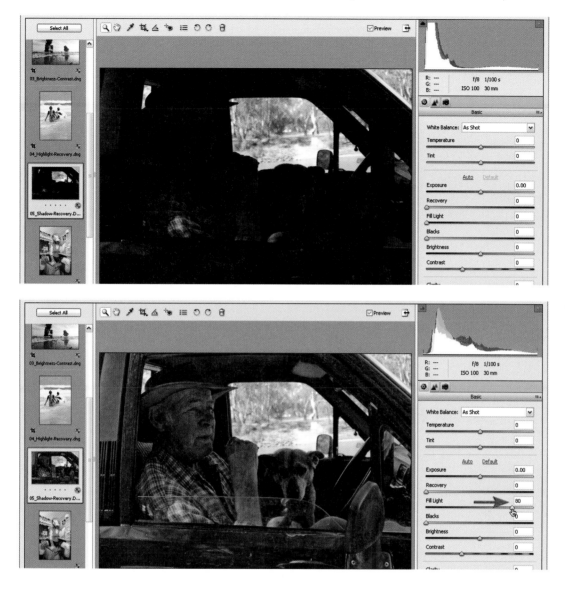

6. Shadow recovery

Great care needs to be taken when using the Fill Light slider to rescue dark shadow tones. In the image above an extreme adjustment is being made to rescue the shadow tones that have been accidentally underexposed due to the bright tones in the center of the viewfinder. Notice how the shadows are slow to clip in such an underexposed file. The shadow tones are moved away from the left-hand wall of the histogram quite easily with the Fill Light slider. With such a heavy application of the Fill Light slider you may find the color saturation becomes excessive so this will need to be addressed using the Saturation or Vibrance sliders.

Note > Be careful with raising the Fill Light value too high, especially with photos taken with a high ISO setting. Fill Light will also brighten noise in the photo and make it more apparent. Photos taken at a lower ISO will be more forgiving to the Fill Light slider.

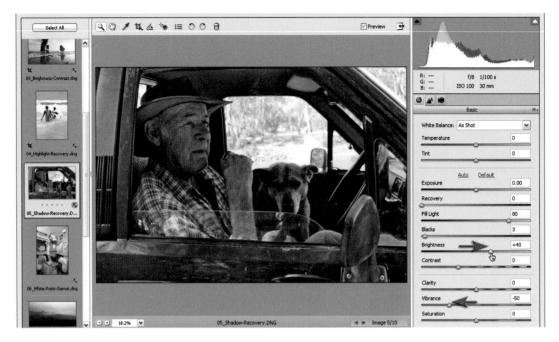

The brightness is raised and the vibrancy reduced to complete the editing of this underexposed file. If you take a look at the Highlight clipping warning there is an indication that there are overexposed highlights in the image. This DNG file, however, was converted from a JPEG file that was processed in-camera and would therefore require the Recovery slider to be used to restore any detail in these brighter areas.

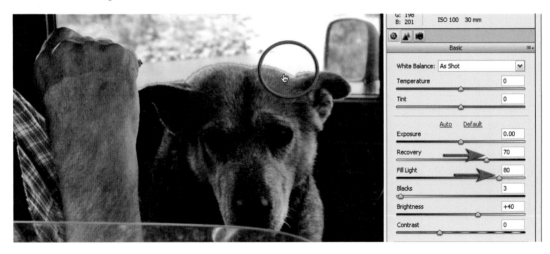

The problem with raising the Recovery slider and Fill Light sliders to high settings in the same image file is that high-contrast edges can acquire edge artifacts. In the image above a dark outline appears around the high-contrast edges in the image. A more pleasing result can be achieved in this instance if the file is opened in the main editing space and the Shadows/Highlights adjustment feature is used instead (go to Enhance > Adjust Lighting > Shadows/Highlights).

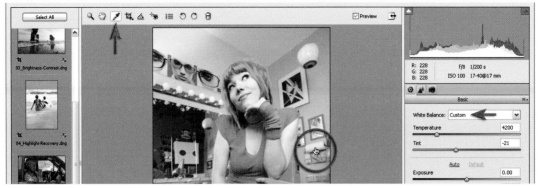

Image of Melissa Zappa courtesy of Victoria Verdon-Roe

7. Gamut control and white balance

In the image above, much of the clipping warning you see when you first open the image is due to colors that are out-of-gamut rather than any luminance clipping. Many of the colors are simply too saturated to be contained by even the larger Adobe RGB gamut. It is, however, possible to put all of these colors back into the gamut with a little bit of care and attention. The first step is to ensure that these warm orange and yellow tones are no warmer than they really need to be (due to a slightly inaccurate Auto White Balance setting in-camera). I have selected the White Balance tool at the top of the ACR dialog and then clicked on the kitchen roll paper hanging on the wall to the right of the image.

Note > If you have not changed your Color Settings in the main Edit space of Photoshop Elements (Edit > Color Settings) to Always Optimize for Print then you may not be able to pull colors back into the smaller sRGB color space in many images.

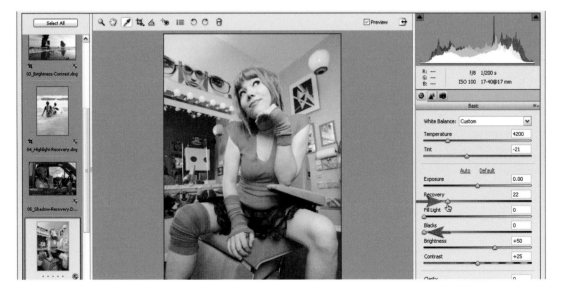

The Recovery slider in this instance is useful for pulling the out-of-gamut colors at the 255 end of the histogram back into gamut, while moving the Blacks slider to 0 will take care of the out-of-gamut colors at the level 0 end of the histogram.

8. Correcting the white balance across a batch of images

As we have seen with editing the previous image, it is sometimes quicker to use the White Balance tool in the ACR interface to color-correct an image by simply clicking on a neutral tone within the image to set the correct color temperature and tint.

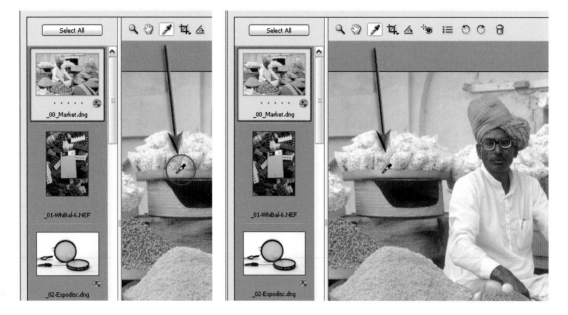

If the subject you wish to capture does not have an obvious neutral tone then you can introduce a neutral tone as a reference point in the first image of the shoot. This will enable you to measure the precise temperature and tint required to color-correct all the other images that share the same lighting conditions.

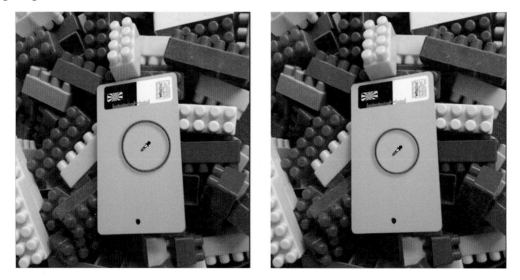

In this image a white balance card (a 'WhiBal' is used in the image above) has been introduced into the image; the White Balance tool is then used to set accurate temperature and tint settings.

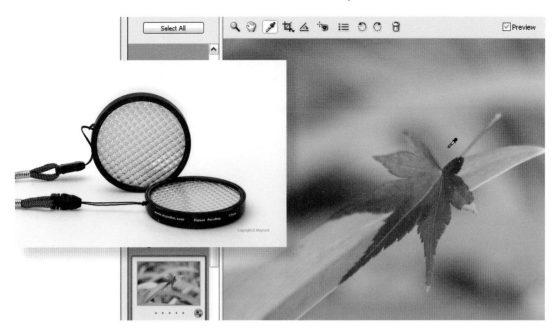

In some scenes there may be no neutral tones to click on and no opportunity to include a white balance reference card in the scene. In these instances it is important to either create a custom white balance setting in the camera at the time of capture or capture a reference image using a product such as the 'Expodisc'. The Expodisc is placed in front of the lens and an image captured by pointing the camera back towards the light source (with the camera set to manual focus). The resulting image provides the photographer with a reference image that can be used to assign the correct white balance to all of the images captured in those lighting conditions.

When you want to assign the correct white balance across a group of images, select multiple Raw files in the Organizer space (PC) or Bridge (Mac) and then open them in the ACR interface.

Select a reference image from the thumbnails on the left-hand side of the ACR interface. Then hold down the Shift key and click on the last thumbnail in the group of images that share the same lighting conditions. Select the White Balance tool and click on the main reference image preview to assign the correct white balance to all of the images.

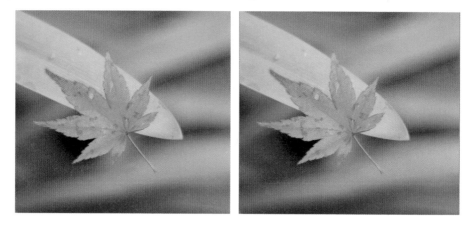

These before and after images of autumn leaves clearly demonstrate how the Auto White Balance setting in the camera has misjudged the correct white balance.

Note > The Expodisc can also be used to create custom white balance settings in the camera, to take accurate incident light meter readings and also to help locate any dust on the camera's sensor (go to www.expodisc.com for more details about this useful product).

PERFORMANCE TIP

As long as the photographer takes frequent reference images as the lighting conditions change (e.g. cloudy, sunny, time of day, etc.), color accuracy is assured with just a few clicks. Remember this color accuracy can only be fully appreciated if both computer monitor and printer are calibrated to display accurate color.

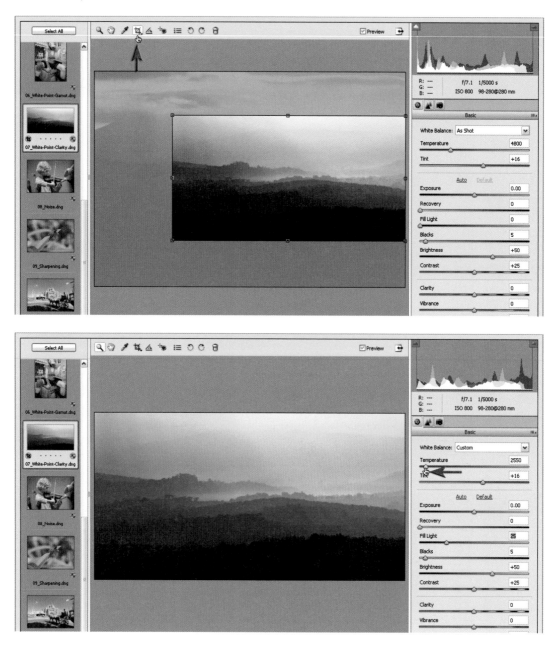

9. Creative use of white balance to tone an image

In the illustration above the Crop tool has been used to crop into the most interesting aspect of this landscape. Even with this more dramatic crop the original white balance of the camera does not capture the mood of the cold winter morning in the valley. Instead of clicking on a neutral tone within the image with the White Balance tool (to create a neutral white balance) the Temperature slider has been lowered to something just above freezing by dragging it to the left! This had induced some extensive saturation clipping but now expresses the mood I am after.

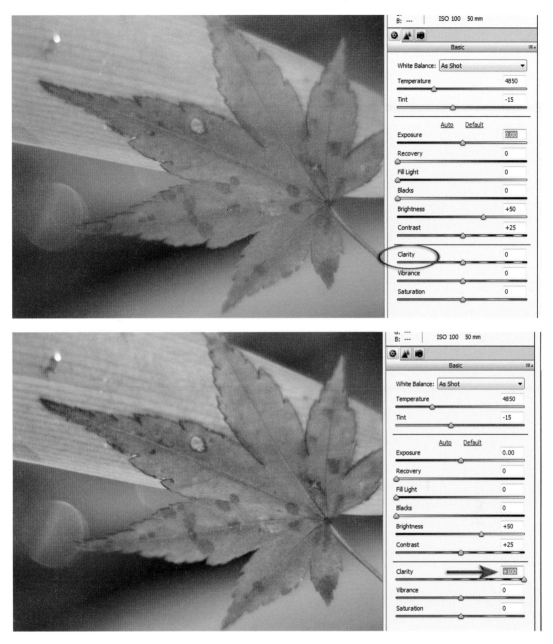

10. Clarity

The Clarity slider can be used to effectively increase localized contrast and give images more apparent depth (and sometimes make them a little sharper). Notice how contrast is raised both in the areas of fine detail and the broader areas of continuous tone. Unlike the Recovery and Fill Light sliders, which have to be used in moderation, this slider is slow to introduce unpleasant artifacts – especially in images where the light quality was soft and even.

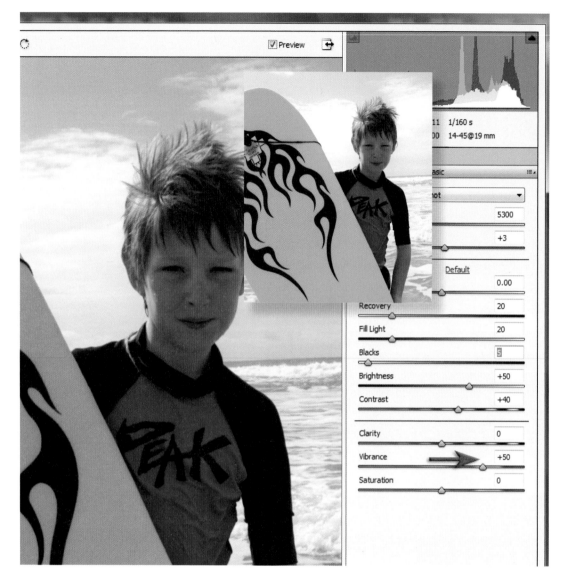

11. Vibrance

Increasing saturation in ACR can lead to clipping in the color channels. Clipping saturated colors can cause a loss of fine detail and texture. The Vibrance slider applies a non-linear increase in saturation (primarily targeting pixels of lower saturation rather than colors that are already vibrant). This adjustment feature has also been designed to protect skin tones from becoming oversaturated and unnatural. The Vibrance adjustment feature should lead to fewer problems when compared to the Saturation control and should be used for most situations where increased color saturation is required.

Note > Choosing Adobe RGB in the Color Settings dialog box in the main editing space (Edit > Color Settings) will provide a working space with a larger color gamut than sRGB. This will allow saturation or vibrance to be increased to a greater degree before clipping occurs.

12. Detail tab (sharpening and noise reduction)

Zoom to 100% and click on the Detail tab (next to the Basic tab) to access the Sharpening and Noise Reduction controls. The Sharpening controls can be left at their default settings if you intend to implement the advanced sharpening techniques (see Project 7) or use the techniques outlined on pages 32-3 (if you wish to apply sharpening settings to a batch of images). The Luminance smoothing and Color Noise Reduction sliders are designed to tackle the camera noise that occurs when the image sensor's ISO is raised.

In the image above, the camera's ISO was set to 6400 (a Nikon D700 DSLR). Both luminance and color noise are evident when the image is viewed at 100% and the Color Noise slider is set to 0. When cameras are set to 100 or 200 ISO it may be possible to leave the Luminance slider at 0 as noise will be low or non-existent. Most files (even the ones captured at low ISO settings) benefit from a small amount of color noise reduction. Be careful not to apply too much, though, as this will steal color from the finer details within the image.

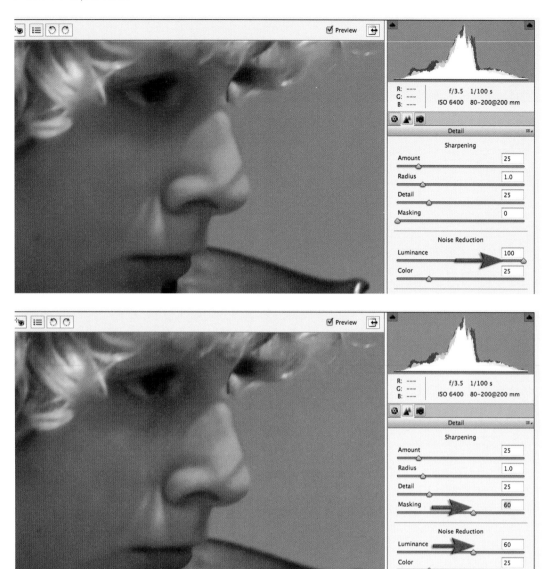

Luminance noise reduction

It is important to remember that the Noise Reduction controls are called 'noise reduction' and not 'noise elimination'. If we drag the Luminance Noise slider too far to the right we will take away too much detail from the image and render the tones too smooth (see the illustration at the top of this page). It is also important to remember that the noise appears a lot bigger now that we are looking at the image at 100% (Actual Pixels) compared to how we will view the image in a screen presentation or a full page print. I am happy to just use a moderate amount of noise reduction (perhaps no more than 60) on my images captured at ISO 6400 in the full knowledge that the images will look reasonably detailed and smooth at 'normal' viewing sizes. So that we don't sharpen the areas of smooth tone, where the noise will be most visible, it is also advisable to drag the Masking slider (directly above the Luminance slider) to a value of around 60.

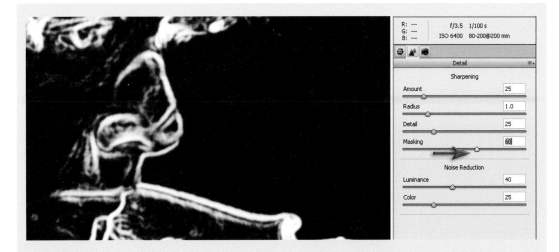

PERFORMANCE TIP

Hold down the Alt key (PC) or Option key (Mac) to see a Threshold view of the masking process. Any areas of the image that appear black will be shielded from the sharpening process.

13. Sharpening multiple files

Just as a white balance setting can be applied across multiple images open in ACR, the same batch processing can be achieved when sharpening images. Although the sharpening controls have vastly improved in the ACR interface, it is still recommended that you sharpen in the main editing space to achieve maximum performance when sharpening (see Project 7 – 'Sharpening').

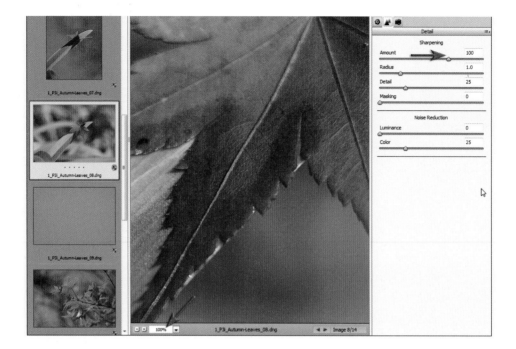

Set the magnification to 100% before sharpening any image in ACR as the results are not visible at smaller magnifications. Start by increasing the Amount slider until the edges that have the most contrast are suitably sharp. Amounts up to 100% are considered normal. If you hold down the Alt/Option key and click and drag the Amount slider the preview is displayed in black and white, which makes it easier to see the effects of the Amount slider. Generally it is recommended to leave the Radius slider at its default setting of 1.0.

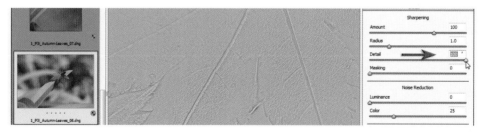

Hold down the Alt/Option key and drag the Detail slider to the left or right to observe the amount of detail that will be targeted for sharpening. Drag to the right to increase detail in the areas of continuous tone and to the left to decrease apparent detail. Let go of the Alt/Option key to observe the effect on the image.

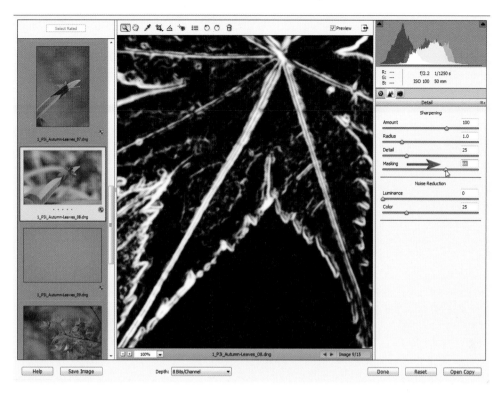

To eliminate the sharpening process from areas of continuous tone we can drag the Masking slider to the right. Hold down the Alt/Option key as you drag this slider to observe the areas of the image that will not be sharpened (as indicated by the black mask).

To apply these settings to the other images in the shoot simply choose the Select All option above the thumbnails on the left side of the ACR interface. The numbers for each slider will be blank if the settings are not the same for all of the selected images. Click on each slider in turn to sync the sharpening settings for all images. Click on Done to apply all of these changes and close the ACR dialog box. Select Save to process the files using the current Raw settings or select one or more images to open in the main editing space of Elements.

Note > Sharpening and other corrections applied over a batch of images may not always be desirable for every image. Check each image in turn to see if specific adjustments are required.

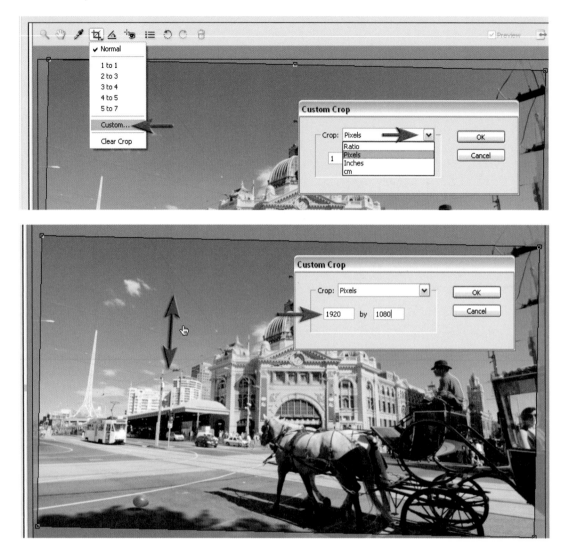

14. Cropping
Cropping an image to a specific output size

In Step 4 ('Straightening an image') we saw how images can be cropped automatically in ACR using the Straighten tool. It is also possible to crop to a particular shape or 'aspect ratio' using one of the presets in the Crop drop-down menu. If you select Custom you can also crop to a particular size as well as a particular shape. Select Custom in the Crop menu and then choose pixels, inches or cm from the Crop drop-down menu in the Custom Crop dialog. In the illustration above I have selected pixels and then entered 1920 by 1080 in the Width and Height fields (the dimensions of a wide-screen full-HD TV). Select OK and then click and drag the cropping marquee over the image to establish a cropping rectangle of the ratio of the two pixel fields. You can then move the crop bounding box inside the image area to fine-tune the design. When you click on the Hand or Zoom tool the rest of the pixels will be hidden from view. You can also press the Enter key to execute the crop, while pressing the Esc key backs out of the crop altogether.

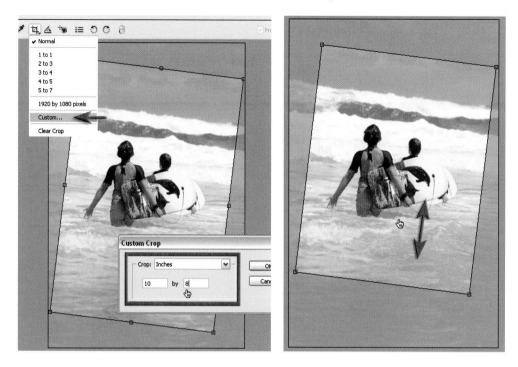

Cropping an image for print

If you return to the highlight-recovery image from Step 5 and click on the Crop tool at the top of the ACR dialog you will see the pixels that were previously hidden from view. If you now select Custom from the Crop drop-down menu and choose inches from the Custom Crop dialog, you will be set to crop the image for a print output size rather than for the screen. I entered in 10 by 8 in the Width and Height fields to create a typical print size and then clicked and dragged inside the crop bounding box to perfect the composition. Note how the horizon line stays parallel to the top edge of the bounding box. The image can be rotated if required by moving your mouse cursor to a position just outside one of the corner handles of the crop bounding box and then clicking and dragging to rotate. Click on the Hand or Zoom tool in the ACR dialog to once again hide from view the pixels that lie outside the bounding box.

15. Processing files that have been optimized

If you click the Done button at the base of the ACR dialog, all of the changes you have been making to these files are saved. The Raw files cannot, however, be printed or displayed in web galleries or screen presentations unless the files are processed as TIFF, Photoshop or JPEG files. This process can be handled by going to the main Edit space in Photoshop Elements and then going to File > Process Multiple Files. In the Process Multiple Files dialog you can browse to your folder of Raw files and then process the files to any format of your choosing. The original Raw files will remain unchanged.

Note > Remember that the processed files will carry the profile as directed by the Color Settings dialog (Edit > Color Settings) at the time you process the files – either sRGB or Adobe RGB.

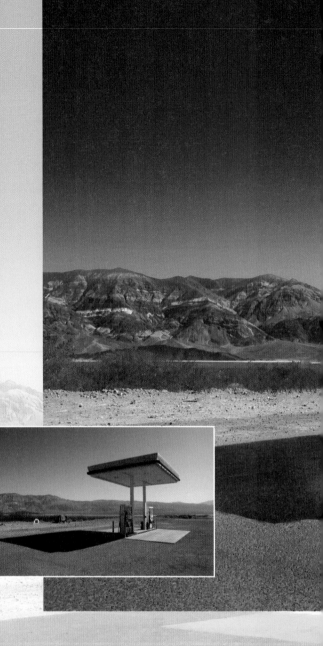

Project 2

Basic Retouching

Sometimes it is not enough just to optimize an image in Adobe Camera Raw (ACR). To achieve maximum performance from our editing software we occasionally need to fine-tune the optimization process by opening the image in the main Edit space of Photoshop Elements and finishing the job using some localized, rather than global, editing techniques.

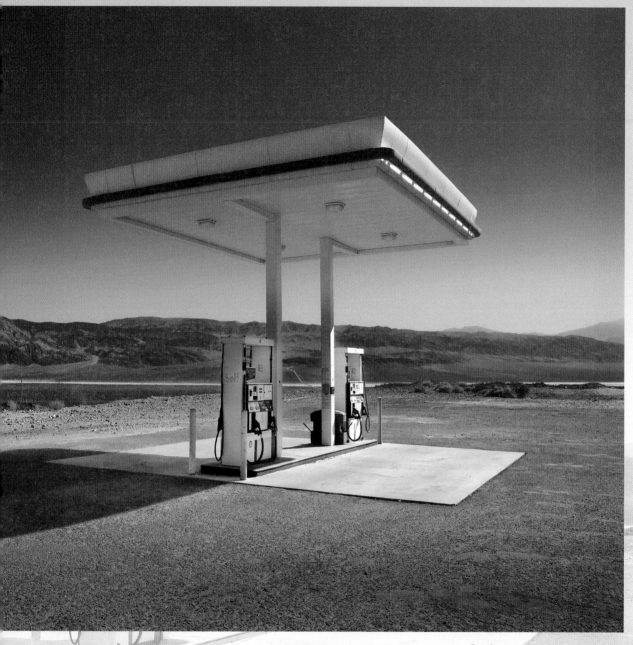

Gas Station, Nevada. Mark Galer

This tutorial guides you through the process of editing non-destructively using a series of adjustment layers, image layers and layer masks. By adopting a non-destructive workflow we can maintain maximum quality and ensure that for every adjustment of color or tone we have a controlling layer that can be re-adjusted or removed at any time.

Color settings

In the full version of Photoshop users have the choice to open an image from Adobe Camera Raw into the Edit space using either the larger Adobe RGB profile or smaller sRGB profile. Photoshop Elements users do not have the option in Adobe Camera Raw to choose a profile but they can ensure that images are opened in the larger Adobe RGB space by going to Edit > Color Settings and choosing Always Optimize for Printing prior to opening Raw images. If after editing the image in the larger color space you decide to post the image to the web (using the smaller color profile) you can always change the setting from Adobe RGB to sRGB by going to Image > Convert Color Profile and choosing sRGB. This will ensure the colors remain accurate when viewed on the web.

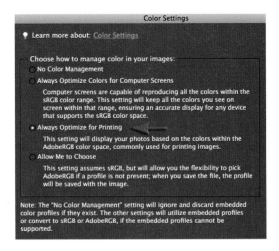

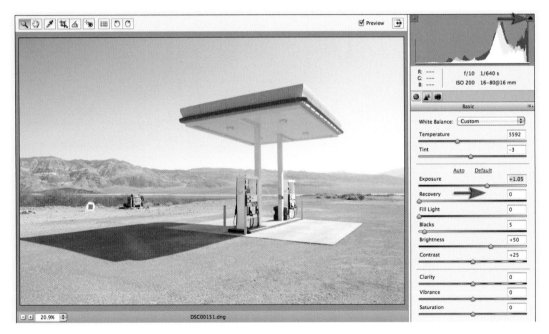

1. Open a Raw image into Adobe Camera Raw (ACR). Sometimes it is worth seeing if ACR can optimize an image by simply clicking on the Auto button (just above the Exposure slider) but the result of taking this course of action for this image would just result in a muddy mess. To optimize the white point for this image I have dragged the exposure slider to the right until I see the black 'Highlight clipping warning triangle' above the right side of the histogram turn white or another color. I have moved the slider back slightly until the triangle turns black again.

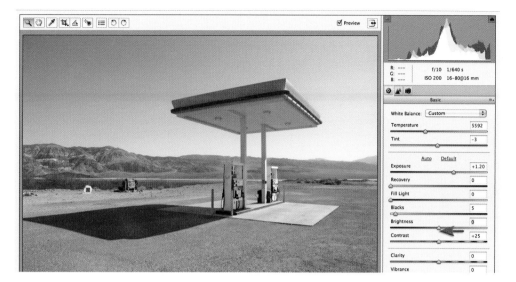

2. In this step I have lowered the Brightness slider to 0 to re-establish the 'gamma' or midtone brightness. The result will be improved contrast values throughout the file. After lowering the Brightness slider I may need to return to the Exposure slider to fine-tune the white point adjustment.

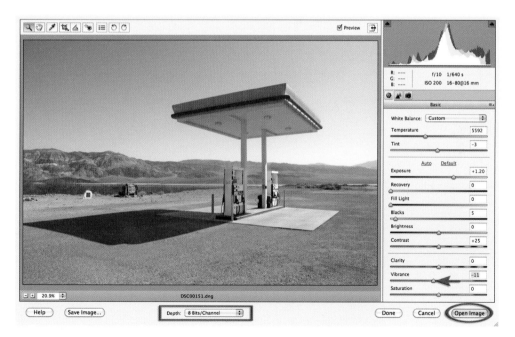

3. The tall blue line on the left side of the histogram shown in Step 2 and the illuminated 'Shadow clipping warning triangle' indicate saturation clipping. The yellow colors are too vibrant for the color gamut of Adobe RGB. These colors can be brought back into gamut by lowering the Vibrance slider to −11. I have set the Depth to 8 Bits/Channel and then selected Open Image to open the image into the main Edit space of Photoshop Elements.

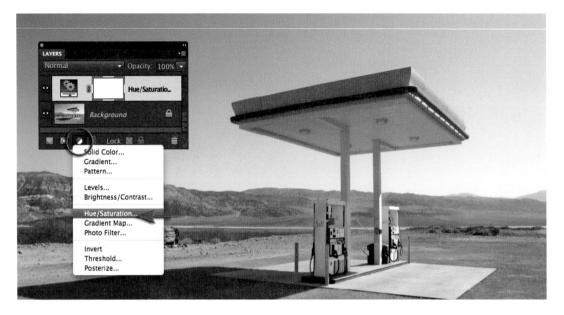

4. In the next three steps I will modify the luminance values of the blue sky and the yellow colors in the image. I have clicked on the Create new fill or adjustment layer icon at the base of the Layers panel and selected Hue/Saturation from the menu. These adjustments are also available from the Enhance menu but they are applied directly to the pixels. Using adjustment layers is a less destructive way of applying adjustments.

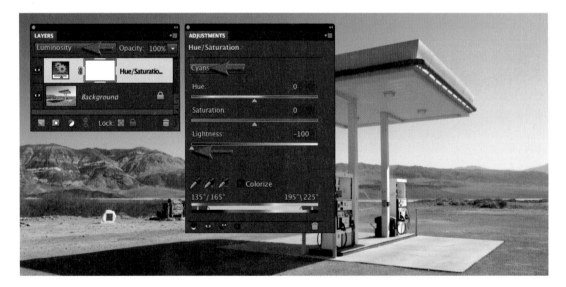

5. I have set the mode of the layer to Luminosity and selected Cyans from the menu in the Hue/Saturation dialog. I have dragged the Lightness slider to –100. I have repeated the process after selecting 'Blues' from the menu. The Luminosity mode applied to the adjustment layer ensures that when the Lightness slider is moved, the saturation values of the colors being adjusted remain constant.

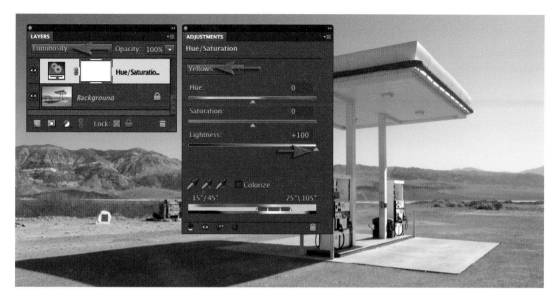

6. I have now selected the Yellows from the menu and raised the Lightness slider to +100. This is as far as we can adjust the luminance values using the Lightness slider in the Hue/Saturation dialog. If we need tones to be darker or lighter we will have to use an alternative adjustment feature and mask the other colors to protect them from the adjustment.

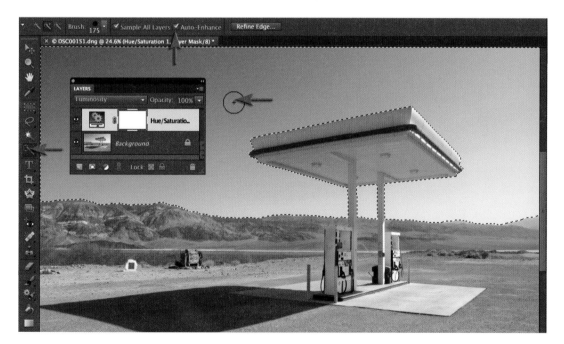

7. To prepare a mask I have selected the Quick Selection tool from the Tools panel and checked the Auto-Enhance option in the Options bar. I have then clicked and dragged the tool over the sky to make a selection of this area of the image.

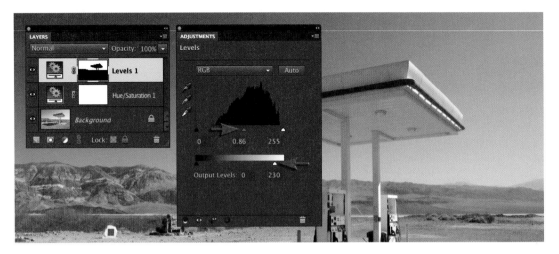

8. I have selected a Levels adjustment layer from the Create a new fill or adjustment layer menu at the base of the Layers panel. Moving the slider directly underneath the histogram to the right will darken the sky even further. As I darken the image the saturation values of the sky will also climb. Dragging the highlight Output Levels slider to the left will reduce the luminance of the highlights on the horizon line and protect the saturation levels of the darkened sky. Switching the mode of the adjustment layer to Luminosity would be an alternative way of modifying the luminosity without raising the saturation. This option, however, would retain the luminance values of the brightest tones.

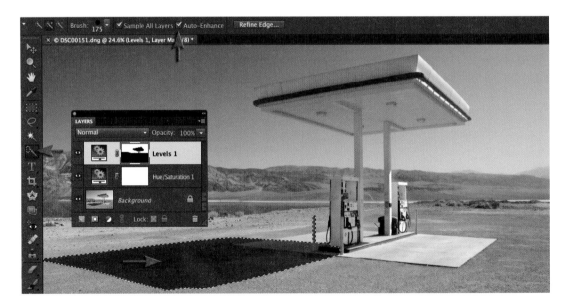

9. The Quick Selection tool has been used to make a selection of the shadow area of the image. If I accidentally select any areas that are not the shadow I can hold down the Alt key (PC) or Option key (Mac) and drag over any area that I want to remove from the selection.

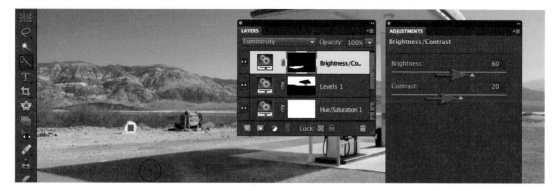

10. I have selected a Brightness/Contrast adjustment layer from the Create a new fill or adjustment layer menu at the base of the Layers panel. Although Brightness/Contrast is a very simple adjustment feature it can lighten the shadows and increase the localized contrast in this area quite effectively. A long time ago the Brightness/Contrast adjustment in Photoshop had a destructive tendency (it would clip highlight and shadow detail), but these days the behavior is as it should be (progressive rather than linear).

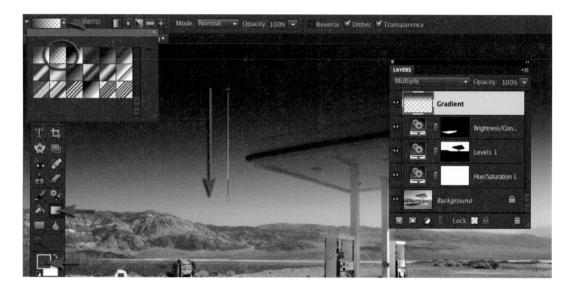

11. I have created an empty new layer by clicking on the Create a new layer icon at the base of the Layers panel. I have then set the mode to Multiply and double-clicked the name of the layer and renamed it Gradient. To sample a color from the sky, and add it to the foreground color swatch, I have selected the Gradient tool from the Tools panel and then, by holding down the Alt key (PC) or Option key (Mac), clicked on a bright blue color in the sky. I have then proceeded to select the Foreground to Transparent gradient from the Gradient picker and the Linear gradient in the Options bar. I have then clicked and dragged a gradient from the top of the image preview to a position just above the distant hills. The Gradient will clip the top of the gas station but this will be fixed in the next two steps.

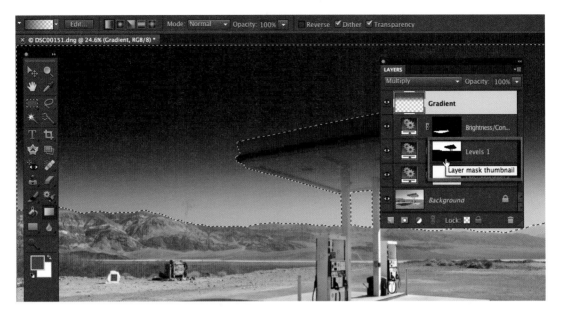

12. By holding down the Ctrl key (PC) or Command key (Mac) and clicking on the Levels 1 layer mask I can load the sky as a selection.

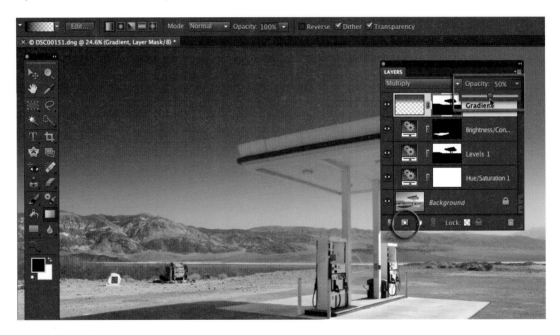

13. With the Gradient layer selected, I can add a layer mask by clicking on the Add layer mask icon at the base of the Layers panel. The selected area and the masked areas are opposite, so the mask is effectively duplicated on the new layer. The luminance of the sky is now likely to be too dark (after the three luminance treatments) so I will need to lower the opacity of the layer to around 50%.

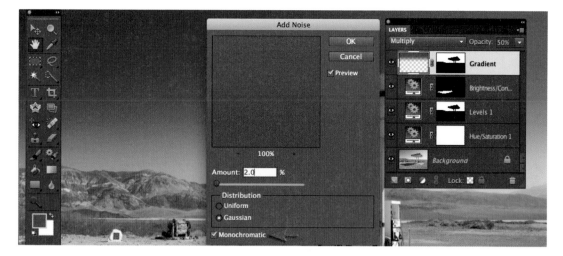

14. Gradients applied to smooth continuous tones can cause banding (visible steps of tone) in the resulting image. The banding, if present, can be reduced by applying noise to the gradient layer. I need to make sure the image is selected rather than the mask (I have clicked on it to make sure it is selected) and then I have applied the Add Noise filter (Filter > Noise > Add Noise). I have set the Amount to 2% and checked the Monochromatic option to avoid adding colored speckles.

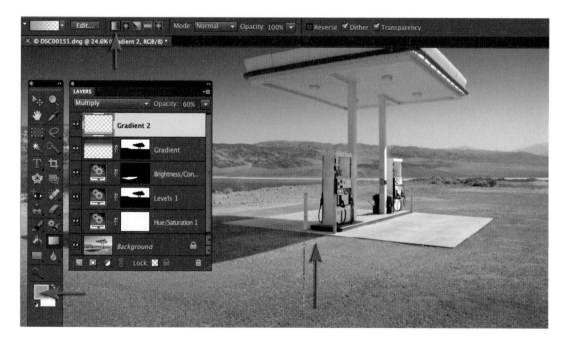

15. I have added an additional gradient to the bottom of the image (creating a new layer, setting the mode to Multiply, sampling the color and dragging a gradient from the bottom of the image). Pressing the keyboard shortcut Ctrl + F (PC) or Command + F (Mac) will apply the last filter used.

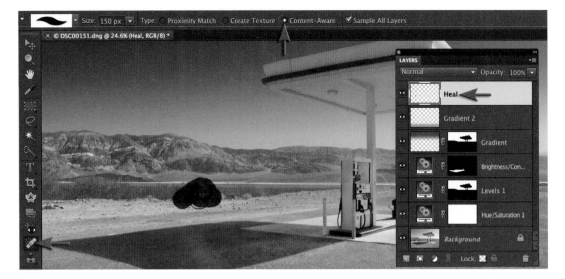

16. The best way to remove small distracting details (or not so small as in the case of this image) is to add a new empty layer and then select the Spot Healing Brush tool. I have selected the Content-Aware and Sample All Layers options in the Options bar then brushed over the things I want to remove. The Sample All Layers option is critical as there are no pixels in the empty layer to be cloned.

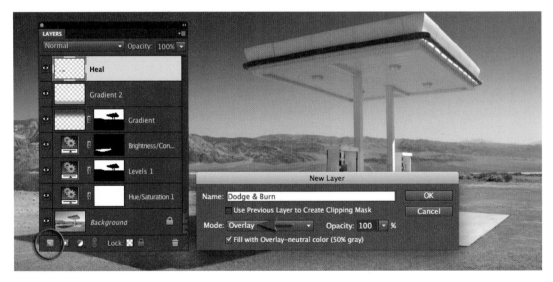

17. Another way of controlling luminance values non-destructively is to 'Dodge' tones lighter or 'Burn' tones darker. There are Dodge and Burn tools in the Tools panel but to work non-destructively I need to create a Dodge & Burn layer. By holding down the Alt/Option key and then clicking on the Create a new layer icon I will open the New Layer dialog. I have named the layer Dodge & Burn – set the mode to Overlay and checked the Fill with Overlay-neutral color (50% gray) option. I then select OK to create a new layer with these settings.

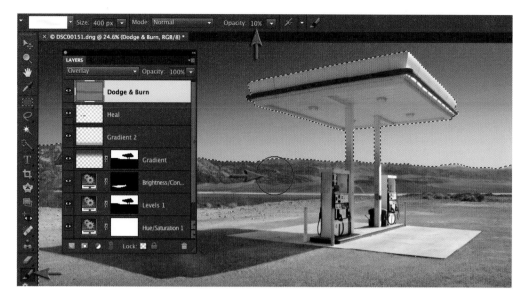

18. I have selected the Brush tool from the Tools panel and set the brush hardness to 0% by clicking on the brush in the Options bar to access the brush settings. I have set the Foreground and Background colors to their default settings and set the Opacity to 10% in the Options bar. I can then paint with black to darken the underlying tones and with white to lighten the underlying tones. It is possible to paint free hand or make a selection to restrict my painting to clearly defined areas (you can only modify selected pixels).

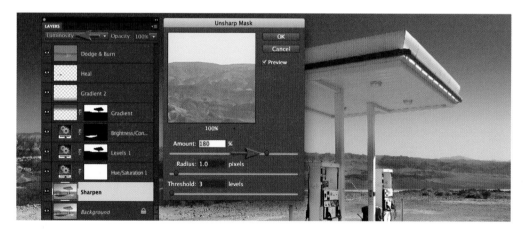

19. I have sharpened the image to complete the project. This was achieved by duplicating the background layer (Ctrl + J or Command + J) and setting the mode to Luminosity (to maintain color accuracy when the edges are sharpened). I then proceeded to go to Enhance > Unsharp Mask and in the Unsharp Mask dialog set the Amount slider to 180 and the Radius to 1.0. I raised the Threshold slider to 3 to protect the smoother tones from the sharpening process and then selected OK to apply the sharpening. I have adjusted the opacity of the Sharpen layer to reduce the amount of sharpening. The tonality of this project can continue to be adjusted after the sharpening process as all the layers above the sharpening layer are interactive.

Project 3

Working Spaces

For photographers shooting in the Raw format we can now optimize and enhance images either in Adobe Camera Raw (ACR) or in the main editing space of Photoshop Elements. Increased flexibility and options bring increased confusion as to where is the best place to edit. Am I in the right space for the right job? What if I change my mind? Decisions, decisions.

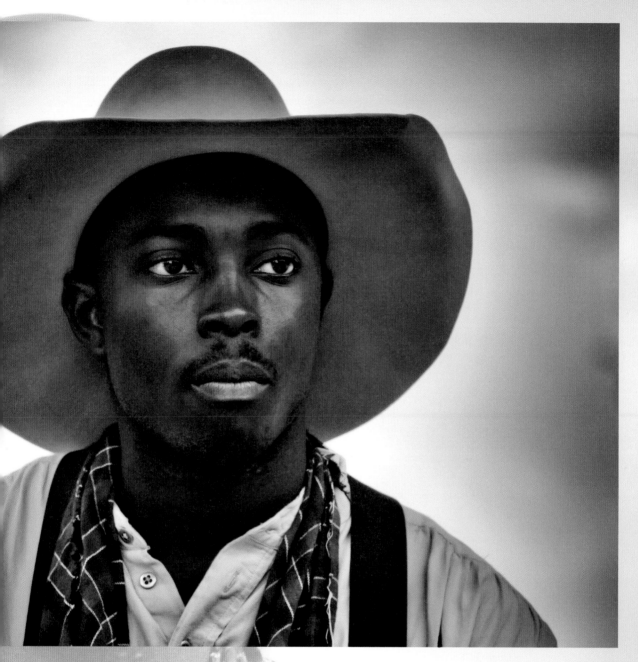

Cowboy – Fort Worth, Texas. Mark Galer

This tutorial provides insights into how we can edit a single file in both spaces. The workflow outlined will give you the flexibility to return to ACR to tweak some of those initial settings – an additional step for those photographers who can never make up their mind.

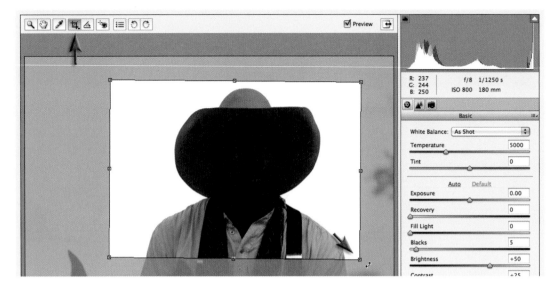

1. I have opened my project image into Adobe Camera Raw (ACR). I have then selected the Crop tool and created a tighter composition by dragging the tool over the head and shoulders of the cowboy. I have moved my cursor to a position just outside one of the corner handles to rotate the crop marquee. I can then select the Hand tool or Zoom tool to apply this crop. It is important to remember that pixels are not discarded in the cropping process in ACR – just hidden from view. This is an advantage to using ACR rather than the main editing space for this task.

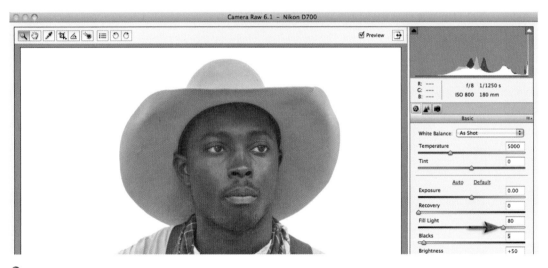

2. No fill flash reached the subject in any usable strength and the exposure compensation used in-camera was insufficient to lighten the dark shadows. In Adobe Camera Raw I can use the Fill Light slider to restore usable detail in these tones. In the main editing space I could use the Shadows/Highlights adjustment feature. The advantage to restoring these tones in ACR, however, is that I am working at the native bit depth of the sensor. Alternatively I could open the file from ACR as a 16 Bits/Channel file but that would then make life difficult in the main editing space of Photoshop Elements.

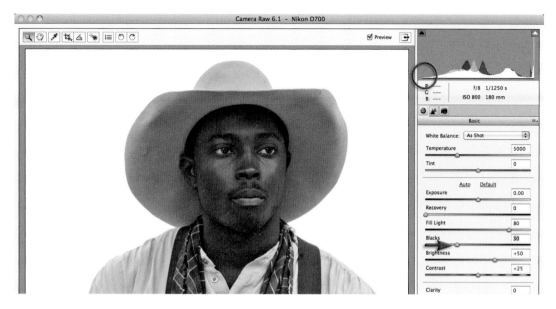

3. If I drag the Fill-Light slider to a value of +80 in ACR I will no longer have a black point in this image, so I need to raise the value of the blacks until the toe of the histogram touches the left-hand side again.

Alternative approach > Raise the Exposure slider to +1.5 and the Brightness slider to +80. The outcome is similar but not the same. The shirt and hat will be brighter as the lightening effects will be applied to all tones and not just the shadows. If using the Exposure slider be sure to switch on the clipping warning (click the triangle above the top right-hand side of the histogram) to ensure you don't lose any detail in the brightest tones of your subject.

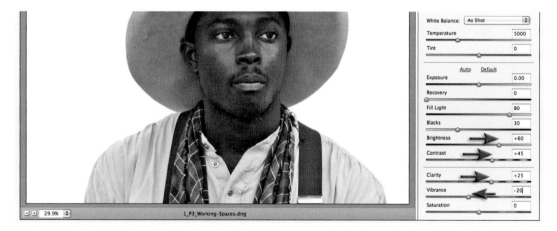

4. Localized contrast in the shadows can be improved by raising the Contrast slider to a value of +45 and the Clarity slider to a value of +25. Lowering the Vibrance slider to -20 will reduce excessive saturation that has been created by this contrast adjustment. I have then raised the Brightness slider to +60.

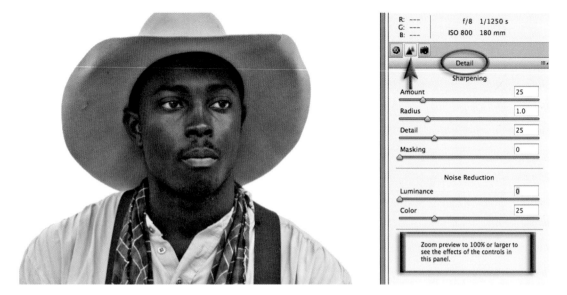

5. If I lighten the shadow tones I will also increase the amount of visible noise within the image. I can reduce this noise by going to the Detail tab in ACR. At the base of this panel you will see the note reminding me to zoom in to 100% or Actual Pixels.

Note > Reducing noise in ACR, rather than in the main editing space, is the most effective and fastest option. The only downside to reducing noise in ACR is that the effect is global, i.e. I cannot restrict the noise reduction to localized areas of the image.

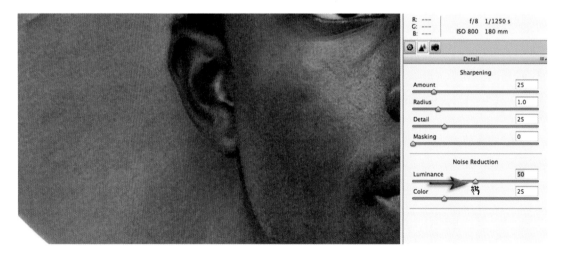

6. I have zoomed in using the keyboard shortcut Ctrl + Alt + 0 (PC) or Command + Option + 0 (Mac) and then raise the Luminance slider to +50. If I raise this slider too far I may remove detail that is important to the sharpness of this image. The Color slider in the Noise Reduction controls can be left at +25 as most of the excessive noise in this file is luminance noise, a result of raising the ISO in-camera and lightening the shadows in ACR.

PERFORMANCE TIP

It is possible to recover the highlights that have been clipped in this image in ACR – but at a cost. The overexposure in the sky can be corrected by raising the Recovery slider, but this causes edge artifacts around your subject due to our work with the Fill Light slider. Raising the Recovery slider will also lower the localized contrast in the rest of the subject, which will make the cowboy appear dull. To avoid these problems we must use a technique within the main editing space of Photoshop.

7. When the file opens in the main editing space of Photoshop I will go to File > Place and then browse to the project Raw file so that I can open it a second time. I have zoomed out so that I can see all of my image in the image window. Using the Place command instead of the Open command will ensure that the Raw file can be re-optimized for the highlights and placed as a 'Smart Object' (a special sort of layer that can be edited non-destructively) above the background layer instead of it opening as a new document.

Note > A Smart Object provides the image editor with a non-destructive 'container' for the information held within a layer. It enables non-destructive scaling of the contents of the layer in a similar way that an adjustment layer applies non-destructive changes to tonal and color information.

8. When the Raw file opens for the second time it will remember all of the settings I used to optimize the shadow tones of this image. I have lowered the Exposure slider by -2.00 stops to darken the sky and then selected OK to place this re-optimized version as a 'Smart Object' above the background layer. If I change my mind about the settings I use at this time I can always delete the Smart Object and Place another version with different settings.

9. The image that has been optimized for the sky has opened in the main editing space with a large cross indicating that it can be scaled if required. I need this layer to be the same size as the background layer so I just need to click on the Commit (check mark) icon in the bottom right-hand corner of the image window or hit the Return/Enter key. I can right-click on this layer (Mac users with a single button mouse need to Ctrl + Click on the layer) to bring up the context sensitive menu so that I can choose 'Simplify Layer' (this command can also be accessed from the fly-out menu in the Layers panel). This will render or 'rasterize' the Smart Object layer as a regular layer. Smart Objects in the full version of Photoshop allow the user to double-click the layer and reopen the Raw file embedded in the layer into the ACR window. Elements users do not have this luxury but I will be offering a workaround for Elements users later in this tutorial.

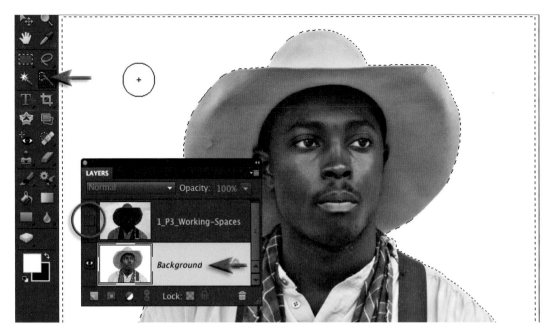

10. I have switched off the visibility of the top layer and then clicked on the background layer in the Layers panel to make this the active layer. I have then selected the Quick Selection tool in the Tools panel and then click-dragged over the sky to make a selection.

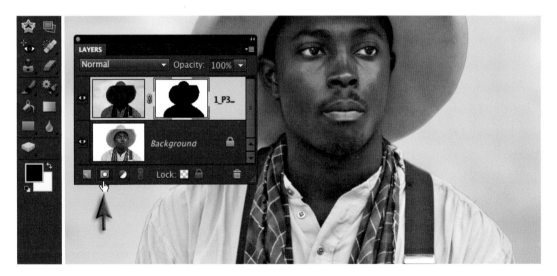

11. To create the mask I have selected the top layer in the Layers panel and switched the visibility of this layer back on. I have then clicked on the Add layer mask icon at the base of the Layers panel. The layer mask has now effectively masked the dark cowboy on the top layer to reveal the lighter cowboy on the background layer. The extreme exposure variation between the two layers has, however, created an unsightly hard edge around the subject. By softening the layer mask in the next step I will create a more gradual transition between the two exposures.

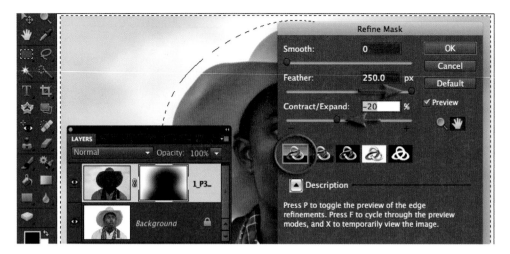

12. I could apply a Gaussian Blur filter to the layer mask to soften the edge of the mask but the Refine Edge feature gives the option of expanding or contracting the mask as well. I have clicked on the layer mask thumbnail to make this the active component of the layer and have then gone to Select > Refine Edge (notice how the dialog changes its name to Refine Mask when we are working with a mask instead of a selection). I have moved the Feather slider to its highest setting of 250 px and moved the Contract/Expand slider to the left to a value of -20. Selecting OK has applied the adjustment to the layer mask.

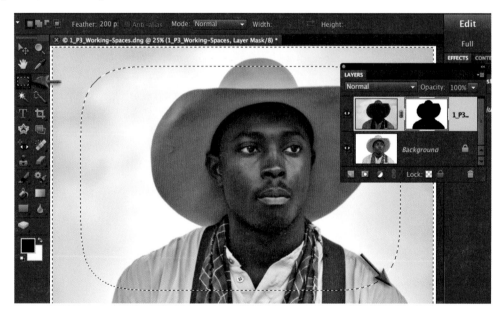

13. Adding a vignette to this image will serve to darken the sky even further. Vignettes cannot be added in the Photoshop Elements version of ACR so this must be done in the main editing space. I have selected the Rectangular Marquee tool and entered in a Feather value of 200 px in the Options bar. Selecting the central portion of the image (the resulting selection will have rounded corners) I have then proceeded to go to Select > Inverse so that the edges of the image are now selected.

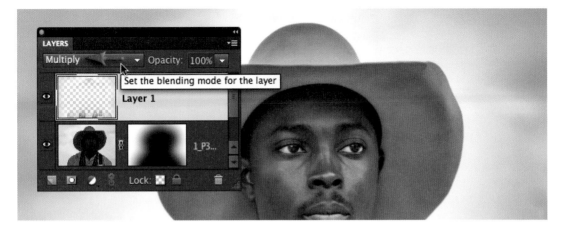

14. I have gone to Edit > Copy Merged and then again from the Edit menu chosen Paste. This action has pasted the visible pixels in the selected area (as opposed to the pixels on the active layer) to a new layer. Changing the blend mode of this new layer to Multiply in the Layers panel has darkened the edges of the image.

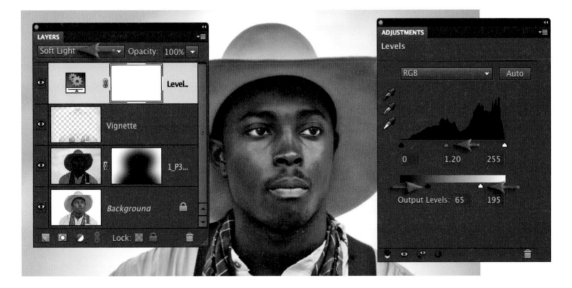

15. To increase contrast in just the midtones of the image (leaving the darkest shadow tones and brightest highlights unaffected) I have added another Levels adjustment layer. I have set the mode of this adjustment layer to Soft Light (one of the contrast blend modes). Moving the Output Levels sliders to 65 and 195 will protect the shadows and highlights from contrast that results from the Soft Light blend mode. Move the central gamma slider to control the final brightness of the image.

Note > If the saturation climbs too high (a result of the increase in contrast) add a Hue/ Saturation adjustment layer and drag the Saturation slider to the left slightly.

16. Now that the project is nearly complete, I am not happy with the brightness of the sky. I feel it still needs to be darker. I could make the sky layer darker just by applying a Brightness/Contrast adjustment directly to the layer, but this composite file is at a lower bit depth than the original Raw file and there is a great risk of 'posterizing' or stepping the tones in the sky if we make large adjustments to tone in the main editing space. The best place to make large tonal adjustments is not in the main editing space but in ACR. In the full version of Photoshop, Smart Objects (the sky layer in this project used to be a Smart Object before we used the command 'Simplify Layer') are very useful when they are created from Raw files (the Raw file is embedded in the working file). Double-clicking a Smart Object in the full version of Photoshop results in the Raw file opening back into Adobe Camera Raw. This allows users to readjust any of the initial settings so that they are re-optimized for the composite file in the main editing space. This feature has, sadly, been turned off for Elements users. I can, however, still adopt this type of workflow in Elements with just a few inconveniences. I can click on the sky layer to select it and then go to File > Place and browse to the original Raw file.

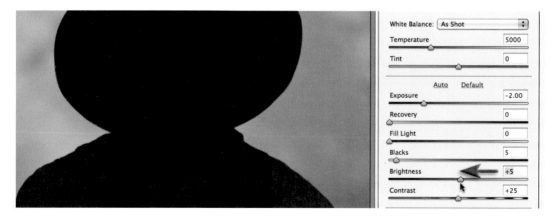

17. When the Raw file opens into ACR the settings will be the same as when I adjusted them for the sky. I am now free to make the sky even darker by lowering the Brightness slider to a value of +5. When I select OK I will place this file a second time in the composite file.

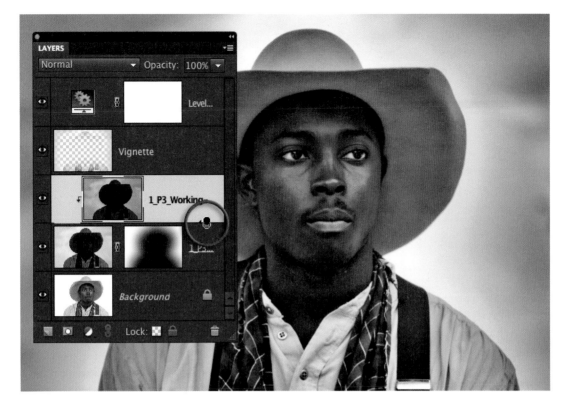

18. I will treat this Smart Object just as I did in Step 9, i.e. click on the Commit icon in the bottom right-hand corner of the image window or hit the Return/Enter key. I can then right-click on this layer (Mac users with a single button mouse need to Ctrl + Click on the layer) to bring up the context sensitive menu and choose 'Simplify Layer'. The sky will now be darkened using the new brightness settings I applied in the Adobe Camera Raw interface. The mask from the original sky layer has to be transferred to the new layer. I can hold down the Alt/Option key and click on the dividing line between the two sky layers to create a clipping mask (this new layer will now use the layer mask on the underlying layer). Alternatively I could hold down the Ctrl key (PC) or Command key (Mac) and click on the layer mask, then select the new layer and click on the Add layer mask icon. If I take this alternative approach I could delete the old sky layer by dragging it to the trashcan in the Layers panel. Although not as streamlined as the full version of Photoshop, this workflow does demonstrate that we can still harness the power of the Adobe Camera Raw interface in a multilayered file in Photoshop Elements using the Place command.

This tutorial shows us the importance of adopting a workflow that allows us to use the strengths of both the Adobe Camera Raw and the main editing spaces within Photoshop Elements.

Project 4

Gradients & Vignettes

One of the top ten most powerful editing tools for Photoshop users, that has been around since the dawn of Photoshop time, is the mighty Gradient tool. This project shows you how you can breathe drama into seemingly lifeless images using some super special tips and techniques, designed to extract the maximum performance from your images.

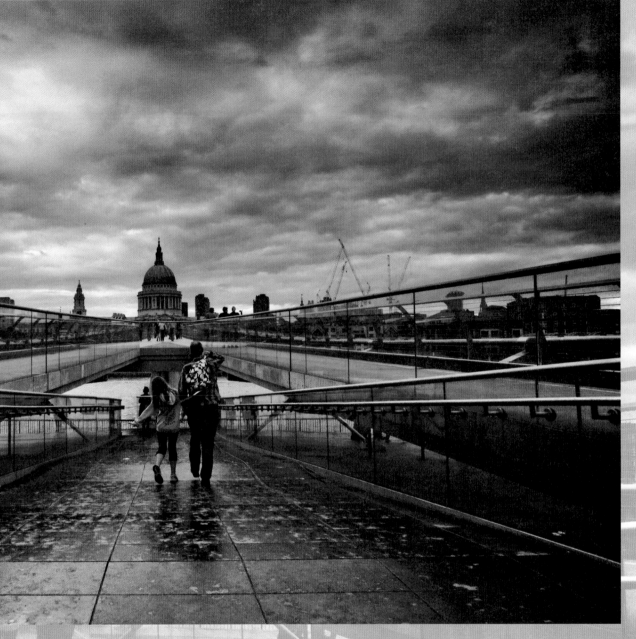

St. Paul's Cathedral from Millennium Bridge, London. Mark Galer

This project explores how we can use a gradient in an adjustment layer mask to merge the same Raw file processed in two different ways. The project will also utilize a colored gradient applied to two new layers that, in turn, have been set to two different blend modes. The idea is to extract every ounce of life from this underexposed image captured on a gray and wet day in London (nothing new here).

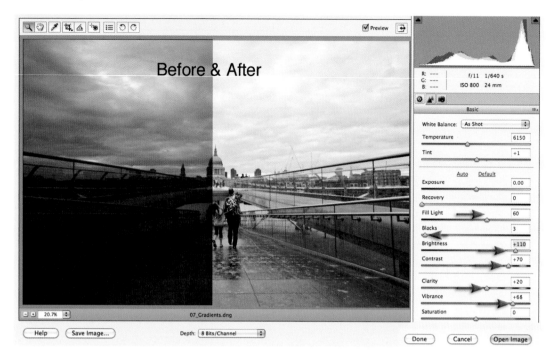

1. I have opened this Raw file in Adobe Camera Raw (ACR) and then optimized the image for the foreground content. I have raised the Fill Light slider to +60, the Brightness slider to +110, the Contrast slider to +70, the Clarity slider to +20 and the Vibrance slider to +68. I have also lowered the Blacks slider to +3 to ensure there is no clipping in the shadows.

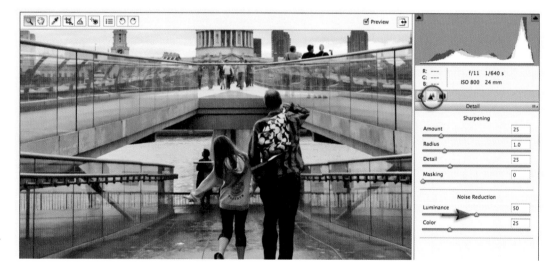

2. To ensure the image is free from excessive noise (this image was captured at 800 ISO and slightly underexposed) I have zoomed in to 100% (Actual Pixels), selected the Detail tab and raised the Luminance slider in the Noise Reduction section to +50. I have then hit the Open Image button to open this file into the main editing space of Photoshop (got to love ACR for fast editing!).

3. When the image has opened in the main editing space I have gone to File > Place and then browsed to the location of the same Raw file I opened in Step 1. Using the Place command instead of the Open command will ensure the Raw file is opened and then placed as a layer above the background layer in my working file.

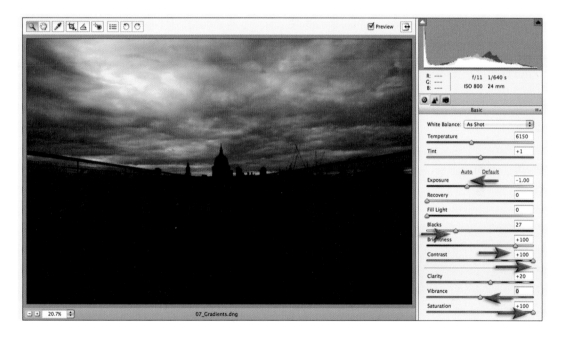

4. When the Raw file opens for the second time I will see all of the settings I used to optimize the image for the foreground. To clear the settings I have clicked the blue word 'Default'. This will clear all of the settings in the Basic panel except for the Clarity, Vibrance and Saturation sliders. I have optimized the image for the sky by raising the Blacks slider to +27 and the Brightness and Contrast sliders to +100. I have left the Clarity slider set to +20, but reset the Vibrance slider to 0 by double-clicking the slider and then raised the Saturation slider to +100. Selecting the OK button has placed the optimized version of the Raw file as a layer above the background layer.

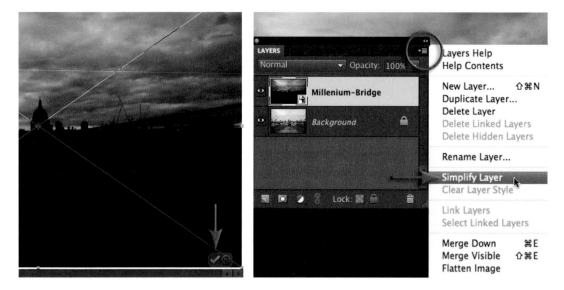

5. The image has been placed as a Smart Object, i.e. not a regular layer. The image is embedded into the layer as a full-resolution file that can be scaled multiple times without losing its quality, i.e. the file is preserved as a full-resolution image no matter how large or small it is scaled until the layer is 'simplified' (this can be very useful for creating photomontages or composite images). The large cross on the image is an invitation to scale this image. I need to keep the layer the same size as the background layer so I have just hit the Commit icon.

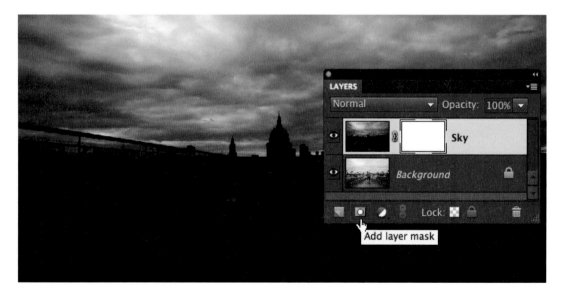

6. I can now start to merge the best of the two exposures using a layer mask to hide the dark foreground information on this top layer. I have clicked on the Add layer mask at the base of the Layers panel and then double-clicked on the name of this top layer and renamed it 'Sky'.

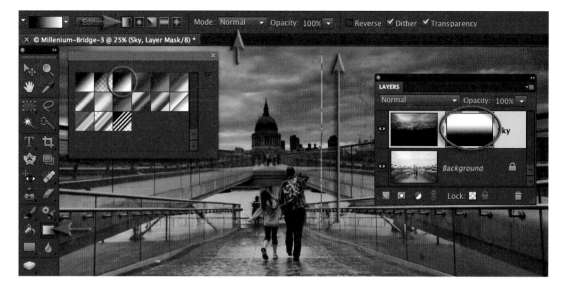

7. Pressing the G key on the keyboard will select the Gradient tool. In the Options bar I have clicked on the little triangle next to the gradient ramp to open the gradient picker. I have then selected the third gradient (Black, White gradient), clicked on the Linear Gradient option to the right of the Edit button and made sure the Mode is set to Normal and the Opacity is set to 100%. I have clicked on the layer mask of the Levels 1 adjustment layer to make this the active component of the layer, and then clicked and dragged a gradient from the base of the people's feet to a position just above the top of the spire on St. Paul's Cathedral. If the top of the cathedral still appears a little dark after dragging this gradient, I can drag a second one slightly higher in the sky. Holding down the Shift key as I drag the gradient will constrain it so that it is perfectly vertical.

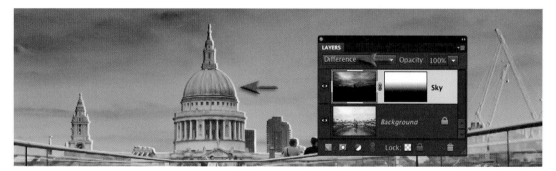

8. To check that I have perfect alignment between these two layers I can set the mode of the top layer to Difference. I can zoom in so that I can see the edge detail along the skyline. If there are white lines visible around the edges I can select the Move tool from the Tools panel and then use the keyboard arrow keys to nudge the two layers into alignment. I can then set the mode of the layer back to Normal when I have finished.

Note > When two layers have been checked for alignment you can Shift-Click both layers and then click on the Lock icon to ensure they remain aligned.

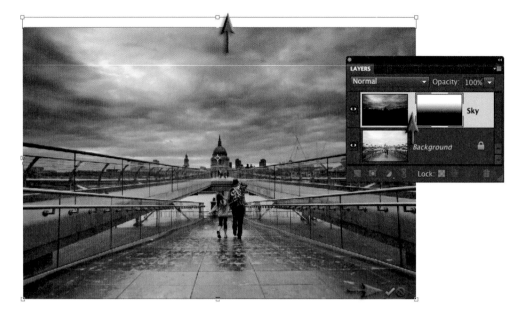

9. The transition between the two layers can be controlled using the Free Transform command. I have clicked on the link between the image thumbnail and the layer mask so that I can modify the gradient in the mask without affecting the image on this layer. I have then proceeded to go to Image > Transform > Free Transform. I have dragged the top handle of the Transform bounding box up to raise the gradient (but not the image) and brighten the skyline area. I have then committed the transformation by clicking on the check mark.

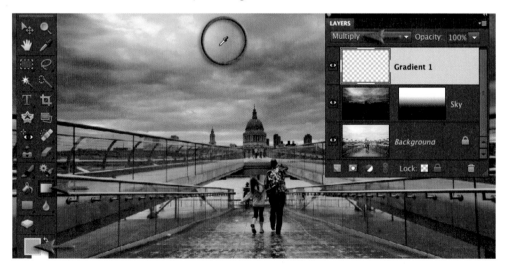

10. I can now increase the drama in the sky by adding a colored gradient. I have clicked on the Create a new layer icon to add an empty new layer and set the mode to Multiply (one of the darkening blend modes) in the Layers panel. With the Gradient tool still selected I can hold down the Alt key (PC) or Option key (Mac) and click on the orange color in the sky to load this as the foreground color.

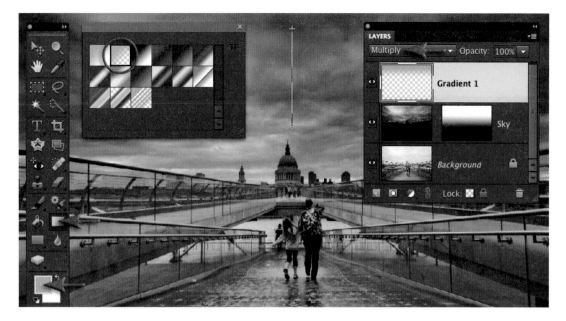

11. I have selected the second gradient (the Foreground to Transparent gradient) in the gradient picker. While holding down the Shift key, I have dragged a gradient from the top of the image window to a position just above the spire on St. Paul's Cathedral. This has enhanced the warm colors that are already an important aspect in this dramatic sky.

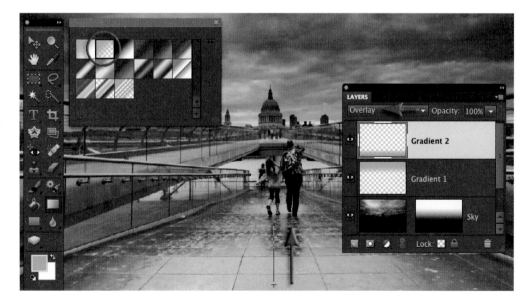

12. I have added another new layer (by clicking on the Create a new layer icon in the Layers panel) and set the mode to Overlay (one of the contrast blend modes). While holding down the Shift key I have dragged a gradient from the base of the image window to a position just higher than the feet of the people in the center of the image. This has mirrored the warm colors that are in the sky in the wet paving.

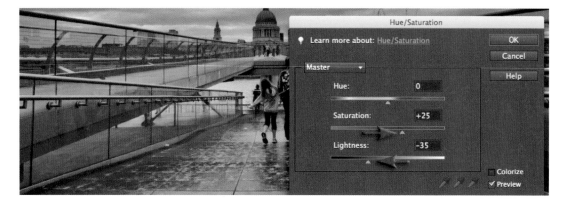

13. To modify how this gradient interacts with the underlying color I have gone to Enhance > Adjust Color > Adjust Hue/Saturation. I have dragged the Lightness slider to the left and the Saturation slider to the right to increase the drama of this gradient.

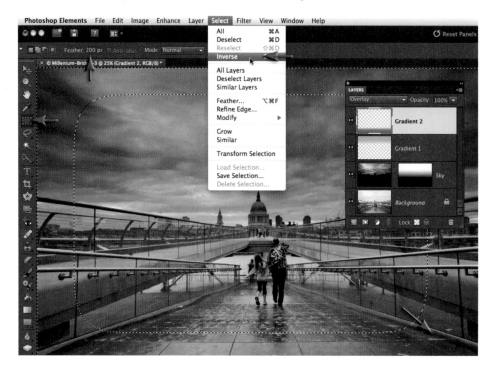

14. I will complete the project by adding a contrast vignette. I have selected the Rectangular Marquee tool from the Tools panel and set a Feather value of 200 px in the Options bar. I have clicked and dragged 10% in from the top left-hand corner of the image to a position just short of 10% from the bottom right-hand corner of the image. This will create a selection with rounded corners. From the Select menu I have chosen 'Inverse'. I can now copy the visible pixels (rather than the pixels on a single layer) by going to Edit > Copy Merged. Again from the Edit menu I have chosen Paste. This has pasted the pixels from the clipboard onto a new layer. There will be no visible change in the image window at this point until I change the blend mode of the layer.

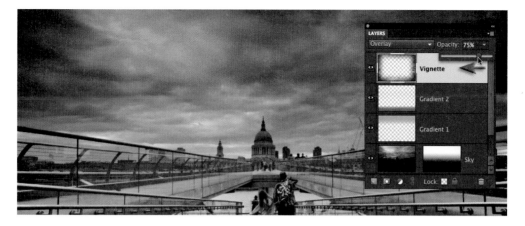

15. It is common to use either the Multiply or Screen blend modes when creating a vignette in this manner (to darken or lighten the edges of the image), but with this project I will use the Overlay blend mode instead to increase contrast and color saturation at the edges of the image. If I find the color is a little excessive, I have the choice to either lower the opacity of the layer or change the blend mode to Soft Light.

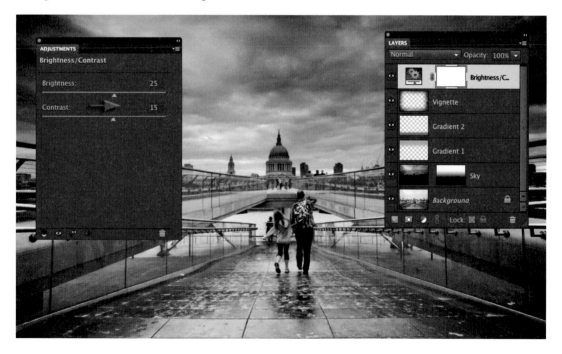

16. To complete the project I will give the tonality a little bit of a lift courtesy of a Brightness/Contrast adjustment layer. I have raised the Brightness to a value of +25 and the Contrast to a value of +15. If I hold down the Alt key (PC) or Option key (Mac) and click the Visibility icon (the eye) on the background layer this will switch the visibility of all the other layers off. I can see just how far I have come. Repeating the action (Alt/Option + click the Visibility icon) one more time will switch the visibility of all layers back on.

Project 5

Curves

One of the most important image adjustment features in a professional photographer's workflow is Curves (a sort of Levels command on steroids). Adobe, in their wisdom, decided to include this feature in Photoshop Elements 5. Color Curves now makes a welcome appearance in the Enhance menu but it is still not available as an adjustment layer. This project shows you several ways to control contrast using adjustment layers to increase your post-production editing power to maximum performance.

Create dramatic images by building in some non-destructive contrast

The revised Brightness/Contrast adjustment feature

If you have been image editing for some time you will know that 'Levels' has always been a superior option for enhancing the brightness and contrast of your image to the Brightness/Contrast feature. Adjusting the brightness or contrast of an image using the Brightness/Contrast adjustment used to be very destructive. For example, if you wanted to make the shadows brighter and elected to use the Brightness/Contrast control all of the pixels in the image were made brighter (not just the shadows), causing the pixels that were already bright to fall off the end of the histogram and lose their detail or become white (level 255). The Brightness/Contrast adjustment feature was fully revised with version 7 so that its behavior now falls in line with the non-destructive nature of the Brightness and Contrast sliders in Adobe Camera Raw (ACR).

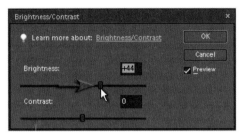

Using the Brightness slider is now like moving the center (Gamma) slider in the Levels adjustment feature, i.e. the image is made brighter whilst preserving the black and white points within the image. The Contrast slider, on the other hand, makes the shadows darker and the highlights brighter but not at the expense of the black and white points of the image. The only problem with the Brightness/Contrast adjustment feature is that it cannot focus its attention on a limited range of tones without using a layer mask, e.g. make the shadows darker or lighter but leave the midtones and highlights as they are.

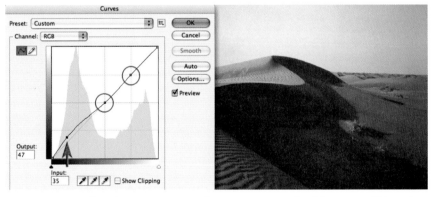

The Curves adjustment feature as seen in the full version of Photoshop

The Curves adjustment feature allows the user to target tones within the image and move them independently, e.g. the user can decide to make only the darker tones lighter whilst preserving the value of both the midtones and the highlights. It is also possible to move the shadows in one direction and the highlights in another. In this way the midtone contrast of the image can be increased with a great deal more control than the new Brightness/Contrast adjustment feature.

Resolving the problem

Now there are three ways to enable you to harness the power of Curves in Adobe Photoshop Elements 10.

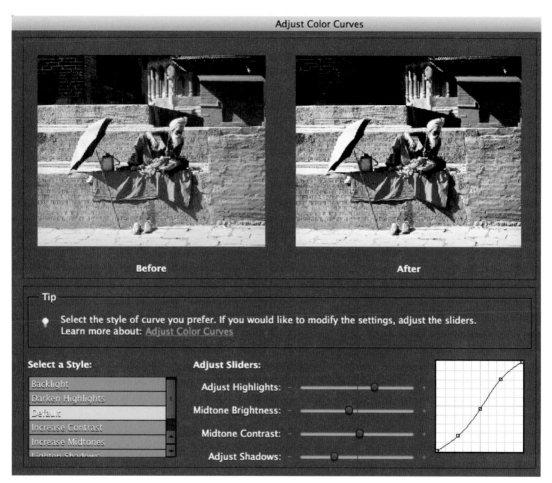

Method 1 – Color Curves

Adjust Color Curves is a user-friendly version of the Curves adjustment feature found in the full version of Photoshop and can be accessed from the Enhance menu (Enhance > Adjust Color > Adjust Color Curves). The user should first set the levels of the image file by using the techniques outlined in Project 1. Unfortunately, Adjust Color Curves is not available as an adjustment layer so it would be advisable to first duplicate the background layer and then apply the changes to this duplicate layer. Select the Default style and then move the sliders to fine-tune the tonality of your image or choose one of style options. It may be necessary to add a Hue/Saturation adjustment layer to modify any changes in the color saturation that may have occurred as a result of the Color Curves adjustment.

Accessing curves as an adjustment layer

The second way of using curves, this time as an adjustment layer, is a bit cheeky and is possible if you have access to a multilayered file created in the full version of Photoshop (the file below is included in the resources for this project that can be downloaded from the supporting website).

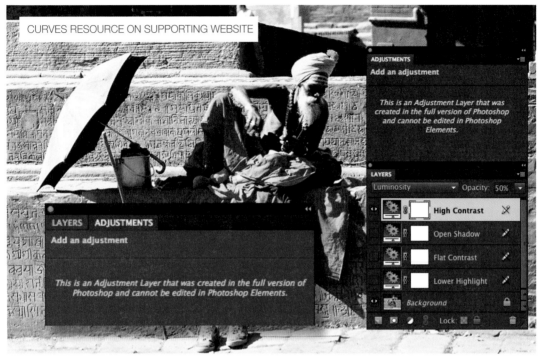

A Photoshop file opened in Elements will allow the user limited functionality to modify the adjustments

Method 2 – Grand theft

One of the great mysteries of life is that although you can't create a Curves adjustment layer in Photoshop Elements you can open an image that already has one. Photoshop Elements allows you to see the effects of the Curves adjustment layer (that was created in the full version of Photoshop), to switch it off and on, and to lower the opacity of the Curves adjustment layer (enabling you to lower the effect of the adjustment layer gradually). You can also drag this Curves adjustment layer into any other image file that is open in Elements (just click on the adjustment layer thumbnail in the Layers panel and drag it into another image window). Theoretically this means that, if you had a single file that was created in Photoshop with a wide range of Curves adjustment layers to suit your everyday image-editing tasks, you could use this as a 'Curves resource' – just drag, drop and adjust the opacity to suit the needs of each image you are editing. The sort of adjustment layers that would be particularly useful would be those that enabled the Photoshop Elements user to increase and decrease image contrast, raise or lower shadow brightness independently, and raise or lower highlight brightness independently. If the adjustment layers contained generous adjustments they could be simply tailored to suit each new image-editing task by just lowering or increasing the layer opacity. The adjustment layers are resolution-independent, which is another way of saying that they will fit any image, big or small – naughty but very nice!

Method 3 – Gradients

The third version is for users of Photoshop Elements who want a little more control, have a guilty conscience or prefer to explore the advanced features of the package they have purchased rather than the one they have not. This method allows you to access the ultimate tonal control that Curves has to offer using a different adjustment feature not really designed for the job but which, when push comes to shove, can be adapted to fit the needs of the image editor seeking quality and control.

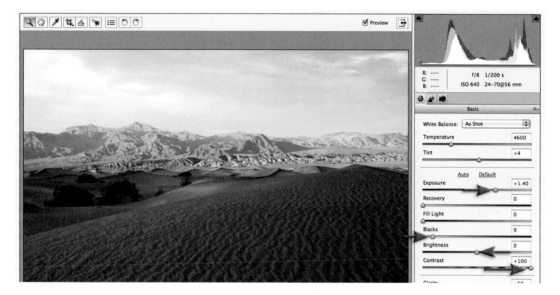

$1.$ The image used in this project is a low contrast Raw image. As you can see in the illustration above, the maximum amount of contrast has been applied after first setting a black and white point using the Exposure and Blacks sliders. Although the image is vastly improved from the unprocessed version, the contrast in the foreground sand dune is still relatively low when compared to the contrast of the distant dunes. I can continue to modify the contrast of localized areas by opening the image into the main Edit space of Photoshop Elements.

$2.$ I have set the Foreground and Background colors to the Default setting in the Tools panel (press the letter D on the keyboard). I have held down the Alt/Option key while selecting the Gradient Map adjustment layer from the Create Adjustment Layer menu in the Layers panel. This has opened the New Layer dialog box. I have selected Luminosity from the Mode menu and clicked OK.

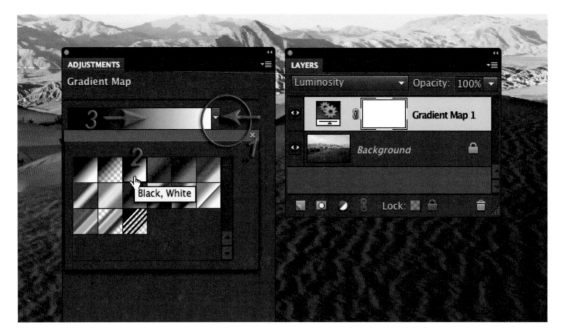

3. In the Adjustments panel I have clicked to open the drop-down menu and then selected the third gradient swatch in the presets menu (Black, White). I have clicked on the gradient above the presets to open the Gradient Editor.

4. I have moved the cursor to just below the gray ramp and clicked to add a 'stop' slightly left of center. I have typed in 25% as the Location and clicked on the color swatch to open the Color Picker.

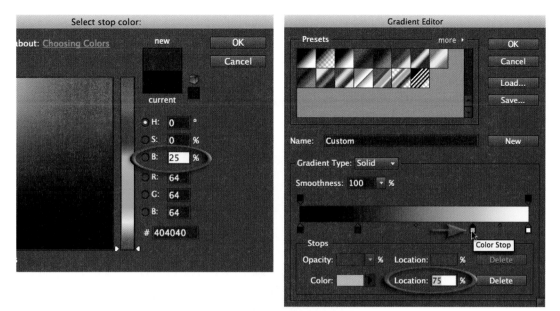

5. I have chosen a Brightness value of 25% and clicked OK (I have also checked to see that a value of 0 is entered in the other two fields of the HSB radio buttons). I have added another stop right of center (at a Location of approximately 75%) and again clicked on the color swatch to open the Color Picker. This time I have chosen a Brightness value of 75% and again clicked OK.

6. A Black/White gradient map in Luminosity mode will leave the existing tonal values of the image the same as before. The magic starts when I start to drag the stops I created to new positions on the gray ramp. Moving the two sliders further apart will lower the contrast whilst dragging them closer together will increase it. A 'color midpoint' also appears between the two stops that I am adjusting to allow me to fine-tune my adjustment. In this project I will concentrate my attention on the foreground sand dune (I am not worried if the sky and distant sand dunes become too bright at this stage). I have dragged the Shadow slider to a position of 30% and the Highlight slider to a position of 50% to increase the contrast. I have moved the color midpoint to fine-tune the shadow contrast. Be amazed – I am now exercising absolute control over the brightness values of my image! This technique allows all of the versatility of a Curves adjustment layer when editing the luminosity of my image.

The Gradient Map adjustment layer set to Luminosity mode acts like a 'hot-wired' Levels adjustment layer. Its advantage is that I can set as many stops or sliders as I like, giving me total control. Any localized areas that require further attention can simply be masked on the adjacent layer mask and tackled separately on a second Gradient Map layer.

Note > If I have a selection active when I choose the Gradient Map adjustment layer, it automatically translates the selection into a layer mask, restricting any adjustments to the selected area.

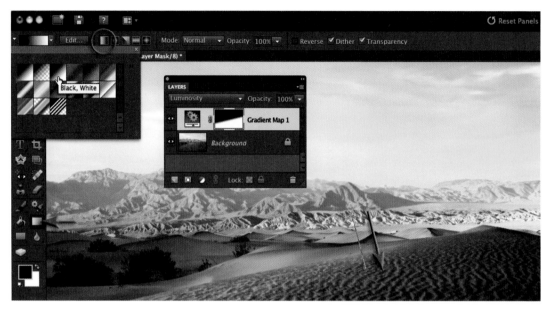

7. If I am looking to achieve a simple global contrast adjustment the project is complete. If, however, I want to enhance the image in a localized area I will use the following technique. I have selected the Gradient Map adjustment layer mask and chosen the Gradient tool from the Tools panel (by typing the letter G on the keyboard). I have chosen the Black/White and Linear options and then dragged a gradient from just below the distant sand dunes to a position just above the sand dune in the foreground. This has shielded the sky and distant dunes from the contrast adjustment applied by the Gradient Map adjustment layer.

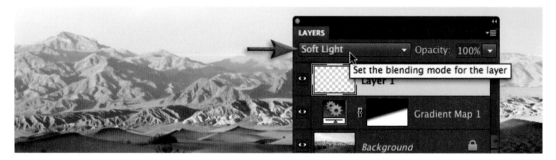

8. I will now balance the tonality in the image by darkening the sky. I have clicked on the Create a new layer icon in the Layers panel and set the blending mode of this new layer to Soft Light.

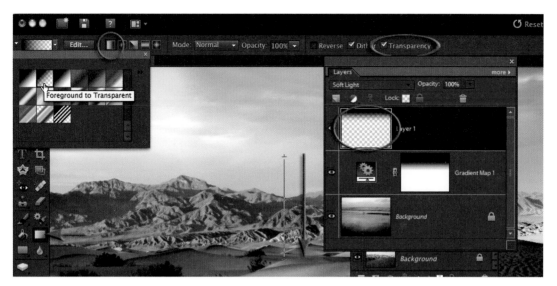

9. I have set black as the foreground color (type the letter D on the keyboard) and then chosen the Foreground to Transparent gradient. I have dragged a gradient from the top of the image to a position just below the distant dunes. Holding down the Shift key as I drag a gradient will 'constrain' the gradient to ensure that it is absolutely straight. I can change the blend mode of this gradient layer to Overlay and Multiply to see the variations of tonality that can be achieved.

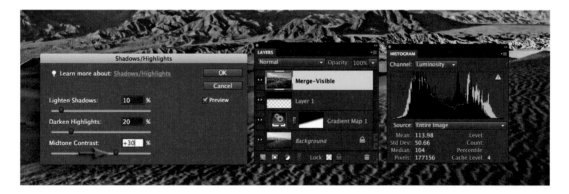

10. Yet another way of targeting tones for adjustment is using the Shadows/Highlights adjustment feature. This very useful adjustment feature is not available as an adjustment layer so I will need to create a 'composite' layer of the work carried out so far before I can apply it, by using a 'Merge Visible' technique. I have selected the top layer in the Layers panel and then held down the Shift + Alt + Ctrl keys (PC) or Shift + Option + Command keys (Mac) while I type the letter E on the keyboard. The new layer should appear on top of the layers stack. I can double-click the name of the layer to rename it 'Merge-Visible'. I have now chosen Shadows/Highlights from the Enhance > Adjust Lighting submenu. I have adjusted the Lighten Shadows and Darken Highlights sliders slightly and then raised the Midtone Contrast to +30. I can watch the effects of raising this slider by clicking on the Preview box and by viewing the histogram in the Histogram panel.

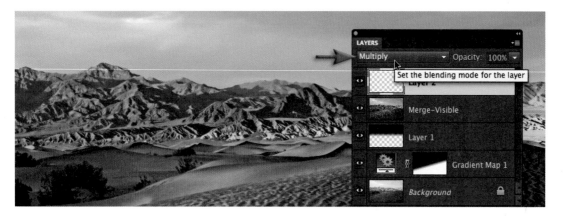

11. I have created another new layer and this time set the blend mode to Multiply. As with the previous gradient I can experiment with alternative blend modes after I have finished creating this second gradient.

Note > I can also set the blend mode for a new layer in the New Layer dialog box.

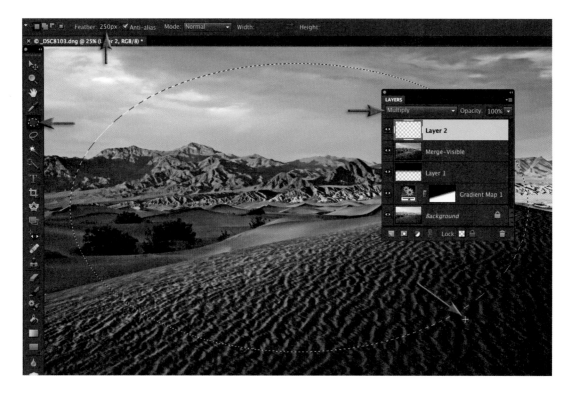

12. I have chosen the Elliptical Marquee tool from the Tools panel and chosen a large amount of feather (increasing the amount of feather as the resolution of the file gets bigger). I have now drawn an elliptical selection in the image window.

Note > I can check how soft the feather is by selecting the Selection Brush tool and choosing Mask from the Mode drop-down menu in the Options bar.

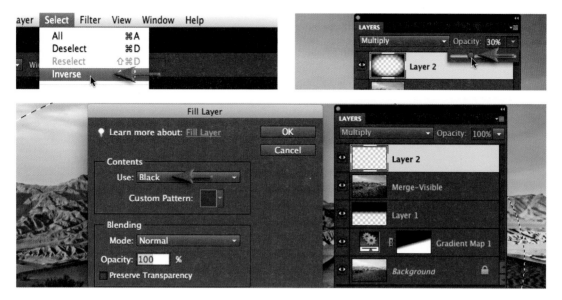

13. From the Select menu I have chosen Inverse (Shift + Ctrl/Command + I) and then from the Edit menu chosen the command Fill Selection. From the Contents section of the dialog box I have chosen Black for the foreground color. I have moved the mouse cursor into the image, chosen a deep blue color from the image window and then clicked OK. I have lowered the opacity of the layer until the vignette is subtle.

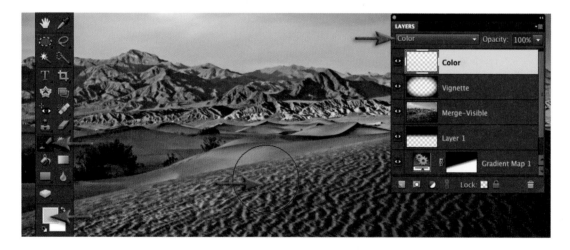

14. To warm the foreground sand dune, I have clicked on the Create a new layer icon in the Layers panel and set the mode to Color. I have selected the Brush tool in the Tools panel and sampled a color from one of the warm sand dunes (by holding down the Alt/Option key as I click on the dune to sample the color). I have adjusted the Opacity of the Brush in the Options bar to 20% and then painted over the dune with a large brush with the hardness set to 0%. I have held down the Alt/Option key as I clicked on the visibility icon of the Background layer in the Layers panel to see just how far I have come.

Project 6

Black & White

When color film arrived over half a century ago, the pundits who presumed that black and white images would die a quick death were surprisingly mistaken. Color is all very nice but sometimes the rich tonal qualities that we can see in the work of the black-and-white photographic artists are something to be savored. Can you imagine an Ansel Adams masterpiece in color? If you can – read no further.

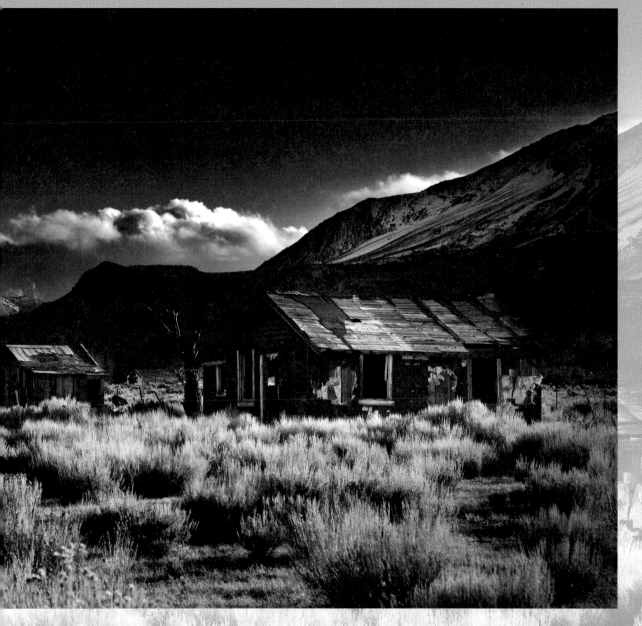

Create dramatic black and white images – Yosemite, California. Mark Galer

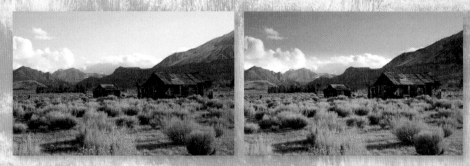

The original color image and the result of choosing the less-than-satisfactory Remove Color command

The conversion from color to black and white

The creation of dramatic black and white photographs from your color images is a little more complicated than simply converting your image to Grayscale mode or choosing the Desaturate command. Ask any professional photographer who is skilled in the art of black and white and you will discover that crafting tonally rich images requires a little knowledge about how different color filters affect the resulting tonality of a black and white image.

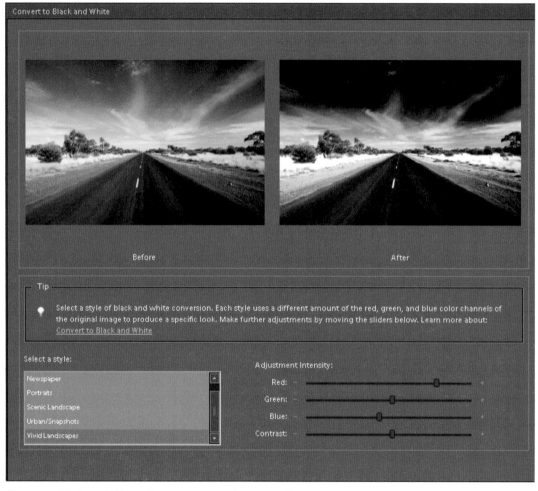

Convert to Black and White allows you to mix the tonal differences present in the color channels. Simply select a style and then adjust the Intensity sliders to create your own custom conversion

As strange as it may seem, screwing on a color filter for capturing images on black and white film has traditionally been an essential ingredient of the recipe for success. The most popular color filter in the black and white photographer's kit bag, which is used for the most dramatic effect, is the red filter. The effect of the red filter is to lighten all things that are red and darken all things that are not red in the original scene. The result is a print with considerable tonal differences compared to an image shot without a filter. Is this a big deal? Well, yes it is – blue skies are darkened and skin blemishes are lightened. That's a winning combination for most landscape and portrait photographers wanting to create black and white masterpieces.

PERFORMANCE TIP

The Maximum Performance actions on the supporting website include a series of automated black and white conversions. The Black&White_Luminosity action creates a single monochrome layer containing the luminosity values of the RGB file. The Red, Green and Blue Channel actions allow you to place one of the three color channels as a black and white layer. These actions would also be useful for accessing the best contrast in order to create a mask, as in the 'Depth of Field' project (pp 122–35).

In the image to the left the Red channel was used as this offered the best detail in the dark skin tones. The contrast was then increased by duplicating the layer and switching the blend mode to Soft Light. The opacity of this duplicate layer was then dropped to 30%. A vignette was added to complete the project

Levels is undoubtedly the most important concept to understand when editing images in Photoshop Elements. When the photographer understands how to optimize levels in localized areas of the image they will be able to release enormous depth and dynamic range to each and every photographic image that is destined for their folio. The most important step to achieve a fine quality image with a broad dynamic range is to use a Raw image rather than a JPEG in the editing process. Choosing the Raw file format instead of JPEG in your camera's settings will allow you to manipulate tone and color to a much greater extent without the risk of introducing image artifacts and tonal banding or 'posterization'. Editing in ACR is performed at the native bit depth of the file (typically 12 or 14 bits) rather than the more usual 8 Bits/Channel in the main editing space. The advantage is that we will now have thousands instead of hundreds of levels at our disposal. You can use a JPEG and follow along with this tutorial but areas of smooth continuous tone, such as the sky, may suffer as a result due to the fact that a JPEG has only 256 levels per channel. Let the show begin!

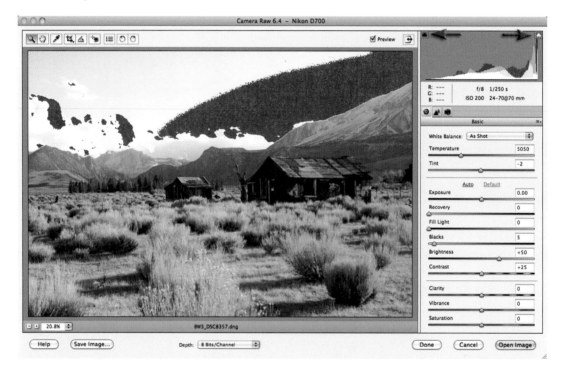

1. I have opened a camera Raw file into Adobe Camera Raw (ACR) and then clicked on the two clipping warning triangles above the histogram so that I can monitor when the brightest or darkest levels become clipped to black or white. In the project image the exposure for the scene was intentionally high (a technique for increasing quality called 'exposing right') and you can see that the sky is clipped at the current exposure (indicated by the red overlay in the image preview). The highlights in the Raw file can be recovered by dragging the Exposure slider to the left. I will, however, take a slightly different approach to this project.

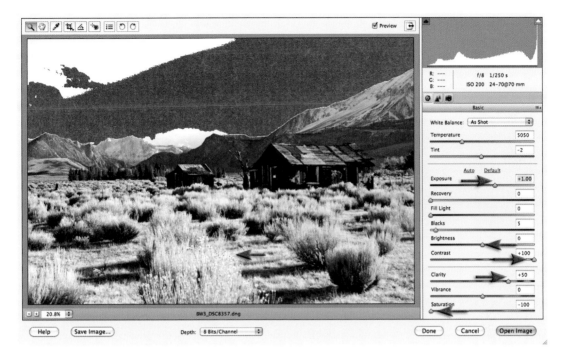

2. In this step I will expand the contrast in everything except the sky. I will ignore the red overlay in the sky and raise the Exposure slider until clipping just starts to appear in the highlights in the foreground. I will now lower the Brightness and raise the Contrast sliders until the buildings are at their optimum tonal quality. Raising the Clarity slider and lowering the Saturation slider will optimize the file for a black and white image. Now that I have optimized the levels for the foreground I can click on the Open Image button to proceed to the main editing space of Photoshop Elements.

3. I will now return to the master Raw file and optimize the tonality for the sky. By going to File > Place and then browsing to my master Raw file I can add this second version of the master file as a layer above my background layer.

4. When the image opens for the second time in ACR it will have the settings from the previous conversion loaded. To optimize the image for the sky I just need to lower the Exposure slider until the clipping warning disappears from the sky and then, shifting my attention to the Brightness slider, lower the brightness until the sky has the correct tonality I am looking for. Then I just need to click the OK button to place this as a layer above my background layer.

5. The image will appear as a 'Smart Object' above the background layer. I must first commit the size by pressing the Enter or Return key and then right-click on the layer and choose 'Simplify Layer'.

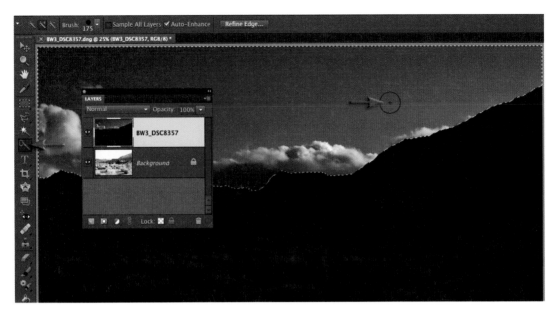

6. We can now create a layer mask on this layer to hide the darker pixels in the foreground. I have made a selection of the sky using the Quick Selection tool and then I added the layer mask by clicking on the Add layer mask icon at the base of the Layers panel. The transition between the two exposures will most likely appear unnatural so we usually need to create a more gradual transition between the two layers.

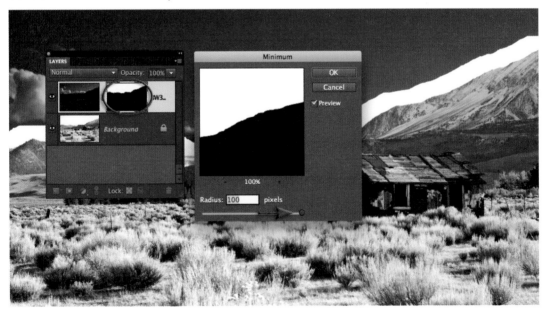

7. To create this gradual transition I will use two filters but it is advisable to play around with the settings I am using to find the most appropriate settings for your own image. I will use the Minimum filter first to move the edge of the mask (Filter > Other > Minimum). I have selected the maximum 100-pixel Radius before selecting OK.

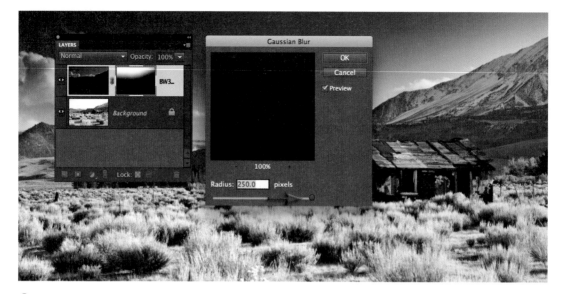

8. I have then applied the maximum amount of Gaussian Blur (Filter > Blur > Gaussian Blur) to soften the edge of the mask. Depending on the image you are working on you might like to experiment with using different ways of blending the two exposures, e.g. you could try painting with a soft-edged brush into the layer mask to manually create a transition between the two exposures.

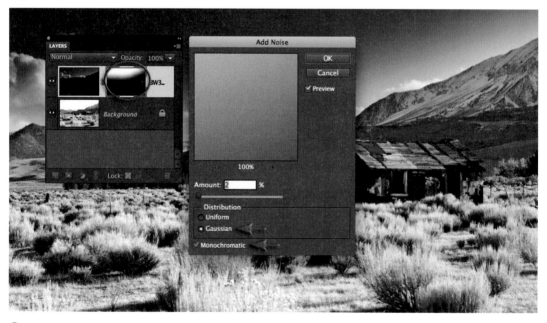

9. Applying a Gradient or Gaussian Blur into a layer mask can lead to banding in areas of smooth continuous tone. To avoid this you can add a small amount of noise to the mask (Filter > Noise > Add Noise). I have added 2% Gaussian Noise with the Monochromatic option checked. You could lower this value to 1% for low-resolution images.

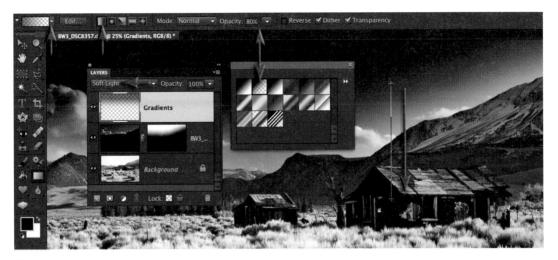

10. In this step I have decided to add a linear gradient to darken the top of the image. I have added a new empty layer (click on the Create a new layer icon at the base of the Layers panel) and set the mode of the layer to Soft Light (this will protect the brighter clouds in the sky from becoming too dark). I have set the foreground color to black and then selected the Gradient tool from the Tools panel and picked the Foreground to Transparent and Linear options from the Options bar. I have then clicked and dragged a gradient from the center of the sky to the horizon line. To adjust the density of the gradient I can either lower the opacity of the Gradient tool in the Options bar prior to adding the gradient or lower the opacity of the Layer in the Layers panel.

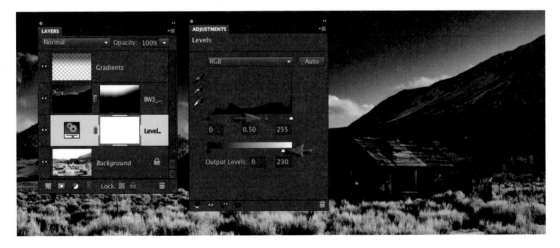

11. In this step I will lower the brightness of the foreground using a Levels adjustment. The adjustment will be global to begin with (affecting all pixels on the layer) but I will then restrict the adjustment to the immediate foreground so that it does not darken the mountains or the buildings. First I must select the background layer before adding a levels adjustment layer from the 'Create new fill or adjustment layer' menu at the base of the Layers panel. I have moved the central Gamma slider to darken the pixels and the white Output Levels slider to lower the white point. This will ensure the buildings (when protected from the adjustment) will be the focal point of the image.

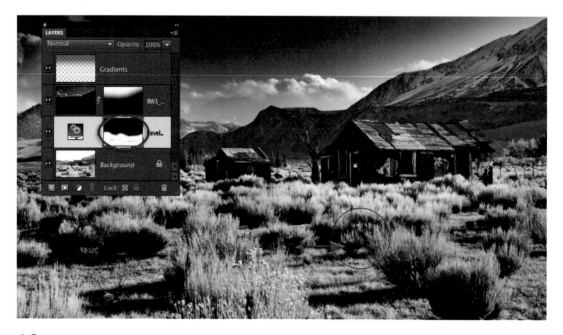

12. To hide the adjustment I can invert the layer mask using the keyboard shortcut Ctrl + I (PC) or Command + I (Mac). I have then selected the Brush tool from the Tools panel and set White as the foreground color. With a large brush set to minimum hardness and the opacity set to 100% I have painted in the adjustment only where I need it (the foreground).

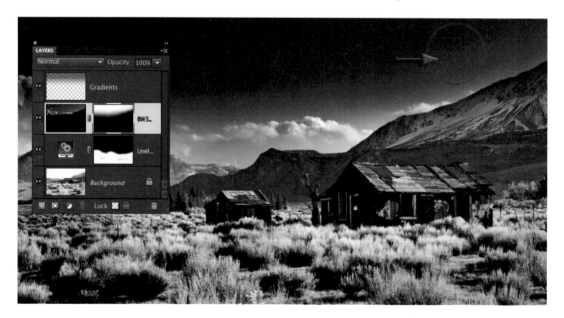

13. At this point I have noticed that the gradual transition between the sky and the foreground has created a halo over the mountain on the right side of the image. By painting with white into the mask on the sky layer the halo can be reduced. Lower the opacity of the brush and ensure the hardness is set to minimum to ensure you cannot see the brush strokes.

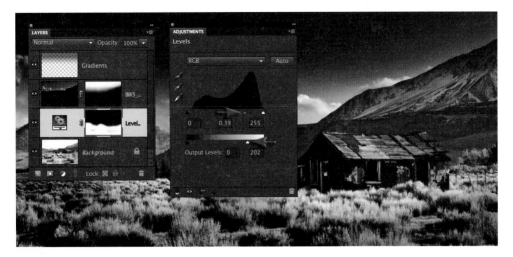

14. You can continue to create the perfect balance between the different tonal elements of the image by adjusting the opacity of the individual layers above the background layer or by fine-tuning the settings in any adjustment layers you have added. In this step I am lowering the brightness and white point even further so that the house becomes the dominant feature.

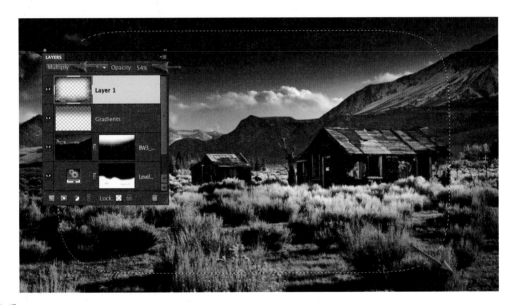

15. In this step I will create a vignette that darkens the edge of the image. This technique will again help the viewer's eye to be drawn into the image. The best technique to achieve this is to stamp the visible elements of every layer to a new layer. I have selected the top layer in the Layers panel and then used the keyboard shortcut Ctrl + Alt + Shift + E (PC) or Command + Option + Shift + E (Mac) to create the Stamp Visible layer. I have then selected the Rectangular Marquee tool from the Tools panel and entered a 250 px feather in the Options bar before selecting the central portion of the image. I have then pressed the Backspace key (PC) or Delete key (Mac) to remove the selected pixels. Switching the blend mode of the layer to Multiply will apply the darkening effect and then I can lower the opacity of the layer until the vignette is reasonably subtle.

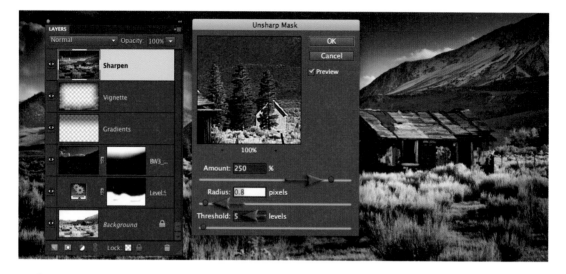

16. To complete the project I have applied output sharpening. I have created another Stamp Visible layer and applied the Unsharp Mask from the Enhance menu. I have used a generous amount of sharpening but kept the Radius very low (between 0.5 and 1.0). The Threshold slider has been raised slightly so that we don't sharpen any artifacts that may be present.

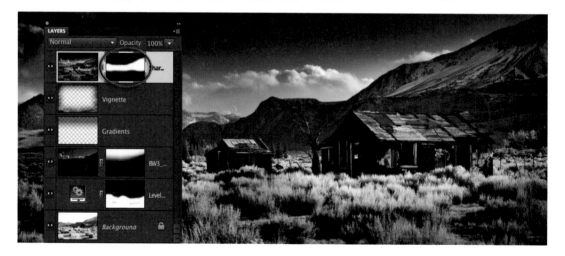

17. To restrict the sharpening to just the primary detail I have added a black layer mask (holding down the Alt/Option key as I click the 'Add layer mask' icon at the base of the Layers panel). I then selected a large brush with the hardness set to minimum and painted into the layer mask to reveal those areas that I wanted to appear sharp. The image is complete and ready for printing. The quality of the tonality should be very high using this technique, so long as I perform the majority of the big tonal adjustments in ACR (at the higher bit depth) rather than the lower bit depth of the main editing space. If you need to make significant tonal changes it is always best to return to ACR using the Place command. Make your tonal changes in ACR and then mask back to the area you need. This technique will reduce the risk of banding or posterization that often occurs in a file that has been edited too much in the main Edit space.

Project 7

Unsharpened

Sharpening

All digital images require sharpening – even if shot on a state-of-the-art digital SLR in focus. Most cameras can sharpen in-camera but the highest quality sharpening is achieved in post-production. Photoshop Elements will allow you to select the amount of sharpening and the areas that require it the most. For images destined for print, the monitor preview is just that – a preview. The actual amount of sharpening required for optimum image quality is usually a little more than looks comfortable on screen.

Advanced sharpening – targeted for maximum impact

The basic concept of sharpening is to send the Unsharp Mask filter on a 'seek and manipulate' mission. The filter is programmed to make the pixels on the lighter side of any edge it finds lighter still, and the pixels on the darker side of the edge darker. Think of it as a localized contrast control. Too much and people in your images start to look radioactive (they glow); not enough and the viewers of your images start reaching for the reading glasses they don't own.

The art of advanced sharpening

The best sharpening techniques are those that prioritize the important areas for sharpening and leave the smoother areas of the image well alone, e.g. sharpening the eyes of a portrait but avoiding the skin texture. These advanced techniques are essential when sharpening images that have been scanned from film or have excessive noise, neither of which needs accentuating by the sharpening filters. So, let the project begin.

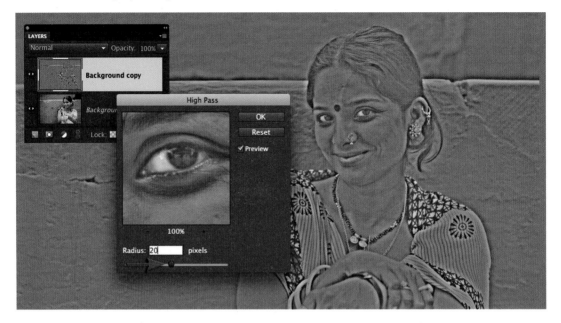

1. The first four steps of the project will set out to create an edge mask that can then be used to restrict sharpening to just the edges of the image. I have duplicated the background layer by dragging it to the Create a new layer icon in the Layers panel. I have then gone to Filter > Other > High Pass. I have increased the pixel Radius to around 20 to 30 pixels for an image captured with a 10 to 24 megapixel camera. I have selected OK and applied the Despeckle filter (Filter > Noise > Despeckle) and also the Dust and Scratches filter (Filter > Noise > Dust and Scratches) using a Radius value of 1 pixel and setting the Threshold slider to 0 Levels.

Note > The High Pass filter is sometimes used as an alternative to the Unsharp Mask if the duplicate layer is set to Overlay or Soft Light mode. In this project, however, we are using the High Pass filter to locate the edges within the image only.

PERFORMANCE TIP

If you have any sharpening options in your camera or scanner it is important to switch them off or set them to minimum or low. The sharpening features found in most capture devices are often very crude when compared to the following advanced technique. It is also not advisable to sharpen images that have been saved as JPEG files using high-compression/low-quality settings. The sharpening process that follows should also come at the end of the editing process, i.e. after adjusting the color and tonality of the image.

2. I have applied a Threshold filter to the High Pass layer from the Filter > Adjustments submenu. The threshold adjustment will reduce this layer to two levels – black and white.

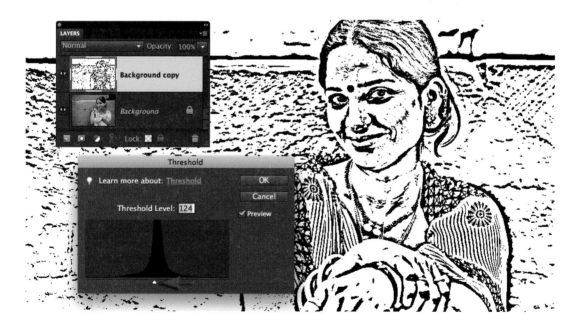

3. I have dragged the slider just below the histogram to isolate the edges that require sharpening. The aim of moving these sliders is to render all of those areas I do not want to sharpen white (or nearly white). I have then selected OK. I am halfway to creating a sharpening mask. The mask will restrict the sharpening process to the edges only (the edges that you have just defined). Increasing or decreasing the radius in the High Pass filter will render the lines thicker or thinner.

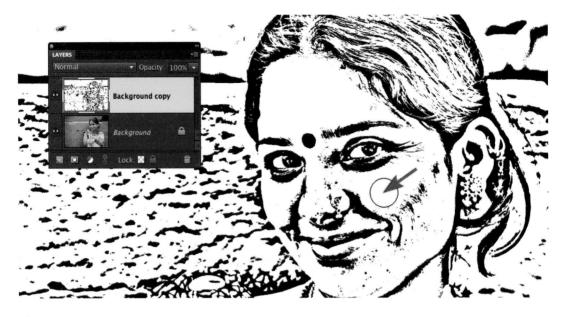

4. I have selected the Brush tool from the Tools panel, set white as the foreground color and the Opacity to 100% in the Options bar. I can paint out any areas that I do not want to be sharpened (areas that were not rendered white by the Threshold adjustment). In the project image the skin away from the eyes, mouth, nose and even the background were painted.

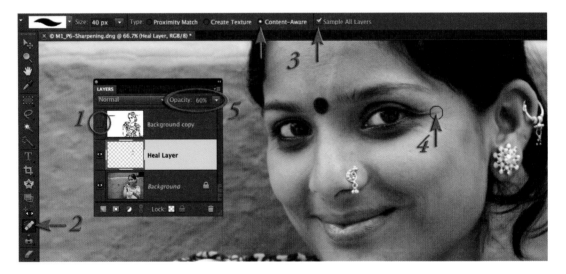

5. I have clicked on the Visibility icon of the background copy layer to hide it momentarily. I can then click on the Background layer to select it and click on the Create a new layer icon in the Layers panel to create an empty new layer. I have selected the Spot Healing Brush tool from the Tools panel and selected the Content-Aware and Sample All Layers options. I have brushed over any of the larger skin flaws and lines around the eyes. I can lower the opacity of this layer in the Layers panel to reintroduce some of this detail if required. I have double-clicked on the name of this layer and called it Heal Layer.

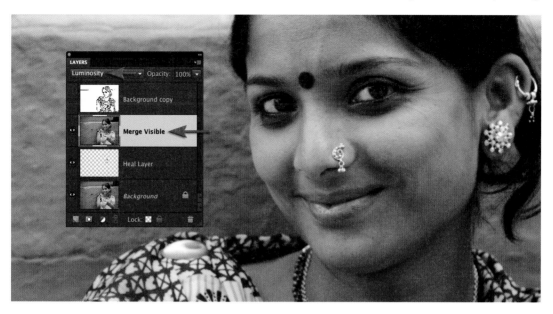

6. With the Heal Layer selected I have held down the Ctrl + Alt + Shift keys (PC) or Command + Option + Shift keys (Mac) and then hit the E key on the keyboard to merge the visible elements to a new layer. I have then named the layer Merge Visible. As this is the layer I will sharpen I have set the Mode of the layer to Luminosity in the Layers panel.

Note > The Luminosity mode will ensure that the edges do not become too saturated after the sharpening process that is applied in the last step of this project.

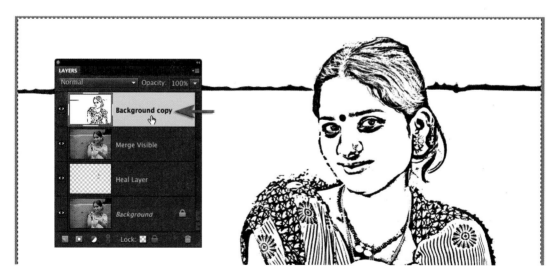

7. I have selected the Background copy layer and switched the visibility of this layer back on. From the Select menu I have chosen All and then from the Edit menu chosen Copy. This copies this edge mask to the clipboard. I have switched off the visibility of this background copy and selected the Merge Visible layer.

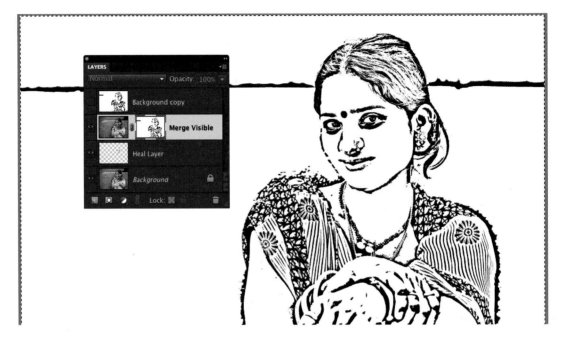

8. With the Merge Visible layer selected I have clicked on the Add layer mask icon in the Layers panel. I have held down the Alt key (PC) or Option key (Mac) and clicked on the Layer mask thumbnail to view the contents of this layer mask. The image preview will appear all white until I then choose Paste from the Edit menu. I have now successfully transferred the edge mask to the layer mask.

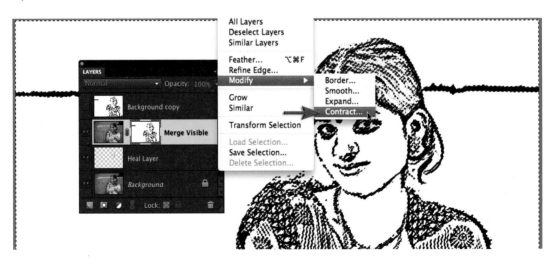

9. The black lines in this layer mask will define the areas of sharpening. The lines can be made thicker by holding down the Ctrl key (PC) or Command key (Mac) and clicking on the layer mask thumbnail to load the white areas of the mask as a selection. I have gone to Select > Modify > Contract and chosen 2 pixels from the Contract dialog box, and then selected OK. From the Select menu I have chosen Inverse so that the black areas are now the selected areas.

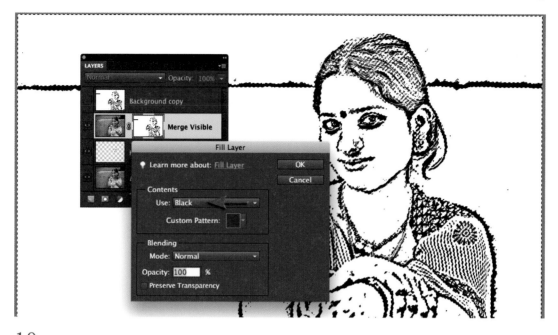

10. From the Edit menu I have chosen Fill selection. I have selected Black as the Contents and then selected OK. The lines will now be rendered 2 pixels thicker on both sides. If this step does not produce the desired effect I will need to make sure the selection was inversed in the previous step prior to filling with black.

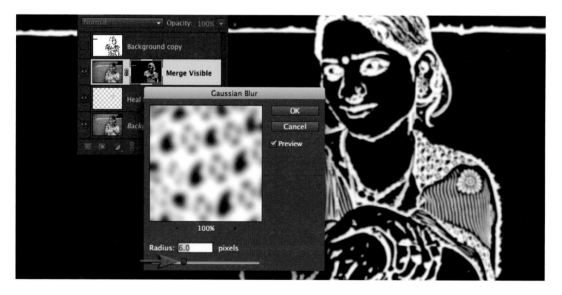

11. With the layer mask selected I can go to Filter > Adjustment > Invert. The lines in the mask should now appear white against a black background. To soften the edges of the mask I can go to Filter > Blur > Gaussian Blur and raise the Radius to 6 pixels and then select OK.

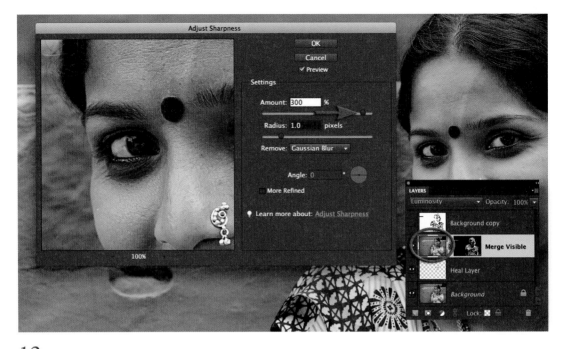

12. This is the step where I get to sharpen my image. I have selected the image thumbnail on the Merge Visible layer in the Layers panel. From Enhance > Adjust Sharpness, I have adjusted the Amount slider to between 100 and 300%. This controls how much darker or lighter the pixels at the edges are rendered. I choose an amount slightly more than what looks comfortable on screen if the image is destined for print rather than screen. The Radius slider should be set to 0.5 pixels for screen images and between 0.8 and 1.5 for print-resolution images. The Radius slider controls the width of the edge that is affected by the Amount slider. The opacity of this sharpening layer can be modified to adjust the overall sharpening effect.

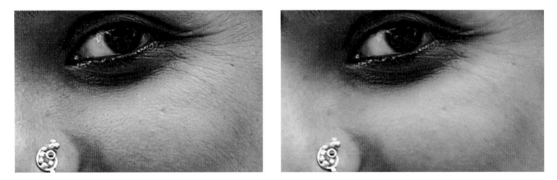

The image on the left shows the impact of the sharpening if a layer mask is not added. The image on the right uses the layer mask that was created in this project. The layer mask ensures areas of the image that would not benefit from the sharpening process are left unaffected. In Adobe Camera Raw it is possible to create quick and easy masks by raising the Mask slider but there is no option to paint into these masks. In the main editing space, however, the edge masks can be custom built to meet the needs of the image you are sharpening.

This image was sharpened using the techniques in this project

Project 8

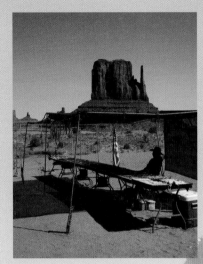

16 Bits/Channel

Multilayered editing in 16 Bits/Channel is the professional's approach to image editing, but it was never supposed to be possible in Photoshop Elements. For this tutorial Mark Galer adopts the age-old adage 'never say never' and demonstrates how you can edit at the higher bit depth until the proverbial cows come home so that you can extract the maximum quality from your Raw files.

This project requires the use of camera raw files, rather than JPEG files. The bit depth of a Raw file is higher than the 8 Bits/Channel of a JPEG file. If files are edited at a higher bit depth the color and tone of the image can be corrected or optimized to a much greater extent without the risk of introducing image artifacts and color banding in the final image. This is essential when the user requires maximum quality for a fine print.

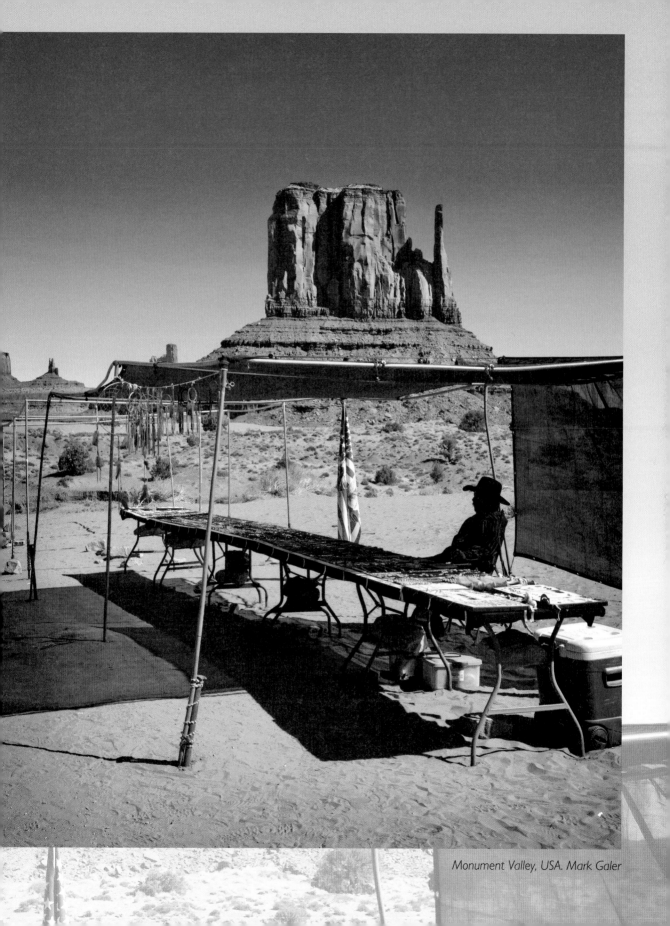

Monument Valley, USA. Mark Galer

All professional photographers know that major edits to color and tone are best done in Adobe Camera Raw (ACR), as these changes are applied at the native bit depth of the sensor (usually 12 or 14 Bits/Channel). This ensures the histogram is kept in pristine condition and massively reduces the risk of tonal banding when the file is opened in the full edit space and then printed or saved for the web. For most photographers, however, the full version of Photoshop is a simple case of overkill. Photoshop Elements can pretty much do most things photographers want and need to do. Perhaps the most disappointing omissions in the budget version of Photoshop, however, are the lack of localized editing features in Adobe Camera Raw. This forces most Elements users to prematurely open the file in the main editing space of Elements to fine-tune some target colors, add a gradient or vignette and do simple spotting to remove the annoying dust bunnies. This editing is usually performed at the lower 8 Bits/Channel, as Photoshop Elements is not supposed to be able to support additional layers or adjustment layers and most editing tools do not function at all in the higher bit depth. Adobe has disabled these features but has mysteriously left enough of an odd assortment of tools and commands available (perhaps by accident) to make multilayered editing at the higher bit depth possible... if you know Mark Galer's secret workarounds.

Note > Although the workflow outlined in this project will demonstrate how we can edit multilayered files at 16 Bits/Channel, we will have to flatten the file before saving as Photoshop Elements will not open multilayered files at the higher bit depth – the price to pay for increased tonal quality.

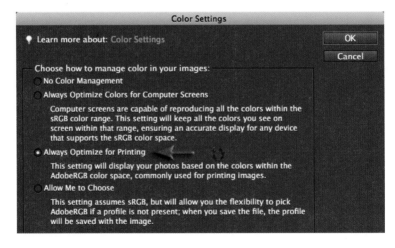

1. The first step in this 'no-compromise' workflow, that will enable us to achieve absolute quality, starts before we open the Raw file. In the main Edit space of Photoshop Elements go to Edit > Color Settings and then select the 'Always Optimize for Printing' radio button. This step will ensure that when we open our images from Adobe Camera Raw (ACR) we will be using the larger Adobe RGB color gamut instead of the smaller sRGB color gamut. This will allow us to achieve more vibrant colors that have more detail when compared with images opened into the smaller sRGB color space.

Note > Images that have the Adobe RGB profile embedded are usually not suitable for the web, so the user must be careful how they export a version of the finished image for the web when the editing is complete (see Step 23).

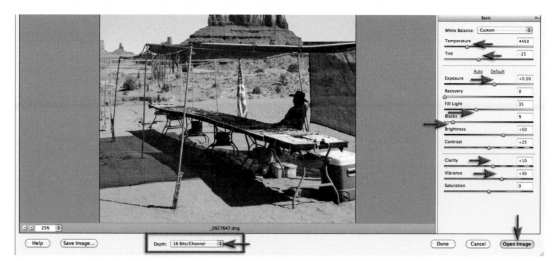

2. Open a Raw image and optimize the color and tone in this space before opening it in the main Edit space of Elements. I have adjusted the Color Temperature, Tint, Exposure and raised the Fill Light slider to +35 to ensure I can see the detail in the shadows. The Blacks, Clarity and Vibrance sliders were also adjusted to fine-tune the image. Ensure your image has a black and white point and that there is no luminance or color clipping (observe the histogram in the top right-hand corner of the ACR dialog). Set the Depth to 16 Bits/Channel (the option is directly beneath the image preview) and then hit the Open Image button to continue the project at the higher bit depth.

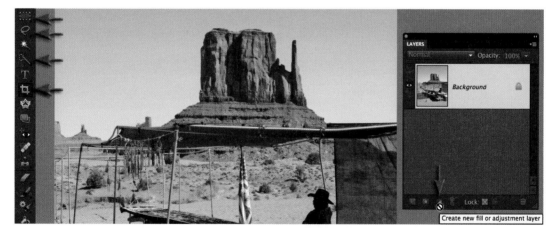

3. If you turn your attention to the Layers panel in the main Edit space you will notice that we have a background layer but that all of the icons at the bottom of the panel are 'grayed out'. This would seem to indicate that no new layers, layer masks or adjustment layers are possible at this higher bit depth. If you try and use the tools from the Tools panel you will find that very few work in the 16 Bits/Channel mode. The tools that do work include the Move tool, Selection tools, Crop tool and the Quick Selection tool. Given that the Magic Wand tool is off-limits it is curious that Adobe left the Quick Selection tool functional, but very handy given what we intend to do in this tutorial.

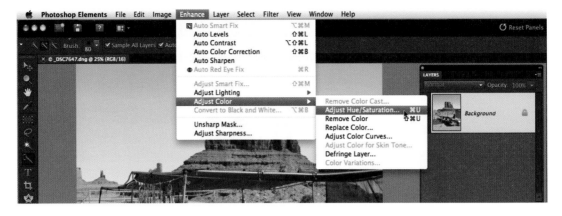

4. You may not be able to use adjustment layers in 16 Bits/Channel mode but you can access the adjustments from the Enhance menu. Global color adjustments (adjustments that affect all pixels) were possible in ACR but I am interested in editing target colors to perfect this file. I would like to modify the hue and saturation of the blue sky and increase the saturation of the sand. Go to Enhance > Adjust Color > Adjust Hue/Saturation. This is the way Adobe intended you to edit in 16 Bits/Channel, i.e. apply your adjustments directly to the background layer. Let's start with how we are supposed to edit in 16 Bits/Channel before getting into the non-conformist way of editing in 16 Bits/Channel.

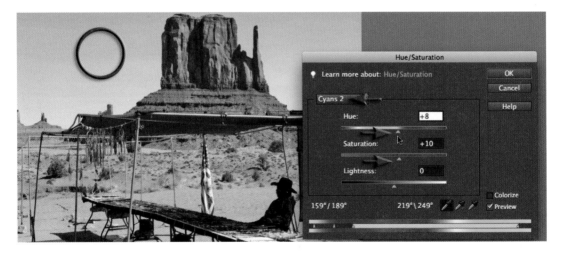

5. I have selected a Hue/Saturation adjustment (Enhance > Adjust Color > Adjust Hue/Saturation). I have then selected Blues from the top pull-down menu. I have moved my mouse cursor into the image preview and clicked in the sky to target this range of color values. You may notice that the word 'Blues' in the dialog now reads 'Cyans 2'. This is because the values we are about to adjust are between Blue and Cyan. I have moved the Hue slider to +8 and the Saturation slider to +10. I have effectively modified a target range of colors within the file. I can further limit or expand the colors I wish to edit by adjusting the stops on the ramp at the base of the dialog. Before I select OK I could also adjust the Yellows by selecting them from the pull-down menu and raising the Saturation slider to a value of +10 to render the sand more vibrant.

6. I will now make a localized adjustment to the rock formation in the center of the image by selecting the Quick Selection tool in the Tools panel and then selecting the Auto Enhance option in the Options bar. I have clicked and dragged the tool over the rock. If I select some sky by mistake, I just need to hold down the Alt key (PC) or Option key (Mac) and drag over the sky to remove it from the selection. When selecting subjects with low edge contrast this may take some time to build up an accurate selection.

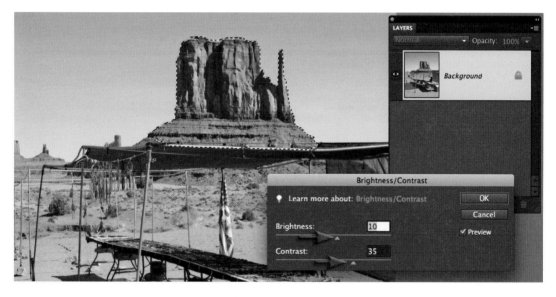

7. I will now adjust the tonality of the rock by going to Enhance > Adjust Lighting > Brightness/Contrast. I have raised the Brightness slider to +10 and the Contrast slider to +35 to give this rock more 'presence' within the image. I have selected OK to apply the changes. The color and tonal changes over the last few steps are destructive when compared to applying these changes via adjustment layers, so be sure to evaluate whether the changes are appropriate before moving on to the next step. In the next steps I will show you how to edit in a non-destructive way using layers, a way that Adobe did not intend for you to be able to do. This workaround has been available for many versions, including the latest version 10, and it still feels a bit 'naughty' every time I use it.

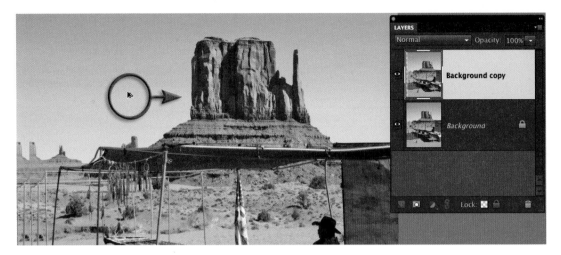

8. In this next step I am going to show you how to apply a vignette to this file using layers. That's right, 'Layers' in 16 Bits/Channel. I have selected the Move tool from the Tools panel, held down the Alt key (PC) or Option key (Mac) and then clicked and dragged the image preview a short distance. Holding down the Alt/Option key, when combined with the Move tool, is a Photoshop keyboard shortcut for copying and this was never disabled when editing in 16 Bits/Channel mode in Photoshop Elements. The result of this action is a background copy layer that should strictly have been off-limits. Now these two layers will not be registered, i.e. they are out of alignment, but in the next step I will put them back in alignment.

9. With the Move tool still selected I have clicked and dragged the layer back into position. The edges of the layer are attracted to the edge of the canvas area so it will snap back into place. If you are not sure whether the two layers are aligned you could switch the mode of the layer to Difference. When the layers are out of alignment you will see 'the difference' at the edges and when the two layers are correctly aligned the image preview turns completely black. Switch the mode back to Normal when this has been achieved.

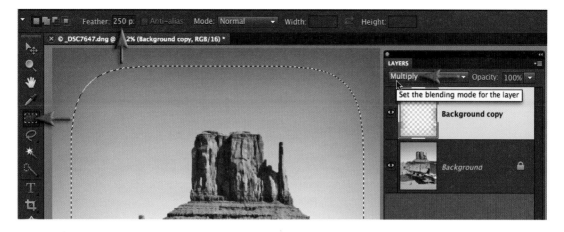

10. I have selected the Rectangular Marquee tool in the Tools panel and set the Feather to 250 px. I have then clicked and dragged the tool from a position just inside the top left-hand corner to a position just short of the bottom right-hand corner before letting go of the mouse button. I have then hit the Backspace key (PC) or Delete key (Mac) to remove the central portion of the layer. To complete the process I have changed the blend mode of the layer to Multiply and then adjusted the layer opacity to fine-tune the vignette. This is non-destructive 16 Bits/Channel editing that was supposed to be reserved for users of the full version of Photoshop. The technique outlined in this step is not reserved for vignettes. I could have effectively adjusted the brightness and contrast of the center rock using this technique (by choosing Inverse from the Select menu before deleting the pixels on the layer).

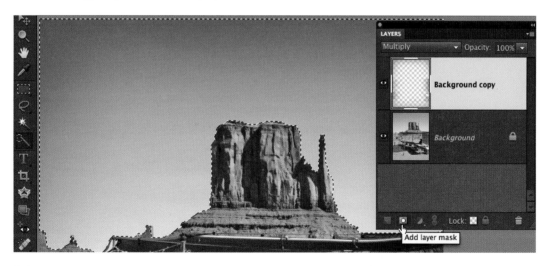

11. If you like the vignette in the lower half of the image but would prefer a linear gradient in the sky, then select the Quick Selection tool and make a selection of the sky. Hit the Backspace (PC) or Delete key (Mac) to remove the vignette from just the sky. Go to Select > Save Selection and name your saved selection 'Sky' before going to Select > Deselect. Click on the Add layer mask icon to hide the vignette and lose the selection with a single click. If you want to get really mischievous, read on. Things are about to get devious!

12. This is where the fun really starts. I can use a duplicate file set to 8 Bits/Channel to action some illegal 16 bit manoeuvres before transferring the goodies back to our 16 bit file. I have gone to File > Duplicate Image and selected OK. I was asked to convert the bit depth of the file as Photoshop Elements does not support 16 bit layers (oh really!), so I just hit the 'Convert depth' button to make a duplicate in 8 Bits/Channel.

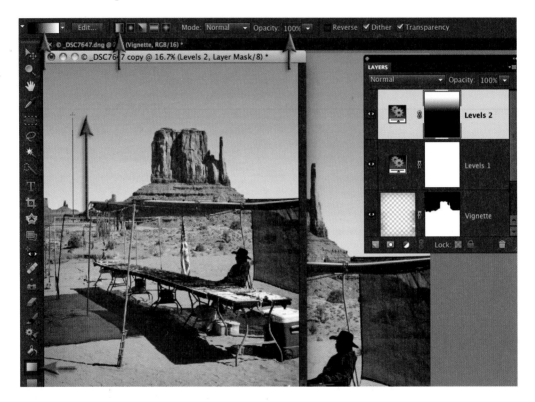

13. In this step I will create a selection (one that cannot be made in the 16 Bits/Channel file) and then move it to the 16 Bits/Channel file. In the 8 bit duplicate file I have added a Levels adjustment layer from the 'Create new fill or adjustment layer' icon at the base of the Layers panel (now active again at the reduced bit depth). I have selected the Gradient tool from the Tools panel and the Black/White and Linear gradient options in the Options bar. I have then clicked and dragged a gradient from the horizon line to a position just above the top of the center rock. I have held down the Shift key as I dragged this gradient to ensure I have constrained the gradient to an absolute vertical gradient.

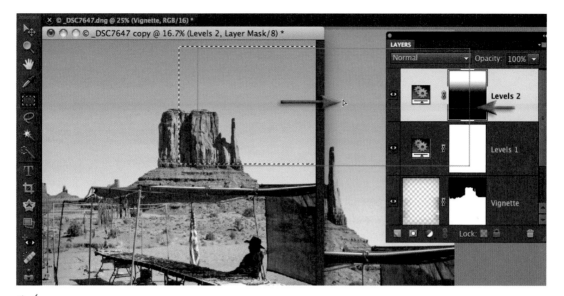

14. To load this gradient as a selection I have held down the Ctrl key (PC) or Command key (Mac) and clicked on the Levels adjustment layer mask in the Layers panel. I have then selected the Rectangular Marquee tool (NOT the Move tool) from the Tools panel and clicked inside the selection and dragged this selection to the image preview of the 16 bit file. When the selection is moved over the 16 bit file preview I have let go of the mouse button.

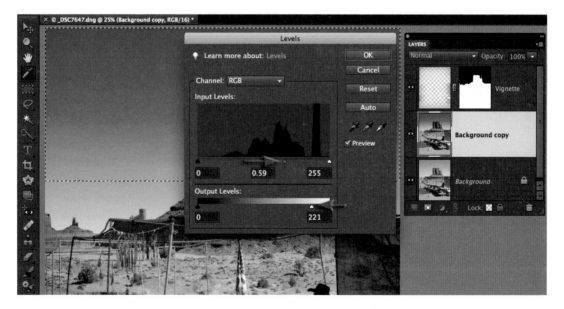

15. I have duplicated the background layer using the technique outlined in Steps 8 and 9, and then I have gone to Enhance > Adjust Lighting > Levels. In the Levels dialog I have moved the central Gamma slider underneath the histogram to the right in order to darken the sky. The darkening will happen gradually due to the heavily feathered selection I have active. If the saturation climbs too high I could move the White Output slider to the left before selecting OK.

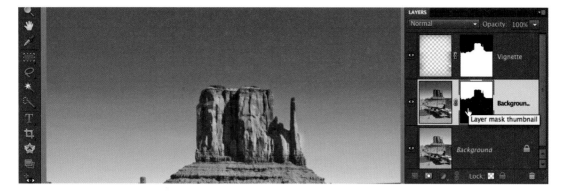

16. As the gradient will also darken the central rock I need to remove the effect from this portion of the image. To load the selection from the layer mask I must hold down the Ctrl key (PC) or Command key (Mac) and click on the layer mask thumbnail on the Vignette layer. I have then selected the layer to which I have just applied the graduated adjustment and then held down the Alt key (PC) or Option key (Mac) before clicking the 'Add layer mask' icon at the base of the Layers panel.

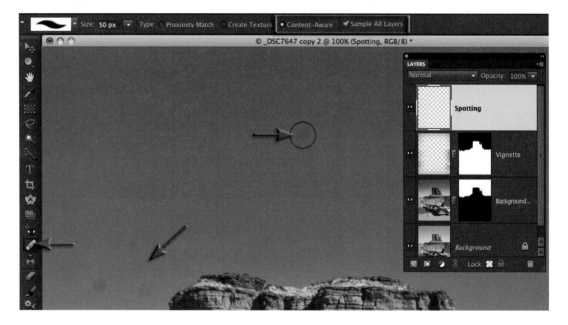

17. The darker sky has made the 'dust bunnies' (sensor dust) more prominent but I cannot remove them using the Spot Healing Brush tool or the Clone Stamp tool as they have both been disabled when editing in 16 Bits/Channel in Photoshop Elements. I have created a second duplicate file (this one will have the darkened sky) and then clicked on the Create a new layer icon at the base of the Layers panel to create an empty layer. I have selected the Spot Healing Brush tool and the Content-Aware and Sample All Layers options in the Options bar. I have then clicked on each of the spots in turn, using a brush size just larger than the offending spot, to remove them from view.

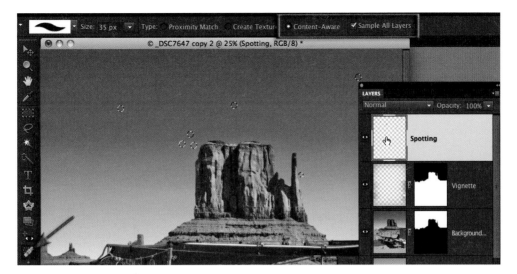

18. Getting these corrected pixels into the 16 bit file is difficult but not impossible (Adobe will not allow us to copy the pixels from this file and paste them into a 16 bit file). As we have seen in a previous step, however, I can move a selection from an 8 bit file to a 16 bit file and this is the first step in this complicated workaround. I have held down the Ctrl key (PC) or Command key (Mac) and clicked on the layer thumbnail to load the pixels on this layer as a selection.

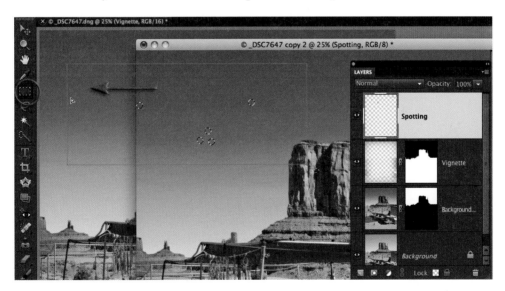

19. In order to move a selection from one file to another I must remember to use a selection tool and not the Move tool, even if the selection tool I picked did not create the selection in the first place (strange but true). I have then dragged the selection from the 8 bit preview over the 16 bit preview and let go of the mouse button. The selection should line up perfectly except this is only a selection and does not contain the healed pixels that I need. I will pick these up by going back to the 8 bit file one last time.

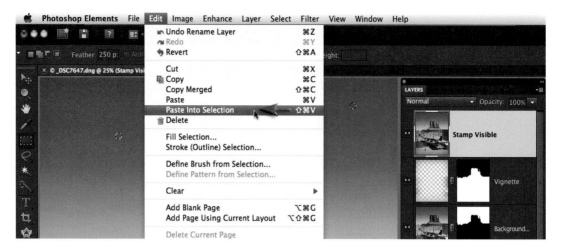

20. From the second 8 bit duplicate file I have gone to Edit > Copy before returning to the 16 bit file. I have created a new layer for the copied pixels to be pasted into. I have then selected the top layer in the 16 bit file and then used the keyboard shortcut Ctrl + Alt + Shift + E (PC) or Command + Option + Shift + E (Mac) to create a 'Stamp Visible' layer in the Layers panel (this layer contains all the visible pixels from the three layers below). From the Edit menu I have chosen 'Paste Into Selection' so that the pixels from the 8 bit file are pasted into the selection (the Paste command cannot be used because it will want to add another layer in the conventional way but this has been disabled).

Note > The technique outlined in the last three steps would effectively allow us to create a 16 bit composite file using two 16 bit files of differing subject matter.

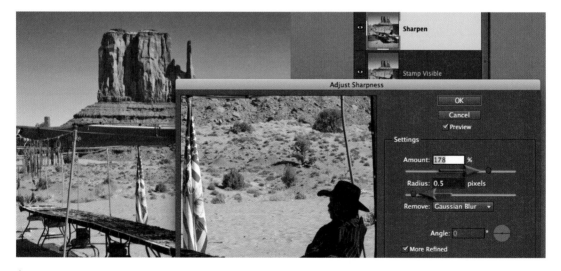

21. Create another Stamp Visible layer using the technique outlined in the previous step and set the mode of the layer to Luminosity. We will use this Stamp Visible layer as our sharpening layer. Go to Enhance > Adjust Sharpness and use a high Amount setting and low Radius setting to effectively sharpen the file. The Luminosity setting will ensure the increased contrast at the edges of the file do not become overly saturated.

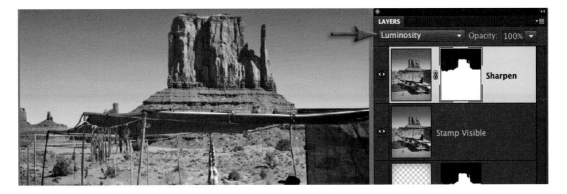

22. I have added a layer mask to the sharpening layer so that I don't subject the smooth continuous tone of the sky to any unnecessary sharpening. My 16 bit editing extravaganza is now complete and I can now print the highest quality files Elements can deliver and/or proceed to the next step to create the finest quality web images.

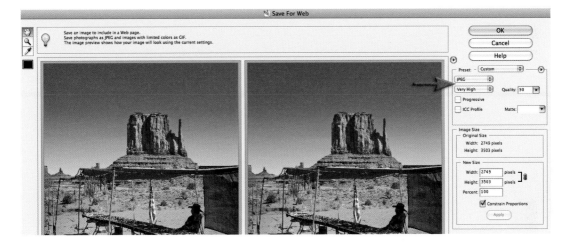

23. To save an 8 bit JPEG file for the web I can go to File > Duplicate and choose the 'Flatten' option. Go to Image > Mode > 8 Bits/Channel and then to Image > Convert Color Profile > Convert to sRGB profile. I can go directly to Save for Web from my master file but the Adobe RGB color profile I have used for this project will mean that the colors do not display correctly if the image is viewed on the web (the colors were optimized for optimum print quality). Before saving my master 16 bit file I need to go to Layer > Flatten Image. You may ask 'Why would I want to flatten my image?' The answer is that although you can save a multilayered 16 bit file using Photoshop Elements, the budget software will not allow us to reopen the file with the layers intact. Although we could happily open this multilayered file in the full version of Photoshop, Photoshop Elements will invite us to 'Flatten' the file once again. The file will still be of a much higher quality than an 8 bit file, even when it has been flattened, it just won't give us the options to change our mind that working with layered files allow. OK, one big 'but…' in a workflow that gives us nothing but sunshine and roses! Just be happy in the knowledge that this single 'but…' is saving you a small fortune!

part 2

enhance

Project 1

Depth of Field

Here we explore the science of making good photographs even more memorable. Discover how to add drama to your landscape images using the 'Fingers of God' tool (aka the Gradient tool with customized settings). Creating effective landscape images is not exactly rocket science. Choose a beautiful landscape just after dawn, or just before sunset, and add dramatic natural lighting to create emotive and memorable landscape images. There is often a lot to think about during the capture of an image, and the time required to consider the appropriate aperture and shutter speed combination for the desired visual outcome often gets the elbow.

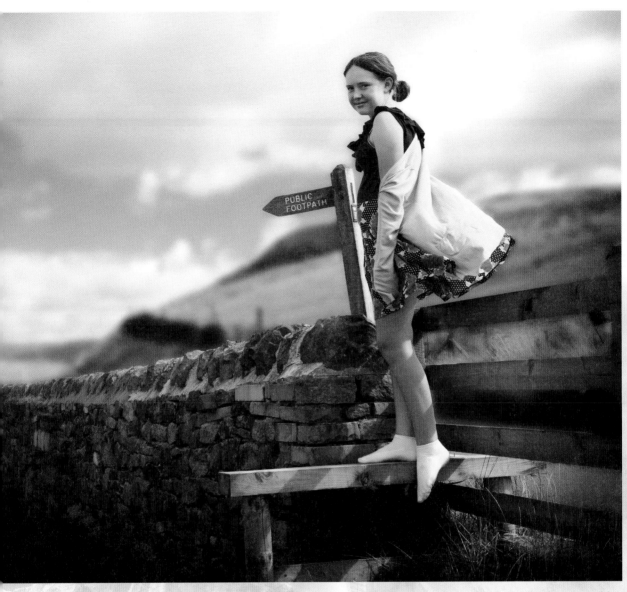

Decrease the depth of field to emphasize your subject

Photoshop Elements can, however, come to the rescue and drop a distracting background into a murky sea of out-of-focus oblivion. Problems arise when the resulting image, all too often, looks manipulated rather than realistic. A straight application of the Gaussian Blur filter will have a tendency to 'bleed' strong tonal differences and saturated colors into the background fog, making the background in the image look more like a watercolor painting than a photograph. The Gaussian Blur filter will usually require some additional work if the post-production technique is not to become too obvious.

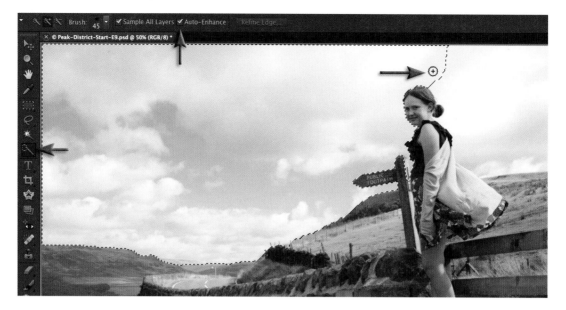

1. I have started the project by dragging the background layer to the Create a new layer icon at the base of the Layers panel to create a duplicate layer. I have then selected the area that I would like to defocus. I have chosen the Quick Selection tool in the Tools panel and the Auto-Enhance option in the Options bar and then clicked and dragged in the sky to select the sky.

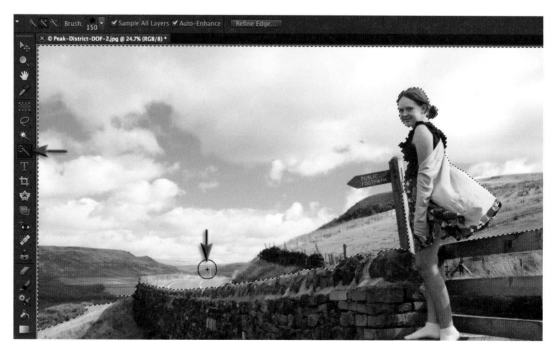

2. I have clicked and dragged a second time to add everything above the wall. No matter how careful I am with the Quick Selection tool I may pick up parts of the subject that I did not want to select. I can correct these errors in the following steps.

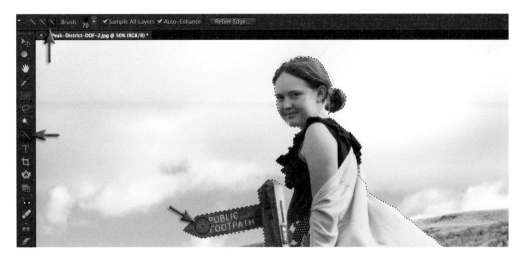

3. I have selected the 'Subtract from selection' icon in the Options bar and clicked and dragged over any areas that need to be removed from the selection. In the illustration above the signpost has been removed from the selection. When I zoom in to Actual Pixels (View > Actual Pixels) I have noticed there are small errors around the signpost and girl. These are difficult to remove using the Quick Selection tool in this image so I will explore other techniques in the steps that follow.

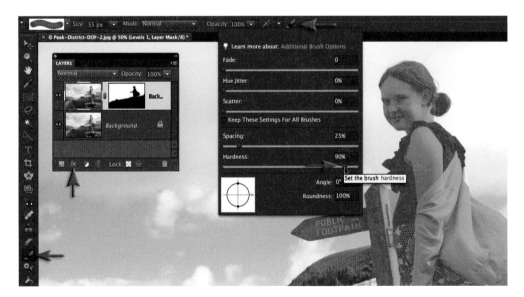

4. I have duplicated the background layer by dragging it to the Create a new layer icon at the base of the Layers panel and then clicked on the Add layer mask icon (also at the base of the Layers panel). Notice in the Layers panel that the selection has been converted into a layer mask. This layer mask will form the basis of my 'depth map' that will control the focus within the image. If I hold down the Alt + Shift keys (PC) or Option + Shift keys (Mac) I can click on the layer mask thumbnail to view the mask as an overlay. I have then selected the Brush tool from the Tools panel and set the Brush Hardness to 90% and the Opacity to 100%.

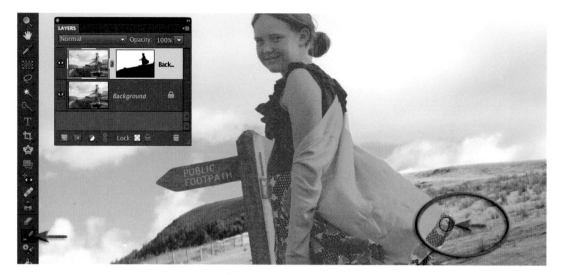

5. I have set the foreground color to black in the Tools panel and then carefully painted along any edges that need to be added to the mask (areas where the Quick Selection tool invaded the subject). If I accidentally paint over an edge I just need to switch the foreground color to white (by pressing the X key) and then paint to remove the mask color. The masked areas will eventually serve to protect the subject matter that I want to appear in sharp focus.

6. I have selected the Polygonal Lasso tool in the Tools panel (situated behind the Lasso tool) and entered in a Feather Radius of 0 pixels in the Options bar. I have then clicked just below the top railing of the wooden fence on one of the inner corners. I have proceeded to click on the other three corners until I have completed the selection of the background behind the fence. I have then gone to Edit > Fill Selection and chosen white as the foreground color from the Contents menu in the Fill dialog. I have selected OK to clear the mask in this area. I have repeated the process on the second gap in the fence. I needed to make multiple clicks as I traced the back of the leg so that the selection in this area was not a straight line before filling with white.

7. I found additional areas that needed to be removed from the mask between the signpost and the girl, along the upright of the signpost, behind the girl's neck and just above the wooden fence (below the skirt that is blowing in the wind). In all these areas the contrast was too low for the Quick Selection tool to make an accurate selection.

8. When the selection is complete I can hold down the Alt key (PC) or Option key (Mac) and click on the layer mask thumbnail to switch from mask view back to normal view. I can then hold down the Ctrl key (PC) or Command key (Mac) and click on the layer mask to load the mask as a selection. I have gone to Select > Save Selection and then entered in a name for my selection before choosing OK. Finally, I have gone to Select > Deselect to lose the active selection. This selection can be loaded by going to Select > Load Selection. In this tutorial, however, I will be able to access the selection from the layer mask (depth map) that I have created.

9. I will need to break the link between the layer and the layer mask before applying the Gaussian blur otherwise the mask and the subject will be blurred at the same time.

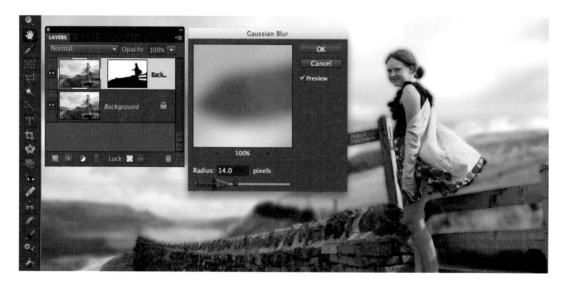

10. I have made sure the background copy layer is the active layer in the Layers panel. I have then gone to Filter > Blur > Gaussian Blur. I have entered in a value for the Radius that drops the focus by the appropriate amount. In this project I have used a very generous 14 pixels before selecting OK. The results at this stage will be far from satisfactory but I will refine the edge of the mask and remove the dark halos from around the subject matter in the subsequent steps. The Gaussian blur filter has caused some of the darker and lighter tones of the subject to bleed in to the smooth blur causing the halos that we can now see. These halos will be removed in a later step.

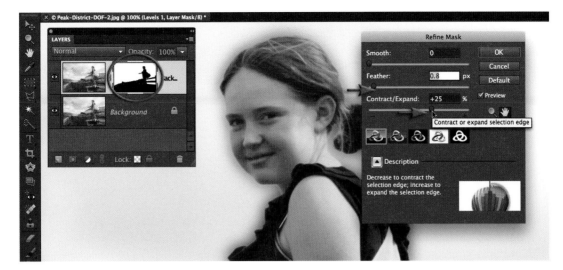

11. I have zoomed in to Actual Pixels (View > Actual Pixels). I have then clicked on the layer mask to make it the active component of the composite file. I have chosen Refine Edge from the Select menu and then used the keyboard shortcut Ctrl + H (PC) or Command + H (Mac) to hide the marching ants. I have raised the Feather slider to 0.8 pixels and moved the Contract/Expand slider to +25% to refine the edge of the mask. I have selected OK to apply the changes.

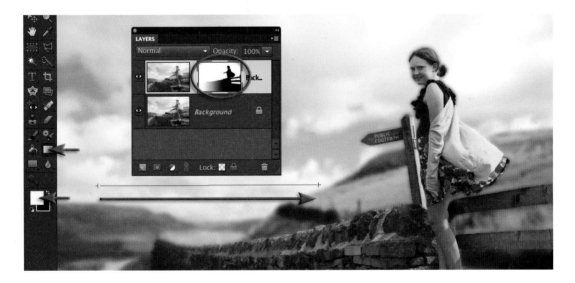

12. I have selected the Gradient tool in the Tools panel and made white the foreground color. I have chosen the 'Foreground to Transparent' gradient from the gradient picker in the Options bar and selected the Linear gradient option. I have set the Opacity to 100% and made sure the Reverse option is NOT checked. I have held down the Shift key and then clicked and dragged a long gradient from the left side of the image to a position just short of the signpost before letting go of the mouse button. This has progressively dropped the focus of the wall as it recedes into the background.

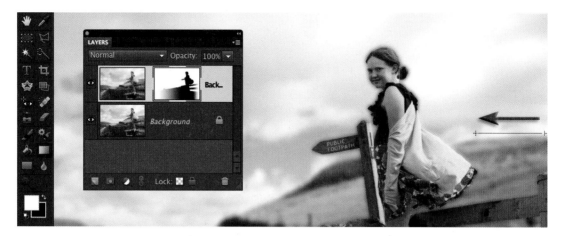

13. I have repeated the process by adding a shorter gradient on the right side of the image. This shorter gradient ends as it meets the back of the dress blowing in the wind. The depth map is nearly complete. I have selected the background copy layer in the Layers panel to make it the active component. If I decide the blur is too heavy then I can simply drop the opacity of the background copy layer in the Layers panel to adjust the focus.

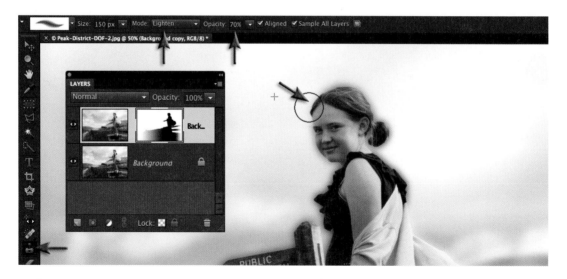

14. I have made sure the image thumbnail and not the mask is the active component of the layer and then selected the Clone Stamp tool in the Tools panel. I have set the Mode to Lighten and the Opacity to 70% in the Options bar. I have set the brush hardness to 0% and then held down the Alt key (PC) or Option key (Mac) and clicked to select a source point just beyond the dark halo. I have then clicked and dragged to paint over the dark halo (notice the '+' as I paint with the Clone Stamp tool which indicates the source of the pixels that I am now painting with). I have clicked and dragged a second time to further reduce the halo. I will need to resample the source point as I move from the left side of the subject to the right side of the subject. I will also need to change the Mode in the Options bar to 'Darken' when I remove the light halo from the back of the pink cardigan.

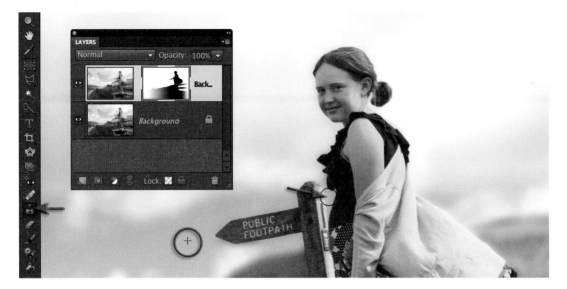

15. I needed to select a source point much further away when removing the halos between the signpost and the girl, behind the neck, and between the top of the fence and the dress. In the illustration above you can see I have selected a source point in the blue sky, well to the left of the signpost, to ensure I use appropriate tones for the cloning process.

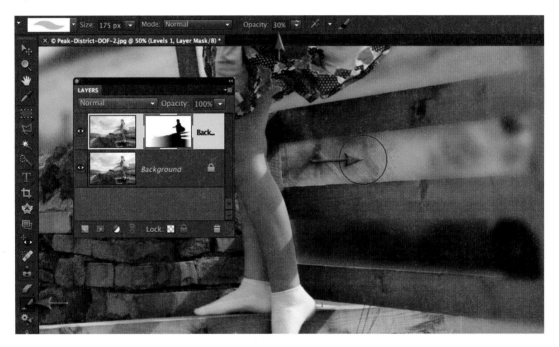

16. I can continue to modify the depth map at any stage. In this step I have decided to increase the amount of focus between the fence rails. This can be achieved by painting with black into the layer mask with a brush that has low opacity and hardness settings. In the example above I have used the brush with a 30% opacity setting.

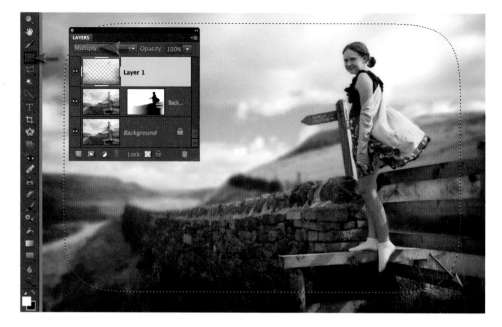

17. To complete the project I will fine-tune the appearance of the image by adding a vignette, adjusting the brightness and contrast of the subject and then applying some sharpening. I have selected the background copy layer in the Layers panel and then used the keyboard shortcut to stamp the visible elements of all layers into a new layer. The keyboard shortcut for a PC is Ctrl + Alt + Shift + E and for a Mac it is Command + Option + Shift + E. I have selected the Rectangular Marquee tool in the Tools panel and then entered in a 250 pixel feather in the Options bar. I have clicked and dragged from the upper left-hand corner of the image to the lower right-hand corner of the image to make a selection of the central portion. I have then hit the Backspace key (PC) or Delete key (Mac) to remove the selected pixels from this layer. I have set the mode of the layer in the Layers panel to Multiply. The blend mode will effectively darken the outer edges of the image. I have double-clicked on the name of the layer and renamed it Vignette.

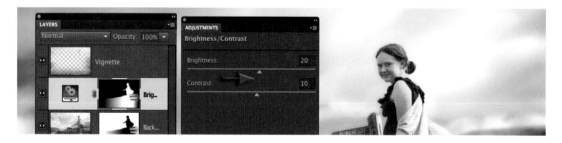

18. I have Ctrl-clicked (PC) or Command-clicked (Mac) the layer mask thumbnail in the Layers panel to load the mask as a selection. I have then clicked on the background copy layer to make it the active layer in the Layers panel. I have gone to Select > Inverse and then from the Create new fill or adjustment layer menu at the base of the Layers panel selected a Brightness/Contrast adjustment. I have raised the Brightness to +20 and the Contrast to +10. This adjustment will only affect the area of the subject that I wanted to remain in sharp focus.

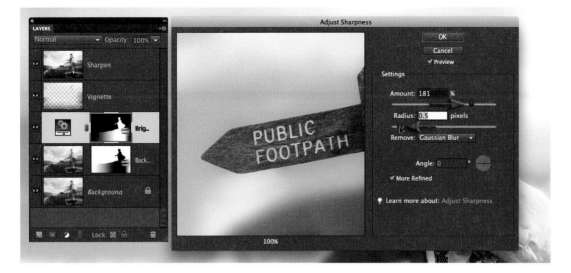

19. I have selected the Vignette layer in the Layers panel and then made another Stamp Visible layer using the keyboard shortcut from Step 17. I have renamed this layer Sharpen and set the mode of the layer to Luminosity (this mode prevents unwanted saturation issues at the sharpened edges). I have gone to Enhance > Adjust Sharpness and set the Amount to 181% and the Radius to 0.5 pixels. I have selected OK to apply the sharpness. I have Ctrl-clicked (PC) or Command-clicked (Mac) the original layer mask I used for the depth map and hit the Backspace key (PC) or Delete key (Mac) to remove the blurred pixels from the Sharpen layer (we don't need to sharpen the pixels that I defocused).

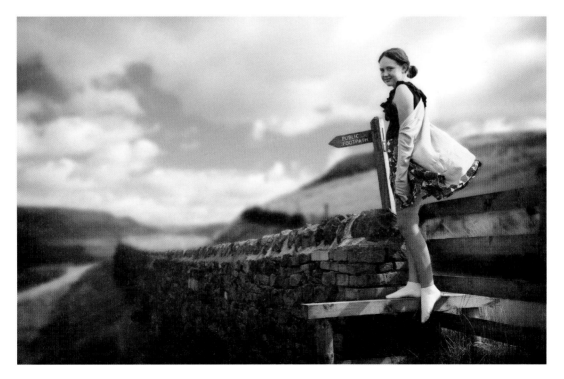

FUTURE DEVELOPMENTS SHIFTING FOCUS

If digital cameras are eventually able to record distance information at the time of capture, this could be used in the creation of an automatic depth map (the Lens Blur filter in the full version of Photoshop can already use channels or layer masks to create automated depth of field effects, but the channel must still be created manually using the techniques outlined in this project). Choosing the most appropriate depth of field could be relegated to post-production image editing in a similar way to how the white balance is set in Camera Raw.

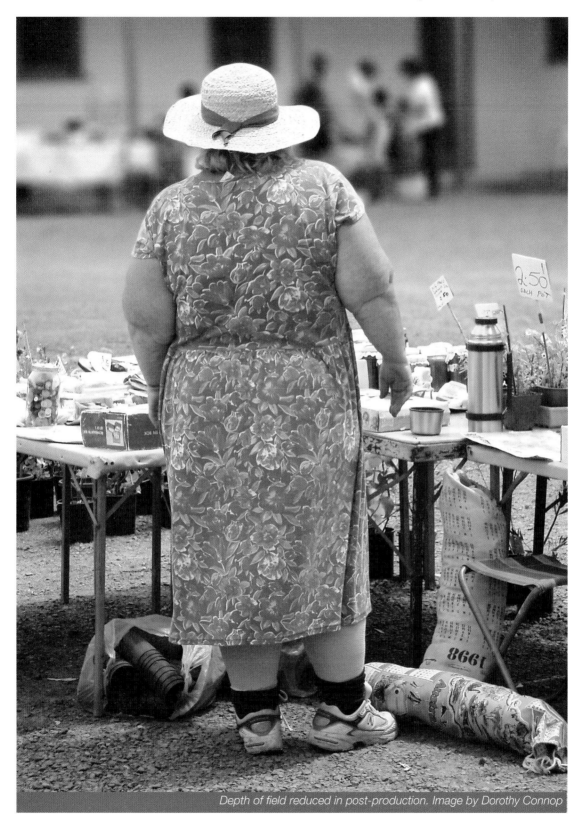

Depth of field reduced in post-production. Image by Dorothy Connop

Project 2

High Key

High key is one of the classic looks in photographic portraiture. The look is 'clean' and 'light' and the images have very few midtones or shadows. The darker tones that remain serve to shape the contours and define important details. If the treatment is clumsily done the image will just look like it has been badly overexposed. To avoid this disaster the final image must display bright highlights that are not clipped (overexposed) and the darker details must have depth and weight.

The camera technique is relatively simple – just photograph your sitter using a large soft light or window light. Choose a light background and ask your sitter to wear light-colored clothing. The rest of the treatment can be created in Photoshop Elements. Unfortunately there is no single adjustment feature or filter that provides the high-key look. A sequence of adjustments and simple masking techniques can, however, deliver the goods every time. The resulting histogram will look like all the levels are making friends with the right-hand wall. Let the show begin.

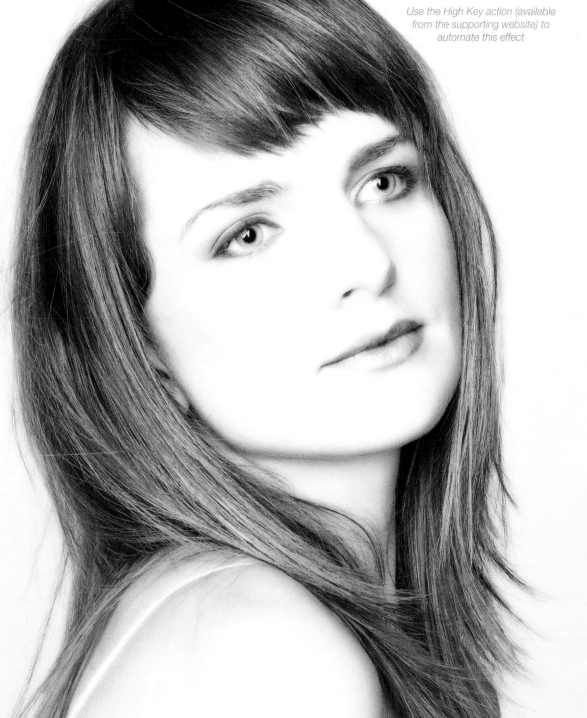

High key – raising midtone brightness without creating the appearance of overexposure. Photography by Ed Purnomo

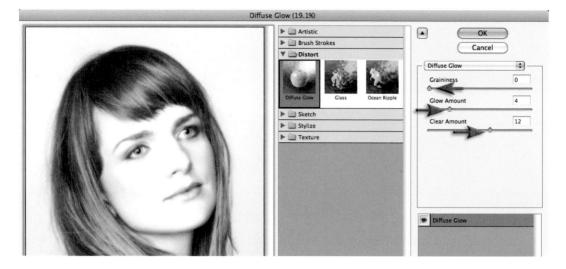

1. A filter that gets close to the desired outcome (close but no cigar) is the Diffuse Glow filter found in the Distort submenu. The result is not bad, but if I take this approach, the brightest highlights will tend to clip to 255 white while the darker tones are softened as the glow bleeds into these surrounding details. If I elect to take this single-step approach, I would first duplicate the layer and set White as the background color before applying the filter. This step will ensure the glow color is appropriate and will give me a layer that I can mask or erase back to restore some of the detail contained on the background layer.

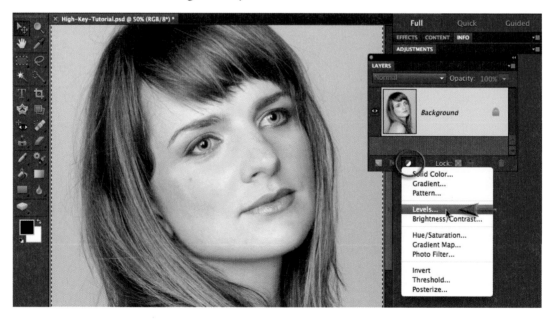

2. This alternative approach aims to brighten midtones while retaining highlight detail and texture, and also preserve the density of the few remaining dark tones. To start this process I will need to go to Select > All and then Edit > Copy. I have then clicked on the Create new fill or adjustment layer icon at the base of the Layers panel and chosen Levels.

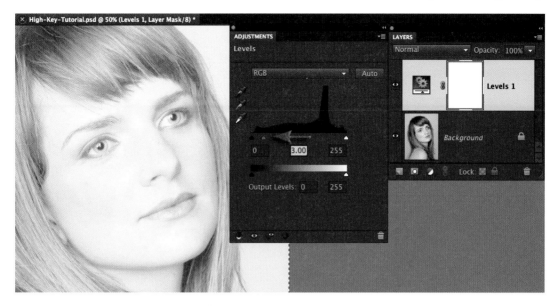

3. In the Adjustments dialog I have dragged the Gamma (gray) slider (the one sitting under the middle of the histogram) to the left until the number in the numerical gamma field reads approximately 3.00. The aim is to make all of the midtones and highlights very bright without making them 255 white. At this stage the dark tones will look thin and washed out (pretty horrible).

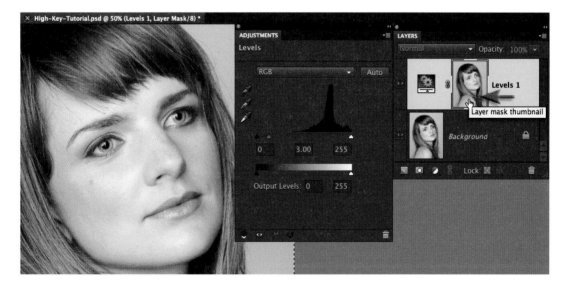

4. In this step I will create a layer mask that will restore the darkest tones. I have held down the Alt key (PC) or Option key (Mac) and clicked on the layer mask thumbnail. The preview window will turn completely white. From the Edit menu I have then chosen Paste. A grayscale version of the portrait will be added to the layer mask. The dark areas of this layer mask will shield the effects of the Levels adjustment more than the lighter areas of the mask. I can optimize the performance of this layer mask by applying adjustments. From the Select menu I have chosen Deselect.

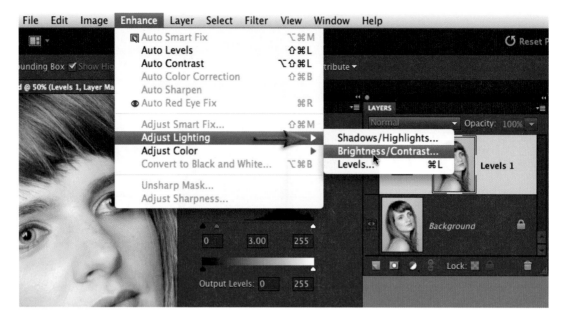

5. If I want to see what the effects of this mask are before I edit it, I just need to click on the Adjustment icon next to the layer mask thumbnail. I need to Alt + click (PC) or Option + Click (Mac) on the layer mask thumbnail again so that I can view the mask as I edit it. When I have finished adjusting or enhancing this layer mask I will return to the normal view so I can see how the modified mask improves the performance of the Levels adjustment. To start editing the layer mask I have gone to Enhance > Adjust Lighting > Brightness /Contrast.

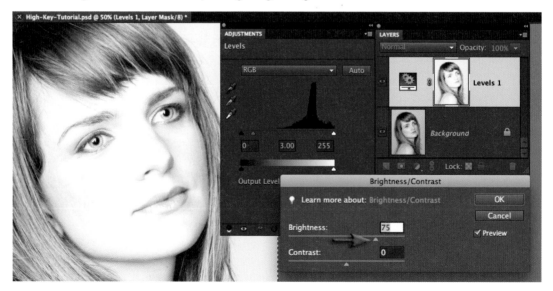

6. I have moved the Brightness slider to the right until the skin tones in the mask are extremely bright, but not so far that I lose the darker tones of the lips and eyes. I have selected 'OK' in the Brightness/Contrast dialog to apply the Brightness/Contrast adjustment to the layer mask.

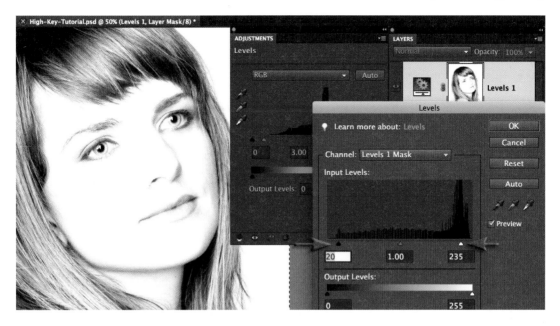

7. This may sound weird but I will now apply a Levels adjustment to a Levels adjustment layer mask. I have gone to Enhance > Adjust Lighting > Levels. I have moved the black Input Levels slider to a value of 20 to clip some of the darker tones in the mask to black and the white Input Levels slider to a value of 235 to further clean up the highlight tones in the mask. I have selected 'OK' to apply this Levels adjustment to the layer mask. The edited mask will now serve to enhance the high-key effect.

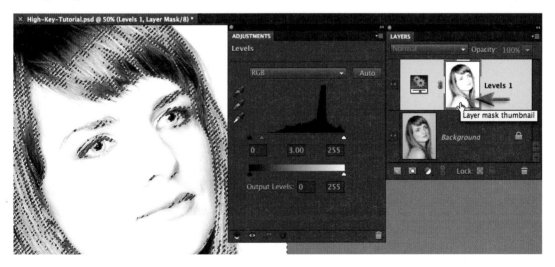

8. In this step I will use the mask I have just edited as the basis for additional adjustment to the image. I have held down the Ctrl key (PC) or Command key (Mac) and clicked on the layer mask thumbnail to load the mask as a selection. I have then clicked on the Create new fill or adjustment layer icon at the base of the Layers panel and chosen Brightness/Contrast.

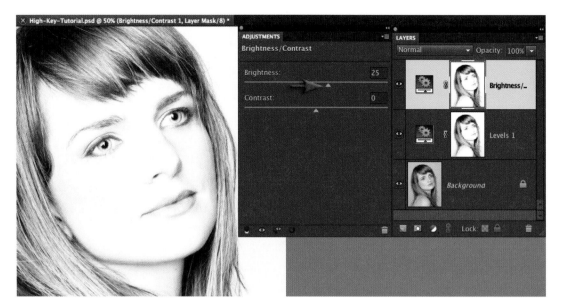

9. When the Brightness/Contrast adjustment dialog appears (complete with a copy of the layer mask from the Levels adjustment layer) I will now be able to see the effects of the masking work. I have moved the Brightness slider to the right until the desired high-key effect is achieved.

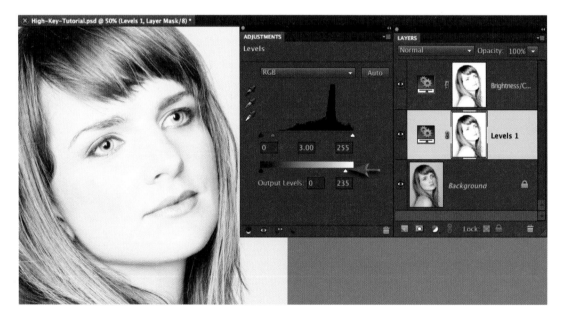

10. The effect can be fine-tuned in a number of ways. We can return to the Levels adjustment layer and modify either the Gamma slider that was originally set to 3.00 and/or move the white Output Levels slider to the left to restore tone to the brightest highlights.

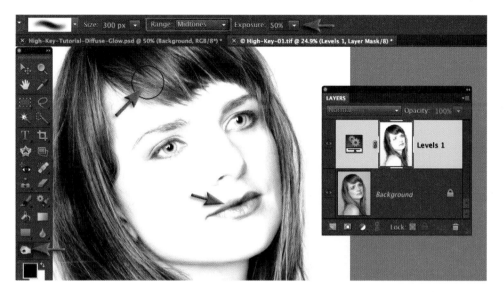

11. To manually restore some selected midtones (ones that I do not want to render very bright) I can hold down the Alt key (PC) or Option key (Mac) and click on the Levels adjustment layer mask. I have selected the Burn tool in the Tools panel that lives behind the Sponge tool (or just press the letter 'O' repeatedly until the hand icon appears in the Tools panel. I have set the Range to 'Midtones' and the Exposure to 50% in the Options bar. I have painted over any significant midtones that I would like to appear darker, e.g. the hair, eyebrows, lips and jaw line. I may need to repeat this on the Brightness/Contrast adjustment layer mask to fine-tune the appearance.

12. If you want the speed and simplicity of the Diffuse Glow filter, but the detail of this high-key tutorial, then go to www.markgaler.com and purchase the High Key action that automates this process. It even comes in four different flavors!

LOW KEY

A low-key image is one in which the dark tones dominate the photograph. Small bright highlights punctuate the shadow areas, creating the characteristic mood of a low-key image. The position of the light source for a typical low-key image is behind the subject or behind and off to one side so that deep shadows are created. In the olden (pre-digital) days choosing the appropriate exposure usually centered around how far it could be reduced before the highlights appeared dull. In the digital age this approach to exposure at the time of capture should be avoided. It is now better to lower the exposure of your image in Adobe Camera Raw rather than via the camera. Underexposure in digital capture leads to banding and additional noise.

'EXPOSING RIGHT'

To improve tonal quality it is recommended to increase the exposure in-camera whenever possible (until you see the flashing or blinking highlights on the camera's LCD screen – usually an option on most DSLR cameras). The popular term for this peculiar behavior is called 'exposing right'. This capture technique leads to improved tonal quality.

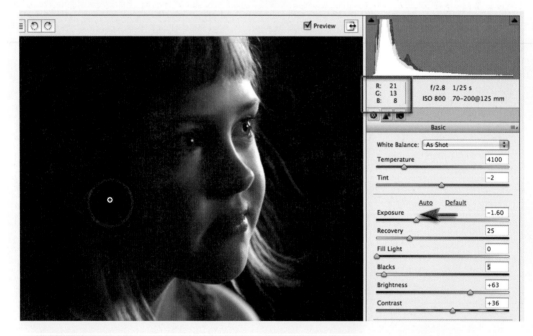

LOWERING THE SUBJECT BRIGHTNESS RANGE

If the highlights are merrily flashing and the shadows are still banked up against the left-hand wall of the histogram the solution is to increase the amount of fill light, i.e. reduce the difference in brightness between the main light source and the fill light. If you are using flash as the source of your fill light it would be important to drop the power of the flash by at least two stops and choose the Slow-Sync setting (a camera flash setting that balances both the ambient light exposure and flash exposure) so that the flash light does not overpower the main light source positioned behind your subject.

The classic low-key image – redefining exposure for a digital age

Project 3

Borders

In the old days, photographers taking their films to a lab to be processed would often have the choice of several different photo edges. You could get your photos printed edge-to-edge or with a white border. Rough edges were popular for a while, as was printing with the negative showing. In this tutorial I'll show you how to replicate some of those effects, as well as the popular 'Polaroid transfer' look. The edges are easy to apply digitally and the results can be stunning.

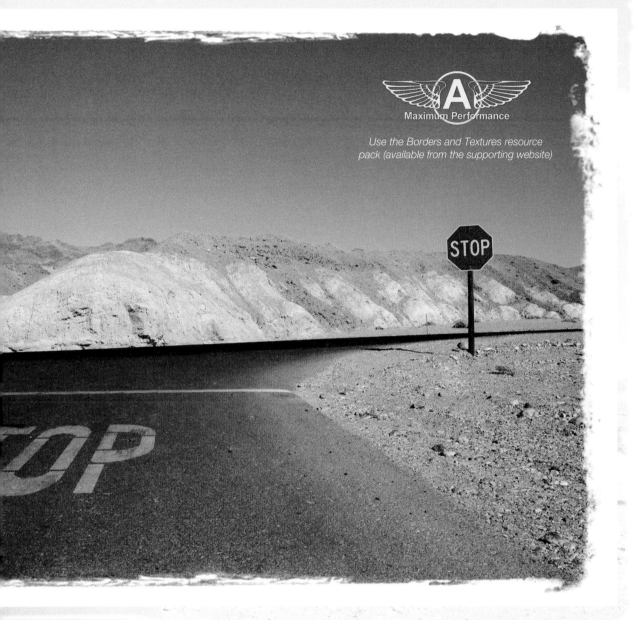

Desert junction, Nevada, USA. Mark Galer

The border for this project is inspired by the 'Polaroid Transfer Technique'. The edge emulates the fluid and organic transition between image and paper that the historic analog process is known for. The edge also introduces a hint of texture from the original film emulsion and paper backing. A project resource pack is available from www.markgaler.com. This pack includes a collection of 10 different paper textures, 4 edge effects and 4 assorted grain files from small to extra large.

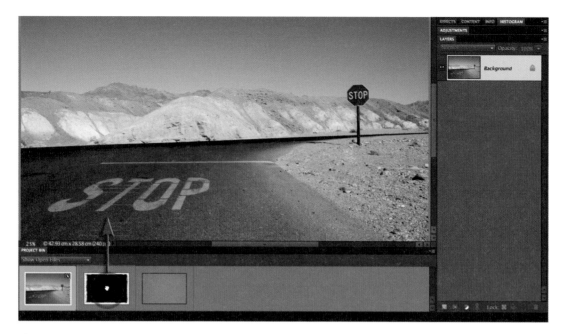

1. I have opened my project files and dragged the 'Border' image (available from the project resource pack) from the Project Bin onto the Image Preview of the 'Stop' image. This has created a two-layered file.

2. The Border file is smaller than my project image file so I will need to change the scale of this layer so that it fits the host image. I have gone to Image > Transform > Free Transform. I have deselected the Constrain Proportions checkbox in the Options bar and then dragged the top-left sizing handle into the corner of the host image. I have done the same thing with the bottom right-hand corner of the image. I can then hit the green 'Commit current operation' icon underneath the corner of the image to commit the transformation.

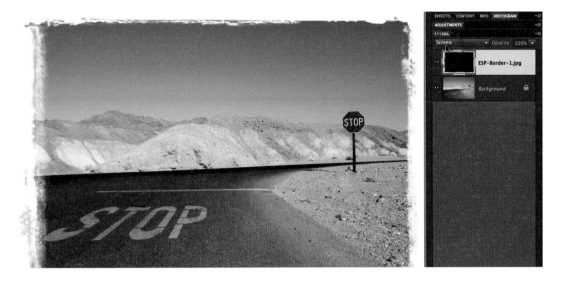

3. In the Layers Panel I have changed the blend mode of the layer from 'Normal' to 'Screen'. If I like what I see the project is complete – it's this simple. The Screen blend mode renders all pixels 'neutral' or invisible so only the white border of the layer remains.

4. But wait, there's more... If I want to add some texture to this image, to complement the grunge edge, then I can drag the 'Grain' file (also in the project resource pack) from the Project Bin onto the project preview. The grain texture simulates film grain in a much more convincing way than the overly gritty Noise filter could ever hope to achieve.

5. I have used the Free Transform technique that I used in Step 2 to resize the Grain layer so that it is a 'good fit' for the host image. I have set the blend mode of the layer to Overlay. As gray is the neutral color for this blend mode only the texture remains visible. I have adjusted the opacity of the layer until I have the right amount of grain for this project (a matter of taste). I could consider the project complete now or I could push on to explore other options.

6. If I want the option of having a black or white edge I can right-click on the Border layer and choose Duplicate Layer from the context menu. I can then go to Filter > Adjustments > Invert and then set the blend mode of this layer to Multiply. As white is the neutral color of the Multiply blend mode, only the black border on this layer is now visible. I have experimented with turning off the visibility of the border layer (by clicking on the eye icon), but found the effect was better with it left on.

7. I would now like to see what this project would look like with a real paper texture around the edge. I have turned the visibility of the black border layer off in order to move on to the next experiment. I have clicked on the background layer to make it the active layer and then clicked and dragged the Lock icon on the background layer to the small trashcan in the bottom corner of the Layers panel to unlock the layer. I have dragged the Paper texture file (also in the project resource pack) from the Project Bin onto the project preview.

8. I have resized this texture layer using the Free Transform command. I have clicked and dragged the paper layer so that it sits below the 'Stop' layer in the Layers panel (or I could have dragged the 'Stop' layer so that it sits above the paper layer). I have clicked on the 'Add layer mask' icon at the base of the Layers panel to add a layer mask that I can use to hide the edges of the 'Stop' layer (now called Layer 0).

9. I have clicked on the Border layer to make it the active layer and then from the Select menu chosen 'All'. From the Edit menu I have then chosen Copy. This will copy the border from this layer to the clipboard.

10. I have clicked on the mask to make it active. I have then held down the Alt key (PC) or Option key (Mac) and clicked on the layer mask a second time. The screen preview will go completely white as I preview the contents of the mask (empty at present). I can then go to Edit > Paste to replace this empty mask with a copy of the 'Border' layer. I must view the contents of the layer mask before I can paste into it.

11. I have gone to Filter > Adjustments > Invert in order to make the border edges black and the interior of the mask white. The black edges of the mask will hide the edge pixels of the 'Stop' layer (Layer 0). If I hide these pixels I will be able to see the pixels of the paper texture below. I can click on any thumbnail other than the layer mask to return to the 'normal' view, rather than the mask view, and then click on the Visibility icon of the Border layer to hide this layer.

12. I can control the color and tonality of the paper edge by adding an adjustment layer above the paper texture layer. I have clicked on the paper texture layer to make it the active layer before selecting an adjustment layer (remember that an adjustment layer will always appear directly above the active layer). Note the visibility of the Border layers are switched off. In this project I have added a Brightness/Contrast adjustment and raised the Brightness slider to +30.

13. If I would like to incorporate the paper texture in the image I can set the mode of the 'Stop' layer to 'Multiply'. The Multiply mode is one of the darkening blend modes so the overall image will appear a little darker. This can be corrected with another adjustment layer.

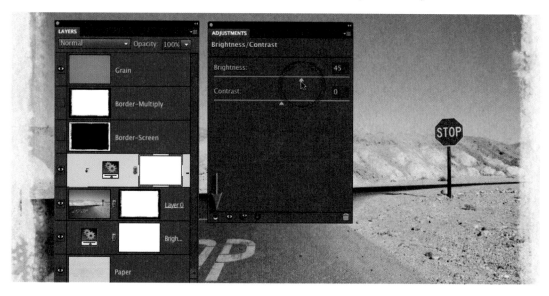

14. I have selected the 'Stop' layer to make it the active layer and then from the 'Create new fill or adjustment layer' menu via the icon in the Layers panel chosen a Brightness/Contrast adjustment. I have clicked on the 'Create clipping mask' icon in the bottom left-hand corner of the dialog to clip this adjustment layer to the 'Stop' layer below. This will ensure that any adjustment I now make will affect the image but not the paper below. I have raised the Brightness to +45 to counteract the effects of the Multiply blend mode.

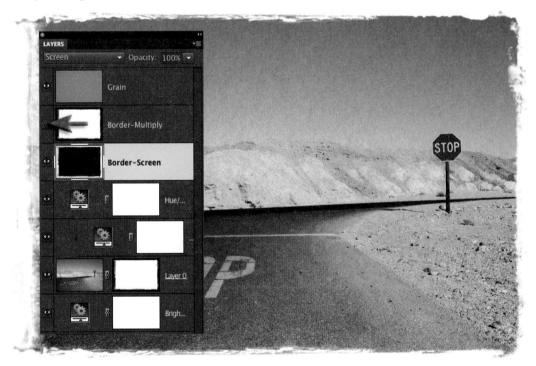

15. The global saturation values can be fine-tuned by adding a Hue/Saturation adjustment layer. This does not have to be clipped to the layer below if I want to adjust all the pixels rather than just the pixels on the 'Stop' layer.

16. What... you want to see more? Another variation would be to turn the visibility of the Border layer back on. This would allow me to see the texture incorporated into the image but revert to a clean white edge. The options are endless...

Project 4

Tilt-Shift Effect

The tilt-shift effect is a popular technique that originated from the use of 'tilt-shift' lenses. Architectural photographers use these specialized lenses to correct the converging verticals of the buildings they are photographing, but they can also be used creatively to shift the plane of focus so that areas of the image are thrown dramatically out of focus. One of the most popular effects is to create a 'toy town' look where figures and cars look like they have been placed in a model village. This effect can be created easily in post-production and the advantage is the cost saving (tilt-shift lenses are extraordinarily expensive) and the fact that the point of focus can be changed at any time, when and if you change your mind.

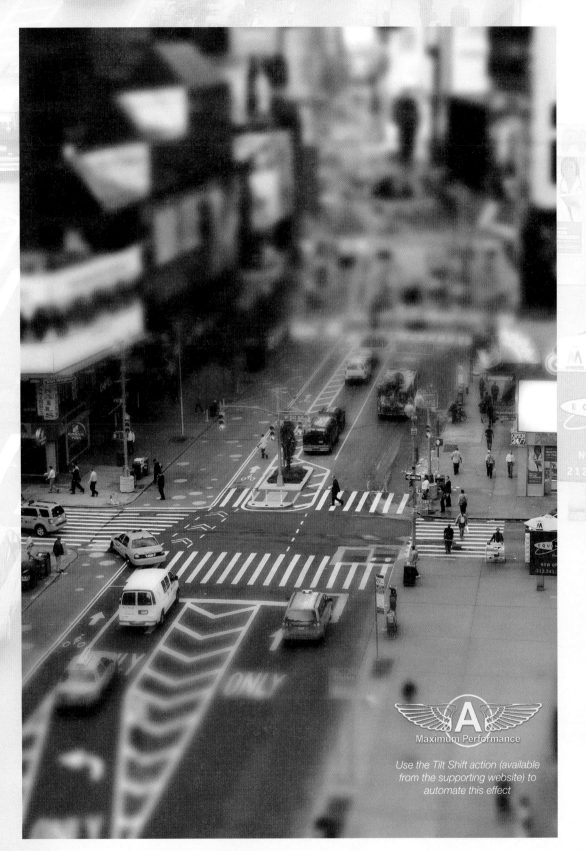

Use the Tilt Shift action (available from the supporting website) to automate this effect

The tilt-shift effect is applied to Broadway, New York City. Mark Galer

1. This technique works best when applied to an image that has been captured from a high vantage point – one where you are looking down on your subject matter. In this project I am using an image I captured in downtown Manhattan.

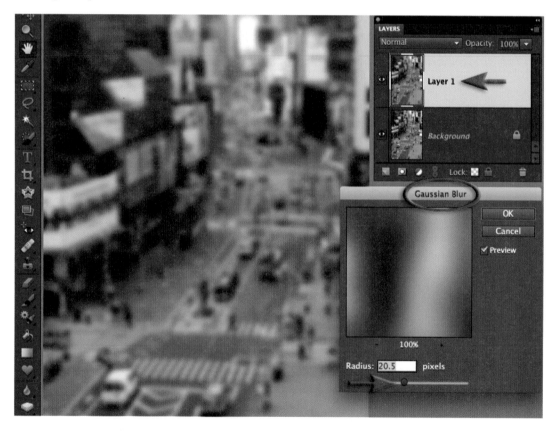

2. The first step is to duplicate the layer (Layer > Duplicate Layer). I have named the new layer 'Layer 1'. I have then applied the Gaussian Blur filter using a Radius of 20.5 pixels (Filter > Blur > Gaussian Blur) and selected OK to apply the filter.

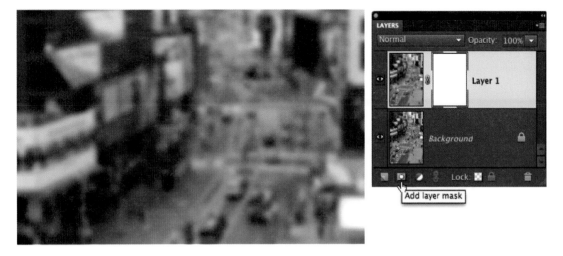

3. In this step I will create a layer mask so that I can hide some of the blurred pixels. From the base of the Layers panel I have clicked on the Add layer mask icon to add a layer mask to this blurred layer.

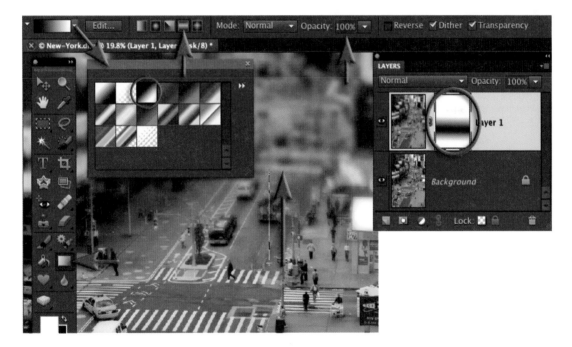

4. I have picked the Gradient tool from the Tools panel and selected the 'Black, White' gradient from the gradient presets (accessed from the Options bar). I have then selected the Reflected gradient option and set the Opacity to 100% (also from the Options bar). To create the tilt-shift effect I have dragged a short gradient from the area I want to be in focus to a point where I want maximum blur. I have held down the Shift key as I dragged this gradient to ensure the gradient is constrained to a perfect vertical. The Reflected option will ensure the blur effect is mirrored on both sides of the sharp focus to create the appropriate effect.

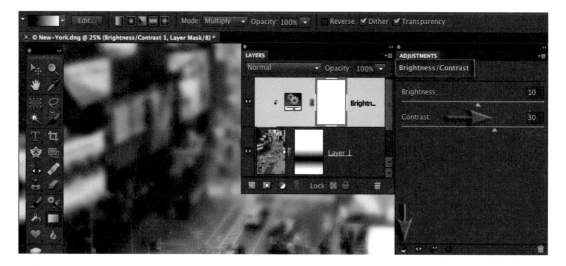

5. The addition of the blur has lowered the contrast in the out-of-focus regions of the image, so I have corrected this using a Brightness/Contrast adjustment that only affects the blurred layer. I have chosen a Brightness/Contrast adjustment layer from the Create new fill or adjustment layer menu at the base of the Layers panel. I have clicked the Clipping icon in the bottom left-hand corner of the Adjustments dialog and then raised the Contrast and Brightness of the blur. This adjustment will not alter the sharp tones on the background layer.

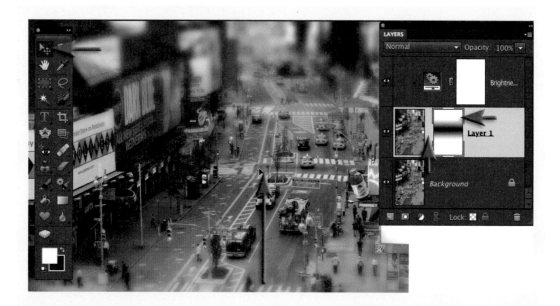

PERFORMANCE TIP

If you want to move the area of sharp focus within the image you must first break the link that sits between the image and its mask. Select the Move tool from the Tools panel, then select the layer mask by clicking on it, and then click and drag in the image preview to relocate the area of sharp focus.

This image uses a radial gradient instead of a reflected gradient to restore an area of sharp focus

Project 5

Cross-Process

In this tutorial we will explore how we can manipulate color to create an old film look or a film that has been processed in the wrong chemicals (on old analog technique called 'cross-processing'). We will also explore how we can add paper textures to further enhance the aged appearance of the project image. These textures can be created with a couple of pieces of paper, some coffee and a flatbed scanner. The first piece of paper forms the background layer for this project and was scanned from the back of an old certificate that had an interesting paper texture. The portrait is added as a layer above this paper background and then a second paper texture is placed above the portrait. This second paper texture was created by scrunching up a piece of photocopy paper and then attacking it with a sponge loaded with strong coffee. The sharp edges of the photocopy paper were then torn and the resulting grunge digitized with the office scanner. A huge range of textures are also freely available by going online to websites such as www.deviantART.com. The supporting website (www.markgaler.com) also has a resource pack with a range of different paper textures and an action for creating that old film look.

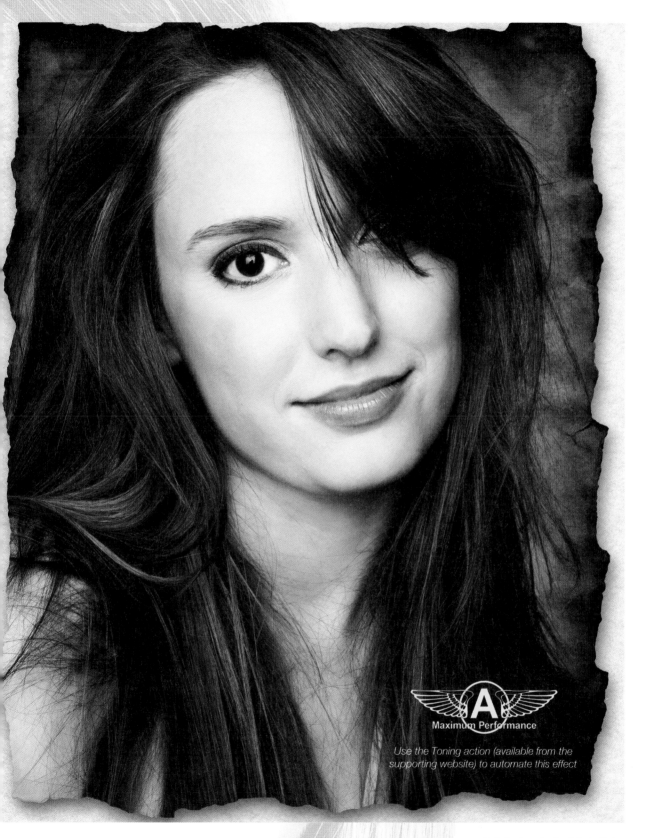

Maximum Performance

Use the Toning action (available from the supporting website) to automate this effect

Alyssia photographed by Ed Purnomo – digital wizardry by Mark Galer

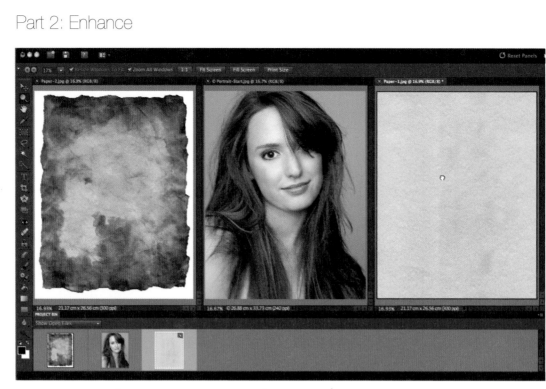

Part One – Creating the aged look

1. I have opened the three project images and dragged the portrait layer thumbnail from the Layers panel (or thumbnail from the Project Bin) onto the Paper 1 image. I have then dragged the Paper 2 thumbnail onto the Paper 1 image to create a file with three layers. The portrait image should sit between the two paper layers.

2. Over the next four steps I will create a mask to hide the outer edges of the portrait. I have used the Magic Wand tool to select the white background surrounding the paper on the top layer, a single click should do the trick, and then I have clicked on the background layer to make it the active layer.

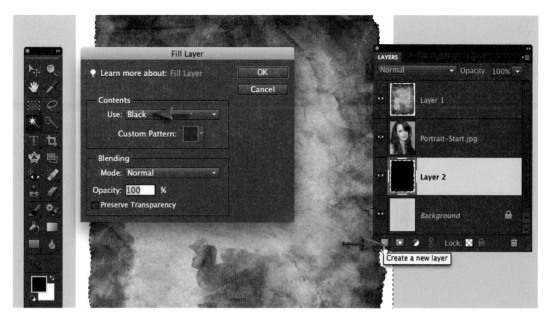

3. I have clicked on the Create a new layer icon at the base of the Layers panel to create an empty new layer above the background layer and below the portrait layer (a new layer will always appear above the layer that was selected when the Create a new layer icon is clicked). I have then gone to Edit > Fill Selection, chosen Black from the Contents menu in the Fill Layer dialog and then selected OK.

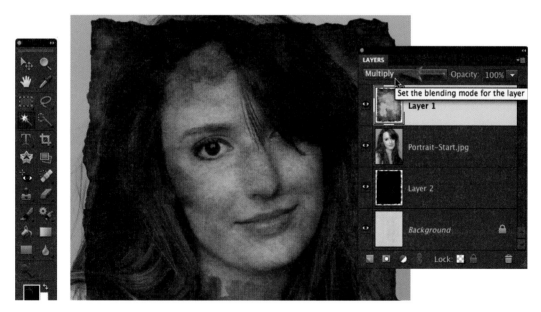

4. I have selected the top layer in the Layers panel and set the blending mode of the layer to Multiply. I should now see the paper texture appear over the portrait. From the Select menu I have chosen Deselect (Ctrl + Backspace on a PC and Command + Delete on a Mac).

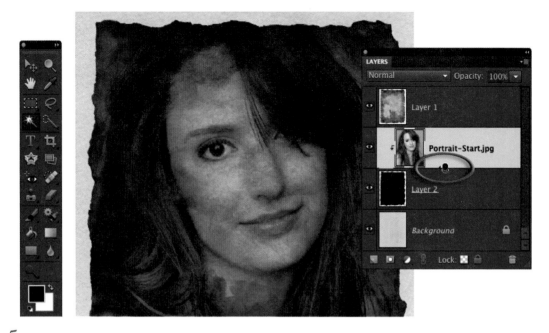

5. In this step I will complete the masking process by creating a clipping mask. This clipping mask will mask the portrait to the edges of the torn paper. I have clicked on the portrait layer to make it the active layer and then gone to Layer > Create Clipping Mask, or I could simply hold down the Alt key (PC) or Option key (Mac) and move my mouse cursor to the dividing layer between the portrait layer and the layer below. I would then click the mouse button when I see the Clipping icon appear.

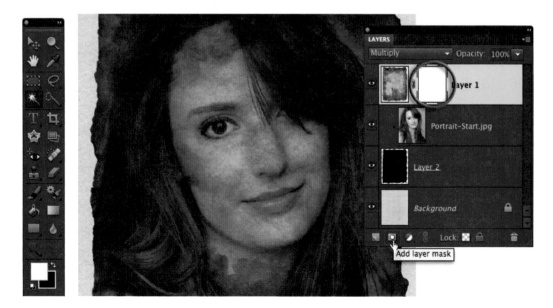

6. In Step 6 I will create a mask to hide some of the unwanted paper texture. I have clicked on the Add layer mask icon at the base of the Layers panel.

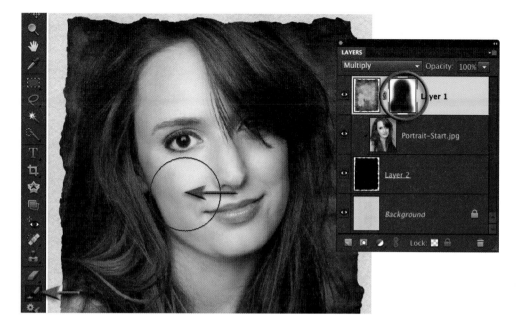

7. I have selected the layer mask thumbnail and then selected the Brush tool from the Tools panel. I have set the foreground color to Black in the Tools panel (by pressing D and then X on the keyboard) and set the Opacity of the brush to 70% in the Options bar. I have chosen a soft-edged brush and then paint over any areas of the skin and hair that have unwanted texture. Brushing a second time should clean these areas nicely.

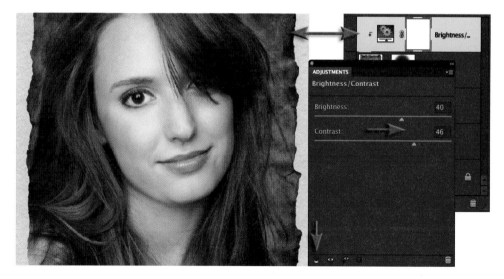

8. In these next two steps I will modify the appearance of the texture. I have clicked on the top layer in the Layers panel to make it the active layer. I have then clicked on the Create new fill or adjustment layer icon at the base of the layers panel and chosen a Brightness/Contrast adjustment. I have clicked on the Clipping icon in the bottom left-hand corner of the Adjustments panel and raised the Brightness and Contrast sliders to +40 and +46, respectively.

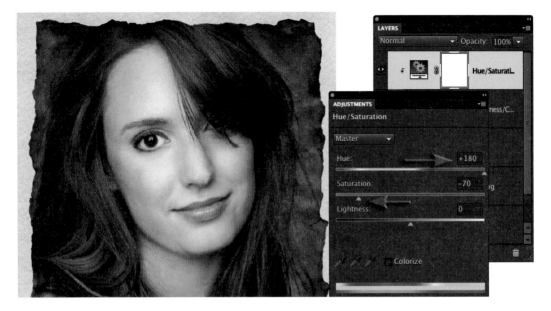

9. I have selected a Hue/Saturation adjustment layer from the Create new fill or adjustment layer via the icon at the base of the Layers panel and clipped this to the adjustment layer below (see Step 8). I have moved the Hue slider to +180 to turn the yellow paper into blue paper and lowered the Saturation slider to -70.

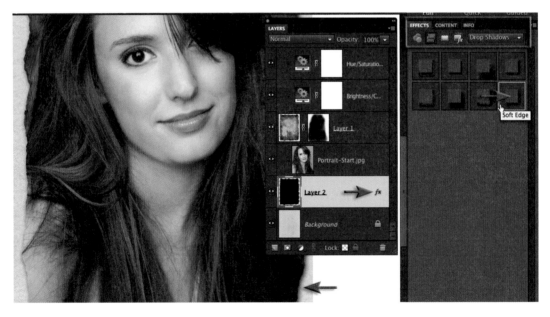

10. In this step I will add a drop shadow to the paper to create some separation between the two paper styles. I have clicked on the layer above the background layer (the one I used as the clipping group mask). I have gone to Layer > Layer Styles > Style Settings and then checked the Drop Shadow checkbox in the Style Settings dialog. Alternatively, from the Layer Styles menu in the Effects panel I could select Drop Shadows and double-click on the Soft Edge style.

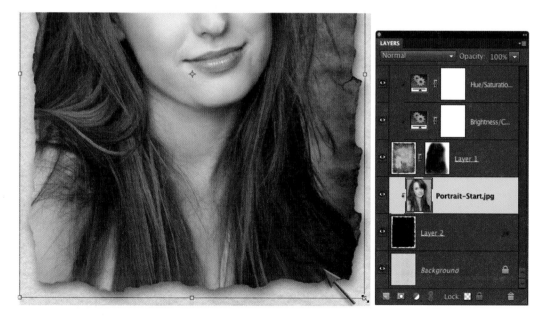

11. Double-click on the '*fx*' icon on the layer to open the Style Settings dialog. Adjust the three sliders and the Lighting Angle to create the perfect drop shadow. I can click on the color swatch next to the Size slider if I want to make my shadow warmer or cooler.

12. It is possible to adjust the size of the image that appears in the clipping mask by selecting it and then going to Image > Transform > Free Transform. If I make my image too small I will see the black clipping mask appear. I need to press the Enter (PC) or Return key (Mac) after scaling the image.

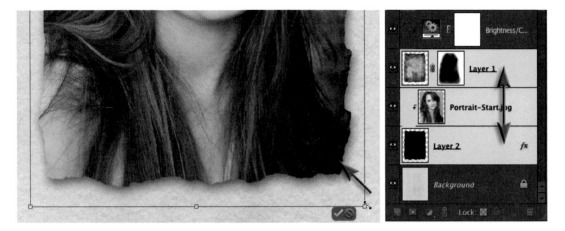

13. If I want to scale the portrait image and the torn paper at the same time, then I must hold down the Shift key and select the torn paper layer, after first selecting the portrait layer, before going to Image > Transform > Free Transform. I can now scale all three layers at the same time.

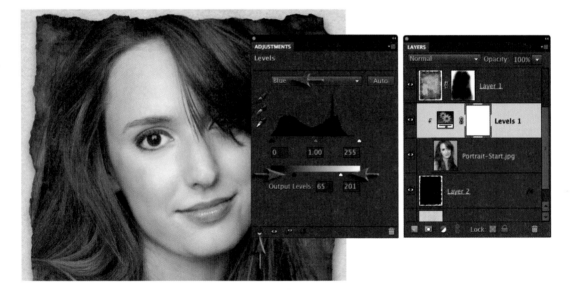

Part Two – Emulating old film

14. In this part of the project I will manipulate the color in the portrait image to create an old film look. I have selected the portrait layer and from the Create new fill or adjustment layer menu in the Layers panel and then chosen a Levels adjustment layer. I have clipped this adjustment layer to the layer below using the techniques outlined in Part One of this project. I have selected the Blue channel and dragged the black Output Levels slider to 65 and the white Output Levels slider to around 200. It is important not to confuse the Input Levels sliders, directly below the histogram, with the Output Levels sliders beneath the gray ramp. Moving the Input Levels sliders would clip the color channels and increase contrast, while moving the Output Levels sliders will lower the contrast of the channel and introduce color.

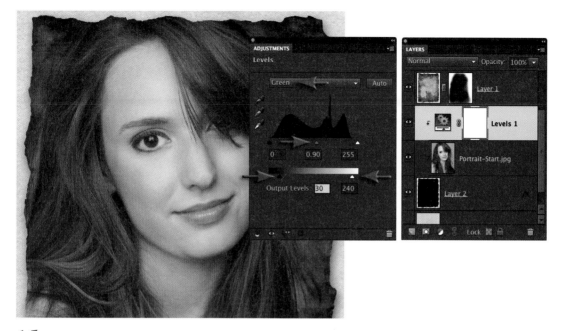

15. In the Levels dialog I have selected the Green channel and dragged the black Output Levels slider to 30 and the white Output Levels slider to 240. I have moved the central Gamma slider directly beneath the middle of the histogram to 0.90.

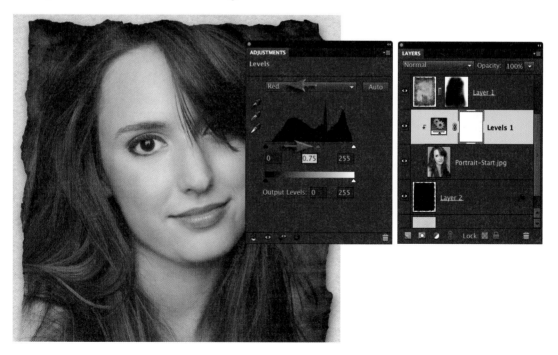

16. In the Red channel I have moved the central Gamma slider to 0.75. I will see the contrast dropping and color casts appearing in my image preview. I will add the contrast back and adjust the saturation of the introduced colors in the next three steps.

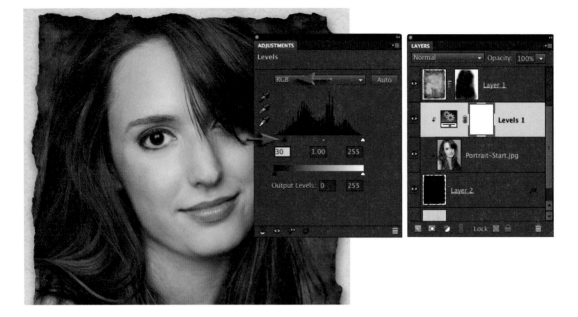

17. The final stage in this Levels dialog adjustment is to move the black Input Levels slider to a value of around 30 to give the shadow tones more depth. Note how these adjustments have not been affecting the paper textures.

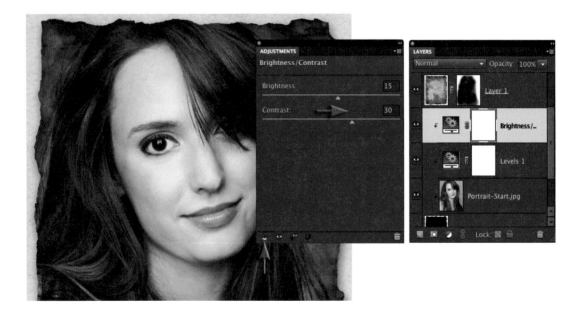

18. I have added a Brightness/Contrast adjustment layer and clipped this adjustment layer to the Level adjustment layer below. I have raised the Brightness and Contrast sliders to +15 and +30 but different images may require different settings.

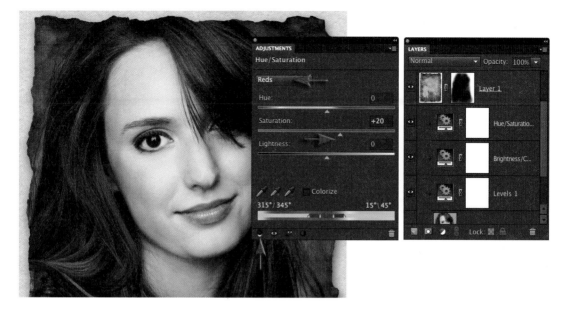

19. I have added a Hue/Saturation adjustment layer and again clipped this to the adjustment layers below. I can use this adjustment layer to control the vibrancy of specific colors within the image. In this project I have decided to make the skin colors more vibrant by going to the Red channel and raising the Saturation slider to +20.

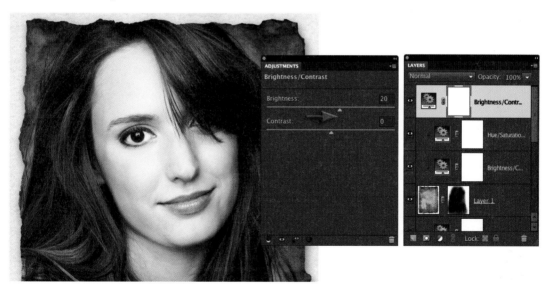

20. I have added adjustment layers to control the color and tonality of the torn paper layer and the portrait layer. Each set of adjustment layers are clipped to the image layer so that they only affect the layer they are clipped to. If I want to affect the tonality or color of the entire composite image I can select the top layer in the Layers panel and then add an adjustment layer that is not clipped. In this project I have decided to increase the overall brightness of the image by raising the Brightness slider to +20.

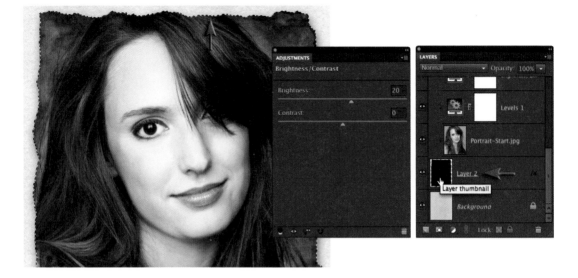

21. To complete the project I have decided to darken the outer edges of the torn paper layer (making sure I don't affect the background layer). I have held down the Ctrl key (PC) or Command key (Mac) and then clicked the clipping mask layer thumbnail in the Layers panel (the one above the background layer thumbnail). This has loaded a selection that I can use to darken the outer edges.

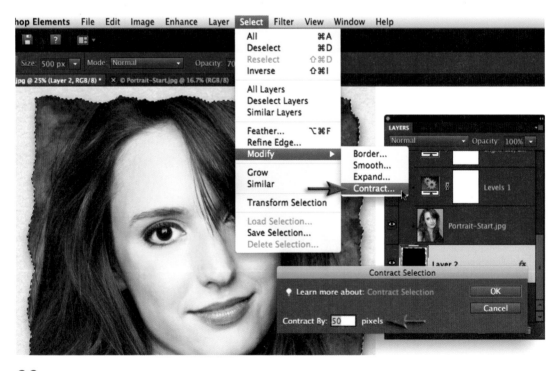

22. I have gone to Select > Modify > Contract. In the Contract Selection dialog I have entered in a value of 50 pixels and then selected OK. I will see the selection edge contract inwards towards the centre of the image.

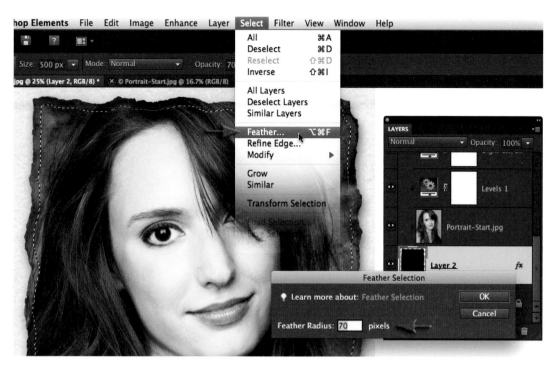

23. I have gone to Select > Feather, entered in a value of 70 pixels in the Feather Selection dialog and then selected OK. This feather process will ensure that the darkening process will happen gradually rather than suddenly.

Note > It is possible to preview how soft you are making a selection edge when using the Feather command. After making the initial selection just choose the Selection Brush tool from the Tools panel and then select the Mask option in the Options bar. Now when you apply the Feather command you will see a preview of how soft the edge has become.

24. I have gone to Select > Inverse so that the outer edge of the image is selected. From the Edit menu I have chosen Copy Merged. Copy Merged allows me to copy what I can see in the image preview rather than the pixels that may be present on a single active layer.

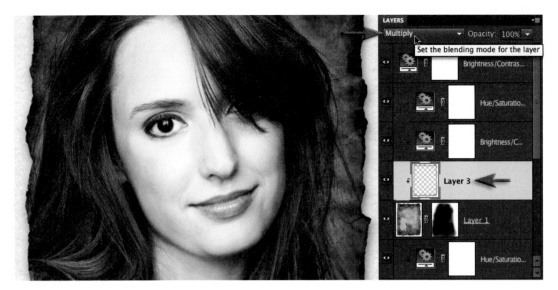

25. I have selected the torn paper layer in the Layers panel so that it is the active layer and then from the Edit menu chosen Paste. The contents from the clipboard will be pasted into a new layer above the active layer. I have checked to make sure this layer is clipped with the layer below and then set the mode to Multiply. If the darkening is too much I can lower the opacity of the layer using the Opacity slider in the top right-hand corner of the Layers panel.

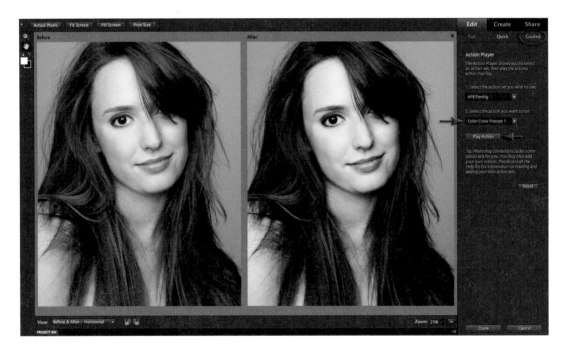

The cross-process effect used in this project is just one of the many different toning effects that can be automated using the Toning action that can be purchased from the companion website. Go to www.markgaler.com for more details.

Alternative toning effects using the Toning action

Project 6

High Impact

Images captured in flat light can sometimes lack detail, depth and drama. It is possible, however, to unleash the hidden potential of an image using post-production techniques. The secret to success lies in the contrast blend modes together with filters and adjustment features that can detect and enhance edge contrast. This depth-charge technique is designed to inject the drama that the start image lacks.

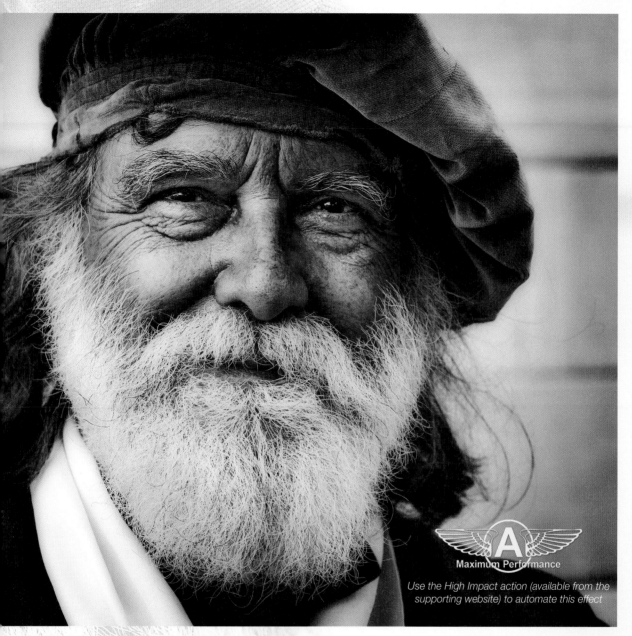

Cooking up some character – a recipe for success

The technique that follows uses a Gaussian Blur 'smooth tone technique' to smooth the broader areas of tone while the fine detail will be preserved and sharpened. The application of a blur filter in a project where the fine detail is important may, at first, sound strange. If, however, the blur is applied in conjunction with a blend mode the sharp detail can be made to interact with the smoother surface tones. The steps that follow enhance the localized contrast and fine detail, and the balance between the resulting smooth contours and the sharp detail creates the drama that is required.

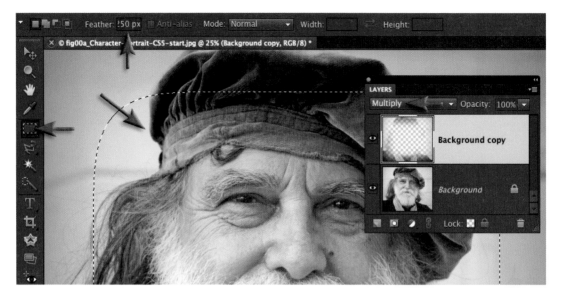

1. I will start this project by darkening the edges of the file. I have duplicated the background layer by dragging it to the Create a new layer icon at the base of Layers panel. I have chosen the Rectangular Marquee tool from the Tools panel and entered 250 px in the Feather field in the Options bar. I have clicked and dragged to make a selection of the central portion of the image. I have then hit the Backspace key (PC) or Delete key (Mac) to remove the central portion of the image on this layer. From the Select menu I need to choose Deselect before setting the mode of the background copy layer to Multiply to apply the darkening effect.

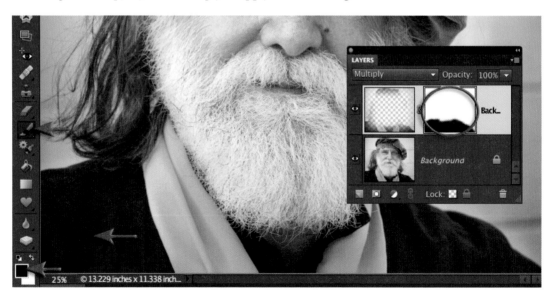

2. I can protect the luminance values of the black jacket by adding a layer mask (I have clicked on the Add layer mask icon at the base of the Layers panel) and then painting with black with a soft-edged brush to hide the pixels in this region.

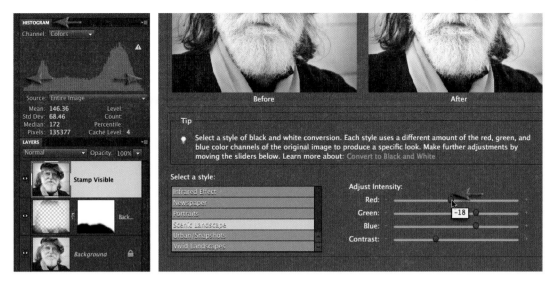

3. I have stamped the visible pixels to a new layer by holding down the modifier keys Ctrl + Alt + Shift (PC) or Command + Option + Shift (Mac) and then pressing the E key. From the View menu I have chosen Histogram. This will help me to retain fine detail in the highlights or shadows when converting to black and white. I have selected Black and White from the Enhance menu and dragged the Red slider to the left and the Green and Blue sliders to the right to brighten the image. I have made sure the shadows and highlights are not clipped to white (avoiding tall peaks either side of the histogram).

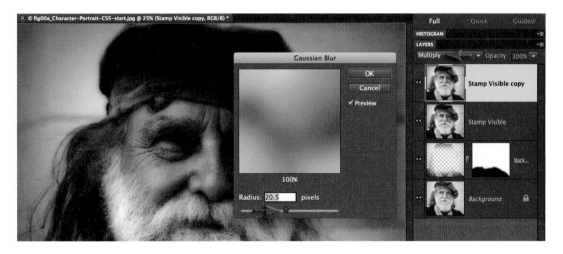

4. I have stamped the visible pixels to a new layer by holding down the modifier keys Ctrl + Alt + Shift (PC) or Command + Option + Shift (Mac) and then pressing the E key. I have set the mode of this new layer to Multiply (don't worry about the darkened image at this stage). To create the softer smooth tones I have applied the Gaussian Blur filter (Filter > Blur > Gaussian Blur). I have chosen a Radius value that gives the image smoother tones but also retains depth. A value around 20 pixels suits the project image. I have selected OK to apply the blur to this layer.

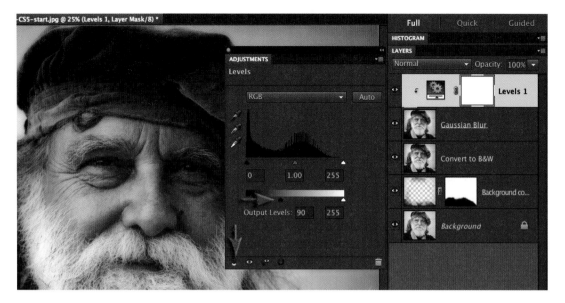

5. From the Adjustments panel I have chosen a Levels adjustment. I have clipped the adjustment layer to the stamp-visible layer using the clipping icon at the base of the Adjustments panel and then moved the black 'Output Levels' slider to a value of 90 to lighten the darkest tones. Clipping the Adjustment layer will restrict the adjustment to just the Gaussian Blur layer.

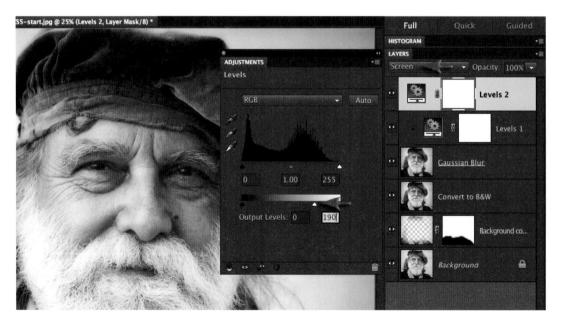

6. I have selected another Levels adjustment layer and set the mode of this layer to Screen. I have then moved the white Output Levels slider to 190 to protect the brightest tones from becoming too light. This second Levels adjustment layer should *not* be clipped with the layer beneath.

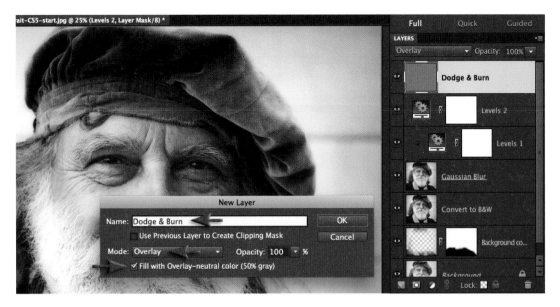

7. To increase the apparent depth in this image I have accentuated the light and shade using a Dodge & Burn layer. I have held down the Alt/Option key and clicked on the Create a new layer icon in the Layers panel. I have named the layer 'Dodge & Burn', selected Overlay as the mode and checked the 'Fill with Overlay-neutral color (50% gray)' checkbox. I have then selected OK to create the layer.

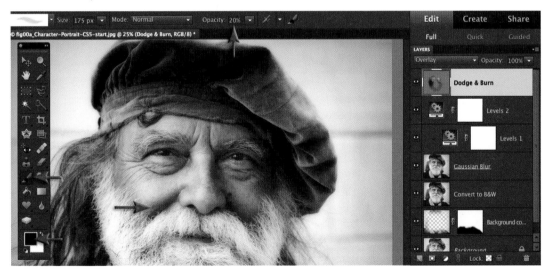

8. I have selected the Brush tool in the Tools panel and set the foreground color to black. I have chosen a soft-edged brush and lowered the Opacity to between 10 and 20% in the Options bar. I have painted around the edges of the cheeks (over the shaded areas). Painting multiple times has built up the shadows, which has in turn, increased the apparent depth and volume of the face. I have zoomed in and worked with a smaller brush on the lower eyelids in a similar fashion as I did with the cheeks.

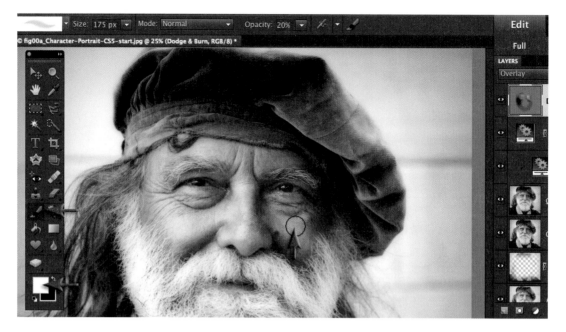

9. I have switched the foreground color to white and painted over the highlight areas within the image (especially the cheeks and eyes). The next two steps will serve to expand midtone contrast and detail.

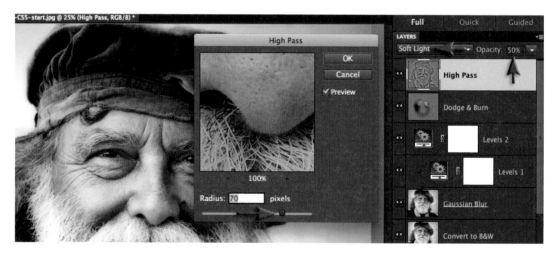

10. I have stamped the visible pixels to a new layer by holding down the modifier keys Ctrl + Alt + Shift (PC) or Command + Option + Shift (Mac) and then pressing the E key. I have set the mode of this 'merge visible' layer to Soft Light and renamed this new layer 'High Pass'. The High Pass filter we use in this step will continue the process of increasing localized contrast. I have gone to Filter > Other > High Pass and then adjusted the Radius to a high setting that gives maximum apparent depth to the image. If the depth added to this image is too much then I can simply lower the opacity of the High Pass layer to achieve the desired outcome. In this tutorial I have lowered the Opacity to 50%.

11. I have stamped the visible elements once again and set the mode of this new layer to Soft Light (as we did in Step 10). I have named this layer Shadows/Highlights and then gone to Image > Adjustments > Shadows/Highlights and then raised all three sliders to 100%. The effect is likely to be too heavy when applied globally to the whole image but this can be corrected in the next step.

12. If the effect of the Shadows/Highlights adjustment is too strong, I can lower the opacity of the layer. To restrict the effect to localized areas of the image I can add a layer mask. I can hold down the Alt/Option key as I click on the 'Add layer mask' icon in the Layers panel to create a black layer mask. I have then selected the Brush tool and set white as the foreground color. I have then painted with a soft-edged brush with the opacity lowered to paint in the adjustment gradually.

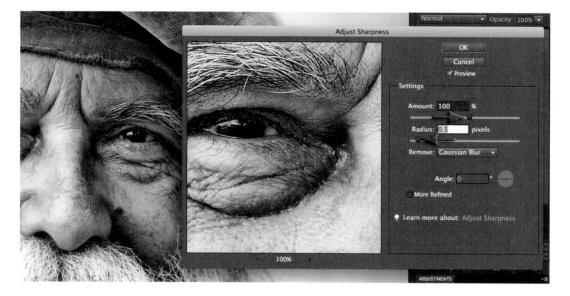

13. In this step I will apply the final sharpening to the image. I have selected the top layer in the Layers panel and then stamped the visible pixels to a new layer (by holding down the modifier keys Ctrl + Alt + Shift (PC) or Command + Option + Shift (Mac) and then pressing the E key). I have gone to Enhance > Adjust Sharpness. In the dialog I have raised the Amount slider to 100 and reduced the Radius slider to 0.5.

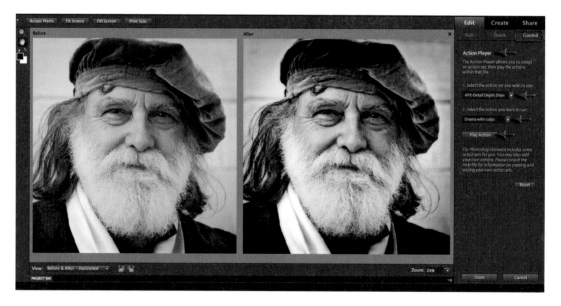

Automated High Impact action

This entire process, except for the Dodge and Burn step, can be automated and is available as an action that can be purchased from www.markgaler.com. The action adds a color layer that can be switched on or off depending on whether you want a color or black and white version.

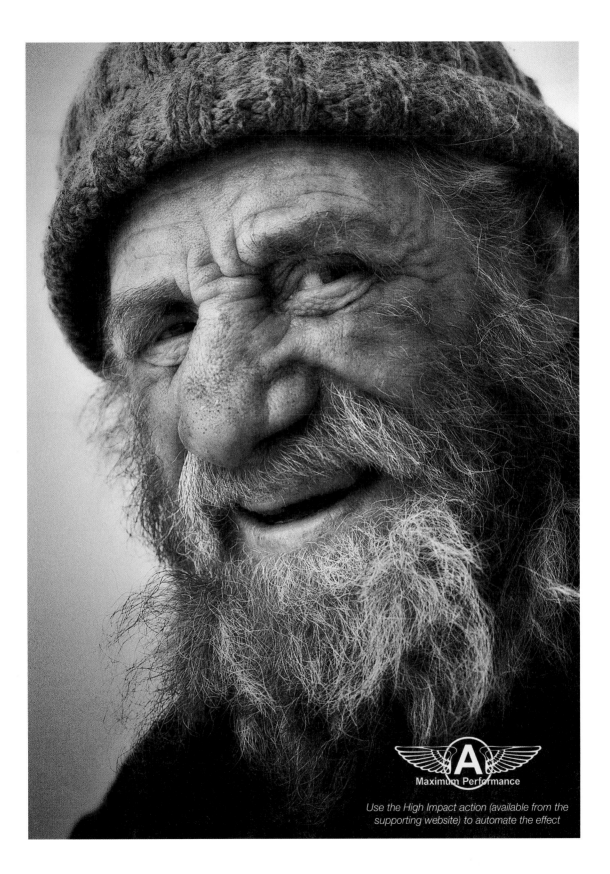

Maximum Performance

Use the High Impact action (available from the supporting website) to automate the effect

Project 7

Glamor Portrait

Cheaper (and more fun) than plastic surgery, we explore how pixel surgery can be used to craft perfect portraits that are bound to flatter the sitter every time. The glamor portrait offers an excellent opportunity to test the effectiveness of a variety of image-editing skills. The portrait is an unforgiving canvas that will show any heavy-handed or poor technique that may be applied.

We will start with a color portrait that has been captured using a soft, diffused light source. This project will aim to perfect various features and not to make such changes that the character of the sitter is lost to the technique. The techniques used do not excessively smooth or obliterate the skin texture, which would lead to an artificial or plastic appearance. The techniques used smooth imperfections without totally eliminating them.

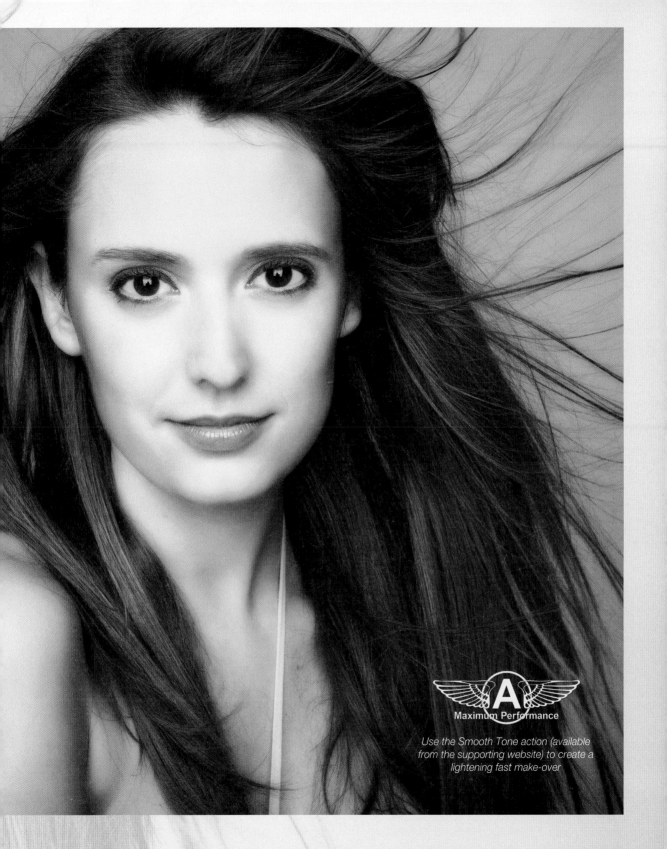

Maximum Performance

Use the Smooth Tone action (available from the supporting website) to create a lightening fast make-over

The 15-minute (after practice) make-over – techniques designed to flatter your model

PERFORMANCE TIP

Use window light or diffused flash to obtain a soft, low-contrast light source to flatter the subject. Avoid direct flash unless it is diffused with a white umbrella. Stand back from your subject and zoom in with your lens rather than coming in close and distorting the features of the face (the closer you stand, the bigger the nose of the sitter appears). A white background is difficult to create if you don't have a studio backdrop and multiple lights but, with a little practice, it is possible to get a near-white background by capturing the subject in front of a white translucent curtain against a brightly illuminated window and with a single introduced light source.

1. The flowing hair in this project was created using a strong fan that caused the young woman to half-close her left eye. This was repeated for all of the images captured using the fan so I will have to use Photoshop Elements to open her eye and restore her natural beauty. To start this process I have gone to File > Duplicate and then in the Duplicate Image dialog selected OK.

2. With the duplicate image I have gone to Image > Rotate > Flip Layer Horizontal. I have selected OK when I am prompted to turn the background into a layer. I have selected both images in the Project Bin and then gone to File > New > Photomerge Faces. I have dragged the original image into the place holder for the Final image and selected the flipped image as the Source. I have aligned the photos by placing the three targets over the eyes and mouth in both images and then hit the Align Photos button.

3. I have selected the Pencil tool in the Photomerge Faces dialog and drawn over the eye that is fully open. The Final image will now acquire the eye from the Source image and the surrounding area is blended so that the composite view is seamless. I have returned to the Full Edit view after completing this process.

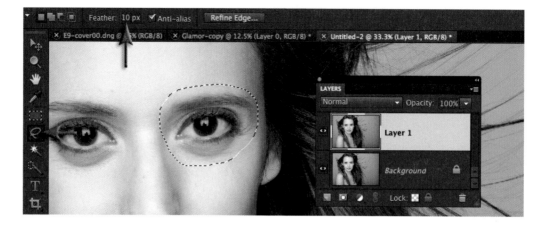

4. Although the new eye has been patched seamlessly I have found that the eye appears a little crooked due to the alignment issues in the Photomerge Faces dialog. To straighten this crooked eye I will need to make a selection of the eye and eyebrow on this top layer using the Lasso tool with a 10 pixel Feather. I have made sure the edge of the selection passes through skin on all sides. From the Select menu I have chosen Inverse and then hit the Backspace key (PC) or Delete key (Mac) to remove the pixels surrounding the eye. I have chosen Inverse from the Select menu again.

Note > The specular highlight in each eye must be in the same relative position when using this technique if you are to avoid making the subject look cross-eyed.

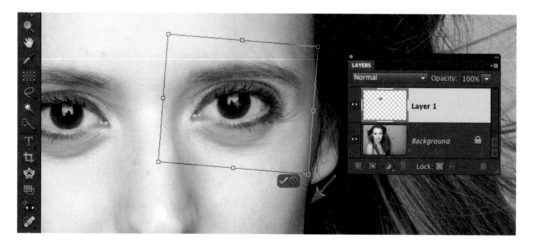

5. I have gone to Image > Transform > Free Transform and dragged just outside the bottom right-hand corner handle to rotate the eye. I have also used the keyboard arrow keys to nudge the eye into position. Dropping the opacity of the layer or switching the mode of this layer to Difference will help me to locate an appropriate position for this eye, as I will then be able to see the half-closed eye on the layer below. I have hit the Commit icon when I finished positioning the eye. As this project contains many layers I will rename each layer as I move through the steps by double-clicking the layer name and entering in a description of what each layer contains, or serves to add to the final image.

6. If the skin of your model appears shiny and is reflecting the lights, you can create a layer that adds some foundation make-up to these areas to restore skin color. I have clicked on the Create a new layer icon in the Layers panel and set the mode to Darken. I have selected the Brush tool from the Tools panel and then held down the Alt key (PC) or Option key (Mac) and clicked on an area of good skin tone to sample the color. This skin color will now appear in the foreground color swatch of the Tools panel. I have dropped the Opacity of the Brush to 20% in the Options bar and set the Hardness to 0% (clicking on the blue-tipped brush in the Options bar to access the Hardness settings). I have then painted over any areas of skin that are too shiny, e.g. the nose and forehead. Painting a second time will build up additional tone. Too much painting will result in a loss of skin texture.

7. I have added another new layer and set the mode of this layer to Lighten. With the same color I can now paint over any of the darker shadows on the face, e.g. painting below the eyes will reduce the shadows in this region. Painting several times will soften these shadows and create a smoother contour for the face.

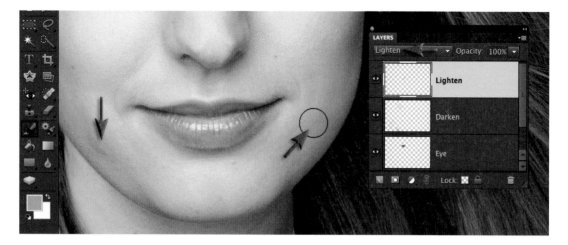

8. This Lighten brush is exceptionally useful as it can seemingly improve the quality of lighting to create gentle and soft contours. In this project image a little additional work around some of the small shadows around the jaw and to the nose will create a more flattering result.

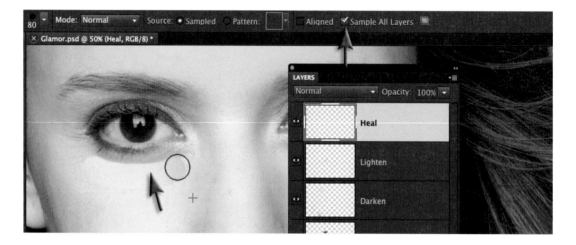

9. It is possible to remove all of the larger skin blemishes and wrinkles in a portrait image or just reduce their appearance (the detail produced by modern digital cameras can be very unflattering). I have clicked on the Create a new layer icon in the Layers panel to add yet another new empty layer. I have selected the Healing Brush tool (behind the Spot Healing Brush tool) in the Tools panel and checked the Sample All Layers option in the Options bar. I have raised the Brush Hardness to 75% and held down the Alt key (PC) or Option key (Mac) and clicked to sample an area of clear skin below one of the eyes. I have then clicked and dragged in a single arc to remove the shadow under each eye. I have avoided painting too close to the eyelashes otherwise I will draw this dark tone into the healing area. I have repeated the process to remove wrinkles, switching to the Spot Healing Brush to remove small skin blemishes. If your image is a portrait rather than an anonymous glamor image, then it is recommended to drop the Opacity of this Heal layer to 50% to return some resemblance of reality.

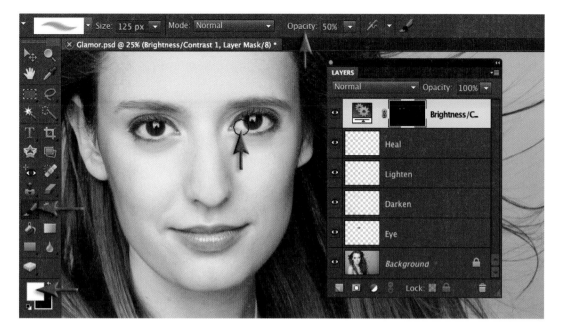

10. I have clicked on the Create new fill or adjustment layer icon at the base of the Layers panel and chosen a Brightness/Contrast adjustment layer. I have raised both sliders to +20 and then used the keyboard shortcut Ctrl + I (PC) or Command + I (Mac) to invert the layer mask to black. I have selected the Brush tool from the Tools panel and set white as the foreground color. I have set the Brush Hardness and Opacity to 50% in the Options bar and then painted over each of the eyes to raise their luminance values.

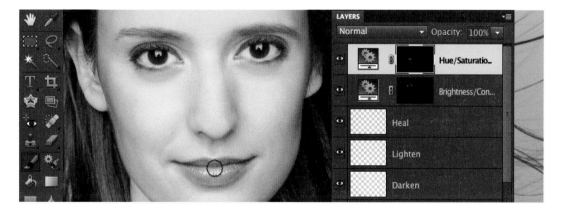

11. I have created a Hue/Saturation adjustment layer, raised the Saturation slider to +25 and again inverted the layer mask to black. I have painted over the lips and the iris of each eye to raise the vibrance of these colors, making sure I did not paint over the whites of the eyes. If the eyes appear bloodshot I can add a second Hue/Saturation layer and lower the Saturation slider to -90. I can then invert the layer mask and paint over the whites of the eyes to create clean tones in this region.

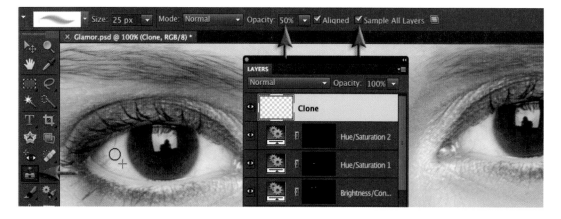

12. If there are any blood vessels that are too prominent in the eyes I can remove them using the Clone Stamp tool. The Clone Stamp tool is bettter than the Heal tool in this instance due to the close proximity of the darker tones. I have added an empty new layer and selected the Clone Stamp tool from the Tools panel. I have checked the Sample All Layers option in the Options bar, zoomed in to 200% and then Alt/Option clicked some clean white tone in the eyes. I have cloned over the problematic areas at 50% Opacity to slowly reduce the visibility of the blood vessels.

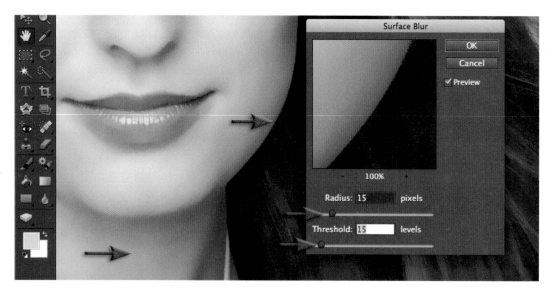

13. I have merged the visible pixels to a new layer using the keyboard shortcut Ctrl + Alt + Shift + E (PC) or Command + Option + Shift + E (Mac) and then duplicated this layer. I have made sure this layer is on top of the layers stack in the Layers panel (this is usually automatic if the top layer is selected before using this keyboard shortcut). I have gone to Filter > Blur > Surface Blur, raised the Radius slider until I get smooth tones across some of the problematic areas (this model has goose bumps on her neck due to a combination of the cold studio and the fan being used). I have set a value for the Threshold slider that keeps the blur behind the higher contrast edges (such as the side of the face). If the Threshold slider is too high the blur will bleed over the edges. If the Threshold slider is too low the smooth tone will be reduced.

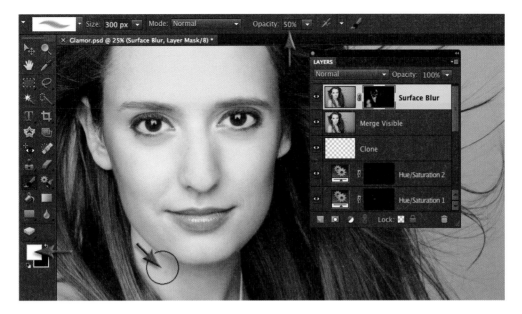

14. I have clicked on the Add layer mask icon in the Layers panel and inverted the layer mask (Ctrl/Command + I). I have selected the Brush tool and set the Opacity to 50% and the Brush Hardness to 0%. I have painted over any areas that need some help in creating smoother tones. This young woman has excellent skin so apart from the goose bumps on the neck there are only minor areas that have needed attention. I have painted in small localized areas around the mouth and the extreme edges of the face. If I paint more than once I will risk losing the skin pores that make the skin look natural.

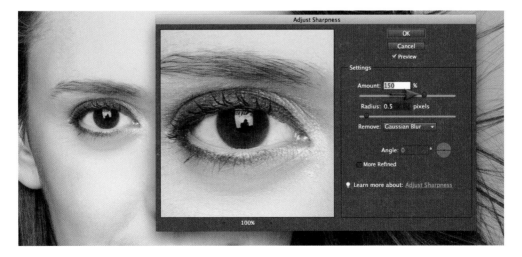

15. I have created another Merge Visible layer (see Step 13) and then gone to Enhance > Adjust Sharpness. I have raised the Amount slider to 150 and reduced the Radius slider to 0.5. I have selected OK and then clicked the Add layer mask icon and inverted the layer mask (Ctrl/Command + I).

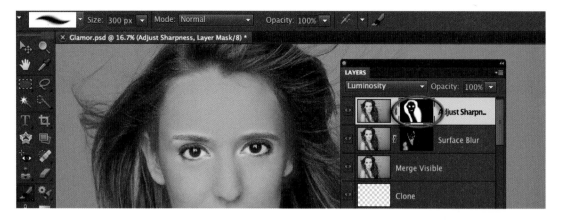

16. I have set the mode of the sharpening layer to Luminosity and added a layer mask. I have inverted the layer mask so that it is filled with black (Ctrl/Command + I) and then painted with white to reveal the sharpening. There is no reason to sharpen the skin so I am painting over the eyes, lips and hair only. To help see where I have painted I can hold down the Alt + Shift keys (PC) or Option + Shift keys (Mac) and then click on the layer mask to reveal the mask as an overlay. Painting with white will remove the overall color and reveal the sharpening.

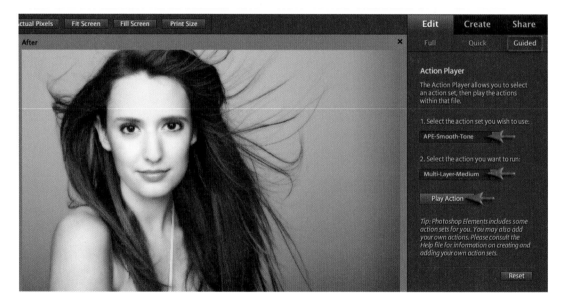

17. If you want to create a smooth dreamy quality for your portrait images you could try applying the Smooth Tone action that can be purchased from the supporting website. After the action has been downloaded and placed in the Actions folder go to Guided > Action Player > APE-Smooth-Tone and select one of the Multi-Layer options. Click on the Play Action button to apply the Smooth Tone technique. If you find the technique too strong select all of the layers that produce this effect in the Layers panel and then select Merge Layers from the fly-out menu. Drop the opacity of the resulting Smooth Tone Layer to reduce the effect.

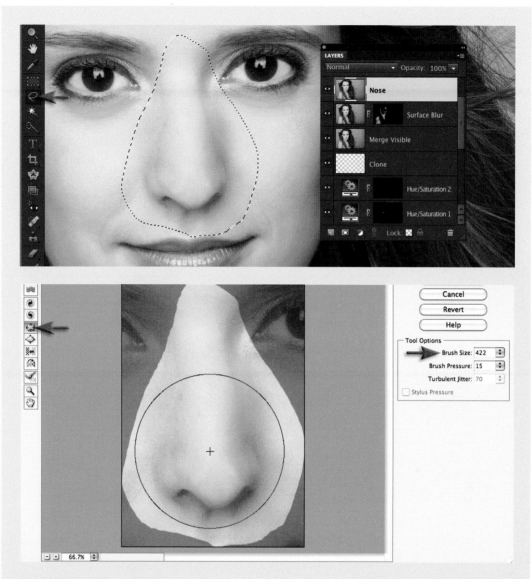

PERFORMANCE TIP

This is not recommended if this is to be a realistic portrait but if glamor is your goal it is possible to give your model a 'nose job' using the Liquify filter. Create a Merge Visible layer (see Step 13) and then make a selection of just the nose. It is possible to 'freeze' pixels to protect them from the actions of the Liquify filter. To activate the freeze in Elements simply make a selection prior to selecting the Liquify filter. Select the area to be modified, being careful to leave out sections of the face that should be protected from the pixel surgery. With the selection active, open the Liquify dialog box (Filter > Distort > Liquify). The areas outside of the selection are now frozen. Select the Pinch tool and then increase the brush size so that it is larger than the nose. A couple of clicks towards the top of the nose will narrow the bridge. A couple of clicks near the end of the nose will reduce its size.

Project 8

Tonal Mapping

In this project I will give my photograph the 'Faux HDR' treatment to create a signature style. I will boost detail by pushing some of Photoshop Elements' adjustments to the max. The final effect is one where the image seems to be part photograph/part illustration.

Blenheim Palace, UK, with the Faux HDR treatment – enhanced detail to give a flat image depth and drama

In commercial photography the post-production treatment is discussed early in the pitch to the agency or client. One of the cutting-edge treatments that is all the rage at the moment, is where maximum detail and surface texture is expanded along with midtone contrast.

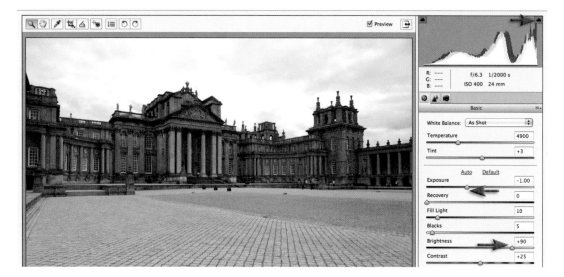

1. This project can be started using a Raw file or a JPEG file. The important aspect of the Raw processing in this technique is to protect highlight detail by lowering the Exposure slider and then raising the Brightness slider. Although there seems to be very little worth recovering in the highlights of this image, one glance at the final image will show you just how much extra detail can be created by applying this tonal-mapping technique.

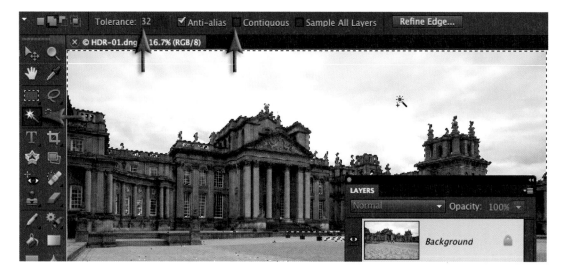

2. This technique will work best if I first reduce the brightness of the sky. I have selected the Magic Wand tool from the Tools panel, set the default Tolerance of 32 and removed the check from the Contiguous box in the Options bar. I have then clicked on the sky to select it, and if there is a portion of the sky that remained unselected, held down the Shift key and clicked again to add this area to the selection.

Note > The Magic Wand is superior to the Quick Selection tool in this instance as it will select all of the tiny islands of sky in the balcony of the palace.

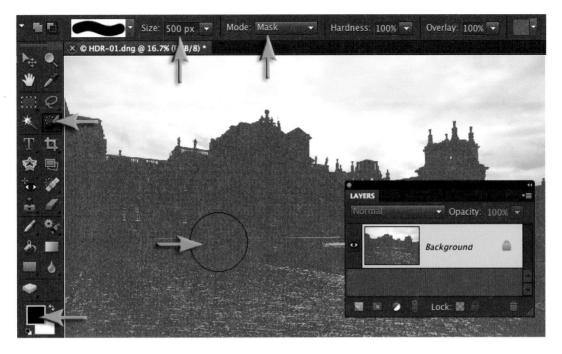

3. I have selected the Selection Brush tool in the Tools panel and chosen the Mask option in the Options bar. I have set the Hardness and Overlay settings to 100% and then painted over the areas in the foreground to create a solid mask.

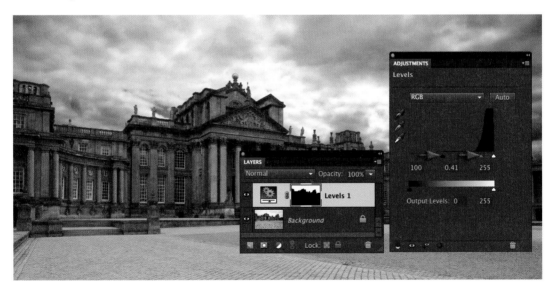

4. I have clicked on the Create new fill or adjustment layer icon at the base of the Layers panel and chosen Levels. I have dragged the black Input Levels slider underneath the histogram to the start of the histogram (around 100) and moved the central Gamma slider to the right to darken the sky significantly (around 0.40).

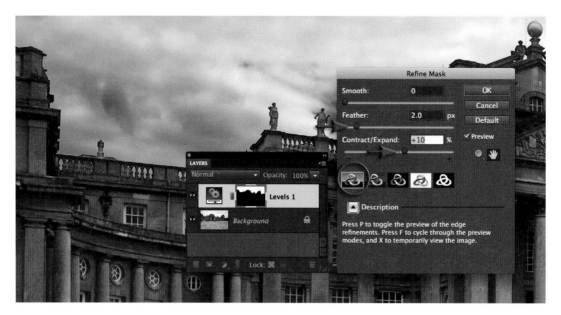

5. The edge of the mask will need some work. I have gone to Select > Refine Edge and chosen the blue Standard viewing icon. I have used the keyboard shortcut Ctrl + H (PC) or Command + H (Mac) to hide the selection edges. I have softened the edge by raising the Feather slider to 2.0 pixels and raised the Contract/Expand slider to +10 to hide any halo that may be visible along the edge before selecting OK.

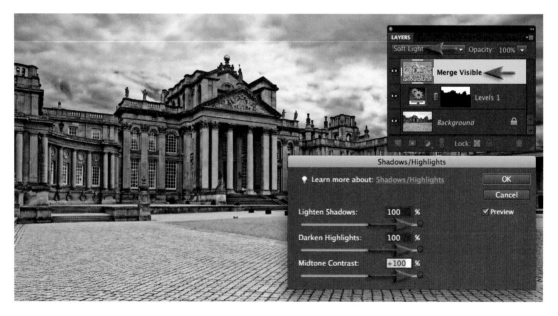

6. I have merged the visible elements to a new layer using the keyboard shortcut Ctrl + Alt + Shift + E (PC) or Command + Option + Shift + E (Mac) and then set the mode of this layer to Soft Light. I have gone to Enhance > Adjust Lighting > Shadows/Highlights and raised all three sliders to +100 and then selected OK.

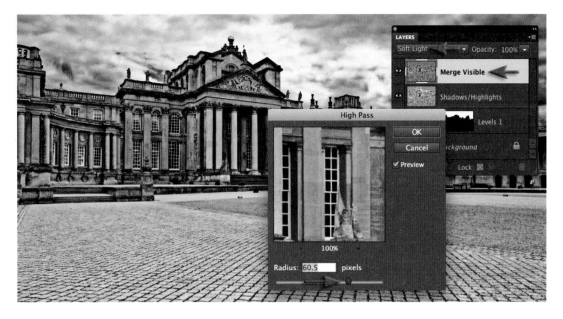

7. I have double-clicked on the Merge Visible layer and renamed it 'Shadows/Highlights'. I have created another Merge Visible layer and again set the mode to Soft Light. I have gone to Filter > Other > High Pass and raised the Radius slider high until the apparent depth of the image increases (around 60 pixels for this project image).

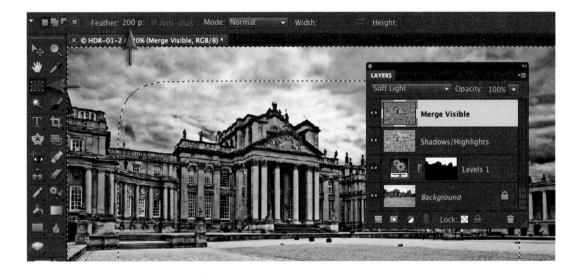

8. In the next two steps I will create a vignette to darken the outer edges of the image to increase the drama further. I have selected the Rectangular Marquee tool from the Tools panel. I have then entered a 200 pixel Feather in the Options bar and dragged from the upper left-hand corner of the image to the lower right-hand corner. From the Select menu I have chosen Inverse so that the outer edges of the image are selected.

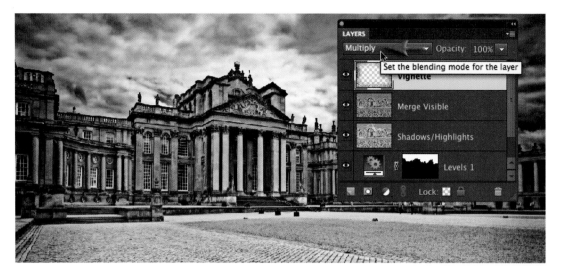

9. From the Edit menu I have chosen Copy Merged (I am copying what I can see rather than what is on the active layer) and then from the Edit menu chosen Paste. I have set the mode of this new layer to Multiply and can adjust the opacity of the layer if required. I have double-clicked on the name of this new layer and called it 'Vignette'.

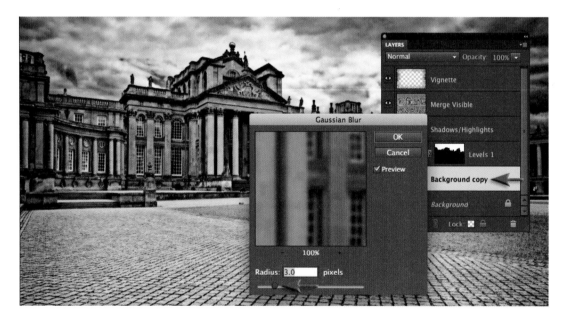

10. If I find the expanded contrast and detail a little too much, I can lower the opacity of the top three layers or add a small amount of Gaussian Blur to a background copy layer. I have clicked on the background layer and used the keyboard shortcut Ctrl/Command + J to create a duplicate layer and then gone to Filter > Blur > Gaussian Blur and entered in a value of around 3 pixels.

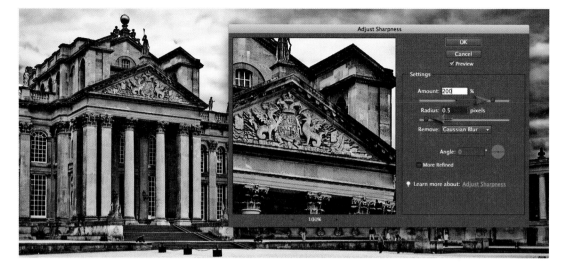

11. If I like the treatment crunchy rather than smooth, I can simply switch off the visibility of this background copy layer and select the Vignette layer to make this the active layer. I can then create a Merge Visible layer (see Step 6) and then go to Filter > Sharpen > Adjust Sharpness. I have raised the Amount slider to 200 and reduced the Radius slider to 0.5 and then selected OK.

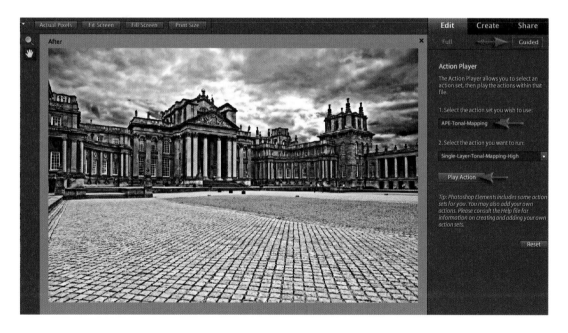

12. This whole process is available as a Tonal Mapping action that can be purchased from the supporting website (www.markgaler.com). The action has to be placed in the Actions folder and then it can be accessed from the Action Player in the Guided Edit section of the Edit workspace. A one-click solution for people in a hurry!

TONAL MAPPING IN ADOBE CAMERA RAW

Detail can be boosted by pushing some of the sliders in ACR to the max. One of the cutting-edge treatments in commercial photography that has been all the rage recently, is expanding maximum detail and surface texture along with midtone contrast. The final effect is one where the image seems to be part photograph/part illustration. Take a look at the website www.davehillphoto.com to get an idea of how this treatment is being applied by one popular US photographer. It is also referred to as an HDR effect, as this expanded midtone contrast can be created when photographers merge images with different exposures and then map the resulting detail. This effect can, however, be created in ACR and the main editing space of Photoshop Elements.

To expand the midtone contrast and edge detail within the image, move the Recovery, Fill Light, Contrast and Clarity sliders all the way to the right (to a value of +100). Lower the Vibrance slider to reduce the excessive saturation in the image that results from raising the contrast slider.

These massive adjustments may upset the brightness of the image. Click on both of the triangles above the histogram to switch the clipping warnings on. Adjust the white point of the image by dragging the Exposure slider to the left or right until thin red lines appear around the edges of the brightest parts of the subject. Adjust the black point of the image by dragging the Blacks slider to the left or right until thin blue lines appear around the edges of the darkest parts of the subject. Drag the Brightness slider to alter the overall brightness of the image and then click the triangles above the histogram to switch the clipping warnings off.

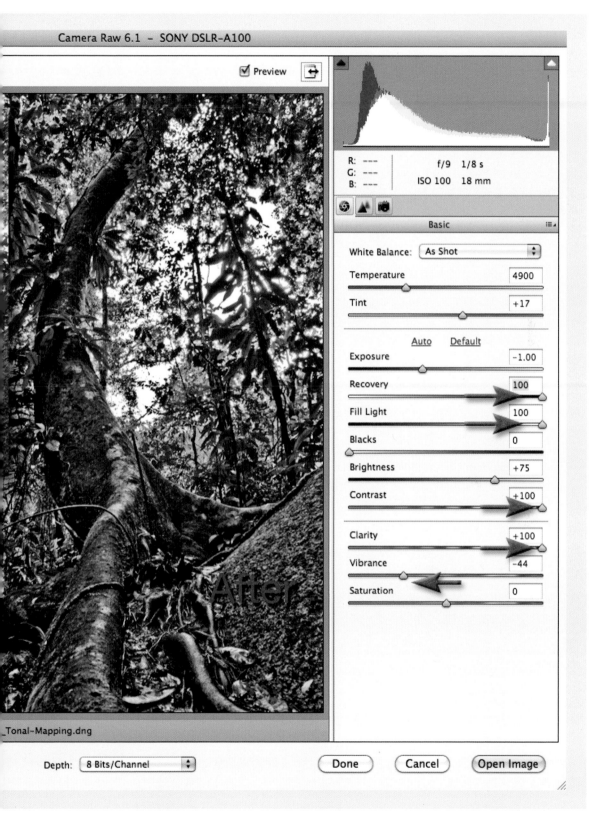

Camera Raw 6.1 – SONY DSLR–A100

☑ Preview

R: ---
G: ---
B: ---

f/9 1/8 s
ISO 100 18 mm

Basic

White Balance: As Shot

Temperature 4900

Tint +17

Auto Default

Exposure −1.00

Recovery 100

Fill Light 100

Blacks 0

Brightness +75

Contrast +100

Clarity +100

Vibrance −44

Saturation 0

_Tonal-Mapping.dng

Depth: 8 Bits/Channel

Done Cancel Open Image

Project 9

Faux Holga

The Holga is a cheap (around US $30), plastic medium-format film camera mass-produced in China. Originally manufactured in the early 1980s for the home market, it has now gained cult status amongst bohemian western photographers who are drawn to the grunge 'art' aesthetic. The camera represents the antithesis of everything that the modern digital camera manufacturers are striving to achieve. If you are looking for edge-to-edge sharpness and color-fidelity then give the Holga a very wide berth. If, however, you are looking to create images that are full of 'character', but without the hassle of going back to film, then you may like to look into the wonderful, and weird, world of Holga-style imagery and give this Photoshop Elements workflow a spin (no Holga required).

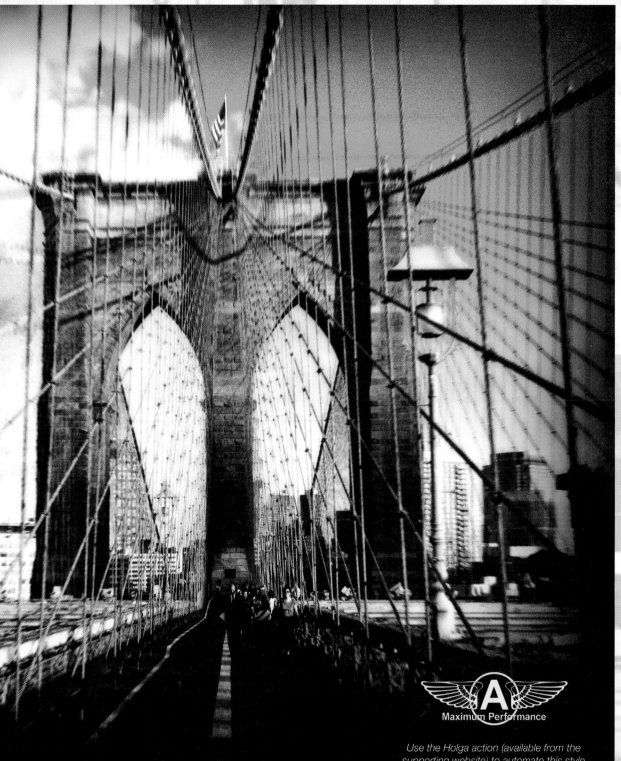

Use the Holga action (available from the
supporting website) to automate this style

Maximum Performance

Getting tired of pin-sharp, noise-free, character-free images from your 24-megapixel Pro DSLR?

Then try this grunge effect to give your images the toy camera aesthetic – think WEIRD, think GRUNGE, think ART!

1. Images produced by the Holga camera are square so I need to grab the Crop tool from the Tools panel, hold down the Shift key to constrain the crop marquee to a perfect square and drag over the central portion of my image. I can then hit the Commit icon or Return/Enter key to get rid of the unwanted pixels.

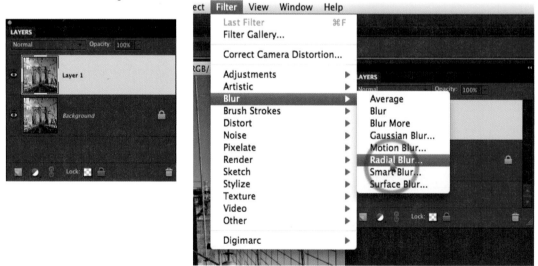

2. I have duplicated the background layer using the keyboard shortcut Ctrl + J (PC) or Command + J (Mac). The background layer will serve as a resource to tone down the final effect in localized areas (if required). The next few steps will start to degrade the sharpness of my image (the Holga camera has a single, simple lens element). With Layer 1 selected in the Layers panel I have gone to Filter > Blur > Radial Blur.

3. In the Radial Blur dialog box I have set the Amount to 3 and then selected the Zoom and Best options. I have clicked where I would like to preserve maximum sharpness in the Blur Center control box (to the right of the Zoom and Best options). There is an element of guesswork in this step but sharpness can be restored later in the process. I have selected the region in the lower center (where I estimate the pedestrians to be crossing the bridge in the actual image). I have selected OK to apply the blur to Layer 1.

4. I have gone to Filter > Blur > Gaussian Blur, selected a Radius of 1.0 pixel and then selected OK to apply the blur to Layer 1. The next blur is called Diffuse Glow, but to make sure the glow is white and not any other color I must set the foreground and background colors to their default setting (by either clicking on the small Black and White box icon in the Tools panel or pressing the D key on the keyboard).

5. I have set the Graininess and Glow Amount to 4 and the Clear Amount to 17 as a starting point. I can increase the Graininess to simulate film grain. Alternatively the grain can be set low in this dialog, as I will have more control over how the grain looks if I apply it to a separate layer. I have selected OK to apply the Diffuse Glow to Layer 1.

Note > Experiment with a lower Glow Amount if the effect is too much for your image.

6. To create a Grain layer I have held down the Alt key (PC) or Option key (Mac) and clicked on the Create a new layer icon at the base of the Layers panel. Holding down the Alt/Option key while clicking on the icon will open the New Layer dialog. I have named the layer 'Grain', set the Mode to Overlay and checked the Fill with Overlay-neutral color (50% gray) checkbox. I have selected OK to create the Layer. The effects of the layer will be invisible at this point in time (courtesy of the blend mode) until the grain is added in the next step.

7. In the Add Noise dialog I have set the Amount to 7% for this 12-megapixel image (adjust it higher or lower if you are using a higher- or lower-resolution image). I have chosen the Gaussian option and selected the Monochromatic checkbox before selecting OK to apply the Noise to the Grain layer. I can adjust the opacity of the layer if the noise is too prominent.

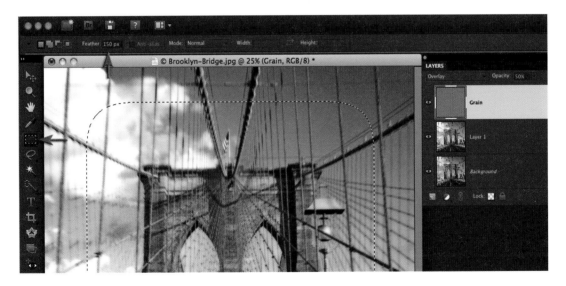

8. I will now replicate the dark vignette that is a characteristic of Holga images. I have selected the Rectangular Marquee tool and set the Feather to 150 pixels (adjust this higher or lower if you are using a higher- or lower-resolution image). I have dragged a rectangular selection so that the central portion of the image is selected (this will leave a border around the edge of the image that is not selected). From the Select menu I have chosen Inverse and from the Edit menu Copy Merged. This has copied the edge pixels to the clipboard. From the Edit menu I have then chosen Paste.

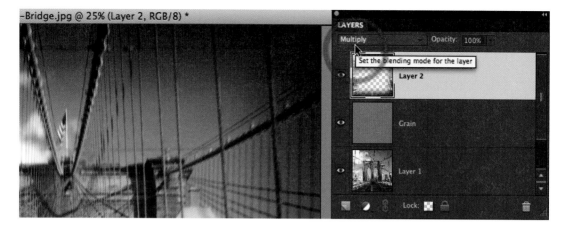

9. The pixels have been pasted to a new layer (Layer 2). At the moment they are identical to the pixels on Layer 1, but when I select the Multiply mode from the Layers panel they can be used to darken down the edges of the image.

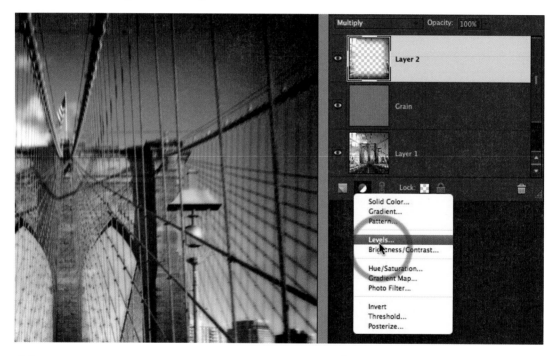

10. Another characteristic of the Holga image is the surreal color palette that is present in many (but not all) Holga images. This is a result of either poor processing or cross-processing of the film (cross-processing intentionally uses the wrong chemicals for the film stock used). I can replicate this look with just a few Adjustment layers. From the Create new fill or adjustment layer menu (accessed from the Layers panel) I have chosen a Levels adjustment layer.

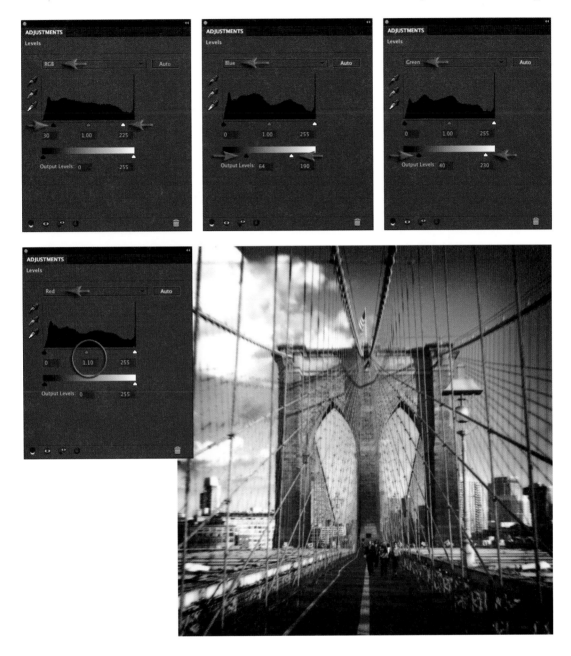

11. I have clipped the shadow and highlight tones by setting the black Input slider to 30 and the white Input slider to 225 (these sliders are located directly underneath the histogram). I have selected the Blue channel from the drop-down menu in the Levels dialog and then dragged the Output Levels sliders to 64 and 190. The Output Levels sliders are located directly underneath the Input sliders. This action has weakened the blacks, rendered the whites slightly dull and introduced a color cast in both. I have selected the Green channel and set the Output sliders to 40 and 230 to increase this effect. Finally, I have selected the Red channel and dragged the central Gamma slider (directly underneath the histogram) to the left so that it reads 1.10.

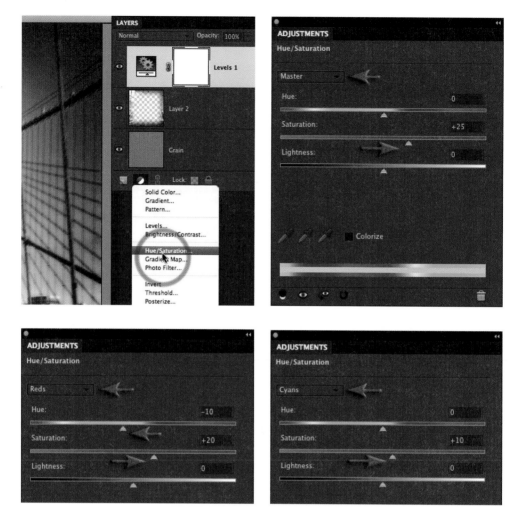

12. I can alter the color and tone using a Levels adjustment but I will need to use a Hue/ Saturation adjustment layer to alter global saturation levels and target specific colors for further attention. I have started by raising the Saturation level to +25 in the Master channel. In the Reds channel I have adjusted the Hue to -10 and raised the Saturation to +20. In the Cyans and Blues channels I have raised the Saturation to +10 for both.

Note > Use these target values as a starting point only. When applying this technique to your own images you may like to try experimenting by raising the saturation levels of key colors within a specific image.

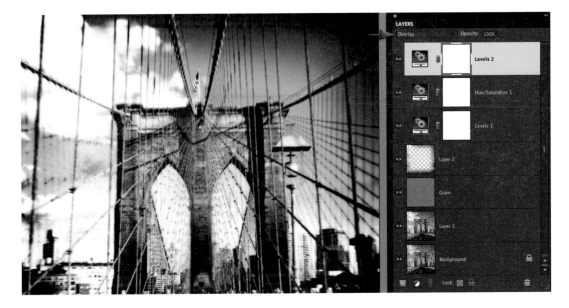

13. To increase the overall contrast I can add another Levels adjustment layer and set the mode to Overlay. If the colors become too 'intense', I can either lower the opacity of the Hue/Saturation layer below or change the mode of this second Levels adjustment layer to Soft Light. If this contrast adjustment layer compromises shadow detail, I can raise the Levels Output slider to a value of approximately +25.

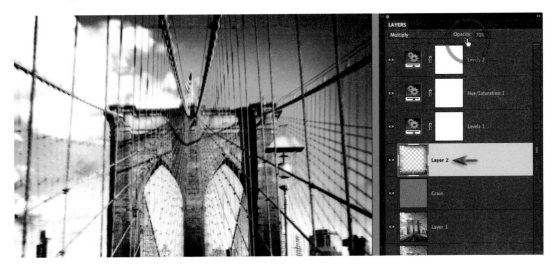

14. Many aspects of the final result can be fine-tuned by going back to the individual layers and adjusting either the settings or the opacity. In the example above, the effect of the vignette layer (Layer 2) is reduced by lowering the opacity. I have painted with black into any of the adjustment layer masks to reduce the effects in a localized region of the image. I will typically paint with a large soft-edged brush, with the opacity setting in the Options bar reduced to around 50%. I can also mask any detail on Layer 1 to restore fine detail where required.

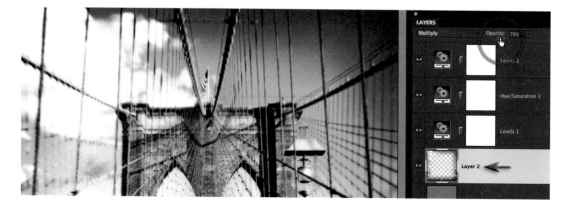

15. Some Holga images 'suffer' (or are 'blessed with', depending on how you look at it) from serious edge clipping and/or light leaks. The corner clipping can be unevenly distributed and more severe than your typical vignette. The corner clipping can be replicated by first creating a new layer and then making another edge selection using the Rectangular Marquee tool with a 150-pixel feather, as we did in Step 8. I have chosen Inverse from the Select menu.

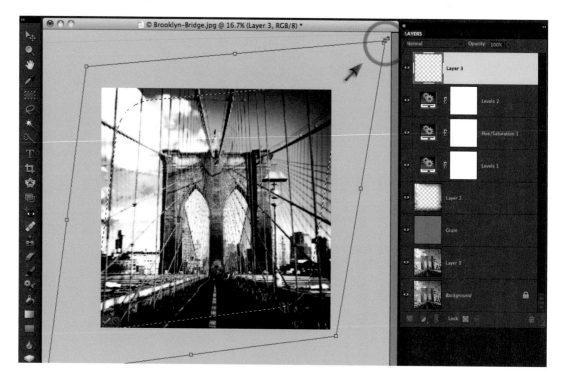

16. I have gone to Select > Transform Selection. Zoom out so that you can see the corner handles of the Transform bounding box. I have held down the Ctrl key (PC) or Command key (Mac) and dragged two of the four corner handles out in a diagonal direction. I have then committed the transformation by hitting the Return/Enter key.

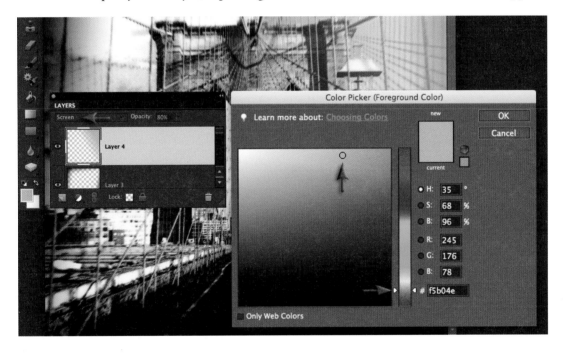

17. I have gone to Edit > Fill Selection and chosen Black as the Contents before selecting OK. I can lower the opacity of the layer, depending on how severe or subtle I want the effect to appear.

18. Light leaks in Holga cameras appear as light orange patches on some frames (some Holga camera owners use black tape around the film loading area of the camera in an attempt to minimize this problem). These light leaks (if required) can be simulated by adding a new empty layer and setting the mode to Screen. I have clicked on the foreground color swatch in the Tools panel to open the Color Picker. I have selected an orange color (around Hue 35°) with Saturation value of around 65 to 70%. I have selected OK and then selected the Gradient tool in the Tools panel. I have chosen the Foreground to Transparent gradient and the Linear Gradient options in the Options bar, and then dragged a diagonal gradient across one of the corners of the image. I can lower the opacity of the layer if I need more subtlety – although to be honest, subtlety is not the name of the game here.

part 3
composites

Project 1

Creative Montage

Masks can be used to control which pixels are concealed or revealed on any image layer except the background. If the mask layer that has been used to conceal pixels is then discarded the original pixels reappear. This approach to montage work is termed 'non-destructive'. In this project we will learn the basics of professional compositing. We will learn how to refine the edge of the mask so that none of the old background pixels are visible and how we can then modify either the background or the subject in isolation so that we can achieve a good match.

Maximum Performance

*Use the Load Selection action
(available from the supporting website)
for easier creation of layer masks*

Forget cutting and pasting – learn the craft of professional montage using advanced masking techniques

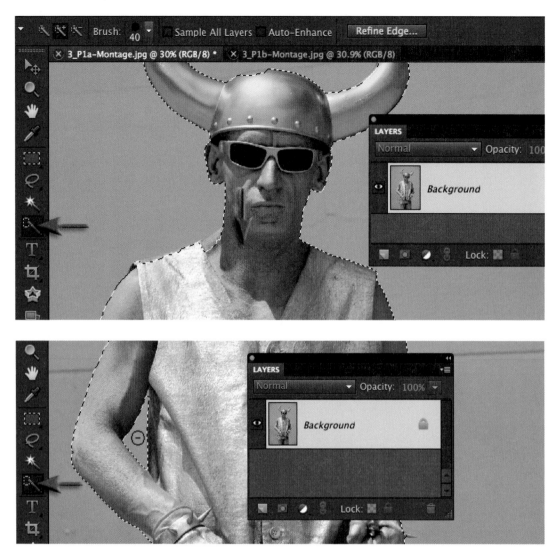

1. The first step is to select either the figure or the background behind the figure using the Quick Selection tool from the Tools panel. The background in this image should be easier than selecting the figure as there are less tonal differences. If the background is complex I would choose to select the figure instead. I have deselected the Auto-Enhance option in the Options bar. With subjects that are easy to select, the Auto-Enhance option can save you time as the edge quality will be refined as you select. The edge contrast of this subject, however, is low in places and no one tool can easily select the entire subject in this image. When this is the case it is better to turn the Auto-Enhance feature off and refine the edge later. After selecting the gold man I have noticed the selection is not perfect. I will need to remove the areas from under the arms and between the legs from the selection. To do this I need to hold down the Alt/Option key and then click and drag over these areas. I have reduced the size of the brush when painting over these regions. I will not spend too long trying to perfect difficult regions of the selection using the Quick Selection tool, as I will use additional techniques to complete the process.

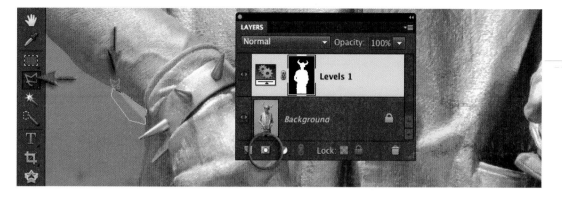

2. In this step I will turn the selection into a mask. With the selection still active I have added a Levels adjustment layer from the Create new fill or adjustment layer menu in the Layers panel. The selection is then converted into a layer mask that I can use to perfect the selection. If I hold down the Alt/Option and Shift keys and click on the adjustment layer mask I can view the mask and the image at the same time. The mask is currently indicating the area that is not selected. I have selected the Polygonal Lasso tool from the Tools panel and set the Feather value to 0 pixels in the Options bar. I have clicked around any area where the mask color needs to be extended to meet the edge of the gold man. I have checked that I have black as the foreground color in the Tools panel and then used the keyboard shortcut Alt + Backspace (PC) or Option + Delete (Mac) to fill the selected area with the mask color.

Note > By unlocking the background layer I could have added a layer mask directly to the subject layer. Perfecting the mask, however, is easier using the technique outlined over the next two steps if the mask sits temporarily on an adjustment layer.

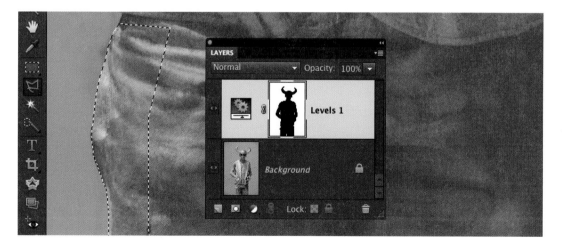

3. To create the perfect selection it will be necessary to remove any mask color that appears over the subject. To do this I can make a selection and fill it with the background color (Ctrl + Backspace (PC) or Command + Delete (Mac)). When the edge is difficult to see because the mask color extends over the edge of the subject, I can go to Filter > Adjustments > Invert (Ctrl/ Command + I). Now I will be able to see the edge clearly and can then make my selection and fill with the foreground color.

4. If you have a steady hand you can also choose to paint directly into the mask using the Brush tool. I have chosen a brush setting of 100% hardness in the Options bar and then painted with black to add to the mask or with white to remove the mask color. I have zoomed in to the image (Ctrl/Command + Spacebar) to ensure the mask is accurate and used the Spacebar to access the Hand tool that will enable me to drag around the image while I am zoomed in. Alternatively I can use the Navigator panel to navigate around the edge of my subject.

Important > Before leaving the mask view I will make sure that the background is covered in the mask color rather than the gold man (Ctrl/Command + I will invert the mask if required). I can Alt/Option + Shift click the layer mask to return to the normal view.

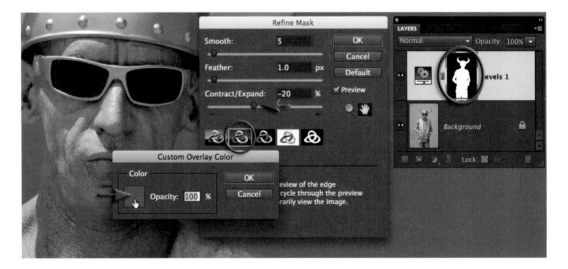

5. The edges of the mask will need to be refined before it can be used for a high-quality montage. I have selected Refine Edge from the Select menu and from the View menu chosen Selection to hide the selection edge. I have double-clicked the Custom Overlay Color option in the panel to open the Options dialog and then set the Color to dark gray and the Opacity to 100%. I have selected OK to apply the color change. I have set the Smooth slider to 5 and the Feather slider to 1.0, and moved the Contract/Expand slider to the left to conceal the white edge that surrounds my subject.

Note > If the subject is gray instead of the background when I enter the Refine Edge dialog I will need to cancel the process and invert the mask before choosing the Refine Edge command.

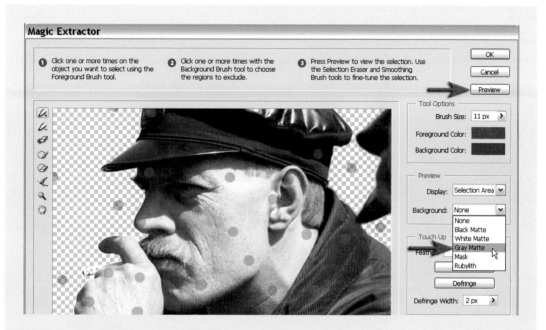

PERFORMANCE TIP

The fact of life is that some extractions can be as painful as pulling teeth! With this in mind Adobe offers you even more magic – the Magic Extractor (Image > Magic Extractor). This is yet another alternative for getting rid of problematic backgrounds. This tool takes a little more time than the Quick Selection tool and is destructive in nature (it deletes the pixels you select with the Background Brush tool) so I would advise duplicating this layer before proceeding. You make little marks or squiggles to advise Photoshop which regions of the image you would like to keep and which regions you would like to delete. Click on the Preview button to see how Photoshop does the hard math to extract your subject from the background. From the Preview menu choose a matte color to view your extracted subject (choose a different tone from the original background or one that is similar to the new background).

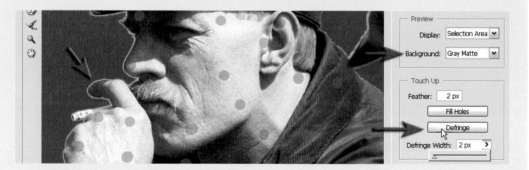

In the Touch Up section of the dialog box select a Feather value (usually 1 or 2 pixels) and then choose a Defringe Width to remove any of the remaining background. Not a bad job – if you don't mind losing the background pixels.

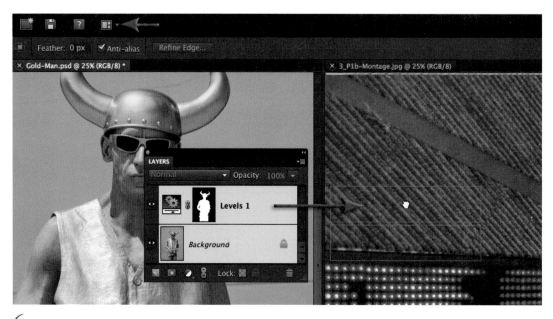

6. In this step I will transfer the subject to its new location. I have opened my new background image and clicked on the Arrange Documents icon in the Application bar and chosen 2-up. I have selected both layers in the gold man file (holding down the Ctrl or Command key and clicking on each layer) and then dragged the layers into the new background file to create a file containing all three layers.

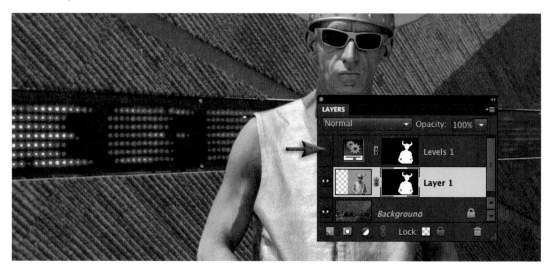

7. In this step I will transfer the adjustment layer mask to the image layer to hide the old background pixels. I have held down the Ctrl key (PC) or Command key (Mac) and clicked on the layer mask thumbnail to load the mask as a selection. I have selected the layer containing the gold man and then clicked on the Add layer mask icon at the base of the Layers panel. I have then clicked on the Visibility icon of the Levels adjustment layer to switch off the visibility (alternatively I could drag the adjustment layer to the trashcan in the Layers panel to delete it permanently).

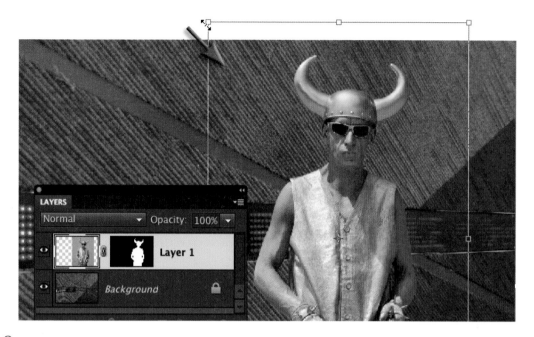

8. In this step I will modify the position and scale of the subject to create the best composition. I have selected Image > Transform > Free Transform (Ctrl/Command + T) and used the keyboard shortcut Ctrl/Command + 0 to fit the Transform bounding box on the screen. I have dragged a corner handle to resize the image so that it sits nicely against the new background (I do not require all of the man's legs to replicate the framing in this project). I have then pressed the Commit icon, or Enter key (PC) or Return key (Mac), to apply the transformation.

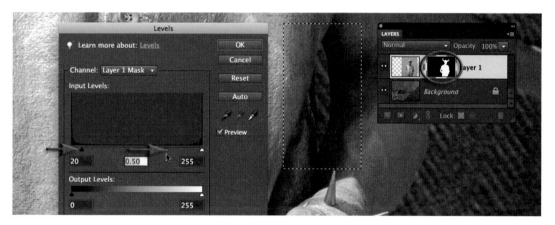

9. In this step I have zoomed in to take a close look at the edges and have noticed a white halo in some regions (from the old background). This can be removed by first selecting the layer mask, then making a selection of the problem area (using a 5-pixel feather if the selection crosses over the edge of the mask) and then applying a Levels adjustment (Enhance > Adjust Lighting > Levels or Ctrl/Command + L) to move the edge of the mask. I have adjusted the central Gamma slider and the black Input Levels slider to the right to remove any of the old lighter background that may still be visible.

10. In the following three steps I will adjust the color values of both layers to create the perfect match. To start this process I have clicked on the background layer in the Layers panel and then chosen a Hue/Saturation adjustment layer from the Create new fill or adjustment layer menu (new adjustment layers are always placed above the active layer). I have selected Reds from the drop-down list in the Hue/Saturation dialog and moved the Hue slider to the right until the red stripes in the image turn yellow. I have then adjusted the saturation to taste.

11. I have now selected the top layer in the Layers panel (the one with the gold man) and chosen another Hue/Saturation adjustment layer from the Create new fill or adjustment layer icon. I have then clicked on the Clipping icon in the bottom left-hand corner of the Adjustments dialog. Clipping the Hue/Saturation adjustment layer to the layer below will ensure the adjustments do not flow down and affect the colors on the background layer.

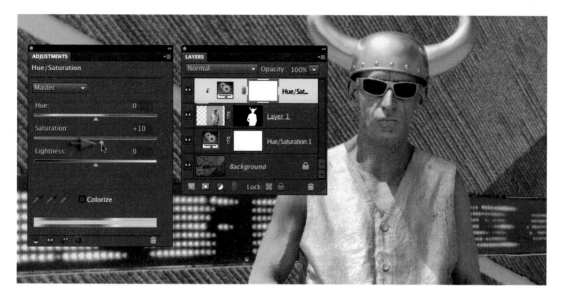

12. I have adjusted the saturation of the gold man to match the saturation of the yellows on the background layer. Notice how the adjustments are only affecting the layer below. The ability to match the color and tonality of a number of different layers in a composite image is an essential skill for montage work. The basic task of replacing the background is complete.

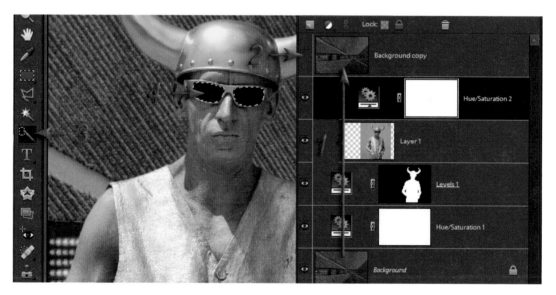

13. In the next three steps I will paste a scaled copy of the background layer into the lenses of the dark glasses. To start this process I have selected and then duplicated the background layer (Ctrl/ Command + J) and then dragged this copy layer to the top of the layers stack. I have switched off the visibility of this copy layer by clicking on the Visibility icon. I have selected the Quick Selection tool in the Tools panel and then clicked both the Sample All Layers option in the Options bar and the Auto-Enhance option. I have then clicked on each lens in the glasses to select them.

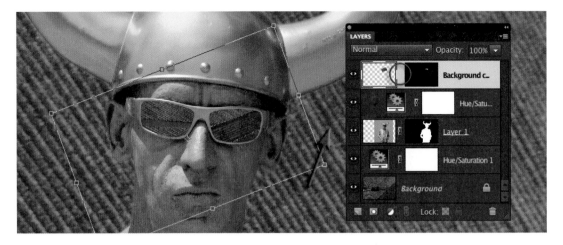

14. I have clicked on the Add layer mask icon in the Layers panel to convert the selection into a layer mask. I have then clicked on the link between the layer thumbnail and the layer mask to break the link between the two components of the layer. I have selected the image thumbnail on the layer and then proceeded to go to Image > Transform > Free Transform and entered in a value of around 20% in either the width or height field of the Options bar. I have then clicked and dragged inside the Transform bounding box to reposition the resized layer over the glasses. I have clicked and dragged on a corner handle to resize further and dragged just outside one of the corner handles to rotate the layer so that the red stripes appear in the lenses of the sunglasses. I have the option to lower the opacity of the layer in the Layers panel if required.

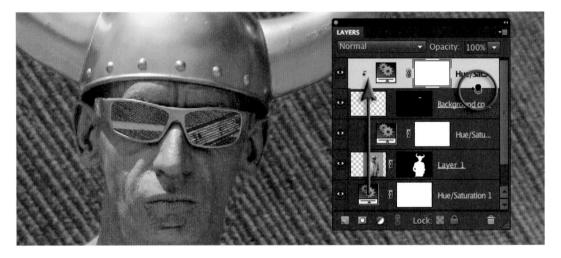

15. To complete the process I have held down the Alt/Option key and clicked and dragged the Hue/Saturation 1 adjustment layer to the top of the layers stack. This action will copy the adjustment layer and change the red stripes to yellow, and it will also affect the color of the golden Viking. I have gone to Layer > Create Clipping Mask to clip this adjustment layer to the transformed background copy layer and limit the changes to the reflections in the glasses. I can also clip a layer by holding down the Alt/Option key and clicking on the dividing line between the two layers.

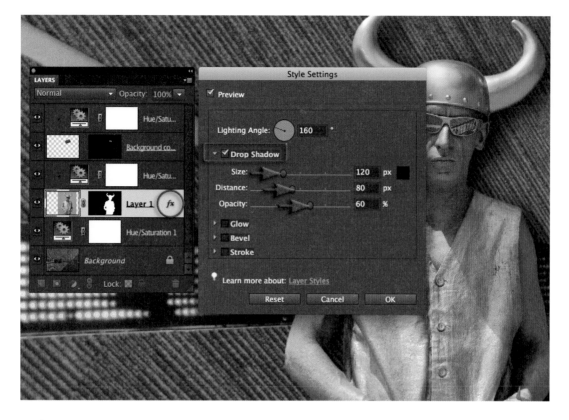

16. In the final step I will add a drop shadow behind the gold man to give the illusion of depth. I have selected Layer 1 in the Layers panel and then gone to Layer > Layer Style > Style Settings. I have checked the Drop Shadows checkbox in the Style Settings dialog. I have increased the Size to 120 px, the Distance to 80 px and the Opacity to 60%. I will now see a drop shadow appear behind the gold man and when I select OK I will see an '*fx*' icon appear on the layer. Double-clicking the '*fx*' icon will reopen the Style Settings dialog. I can move my mouse cursor into the image window and drag the shadow to the right-hand side of the image (the left-hand side of the gold man) to match the direction of the light source in this image.

Note > This project has introduced a non-destructive approach to montage. Any aspect of the composite image can be re-edited as none of the pixels for the old background were permanently changed or deleted during the compositing process.

Project 2

Replacing a Sky

For people who seem to find themselves in the right place at the wrong time! Have you ever traveled long and far to get to a scenic vista only to find that the lighting is useless and the sky is a little short of inspiring? Do you make camp and wait for the weather to change or reluctantly and humiliatingly buy the postcard? Before you hit the Delete button or assign these 'almost rans' to a never-to-be-opened-again folder to collect digital dust, consider the post-production alternatives. Photoshop Elements lets you revisit these uninspiring digital vistas to inject the mood that you were looking for when you first whipped the camera out from its case.

Change the sky to change the weather and drama of the scene

I think every photographer can relate to the intrepid explorers of the Australian Outback who, after scaling the highest peak in the area with great expectations, decided to call it Mount Disappointment! One can only conclude that they were expecting to see something that was simply not there. This something extra could be made real so that all of your landscapes live up to your high expectations – with just a little digital help.

Check out the supporting website (www.markgaler.com) to access an extensive stock library of royalty-free skies.

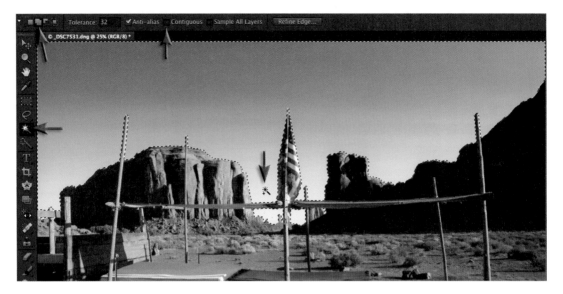

1. In the first two steps of this project I will set out to create an accurate selection of the sky that I want to replace. I have started the process by opening my project images and selecting the Magic Wand tool from the Tools panel. Sometimes the Quick Selection tool is better at making difficult selections but in this case the Magic Wand tool is the fastest tool for the job, due to the pockets or islands of sky in the center of the image. I have left the Tolerance set at its default value of 32, selected the 'Add to selection' option and unchecked the Contiguous box in the Options bar. I have clicked once on the sky, near the flag, to make an initial selection and then clicked again in areas of the sky that were not selected initially. Deselecting the Contiguous option has ensured that the islands of sky near the horizon are selected without having to click on them.

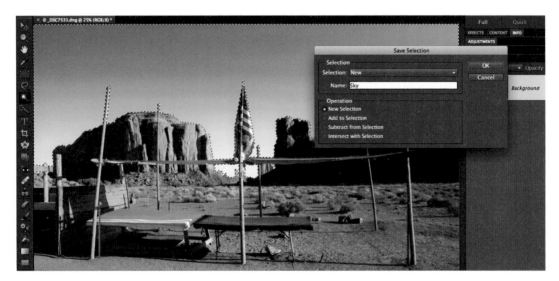

2. I have saved the selection by going to Select > Save Selection and naming it 'Sky', and then selecting OK. From the Select menu I can now choose Deselect. The selection I have saved will be used in a later step.

3. Over the next three steps I will add the new sky as a layer above my background image and modify the size and shape to suit the host image. I have clicked and dragged the thumbnail of my sky image from the Project Bin onto the preview of my project image to create a file with two layers.

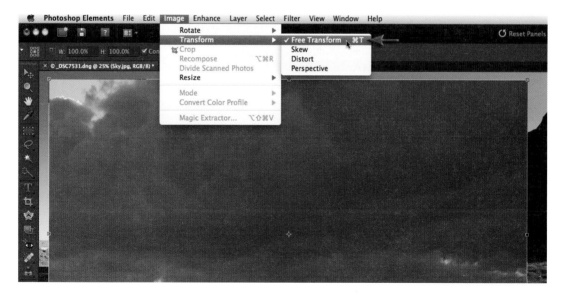

4. As the sky image was captured using a lower-resolution camera I need to resize the sky to fit the host image. I have gone to Image > Transform > Free transform. I have then clicked and dragged the corner handles to resize the width of the sky to fit the larger image.

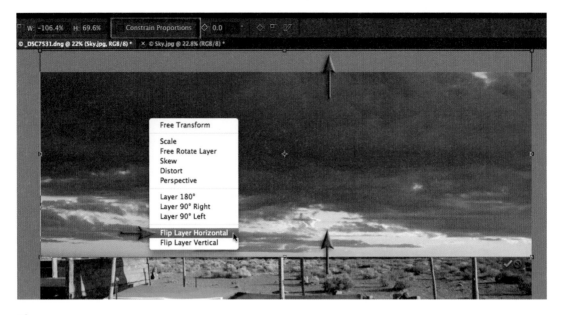

5. I have unchecked the Constrain Proportions checkbox in the Options bar and clicked and dragged the central resizing handle upwards, so that the bottom of the new sky is just below the horizon line in the host image. The top handle has been dragged upwards to perfect the composition. In order to match the lighting direction I also need to right-click inside the Transform bounding box to access the context sensitive menu. I have chosen Flip Layer Horizontal so that the lighting direction in both images is consistent and then hit the Enter key (PC) or Return key (Mac) to commit the transformation.

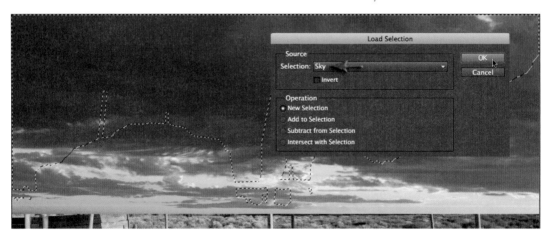

6. In the next two steps of the project I will hide or 'mask' the pixels of the sky layer that I do not want to see. Masking is always a better workflow option than deleting pixels, as this will give me more options to perfect the quality of the edge or reposition the sky in future steps. Masking is termed a non-destructive editing procedure. Deleting or erasing pixels should always be avoided where a non-destructive option is available. I have gone to Select > Load Selection and chosen 'Sky' from the Selection menu. I have selected OK to load the selection that I saved in Step 2.

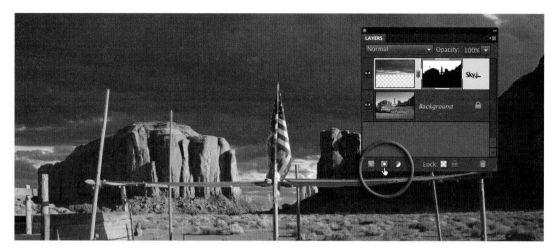

7. To convert the selection into a mask I have clicked on the Add layer mask icon at the base of the Layers panel. This mask has effectively hidden the sky that is not required.

Note > If you need to reposition a sky just click on the chain link between the layer thumbnail and the layer mask. Click on the layer thumbnail to make this the active component of the layer and then move or transform the layer a second time.

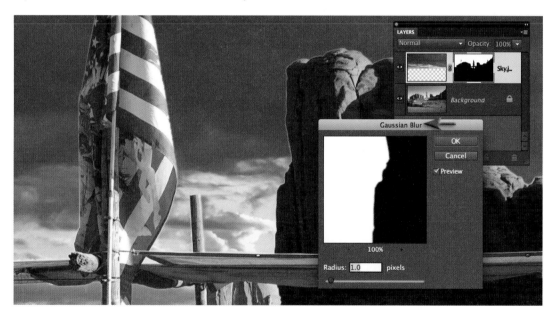

8. The remaining steps in this project are designed to show you how I can modify the sky so that it looks like it belongs in the host landscape. To achieve this I must refine the edge of the mask and then modify the color and tonality of the new sky. I have clicked on the layer mask to make it the active component of the layer. I have gone to Filter > Blur > Gaussian Blur and chosen a Radius of 1.0 pixel and then selected OK. The blur filter will create a feathered edge for the mask.

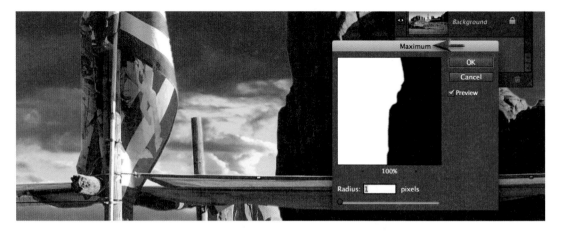

9. I have zoomed in to 100% Actual Pixels (View > Actual Pixels or double-click on the Zoom tool in the Tools panel) so that I can see an accurate preview of the edge between the new sky and the landscape. It is usual to see a white line between the edge of the landscape and the new sky. I can move the edge of the mask by going to Filter > Other > Maximum. A Radius value of 1 pixel will usually improve the position of the edge. I have selected OK to apply the changes. At this stage the edge will be better but may not yet be perfect.

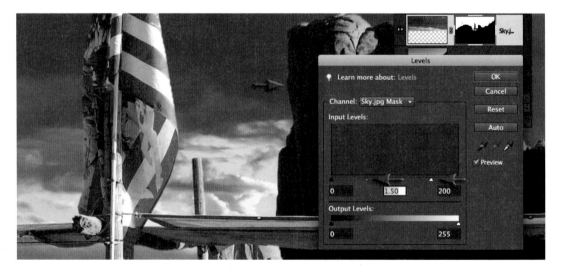

10. To fine-tune the edge I can use a Levels adjustment on the layer mask. I have gone to Enhance > Adjust Lighting > Levels. In the Levels dialog I will not see much of a histogram, as the mask is mostly black and white, but we can perfect both the position of the edge and the sharpness of the edge using the three sliders beneath the histogram window. I have moved the central Gamma slider to perfect the position of the mask edge and then moved either the white or black Input Levels sliders to move the leading or trailing edge of the mask. I have pressed the Spacebar and dragged the image in the preview window to view different parts of the mask edge. I don't need to worry if I cannot perfect all parts of the edge in this step. I just need to get the majority of the edge looking OK and leave the larger errors for the next step.

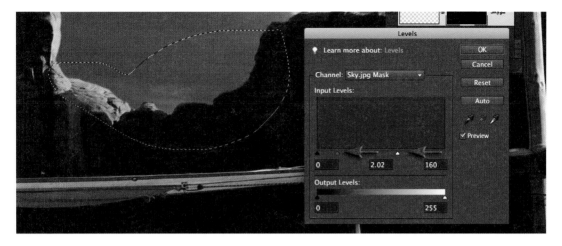

11. The previous three adjustments can also be made using the Refine Edge command (found in the Select menu). The adjustments techniques outlined in this tutorial, however, offer greater flexibility as I can apply them to localized areas of the mask (the Refine Edge command can only edit the entire mask). I have located an area of the mask that still has evidence of the old lighter sky and then selected the Lasso tool in the Tools panel. I have entered a value of 5 pixels in the Feather box in the Options bar and then made a selection of the edge that requires further modification. I have applied a Levels adjustment to just the selected area that is still problematic. The keyboard shortcut for applying a Levels adjustment is Ctrl + L (PC) or Command + L (Mac). Adding the Alt or Option key into the keyboard shortcut will open the Levels dialog with the last used settings.

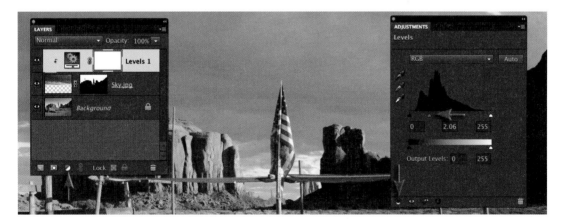

12. In this step I will set out to lighten the sky so that the darker tones of the new sky do not look out of place when placed next to the lighter tones of the host image (near the horizon). I have gone to the Create new fill or adjustment layer menu at the base of the Layers panel and chosen a Levels adjustment. I will need to clip this adjustment layer to the sky layer below by clicking on the Clipping icon in the bottom left-hand corner of the Levels dialog. Clipping this adjustment layer to the sky layer will ensure the adjustments I am about to make only affect the sky and not the background layer as well. I have moved the central Gamma slider beneath the histogram to a value of around 2.00.

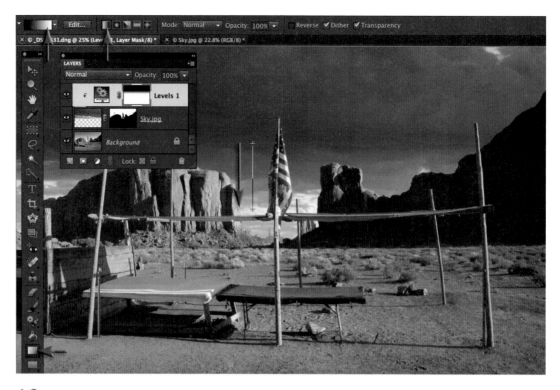

13. In this step I will return the rich, deep tones to the top of the sky (away from the horizon line). I have selected the Gradient tool from the Tools panel and then selected the Black, White option from the gradient presets in the Options bar. I have selected the Linear gradient option and checked that the Opacity is set to 100%. I have clicked and dragged a short gradient from the top of the flag to a position just above the horizon line before letting go of the mouse button. The tonality of the sky should now look at home in the host image.

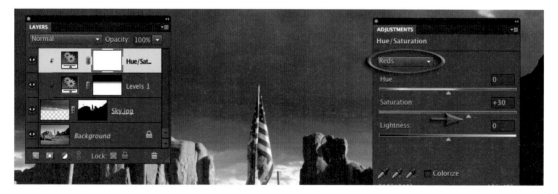

14. I have selected a Hue/Saturation adjustment layer to control the colors of the sky. This adjustment layer has been clipped to the adjustment layer below to ensure any adjustments are restricted to the sky only. In this project I have selected the Reds in the Hue/Saturation dialog and then raised the Saturation slider to +30 to bring out the warm tones on the underside of the clouds.

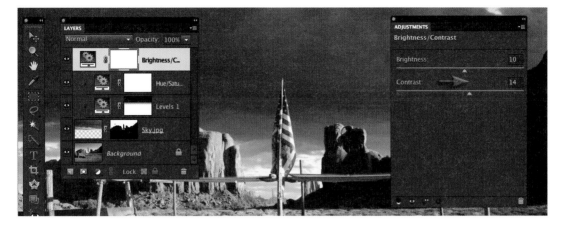

15. To control the overall tonality of the entire project image I can add one final adjustment layer (one layer to control them all)! I have added a Brightness/Contrast adjustment layer and then dialed in my preferred brightness and contrast settings. In this project I have used values of +10 Brightness and +14 Contrast.

16. The icing on the cake for this project is to add a final vignette. I have used my Vignettes action (which can be purchased from www.markgaler.com) as a one-click speedy solution to the process. If you choose to download the actions they can be accessed through the Guided section of the main Edit interface after installing them in the Actions folder. The actions can be found in the Action Player of the Guided section and a variety of different flavors of each action are available. I have chosen a preset that is designed for files that already have multiple layers in place. The actions are non-destructive and will leave all your original image editing intact.

Project 3

Model: Matthew Nicholson

Layer Blending

Blending layers enables textures or patterns from one image to be merged with the form in another image. Blending two images on the computer is similar to creating multiple exposures in a camera or sandwiching negatives in a traditional darkroom. Photoshop Elements, however, allows a greater degree of control and flexibility over the final outcome. This is achieved by controlling the specific blend mode, position and opacity of each layer. The use of layer masks can help to shield any area of the image that needs to be protected from the blend mode.

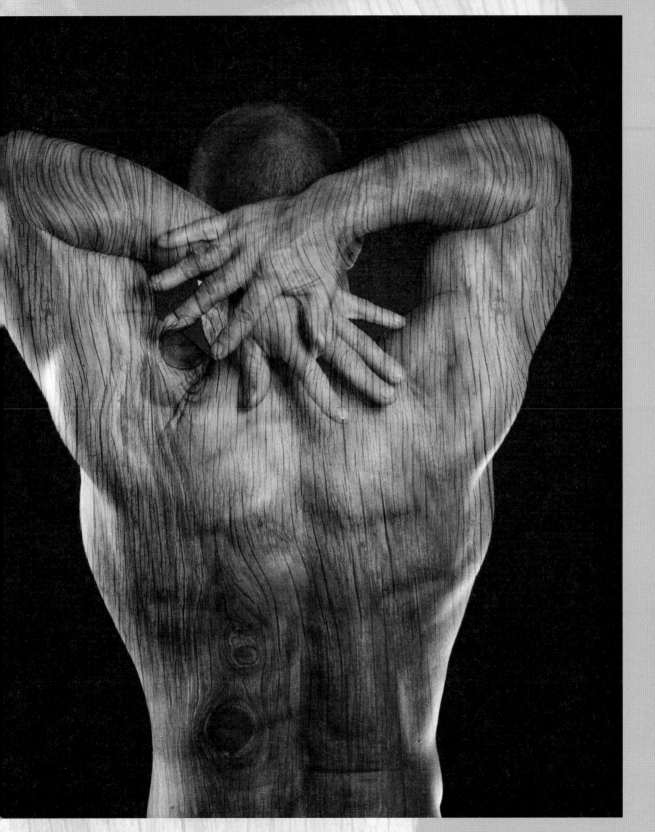

Body art – blend a texture or pattern with your subject to create a dramatic or surreal effect

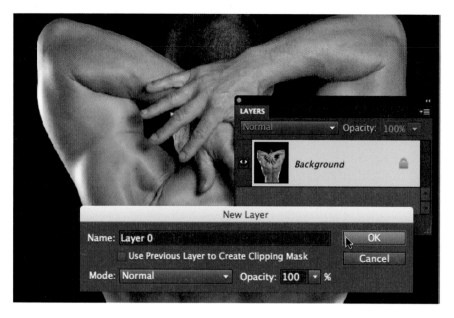

1. We need to unlock the background layer before we begin this composite image. Double-clicking the background layer in the Layers panel opens the New Layer dialog; we select OK to accept the 'Layer 0' name. Now that the layer has been unlocked, we shall be able to add a mask to this layer and new layers below (this is not possible when the layer is a background layer).

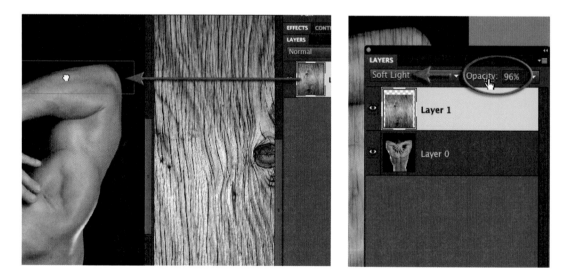

2. With both source images open in the Project Bin, we click and drag the layer thumbnail of the wood-grain texture image into the body image window. Holding down the Shift key as we let go of the texture thumbnail centers the image in the new window. The Move tool can be used to reposition the texture and the Free Transform command (Image > Transform > Free Transform) may be used to resize the texture image so that it covers the body entirely. The blend mode of the wood layer is set to Soft Light or Overlay and its opacity is adjusted till a visually satisfying outcome is created.

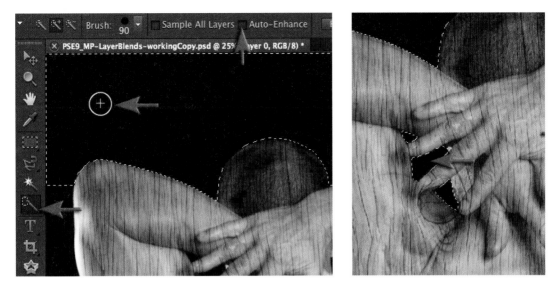

3. Making sure the layer with the image of the person is active, we select the Quick Selection tool from the Tools panel. The Auto-Enhance option in the Options bar should be deselected before an initial selection is made by dragging the tool over the black background of the target image. Clicking and dragging over any islands of black background between the subject's fingers adds these areas to the selection (the size of the brush can be changed if needed). Hold down the Alt/ Option key and drag over any areas that need to be removed from the selection.

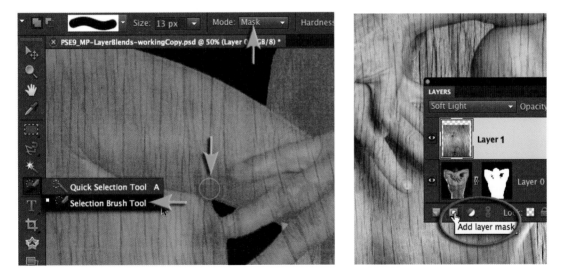

4. In order to fine-tune the selection, we use the Selection Brush tool in Mask mode. Painting over any gaps in the mask (using a brush at 100% Opacity) helps perfect the resulting selection. By zooming in and moving around the edge of the body we can ensure all of the body is fully masked. When this step is complete, we can switch back to Selection mode in the Options bar. With the selection (created in Step 3) still active, the newly created Layer 0 is selected and a layer mask is added by clicking on the Add Layer Mask icon at the bottom of the Layers panel.

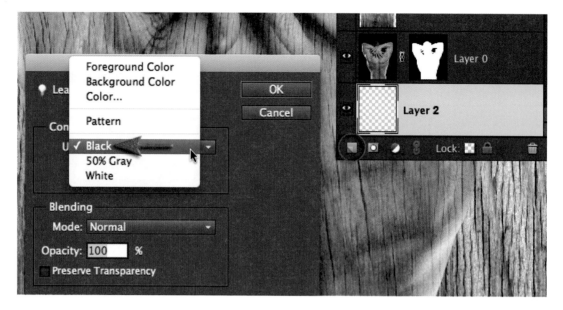

5. Holding down the Ctrl/Command key and clicking on the Create New Layer icon in the Layers panel creates an empty new layer below Layer 0. We select Edit > Fill Layer and choose Black as the fill color. Selecting OK creates a black layer (Layer 2).

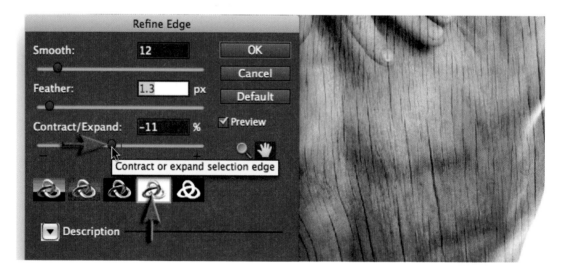

6. Click on the layer mask thumbnail in the Layers panel and then from the Select menu we choose the Refine Edge command. Double-clicking the Custom Overlay Color option provides access to the Overlay options. The On White preview option in the Refine Edge dialog helps us accurately estimate how appropriate the edge of the mask is for our final result and choose the optimum settings. This displays the selection against a white background and any flaws in the mask are easier to locate. The Smooth and Feather sliders are adjusted to help refine the edge. The Contract/Expand slider can be dragged to the right to hide any of the dark edges from the original black background. We select OK when a nice clean edge has been achieved.

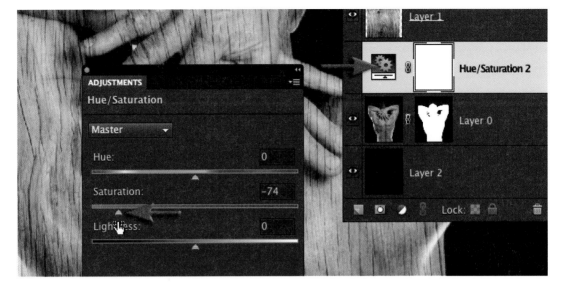

7. Flesh tones from the body are overpowering the colors of the wooden texture, we shall adjust the saturation of the wood-grain texture to create overall colors that are more woodlike. We insert a Hue/Saturation adjustment layer above the image of the human figure and adjust the Master Saturation slider till the desired color panel is achieved.

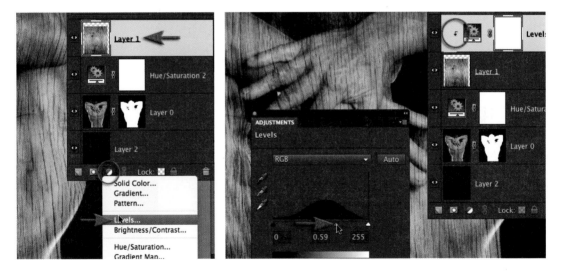

8. Next we shall adjust the local contrast in the image to emphasize the grain effect and make it 'pop' a bit more. With the wood-grain layer active, we hold down the Alt/Option key and add a new Levels adjustment layer. In the resulting dialog box, we make sure the option to 'Use Previous Layer to Create Clipping Mask' is selected. This creates a Levels adjustment layer that will only affect the wood-grain – this is indicated by the little arrow that points down (next to the Levels layer thumbnail). The desired visual impact in the image is achieved by adjusting the shadow, midtone, and highlight sliders.

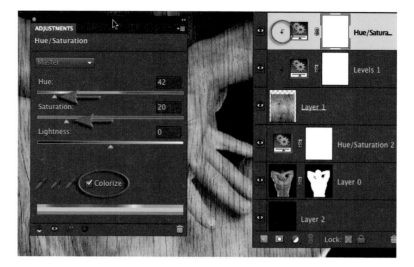

9. We add a Hue/Saturation layer as a clipping mask to the wood-grain layer, this time to make local adjustments to the color of the wooden overlay. With the Colorize option selected in the Hue/Saturation adjustment panel, we first adjust the Hue followed by Saturation using the sliders to achieve the colors that have the most visual appeal.

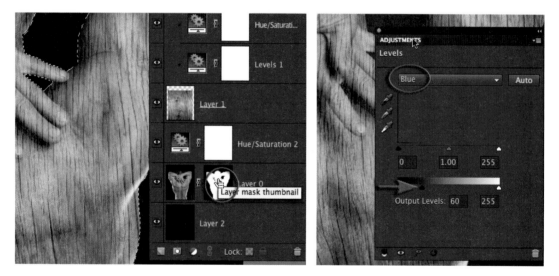

10. Holding down the Ctrl/Command key and clicking on the layer mask thumbnail loads the mask as a selection. Clicking on the layer with the human figure (Layer 0) we make this the active layer and then select a Levels adjustment layer from the Create Adjustment Layer menu in the Layers panel.

11. The layer mask is inverted by choosing Select > Inverse. In the Levels dialog, the black Output Levels slider is dragged to the right to lighten the background to a dark gray tone. From the Channel menu, we select the Blue channel and once again drag the black Output Levels slider to the right to introduce a blue color to the gray background. The precise shade of blue can be controlled by adjusting the black Output Levels slider in either the Red or Green channel.

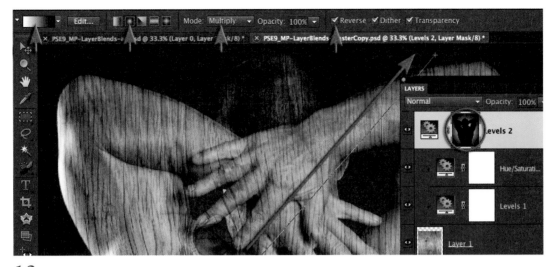

12. We select the Gradient tool in the Tools panel and choose the Foreground to Transparent and Radial Gradient options with black selected as the foreground color. The Opacity is set to 100% and the Reverse, Dither and Transparency options are selected. Clicking and dragging the Gradient tool from a position in the center of the man's body out past the top right-hand edge of the image window creates a striking backlight effect.

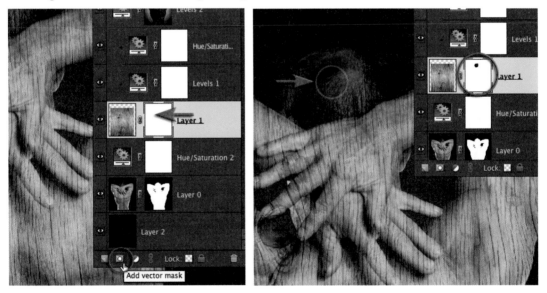

13. At this stage, applying and adjusting the layer blends is complete but examining the image closely reveals that the wooden texture also covers the model's head and some may feel this looks slightly unnatural. To correct this, we can add a layer mask to the wood-grain layer and paint over the model's head (with the newly added mask as the active layer) using a soft black brush.

With this step the core objectives of this project are complete. However, if the model had really been 'carved' from wood, the eye of the critical observer would expect to see more variation in the wood-grain across the body. In the next section, we shall learn how to warp the texture so that it follows contours on the model's body, creating an even more believable illusion.

LIQUIFY: WARPING TEXTURES OVER CONTOURS

A potential criticism of the layer blending technique we have discussed in this project is that, depending on the subject and texture being used, the finished image can look as if the texture was simply projected onto the subject. A more believable result might be achieved if we could make the texture look as if it followed the contours of the subject. In this section, we shall learn how to do just that using the powerful Liquify tool in Photoshop Elements 10.

In this instance, the texture runs lengthwise down the body and is uninterrupted as it moves up the back and onto the model's arms and fingers. The desired effect would be achieved if we could create warping and variation within the texture in these regions.

With the human figure as the active layer, we create a selection around the model's arms and fingers, to ensure any changes we make are restricted to these areas. We can use the Quick Selection tool to isolate the areas we want to change.

Once the selection is complete, the rest of our work shall focus on the wood-grain texture layer. We shall create a backup of the wood layer by holding down the Alt/Option key and dragging the layer thumbnail of the texture down – this preserves a pristine copy of the layer we can always go back to. We must ensure that the texture has been selected as the active layer. With the selection still active, we choose Filters > Distort > Liquify.

Although the interface can be a bit overwhelming when one sees it for the first time, making friends with it is easy by trying simple experiments and having fun. With a little bit of practice, Liquify quickly becomes one of the most powerful tools at an image retoucher's disposal.

At this point we will not be able to see the wood layer interact with the layers below, until we commit the changes that are made in this step. Using the Smudge tool and a very large brush we begin warping the wooden texture. The key is to not feel restricted and try various approaches to create the right amount and type of distortion needed for an image. In this instance, we simply want to break up the linear flow of grain in the wooden texture. We continue working on different areas within the selection and press OK when done to see how these changes affect the overall image. It is important to be prepared to have a few attempts at this before a satisfactory outcome has been created.

Using this approach we can see that the finished image now has enough variation within the texture, particularly around contours, so that it looks much more believable. When used in combination with striking subject matter and unusual textures this technique can create some astonishing results.

Project 4

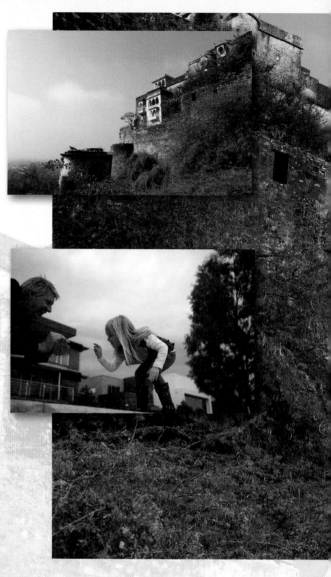

Little Big World

Ever since Gulliver went for his now famous travels, we have been conjuring up dreams of a world where giants and little people are part of every day life. In this project we transport a little girl playing make-believe with her father to a magic place where she can tickle miniature castles. This fascinating illusion is created by using perspective to our advantage. We combine two images, both captured from a low angle. Further, we have taken care to ensure that the direction and type of daylight are well matched between the two images. These factors combine to help us place the little girl next to the castle and create an acceptable composite image.

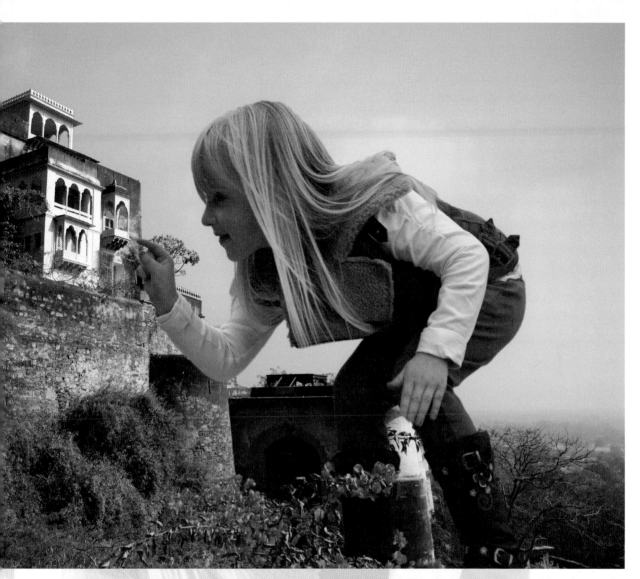

Land of the giants – for this startling illusion we combine two still images, carefully captured from low angles

Model: Leah Parke

A broad rule to follow when capturing images that might be suitable for creating *Land of The Giants* style images, is to capture the subject from a low angle. Depending on how dramatic the difference in size needs to be, the landscape where the 'giant' will be placed, may be captured from a low angle (as we have done here) or a much higher bird's-eye view if possible. This creates a contrast in scale that results in a dramatic image, particularly if lighting is well matched also. After compositing elements from the two images, we shall complete the image by shifting the colors of the surrounding environment in the background image (or *plate*) to create a more hyper-real look.

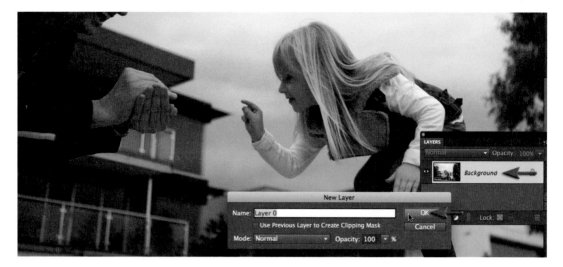

1. The first step in most compositing projects is to unlock the background layer. Double-clicking on the background layer in the Layers panel opens the New Layer dialog; we select OK to accept the 'Layer 0' name. Once this layer has been unlocked we are able to introduce new layers below it or to add layer masks. This flexibility is not available when the layer remains a background layer. For this shot, the little girl's father pretended he had tiny magic creatures hiding in his hands. Intrigued, the little girl inched her way into the perfect position within the frame, allowing us to capture a beautiful moment of genuine curiosity.

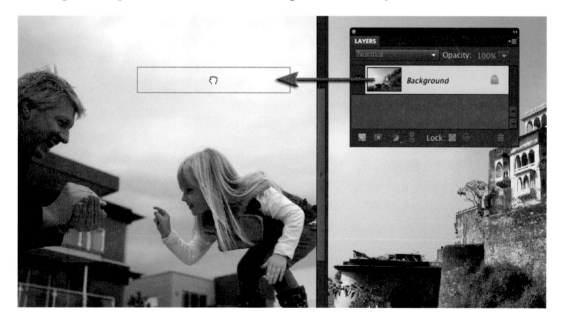

2. With both source images open in the Project Bin, we click and drag the layer thumbnail of the castle image into the scene with the little girl. Holding down the Shift key as we let go of the texture thumbnail centers the new layer in the composite scene.

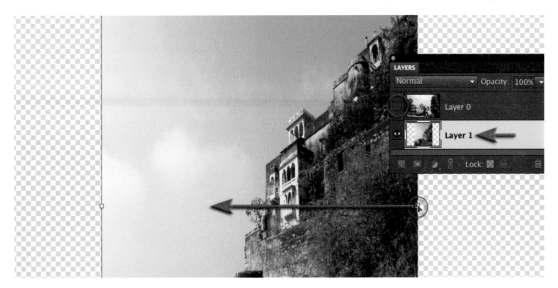

3. In the Layers panel, we drag the castle layer and place it below the scene with the child. The castle is facing the wrong way for the composition we are trying to create, so we will need to flip it horizontally. We use the key combination Ctrl/Command + T to transform the castle layer. Holding down the Shift + Alt/Option keys we drag the horizontal transformation handle in the opposite direction to flip the layer horizontally.

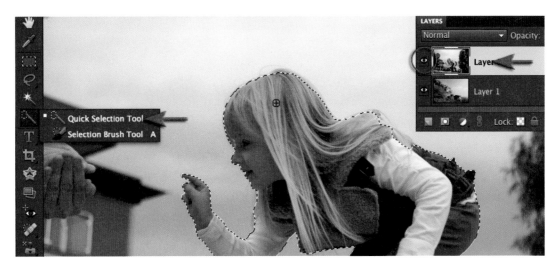

4. The model was intentionally placed against a neutral background to make the process of creating a selection easier. Making sure the layer with the image of the child is active, we select the Quick Selection tool from the Tools panel. An initial selection is made by dragging the tool over the model. Areas that need to be removed from the selection can be eliminated by holding down the Alt/Option key and dragging over those regions. The size of the brush can be changed as needed to help create an accurate selection. The [key makes the brush incrementally smaller and the] key does the opposite.

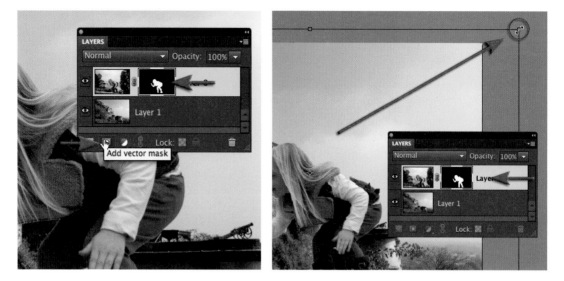

5. Once the selection has been created we click on the Add mask icon in the Layers panel, transporting the little girl to the castle. Ctrl/Command + T allows us to resize the layer containing the child and find the most appropriate contrast in scale with the castle and foreground foliage. We also reposition the little girl so that she appears to be peering into the balcony of the castle.

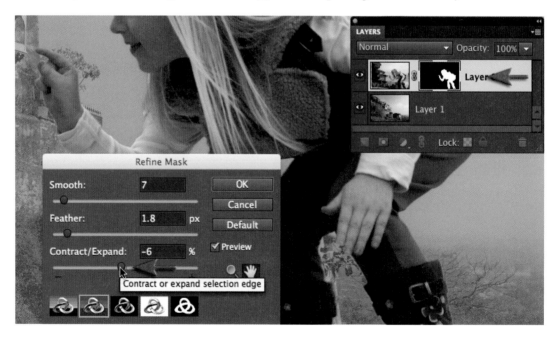

6. The image is starting to take shape but we need to refine the layer mask for the two images to merge seamlessly. With the layer mask active, from the Select menu we choose the Refine Edge command. The Smooth and Feather sliders help refine the edges of the layer mask. The Contract/ Expand slider can be adjusted to remove any evidence of the original background. We select OK when a good, clean mask has been achieved.

7. To help the little girl really 'fit into' the new background we shall overlap some of the foreground foliage over her boots. To do this, we paint over the layer mask, which we refined in Step 6, with a small black brush. Working slowly and changing the softness of the brush allows us to reveal enough fronds of the foliage for our model to settle into the new composition. The Shift + [keys make the brush incrementally softer and the Shift +] keys create a progressively harder brush.

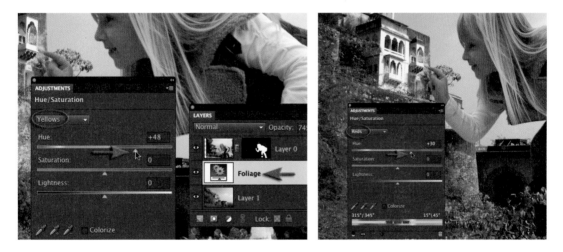

8. To add to the hyper-realism of the finished image we shall tweak some of the dominant colors in the scene. We add a Hue/Saturation adjustment layer above the layer containing the castle. In the Adjustments layer panel, we choose Yellows from the drop-down list and drag the Hue slider to the right. This targets the foliage around the castle. To remind us what this layer influences we shall rename it 'Foliage' by double-clicking the layer and typing in its new name. We shall repeat the steps above to add another Hue/Saturation adjustment layer that targets the Reds in the image – this will change the colors of all the flowers and creates a more restricted color panel within the image. The new adjustment layer can be renamed 'Flowers'.

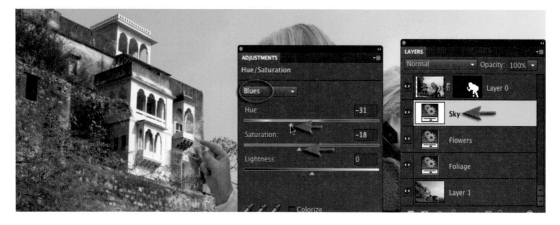

9. Using the same technique, we target the sky and change the mood of the scene by shifting the Hue and Saturation of all the Blues in the scene using a Hue/Saturation adjustment layer. When making these changes the number values associated with the adjustment sliders act as guides – it is important to carefully inspect the impact each adjustment has on the image to determine the best setting for each slider.

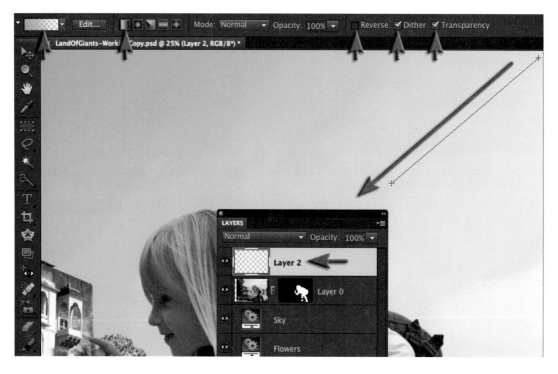

10. We shall use a gradient to create better balance in the density and colors of the sky. Using the color-picker tool we sample the newly changed color of the sky. Selecting the Gradient tool, we ensure that the following settings have been selected in the Options bar: Foreground to Transparent, Linear Gradient, Dither and Transparency. We must also make sure the Reverse option is not active. We click and drag in a diagonal from the top-right of the image.

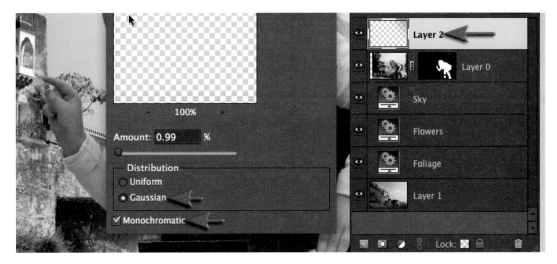

11. To get smooth gradients and avoid any *stepping* of colours, we select Filter > Noise > Add Noise. We only need a very small amount of noise (about 1%), but it should be Monochromatic and distributed in a Gaussian pattern.

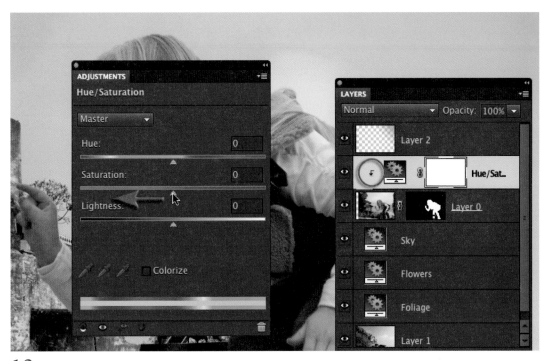

12. Any marginal difference in color that may remain between the background (or *plate*) image and the image of the child can be corrected by holding down the Alt/Option key and adding a Hue/Saturation layer. By selecting the Use Previous Layer as Clipping Mask option, we can restrict any Hue or Saturation adjustments purely to the image of the child. Finally, sharpening can be applied to the finished image depending on whether the image is intended for print or screen viewing.

Project 5

Faux Renaissance

In this project we take a slight detour and create an image that has more creative license. The subject is a bit more exotic and we are going to apply a *faux-renaissance* treatment to achieve the final outcome – a distinctly vintage feel. This marks a departure from our focus on photorealism, where the emphasis has been on convincing representations of reality.

A knight's tale – we travel back in time using grunge textures to create a pseudo-renaissance masterpiece

We shall combine many of the skills we have covered in previous projects to achieve this effect. In particular, we introduce a technique of using layered textures and gaussian noise to give the image an aged look. The treatment is characterized by warm tones, dense textures and heavy, dramatic skies. This particular look is very popular commercially and can be seen in use in film posters and album covers.

1. We are going to shift the castle so that it sits lower in the image, making room for the knight to appear in the image without covering up too much of the period architecture. We begin by double-clicking on the background layer to unlock it. We do this in order to adjust the overall composition by adding more layers behind this layer.

2. Using the Move tool we shift the background layer about a third of the way down and across; this reveals blank areas on the canvas. We shall extend the background image to fill the empty canvas area on the left. We duplicate the original background image by dragging it to the Create a new layer icon at the bottom of the Layers panel and nudge it down using the Move tool so that the horizon lines between the two identical background images match up. The seam between the two sections does not have to be perfect, as it will be covered by the knight when he is placed into the scene. The blank area at the top of the image will be replaced later by a new layer containing a sky with dramatic clouds.

3. A layer mask is added to the copy of the background image. Using a large soft brush and the layer mask active, we paint with black over the seam between the two images. There is sufficient overlap so that the edges between the two images can be blended to create an imperceptible join.

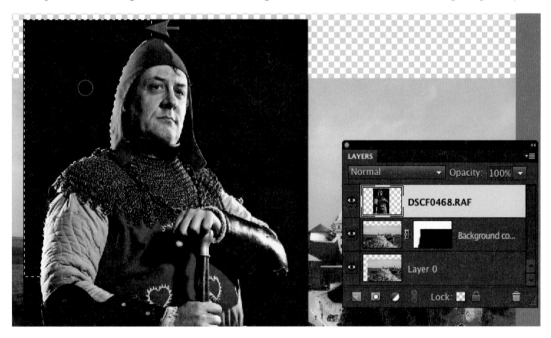

4. The image of the knight is then added to the scene and using the Quick Selection tool we create a selection that separates him from the black background against which he was originally photographed. Add a layer mask to complete this step. You may need to use the Select > Refine Edge dialog to fine-tune the mask.

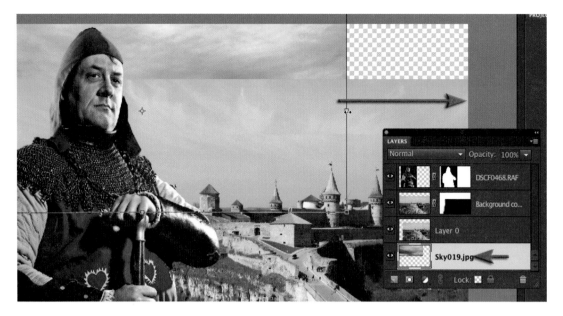

5. The image of the sky with dramatic clouds is added as a new layer. In the Layers panel we move the new layer down so that it becomes the bottom layer. Next, we use Image > Transform > Free Transform to adjust its dimensions. The horizontal dimension handles are used to ensure it fits the width of the canvas. We also make sure the top of the clouds layer is aligned with the top edge of the canvas. This removes any remaining blank areas.

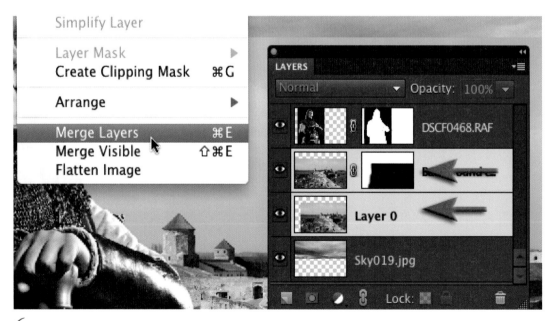

6. Now that extending the background has been resolved, we no longer require the two overlapping background layers to be separate. Holding down the Shift key we select the two layers, then choose Layers > Merge Layers.

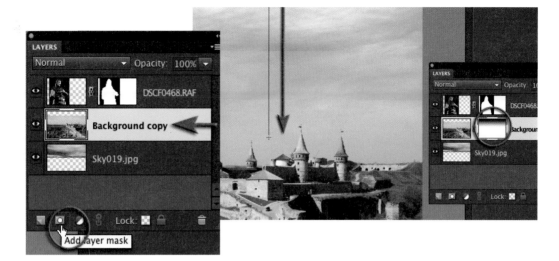

7. We need to create a smooth blend between the new sky and the sky in the background of the original image. We shall add a layer mask to the flattened background layer. Using the Linear Gradient tool, we drag down from the sky towards the castle. This causes the mask to start off solid at the top but begin to fade as it gets closer to the middle of the image, near the horizon line.

Note > The gradient must start with black and end with white or transparent.

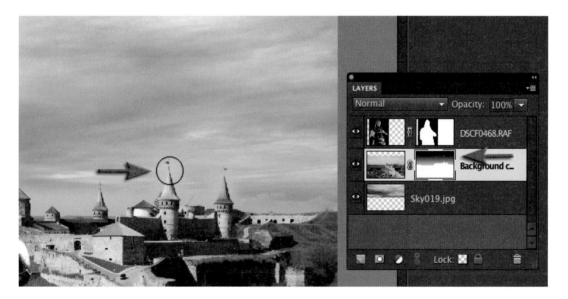

8. Using a soft black brush and the layer mask still active, we go over the castle towers and make sure the mask is not hiding any of the castle details. This technique is an interesting way to *cheat* instead of making careful masks that preserve minute detail in the horizon or sky line. It works well in this instance because the color of the sky being introduced into the scene is quite close to that of the existing sky. The key elements of the image, in terms of composition, are now falling into place.

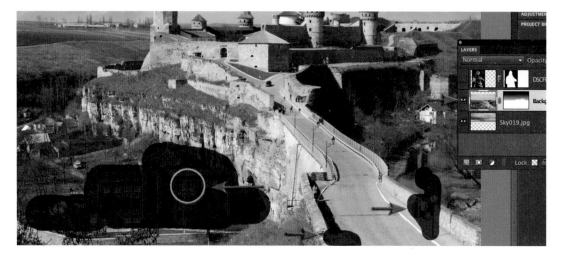

9. To protect against the scrutiny and barbs of the critical observer, we shall go over the scene and minimize any evidence of modern influences within the landscape. Using the Spot Healing Brush in Content-Aware mode, we shall go over buildings, tourists, traffic signs and any other anachronisms that might distract from the visual narrative. When removing large buildings we don't need 100% accuracy; any artifacts that might remain shall be lost in the grunge of the texture layer introduced in the next step.

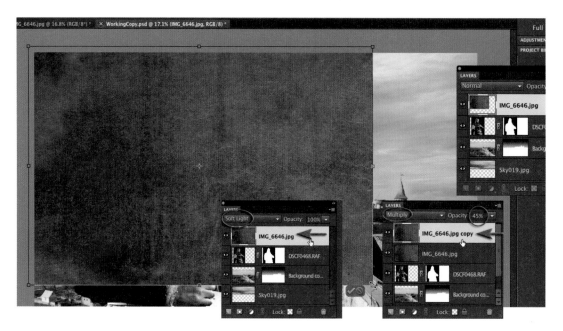

10. The texture, which is an image of wet cardboard, is added as a layer over our image. From the Image Menu we choose Transform > Free Transform and stretch the texture layer to cover the entire image. Next, we change the blend mode for this layer to Soft Light. We also create a duplicate of this layer by dragging it to the Create a new layer icon at the bottom of the Layers panel. The blend mode of the new layer is changed to 'multiply' and its opacity reduced 'to taste'.

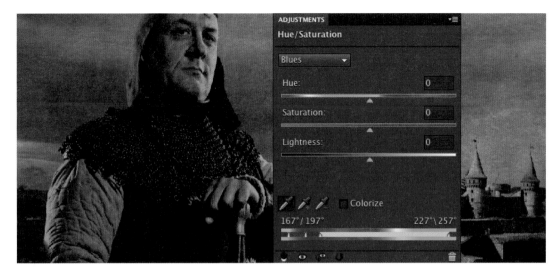

11. Holding down the Alt key as we create a Hue/Saturation adjustment layer above the knight, creates a clipping mask layer which will restrict the effects of all adjustments to the current layer only. We shall reduce the Master Saturation slightly, then select the Blues channel. Using the Eyedropper tool a swatch of blue from the knight's livery is selected. Next, the Hue slider for the Blues channel is adjusted to change the royal-blue livery to a rich maroon, which works better with the warm color panel of the rest of the image.

12. We create a new layer and from the Edit menu choose Fill Layer to fill it with 50% Gray. The blend mode for this layer is then changed to Soft Light, which makes it transparent. Not to worry, the layer is still very much present and this allows us to introduce the final element of texture and age to the image.

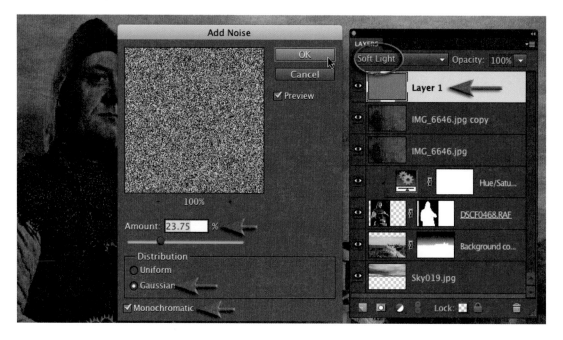

13. From the Filters menu we choose Noise > Add Noise. We can be quite liberal with the amount of noise we add to this layer, but must ensure that the Gaussian Distribution and Monochromatic options are selected. Once the noise has been added, we choose Filters > Blur > Gaussian Blur and add about 2% blur to this layer.

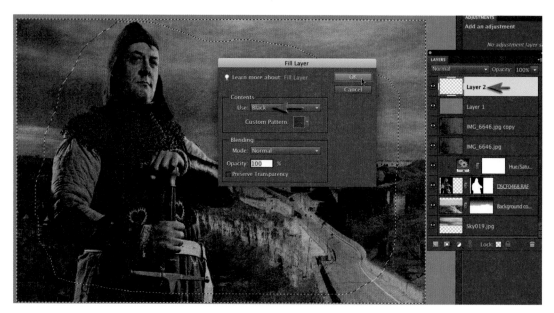

14. Using the Lasso tool we make a coarse elliptical selection of the image. Next, we invert the selection by using the Ctrl/Command + Shift + I keys. We then fill the selection with black by clicking on the Edit menu and choosing Fill Layer and the color Black.

15. The mode of this layer is set to Multiply, from the Filter menu we choose Blur > Gaussian Blur and use a generous Radius to feather the edges of the fill area. The Opacity of the layer is reduced to about 40–50%.

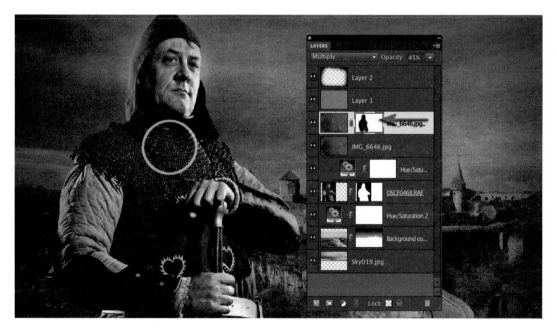

16. Finishing touches to the knight are created by adding a layer mask to the texture layer in Multiply mode and going over it with a soft black brush with low opacity. Masking this layer has a dodge like effect by making the knight appear brighter than the rest of the image. It also removes excess grunge texture from this layer. As a final step, we may sharpen the image for print or screen use.

Project 6

Multiplicity

One of the best-kept secrets in the Photoshop Elements essential toolkit is the Group Shot Photomerge feature. Originally designed to meet the challenge of capturing family portraits, the Group Shot feature is especially useful when someone in a group has blinked or looked away. However, we shall put this feature to a different use, creating a hyper-real image where multiple 'copies' of the same person interact within the scene. Such an approach may be used to capture the vibrant personality of the subject or to create a visually compelling narrative.

Merge the best aspects of several images to create a single image with the strongest impact. Model: Brad Parke

Planning and preparation is required at image capture and post-production stages. A quick sketch of the concept and the sequence in which images are to be captured will help position the subject and props correctly. While Photomerge can often produce remarkable results even with hand-held images, we used a tripod to minimize variation in perspective between shots. Beyond this, it was a matter of capturing a separate image by placing the young model in a different position for each 'character' and just having fun. In this project we shall merge each of the separate images to create the final image. Finally, we look at how to create a unique visual *treatment* using Adobe Camera Raw.

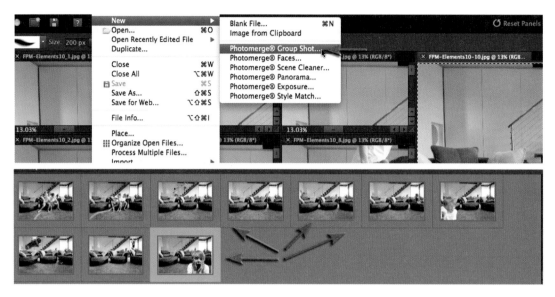

1. The Photomerge Group Shot feature can merge up to 10 separate images into a single composite. We open all of the 10 files we need for our image in the Photoshop Elements 10 Project Bin. Holding down the Ctrl/Command key we select each of the images in the Project Bin. From the File menu, we select File > New > Photomerge Group Shot.

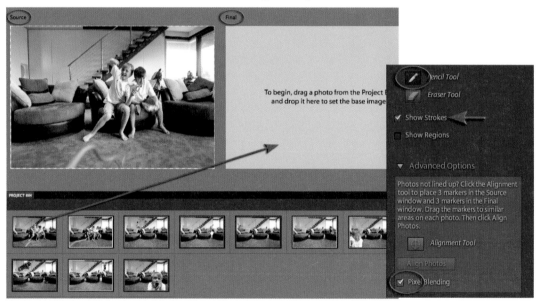

2. The stage is set for our composite image. We begin building up the scene with the two central 'characters'. We drag the first image to the pane titled Final, which is on the right-hand side of the screen. In the Advanced Options panel on the right, the Pixel Blending and Show Strokes options are selected. We can add more elements to the scene by selecting the next candidate from the Project Bin at the bottom of the screen and painting over the particular element to be included using the Pencil tool.

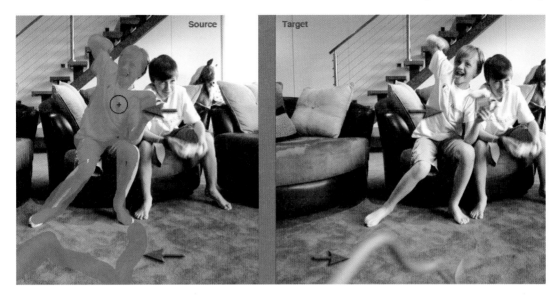

3. Clicking on a thumbnail in the Project Bin updates the Source pane on the left to display the corresponding image. As we paint over the element to be included, the pane on the right updates to include the new element that was just added to the scene.

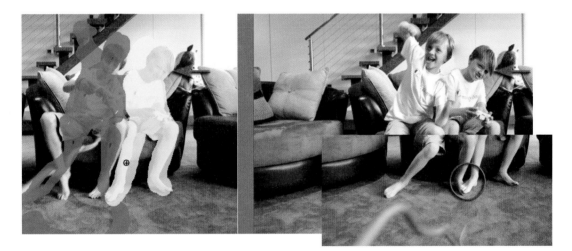

4. The Group Shot feature shows regions selected within each new source image using a mask of a different color. Painting over areas where elements overlap sometimes creates strange misshapen artifacts. If this occurs, we simply undo the step using Ctrl/Command + Z and redo the step with a more accurate pencil stroke. In addition, we must make sure the Pixel Blending option is selected in the Advanced Options panel on the right of the screen. Accuracy can be further improved by changing the size of the Pencil tool (using the '[' and ']' keys). Zooming into the image (using the Ctrl/Command and the + keys to zoom in and Ctrl/Command and - keys to zoom out) before painting provides excellent results as well. To move around within the image while zoomed in, we hold down the Spacebar key and move the image using the mouse.

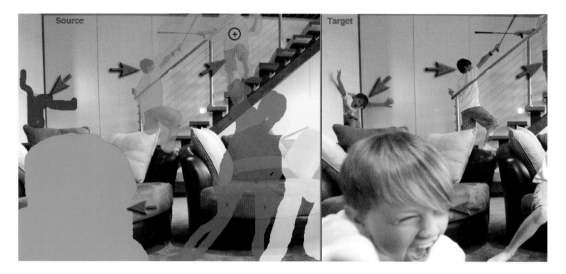

5. We continue to add more characters to the scene using the same approach. The remarkable Group Shot feature performs its magic each time and the final image continues to take shape. The process is almost as simple as painting by numbers. Photoshop Elements 10 does a very good job of guesstimating which regions of an image should be included in the final image. With a bit of patience the results can be quite startling, however, it's not an exact science and may require more than one attempt before an entirely successful outcome is achieved. When the scene is complete and we are satisfied with the quality of selections and the blending between the edges of overlapping images, we click on Done.

6. The finished image is saved as an uncompressed TIFF file, without layers. This will give us a file with sufficient information to manipulate colors and textures in Adobe Camera Raw without compromising the quality of the final outcome. We reopen the TIFF file in Photoshop Elements 10 Editor, but select the Camera Raw Format option in the File > Open dialog box.

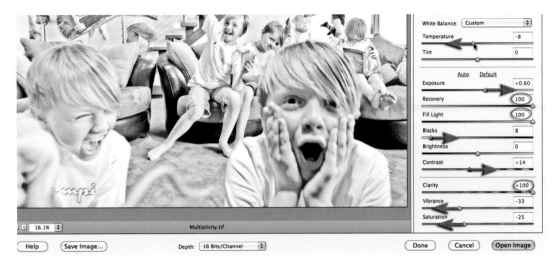

7. We shall emphasize the over-the-top mood in the image using Adobe Camera Raw. This particular *treatment* exaggerates textural detail and is currently very popular. Drama is introduced by moving the Clarity, Fill Light and Recovery sliders to their maximum values. This makes the image almost ridiculously saturated and surreal. We bring back a bit more control by reducing the Vibrance and Saturation values. Contrast can be controlled using the Blacks and Contrast sliders. Finally, exposure can be pushed to 'taste' by a half a stop or even a whole stop to create a fresh, clean 'Euro-commercial' look. The Recovery and Clarity sliders may need to be tweaked 'to taste' to reduce artifacts such as halos around figures in the scene.

8. The image is now complete. The final scene captures not just the exuberance of an active child, but also the remarkable abilities of the Group Shot feature. With a bit of imagination, a touch of planning and a well-placed tripod the mind boggles at the possibilities.

Project 7

Preserving Shadows

The truck used in this project was photographed in the hills of southern Queensland, Australia, while the river dock hails from more than a thousand miles south on the banks of the Yarra river in Melbourne, Victoria. Unlikely bedfellows, but with a little craft the two can lie together comfortably within the same frame – but only if the shadow retains all of its subtlety and is delicately transplanted to its new home on the wooden dock.

Maximum Performance

Use the Load Selection action
(available from the supporting website)
for easier creation of layer masks

The 'shadow catcher' technique – designed to preserve the natural shadows of a subject

1. To start the project I need to select the subject I want to relocate. I have opened the project image and then made an accurate selection of the truck (without its shadow) using the skills from the previous projects. If you are following along with the image from the project resource folder you can load a pre-made selection using the Load Selection action, available to purchase, from the supporting website www.markgaler.com . If this action has been placed in the Actions folder go to Guided Edit > Action Player and look for the Load Selection action. Click on the Play Action button to fast track this process.

2. In this step I will hide the pixels around the subject using a layer mask. To add a layer mask to this layer I have dragged the Lock icon on the background layer to the trashcan in the corner of the Layers panel. I have clicked on the Add layer mask icon at the base of the Layers panel to hide the background surrounding the truck. I don't need to worry about losing the shadow at this stage as it will reinstated later in the project.

3. In this step I will refine the edge of the mask. The path that was embedded in this file (the one loaded with the Load Selection action) has a hard edge that will need to be refined. I have gone to Select > Refine Edge and raised the Feather slider to 1.0 and moved the Contract/Expand slider to -15 to ensure there is no halo surrounding the truck. Selecting the Black Matte option in the Refine Mask dialog will enable me to see if the edge has been contracted enough (note how a temporary layer called Black Matte appears automatically in the Layers panel). I have selected OK when the edge is looking good and then saved this file as a Photoshop (PSD) file and named it 'Truck'.

Important > I will not close the file as I will now isolate the shadow which will be used in the final composite.

4. Over the next four steps I will restore the shadow and replace the old background with white pixels. I have started this process by holding down the Ctrl key (PC) or Command key (Mac) and clicking on the layer mask to reload it as a selection. I have then held down the Shift key and clicked on the layer mask to switch the visibility off. From the Create new fill or adjustment layer menu I have chosen a Levels adjustment. The active selection will be turned into a new layer mask. I have used the keyboard shortcut Ctrl + I (PC) or Command + I (Mac) to invert this mask.

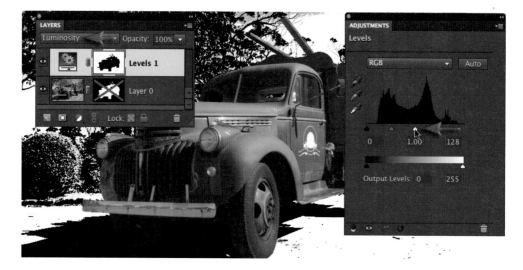

5. In this step I will isolate the shadow from the surrounding pixels (rendering the pixels around the shadow white). I have held down the Alt/Option key and adjusted the white Input Levels slider to the left (the Alt/Option key will give me a threshold view). As I drag the slider to the left I will see increasing areas of tone being clipped to white. I have continued to drag the slider to the left until the shadow appears as an island of black tone surrounded by white clipped tone. I have set the mode of the Levels adjustment layer to Luminosity to preserve the original Hue and Saturation values of the shadow tones. This adjustment layer by itself is not enough to render some of the darker tones in the background white (the trees and bushes).

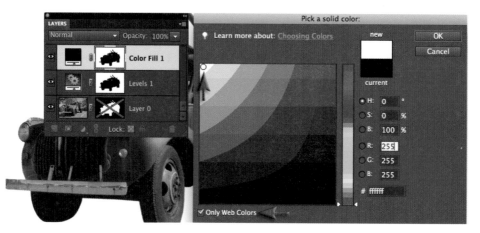

6. In this step I will add the white pixels around my subject. I have held down the Ctrl/Command key and clicked on the adjustment layer mask from the Levels 1 layer to load it as a selection. From the Create new fill or adjustment layer menu in the Layers panel I have chosen a Solid Color adjustment layer. I have selected White as the color and then selected OK to create a Color Fill layer.

Note > I need to make sure the color I pick from the Pick a Solid Color dialog is 255 in all three channels. A quick way of doing this is to select the Only Web Colors option and then click in the top left-hand corner to select white.

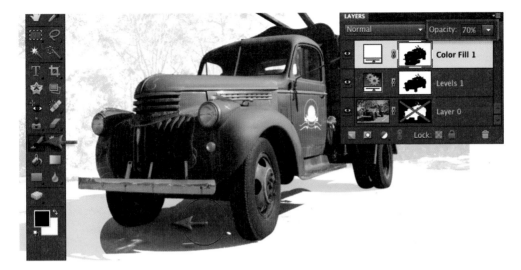

7. In this step I will restore the shadow. I have temporarily lowered the opacity of the Color Fill (Solid Color) layer so that I can see the shadow, selected the Brush tool from the Tools panel and chosen a hard-edged brush set to 100% Opacity in the Options bar. With black selected as the foreground color I have painted over the shadow to mask this area on the Color Fill adjustment layer mask (no accuracy is required). The painting action will reveal the white pixels that surround the shadow (courtesy of the Levels adjustment layer). When the masking is complete I have set the opacity of the Color Fill layer back to 100%. The end result of this step is a truck and a shadow with nothing else visible from the old background. I have then saved this file as a Photoshop (PSD) file and named it 'Shadow'. I can now close this file.

8. I can now add the subject (truck) and shadow files to my new background. After opening my new background image I have gone to File > Place and chosen the 'Shadow' image that I saved in the previous step (placing the file instead of adding the three layers to the new background will allow me to scale the subject non-destructively). The Shadow file will appear with a large bounding box with a cross through it, inviting me to scale the image. I can hit the Commit icon or right-click and choose Place from the context menu. I have then gone to File > Place and chosen the Truck image that was saved in Step 3. When the file appears I have committed the file without altering the size.

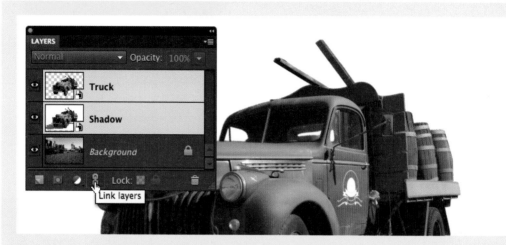

PERFORMANCE TIP

The two layers I have just placed are called Smart Objects (you will see a Smart Object symbol in the corner of each layer thumbnail). Smart Objects are non-destructive containers (the original PSD file is enclosed in each). You can transform the shape and size of the embedded image repeatedly, without lowering the quality of the final image – a great feature for compositing work. If you need to change the size or position of the truck, however, you will also want to change the shadow at the same time. Select both Layers (hold down the Shift key and click on each layer) and then click on the Link layers icon in the Layers panel. Now when you transform one layer the other will be modified at the same time.

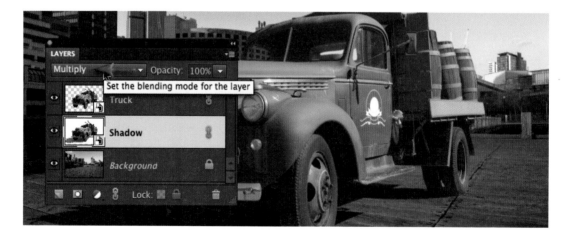

$9.$ To restore the new background to view I have set the blend mode of the 'Shadow' layer to Multiply. White is a neutral color in the Multiply mode so the area surrounding the truck will now be filled with the background layer. The shadow on this layer will, however, darken the background layer. The truck on the top Smart Object layer completes the picture. I have clicked on the Visibility icon of the Truck Smart Object a couple of times to see how this layer contributes to the final outcome.

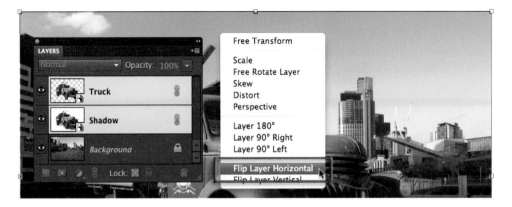

10. I can change the scale and the position of my subject using the Free Transform command. I have used the keyboard shortcut Ctrl + T (PC) or Command + T (Mac) to access the Free Transform command. I have then right-clicked in the Transform bounding box to access the context menu and chosen Flip Layer Horizontal to ensure the lighting direction of the truck image is consistent with the lighting direction of the new location. You may need to flip the background instead of the subject if you have elements such as text that prevent you from flipping a layer.

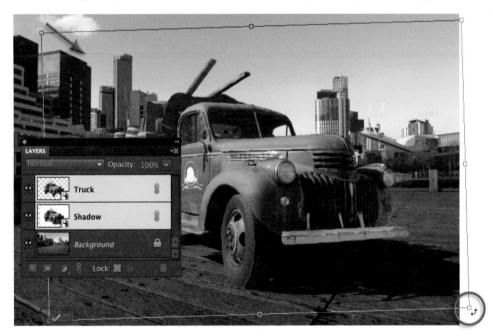

11. With the Transform bounding box still active I am now free to reposition the Truck layer (by clicking and dragging inside the bounding box), scale the image (by clicking and dragging one of the corner handles) or rotate the image (by clicking and dragging just outside one of the corner handles). I have hit the Commit icon, or pressed the Enter key (PC) or Return key (Mac) to apply the transformations.

Note > I can repeat this process many times without the risk of lowering the overall quality.

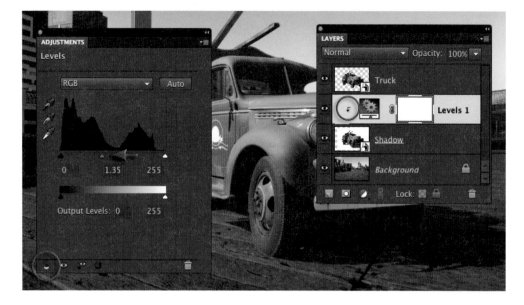

12. The next few steps will ensure each component is optimized so that it looks natural. To adjust the density of the shadow I have clicked the Shadow layer and from the Create new fill or adjustment layer menu chosen Levels. I have clicked the Clipping icon in the bottom left-hand corner of the Adjustments dialog to ensure the changes I am about to make only affect the shadow and not the background. I have dragged the central Gamma slider beneath the histogram to the left or right to lighten or darken the shadows under the truck until it appears correct.

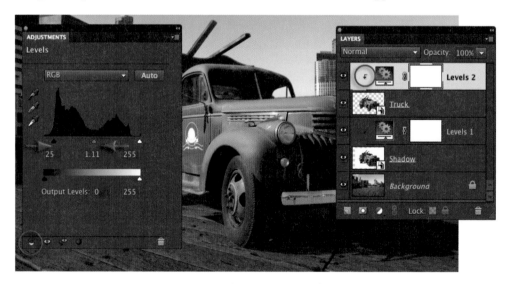

13. To adjust the brightness and contrast of the truck I have clicked the Truck layer and from the Create new fill or adjustment layer menu chosen Levels again. I have clicked the Clipping icon in the bottom left-hand corner of the Adjustments dialog to ensure the changes only affect the truck and not the underlying layers. I have raised the black Input slider to increase the density of the dark tones and moved the central Gamma slider to the left to restore the brightness values.

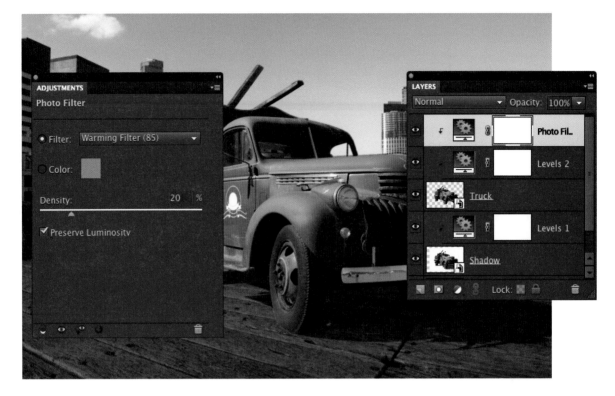

14. The color temperature (white balance) of the two images is slightly different. To correct this difference I have added a Photo Filter adjustment layer above the Truck and Levels 2 layers. I have clipped this adjustment layer with the layers below and in the Photo Filter dialog chosen a Warming Filter (85) and adjusted the Density until the white balance between the two images appears consistent. The three aspects of this composite file (the location, the truck and its shadow) are now working as one to give realism to the final outcome.

PERFORMANCE TIP

When looking to capture location files that would be useful for compositing techniques, such as the one outlined in this project, try to ensure a broad open space in the foreground of the shot. This can be created by using a wide-angle lens or a higher vantage point with the camera angled-down. When capturing the subject for the composite file try to ensure the shadow is cast over a texture that matches the new location. Alternatively, if the shadow is falling over a smooth texture the shadow will take on the texture of the new background. Another factor to consider is sharpness. Try to avoid taking images for compositing that use a wide lens aperture that results in shallow depth of field. This will make the compositing task either more difficult or impossible. If a wide aperture is unavoidable make sure the focus for the location image is centered around the position where the new subject is to be located.

THE BEST TECHNIQUE FOR SUBTLE SHADOWS

The technique we have worked through to preserve shadows provides those photographers burdened with a meticulous eye a useful way of retaining and transplanting subtle and complex shadows. Observe the subtle shadow cast by the leaf above that would be virtually impossible to recreate using any other technique. The primary circumstances that prevent this technique from being used are when the shadow falls over a surface with a different texture to the one in the new location, or the surface over which the shadow falls is particularly uneven or moves from a horizontal to a vertical plane over the length of the shadow.

PERFORMANCE TIP

If it is not possible to preserve the original shadow, try to capture a second image from the direction of the light source. This second image will allow you to create a more accurate shadow than by simply using the outline of the subject as seen from the camera angle instead of the direction of the light source.

This process would include the following steps:

- Make a mask of your subject and place it on a layer above a background.
- Import the second image captured from the direction of the light source and position it between the subject layer and the background layer.
- Make a selection of the subject in this second image (your shadow resource).
- Create a new empty layer that sits below the actual subject and above the background layer, and then fill this selection with black.
- Hide or delete the layer that the selection was made from.
- Place your new shadow layer in Multiply mode.
- Lower the opacity of your shadow layer and apply the Gaussian Blur filter.
- Use the Free Transform command to distort and move the shadow into position.

Project 8

Displacement

Create a showpiece montage by creating a patriotic background for this classic 1957 Thunderbird using some fiendishly clever digital deeds. Wickedly good stuff! The car was photographed by Shane Monopoli for Exclusive Photography in Australia (hence the right-hand drive) and prepared for the subsequent montage using the shadow preservation skills from the last project.

Maximum Performance

Use the Load Selection action
(available from the supporting website)
for easier creation of layer masks

1957 Thunderbird by Shane Monopoli for Exclusive Photography

The layer blend modes are an effective way of merging or blending a pattern or graphic with a three-dimensional (3-D) form. By using the blend modes the flag in this project can be modified to respect the color and tonality of the undulating silk beneath it. The highlights and shadows that give the silk its shape can, however, be further utilized to wrap or bend the flag so that it obeys the material's shape and sense of volume. This can be achieved by using the Displace filter in conjunction with a 'displacement map'. The 'map' defines the contours to which the flag must conform. The final effect can be likened to 'shrink-wrapping' the flag to the 3-D form of the undulating silk.

How it works > The brightness level of each pixel in the map directs the filter to shift the corresponding pixel of the selected layer in a horizontal or vertical plane. The principle on which this technique works is that of 'mountains and valleys'. Dark pixels in the map shift the graphic pixels down into the shaded valleys of the 3-D form, while the light pixels of the map raise the graphic pixels onto the illuminated peaks of the 3-D form.

1. A silk dressing gown was photographed using the available light. For this image to act as an effective displacement map the contrast must, however, be expanded. An effective way of expanding contrast in Photoshop Elements is to duplicate the layer and set the top layer to Overlay blend mode. Note the changes to the histogram by viewing it in the Histogram panel.

Note > I have duplicated my image file to ensure the original file is retained as a master and not lost by this manipulation. You could either copy your image file before you start the project or go to File > Duplicate before you proceed to Step 2.

2. I have gone to the Image menu and from the Mode submenu selected Grayscale. I have chosen the option Flatten when the warning dialog box appeared and OK when the Discard Color Information warning appeared.

Note > The displacement map must be in Grayscale otherwise the color channels will upset the appropriate displacement effect.

3. To further improve the effectiveness of the displacement map I must blur the image slightly. This effect of blurring the map will smooth out the lines of the flag as it wraps around the contours of the silk. Too much blur and the undulations will be lost; too little and the lines of the flag will appear jagged as they are upset by any minor differences in tone. I have gone to Filter > Blur > Gaussian Blur and started by selecting a Radius of around 10 pixels. You could increase or decrease this radius when working with images of a different resolution.

4. I have saved the image (displacement map) as a Photoshop (PSD) file. I have then closed the blurred Grayscale file as the map is now complete. I will need to choose this file when the Displacement filter asks for the location of my map, so I must make a mental note of where it has been saved to on my computer.

5. Over the next seven steps I will make a flag graphic merge with the underlying form of the silk. To start this process I have opened or selected the original RGB image file that I created my map from. I have also opened the flag image that I intend to displace. With the flag image as the active window I have chosen the 2-up view from the Arrange Documents icon in the Application bar. I have dragged the thumbnail of the flag image from the Layers panel into the window of the silk image to create a multilayered file and have then closed the Flag file.

6. I have set the blend mode of the flag layer to Multiply. When displacing a graphic or a texture it is worth ensuring there is enough 'elbow room' (when I displace the flag it will break away from the edges of the file and reveal the edges of the background layer if they are the same size). I have used the Free Transform command (Ctrl or Command + T) to enlarge the flag layer so that it is a little larger than the background layer.

7. This is the step where I get to distort or displace the flag pixels. I have gone to Filter > Distort > Displace. I have entered the amount of displacement in the Horizontal and Vertical fields of the Displace dialog box. The size of the displacement is dependent on the resolution of the image I am working on. I have chosen amounts of 40 for both fields for the image used in this project. Increasing the amount to greater than 60 for either the Horizontal or Vertical Scale will increase the amount of distortion in this project image, but will also start to break off islands of color from the design of the flag, indicating that the limit of the effect has been exceeded. I have selected OK in the Displace dialog box and in the Choose a Displacement Map dialog box I have browsed to the displacement map I saved in Step 4. I have selected Open and my flag will now miraculously conform to the contours of the silk. If I am not entirely happy with the results I can go to the Edit menu and choose Undo, and then repeat the process choosing smaller or greater amounts in the Displace dialog box.

8. If some of the stars are excessively distorted I can switch off the visibility of the background layer and select the Brush tool from the Tools panel. I can then hold down the Alt/Option key and click on the blue to sample the color and paint over any parts of a star that have been excessively distorted.

9. In this step I will modify the tonality of the flag. I have clicked on the Create new fill or adjustment layer icon in the Layers panel and chosen a Levels adjustment layer. I have then dragged the Highlight slider to the start of the histogram to extend the dynamic range and make the highlights and midtones appear brighter.

10. In this step I will modify the color of the flag. I have clicked on the Create new fill or adjustment layer icon and chosen a Hue/Saturation adjustment layer. I have lowered the saturation slider to -40 and then created a Merge or Stamp Visible layer using the keyboard shortcut Ctrl + Alt + Shift + E (PC) or Command + Option + Shift + E (Mac).

11. To create a softer looking flag I can apply either a 2-pixel Gaussian Blur to the Merge Visible layer (Filter > Blur > Gaussian Blur) or I could apply one of my Smooth Tone actions (available to purchase from the supporting website www.markgaler.com). After placing the action in the appropriate support folder on my computer I can access the action from the Action Player (Edit > Guided > Action Player). I have made sure I have used the Multi-Layer Medium option before hitting the Play Action button. My dramatic and colorful background is now complete.

12. To introduce my subject to this displaced background I have gone to File > Place and chosen an image I have previously saved called 'Shadow' (this file was prepared using the techniques outlined in the previous project). I have committed the scale when the image appeared. I have then gone to File > Place and chosen the Car image I saved (also using the techniques outlined in the previous project). Again, I have committed the scaling when the image opened.

13. In this step I will ensure the two layers are perfectly aligned. I have zoomed in to 100% Actual Pixels and set the mode of the Car layer to Difference. What I should see is an absolute silhouette of the car and there should be no white lines visible around the edges of the detail. If there are white lines I can select the Move tool from the Tools panel and use the keyboard arrow keys to nudge the top layer into alignment. When perfect alignment has been achieved I can set the mode of the top layer back to Normal.

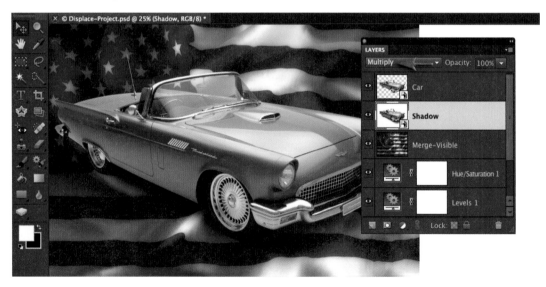

14. In this step I will hide the white pixels that surround the shadow. I have selected the Shadow layer in the Layers panel and then changed the blend mode of this layer to Multiply. The car now appears with its shadow above the flag.

Note > The transparency around the car was created using the technique outlined in the Preserving Shadows project (Project 7, pp. 280–91). The layer mask that creates the transparency has been adjusted to 50% gray in the region of the windscreen to allow the flag to show through at a reduced opacity.

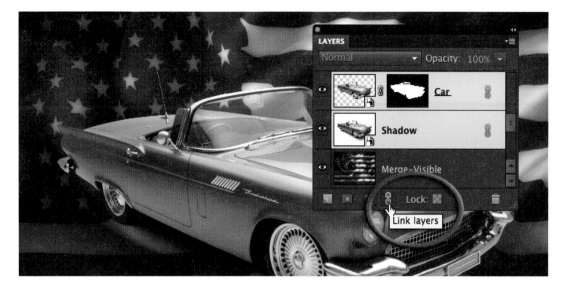

15. In this step I will scale and move the subject into position. I have selected both the Shadow and the Car layers (by holding down the Shift key as I select them) and then from the base of the Layer panel chosen the Link layers option. I have selected the Move tool from the Tools panel and moved the car into the perfect location against the flag. As both these layers are Smart Objects they can also be scaled non-destructively.

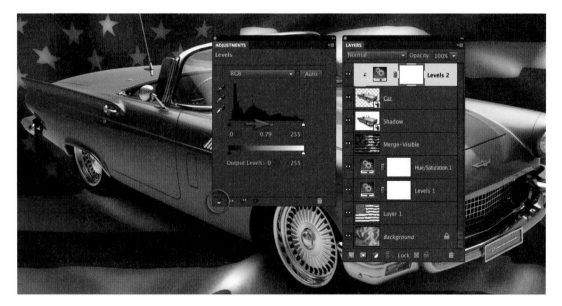

16. I will now render the rear of the car slightly darker than the front. From the Create new fill or adjustment layer icon I have chosen a Levels adjustment. I have clicked the Clipping icon in the Adjustments panel so the Levels layer is clipped with the Car layer underneath. I have then adjusted the central Gamma slider underneath the histogram to the right to darken the car slightly.

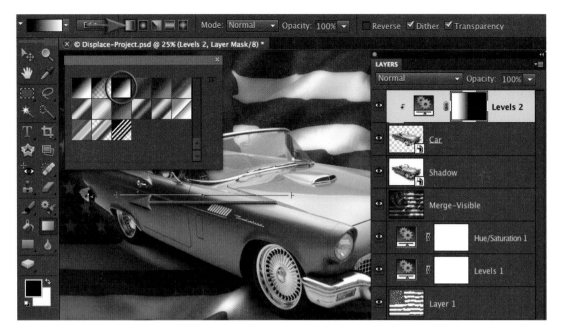

17. From the Tools panel I have selected the Gradient tool, the Black, White gradient from the gradient picker and the Linear Gradient from the Options bar. I have then dragged a long gradient from the front to the rear of the car to shield the front of the car from the adjustment.

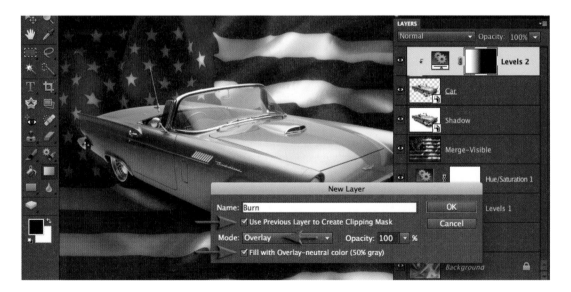

18. As this car was photographed against a bright background, the lighting on the lower panels is a little too light. To modify the lighting so that it looks consistent with the new background I will create a Dodge and Burn layer. I have held down the Alt/Option key and clicked on the Create a new layer icon. I have checked the Use Previous Layer to Create Clipping Mask option, set the Mode to Overlay and then checked the Fill with Overlay-neutral color (50% gray) option.

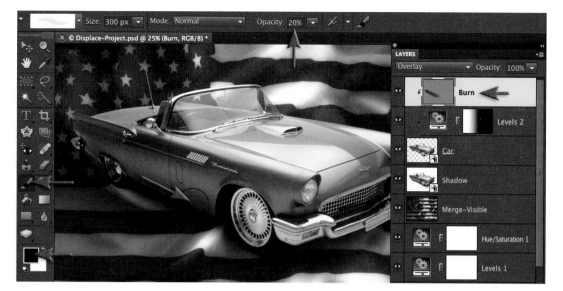

19. From the Tools panel I have selected the Brush tool and set black as the foreground color. I have set the Brush Hardness to 0% by clicking on the Brush in the Options bar, and set the Opacity of the brush to 20%. I have painted over the trunk and the lower portions of the panels to darken the car in this region.

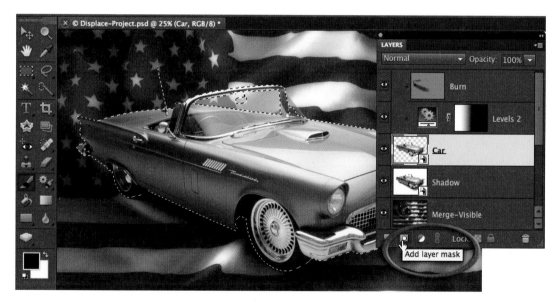

20. In this step I will refine the edge of the car. The car was isolated in the original Photoshop file using a layer mask. This mask cannot be accessed inside the Smart Object in Photoshop Elements, but we can hold down the Ctrl key (PC) or Command key (Mac) and click on the Car layer in the Layers panel to load the transparency as a selection. I have clicked on the Add layer mask icon at the base of the Layers panel to add a new layer mask. This action alone may improve the quality of the edge. If the mask needs fine-tuning I can go to Select > Refine Edge.

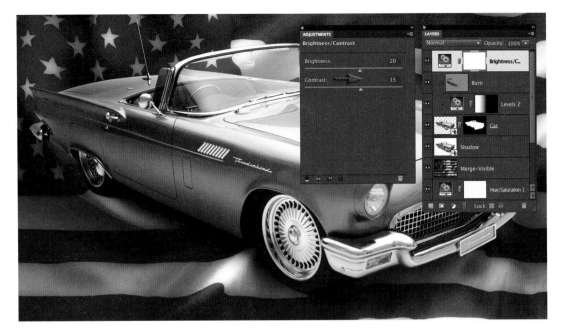

21. To complete the project I will use some adjustment layers to optimize the color and tonality of the final file. From the Create new fill or adjustment layer icon in the Layers panel I have chosen a Brightness/Contrast adjustment layer and optimized the tonality of the image. I have raised the Brightness to +20 and the Contrast to +15 in this project.

22. I can warm the tones of the car by adding a Photo Filter adjustment and selecting the Warming Filter 85 option to give the image a classic golden glow. I have lowered the Density slider slightly as the warming filter was a little too strong.

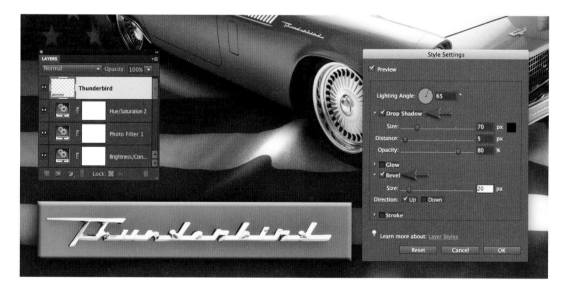

23. The third and final adjustment is another Hue/Saturation adjustment layer that is used to drop the overall Saturation levels a little more (-25 in this project) to give the aged look.

24. I have used a detail photograph from the side of the car to complete the project. After opening the file I have used the Free Transform command (Ctrl/Command + T) to move and scale the emblem. I have gone to Layer > Layer Style > Style Settings and checked the Drop Shadow and the Bevel checkboxes. I have then fine-tuned the sliders of both of these sections and adjusted the Lighting angle to around 65° so that it is consistent with the lighting direction for the flag and the car. My classic make-over is now complete.

Project 9

Photomerge

Photomerge is capable of aligning and blending images without any signs of banding in smooth areas of transition. The new and improved Photomerge first made its appearance in Photoshop Elements 6 and the stitching is now so clever it will really have you amazed at the quality that can be achieved.

Spot the joins – upgrade to 30 megapixels with seamless stitching

The quality will be even better if you capture vertical images with a 50% overlap using manual exposure, manual focus and Manual White Balance setting (or process the images identically in Adobe Camera Raw). The results are now usually seamless – an excellent way of widening your horizons or turning your humble compact camera into a megapixel blockbuster (5 x 12 megapixels ÷ 50% = 30 megapixels).

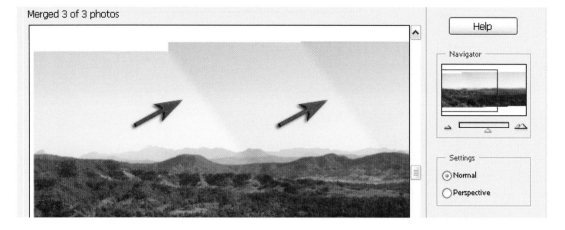

The Photomerge feature in version 5 of Photoshop Elements left a lot to be desired. All of the flaws and weaknesses of this feature were, however, removed with the release of Photoshop Elements 6.

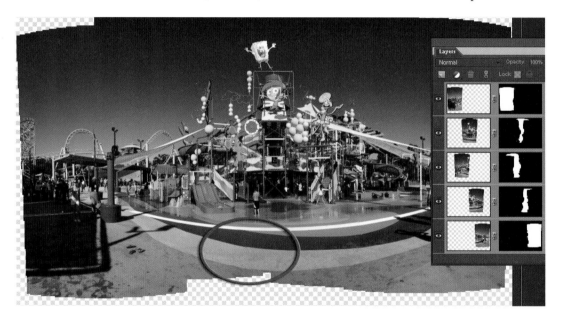

Now, the only limitation you may run up against is Photoshop Elements' ability to align and blend strong geometric lines that come close to the camera lens. If the camera is hand-held to capture the component images (i.e. you have not used a specialized tripod head designed for professional panoramic stitching work) then the problem of aligning both foreground and distant subject matter is a big problem for any software (Photoshop Elements handles it better than the rest). The camera should ideally be rotated around the nodal point of the lens to avoid something called parallax error. You will probably not encounter any problems with the new Photomerge feature unless you are working with strong lines in the immediate foreground. Notice how the curved lines in the image above are slightly crooked due to the fact that these images were shot with an 18 mm focal length and the circled lines are very close to the lens. Still pretty good – but not perfect.

1. The images for this project were captured as Camera Raw files but it is strongly recommended when using an older computer or a computer without a lot of RAM to downsample the images before attempting this project. To efficiently downsample multiple images go to File > Process Multiple Files. Select a Source folder of Raw images (hit the Browse button) and then select the destination folder where you would like your processed files to be saved. Check Resize Images and select the optimum height of the finished project in pixels. Check Convert Files to and choose the JPEG Max Quality option and then select OK to process the images.

Note > If you wish to make a monster panorama, select all of the Camera Raw files and open them in Adobe Camera Raw (ACR). Choose the Select All option in the top left-hand corner of the dialog box and select OK. Choose Image Settings for these images in ACR and then click Open Images.

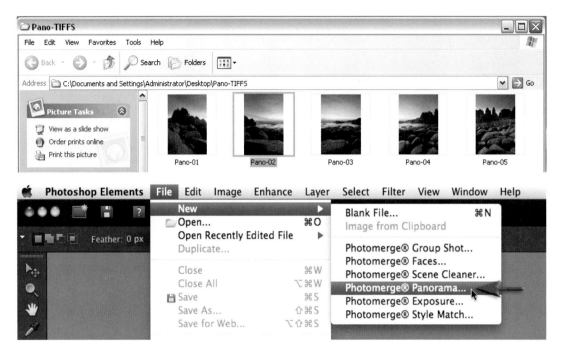

2. To start the Photomerge process I have selected all of the processed images (from my destination folder I created in the Process Multiple Files dialog box) and have then opened these images in Photoshop Elements. From the File > New menu I have chosen Photomerge Panorama.

3. In the Photomerge dialog box I have clicked on the Add Open Files button and selected the Auto radio button in the Layout options. I have selected OK and let Photoshop Elements do all of the work – and what a lot of work it has to do, aligning and blending all of these images.

Note > Photomerge can also handle multiple exposures (images taken of the same part of the scene using different exposure settings in-camera) and juggle which is the best exposure to use for any given location in the panorama.

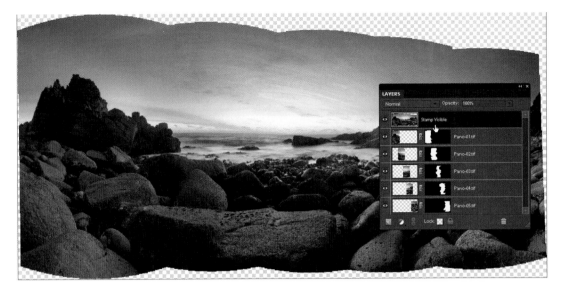

4. Prior to Elements 6 many more steps of manual techniques were required to circumnavigate the shortcomings of Photomerge – but as you can see from the results in this project I just about have perfection handed to me on a plate. Fantabulous! (I know that's not in the dictionary but neither is Photomerge – yet.) If I used the full-resolution images I probably would have gone and made a cup of coffee while Photoshop Elements put this one together and would now be considering downsampling my file – but wait, I have noticed a couple of small glitches in this result.

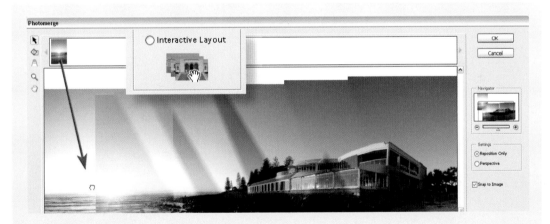

PERFORMANCE TIP

The Auto layout setting gets it right pretty much all of the time. Occasionally you may need to select either the Perspective or Cylindrical options for very wide panoramas. Interactive Layout can be selected when Photoshop Elements is having trouble deciding where one or two of the component images should be placed. This can occur when there is little detail in the image to align, e.g. a panorama of a beach scene where the only obvious line in the image is the horizon. When this occurs you will need to drag the problem file into the best location in the Interactive Layout dialog box.

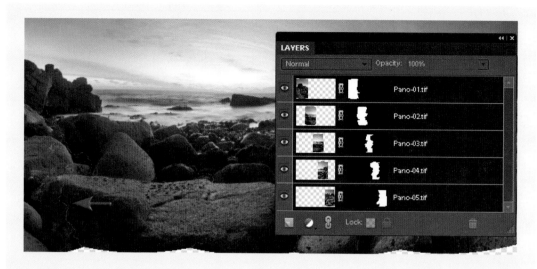

PERFORMANCE TIP

If you downsample before you flatten your file you will probably encounter hairline cracks after reducing the image size. The solution to this problem is to either flatten the file or stamp the visible content to a new layer (Ctrl/Command + Shift + Alt/Option and then type the letter E) before you reduce the size of the image.

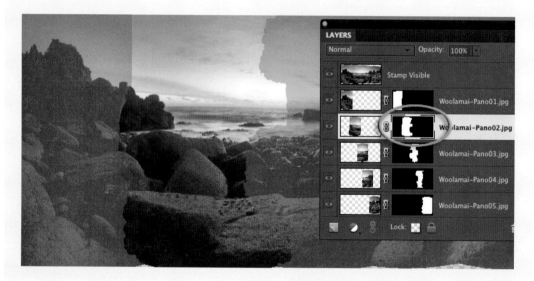

If you hold down the Alt/Option key and click on each layer mask in turn you will notice that Elements uses hard-edged layer masks to hide or reveal the piece of the jigsaw puzzle that makes up the final panorama. The panorama has seamless joins because Photoshop has adjusted or 'blended' the color and tonality of the pixels on each layer. Any pixels concealed by the layer masks have not been subjected to these color and tonal adjustments. This, in effect, means that the user cannot override which bit of each layer is visible as the hidden pixels have not been color-matched.

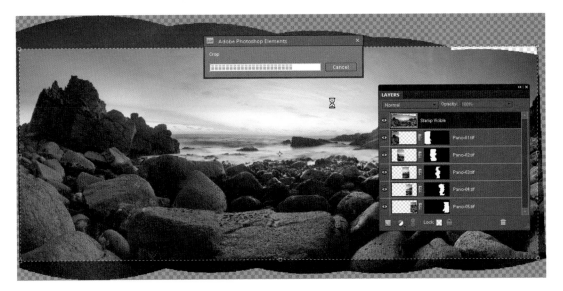

5. To perfect this panoramic image I have stamped the visible elements to a new layer (Ctrl + Shift + Alt and then typed the letter E on a PC or Command + Shift + Option and then typed the letter E on a Mac). I have cropped away most of the transparent pixels before flattening the file, making sure I selected the No Restriction option in the Options bar and leaving the Width and Height fields blank. This is a big image (especially if I used the full-resolution files) so I am not surprised if things are a little slower in computer land right now.

6. There is a small area of transparency at the top of the frame that will need cloning (I did not want to crop too tight at the top of the frame). I have selected the Clone Stamp tool from the Tools panel and then cloned in some new sky from immediately below the transparent area. I have created an empty new layer to clone into and have checked the Sample All Layers option in the Options bar. Only when I am happy with the patch job will I select Merge Down from the Layers fly-out menu.

7. When stitching just two or three images Photomerge Panorama gets it right pretty much all of the time. When stitching much wider panoramas, where there is a good deal of foreground detail, I may find a couple of alignment errors. These images I am working with were captured using a wide-angle lens and the foreground rocks are just in front of the tripod. If I had used a specialized panorama tripod head the effects of parallax error would not be a problem. Photomerge in this instance, however, has met its match. The foreground rocks all match perfectly but that horizon line has a small break and is undulating. I can fix this by selecting the Rectangular Marquee tool and making a selection that just touches the horizon line at the lowest point. I have made sure the Feather option in the Options bar is set to 0. From the Select menu I have chosen Inverse.

Note > The stitching errors may change depending on the resolution (pixel dimensions) of the files you choose for Photomerge to align and blend.

8. I have gone to Filter > Distort > Liquify. I can choose either the Warp tool or the Shift Pixels tool to nudge the horizon line down towards the red frozen area (created from the selection I made in the last step). I have increased the size of the brush to 400–500 pixels and decreased the Brush Pressure to a lowly 5 pixels. If using the Warp tool I can just click and drag to push the pixels into alignment. If using the Shift Pixels tool I will need to click and drag to the left in short strokes. When the horizon line is sitting on top of the red rectangle I can select OK to apply the changes to this image.

9. Pushing the pixels down onto the selection in Liquify will create an unnaturally hard edge to the horizon. This can be fixed by selecting the Blur tool in the Tools panel and a Strength setting of 50% in the Options bar. I have zoomed in so I can see the effects of my painting and then painted along the edge to soften it.

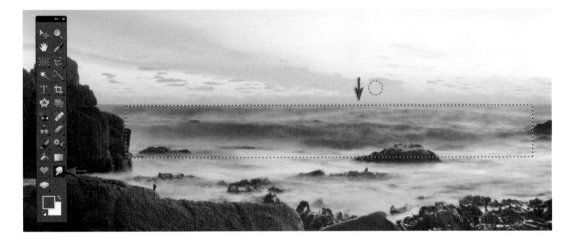

10. If I find that there are still a few areas of the horizon line that could be nudged straighter, I could either repeat the Liquify step or make a selection just below the horizon line again and Inverse the selection (Select > Inverse). Then I could use the Smudge tool with a very low Strength setting to push the pixels towards the selection edge. Remember that only selected pixels can be moved.

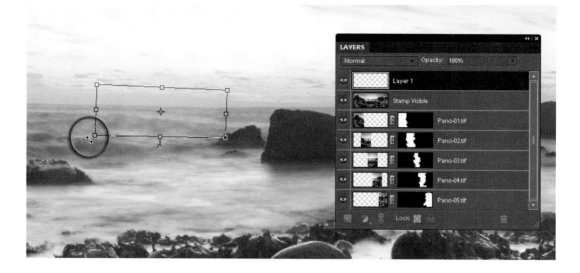

11. If I find a physical break in the horizon line or on the rocks either side of the horizon line I can create a patch to hide the awkward break. I have used the Rectangular Marquee tool with a Feather radius of 10 pixels and made a small selection just next to the break. I have chosen Copy and then Paste from the Edit menu to put the patch onto its own layer. I have then gone to Image > Transform > Free Transform. I can now slide and rotate the patch into position. If I hold down the Ctrl key (PC) or Command key (Mac) I can distort the shape of the patch so that I can achieve a seamless fix.

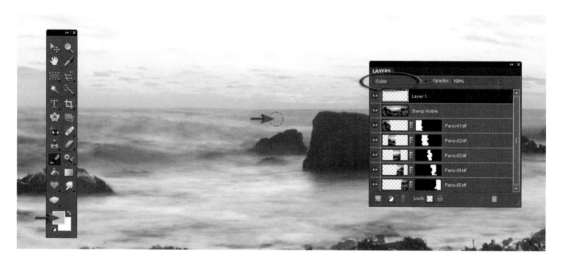

12. If the patch does not match the color of the tones I can create an empty new layer and set the mode of this layer to Color. I have selected the Brush tool in the Tools panel, held down the Alt or Option key and clicked on a more appropriate color to load this into the Foreground Color Swatch in the Tools panel. I have then painted over the area that needs adjusting to further perfect the patched area.

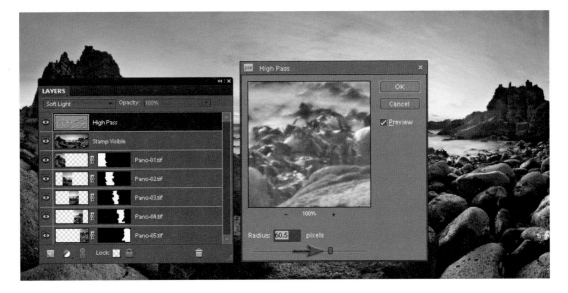

13. To finish this project I will stamp the visible layers to a new layer (Ctrl + Shift + Alt + E for a PC or Command + Shift + Option + E for a Mac), setting the mode to Soft Light in the Layers panel and removing the color (Enhance > Adjust Color > Remove Color). I have then gone to Filter > Other > High Pass and used a generous Radius setting (60 to 70 pixels) to enhance the midtone contrast and then selected OK. I can lower the opacity of the layer if I want a more subtle effect.

Note > At a low radius setting the High Pass filter can be used to sharpen the image, but at much higher radius settings the effect is to increase localized contrast and apparent depth.

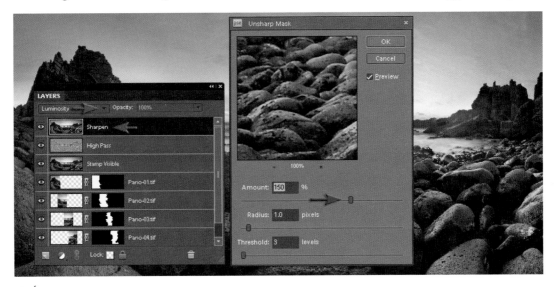

14. To sharpen this project I will start by stamping the visible layers again and setting the mode of the layer to Luminosity in the Layers panel. I have gone to Enhance > Unsharp Mask and used an appropriate amount of sharpening to enhance the details within the image (I have used settings of 150 for the Amount, 1.0 for the Radius and 3 for the Threshold).

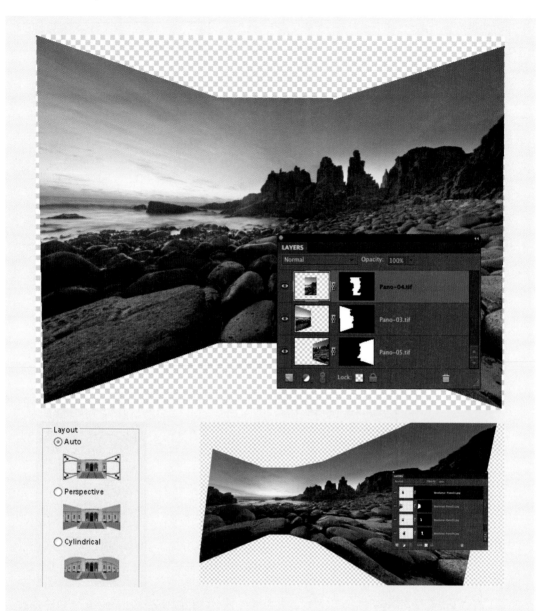

PERSPECTIVE OR CYLINDRICAL

When I selected Auto in the Layout section of the Photomerge Panorama dialog, Photoshop elected to use the Cylindrical option. This option is usually preferable and is usually selected by Auto when you are stitching wide panoramas. When stitching two or three images together you may find that Photoshop decides to use the Perspective option or you can choose this option to override the Cylindrical option if it is chosen by Auto. The Perspective option creates a bow-tie effect when stitching three images and is useful for creating a realistic perspective with straight horizon lines. When this option is used for more than three images, however, the distortion required to create the effect tends to be extreme for the images on the edge of the panorama and cannot therefore be considered as a usable option.

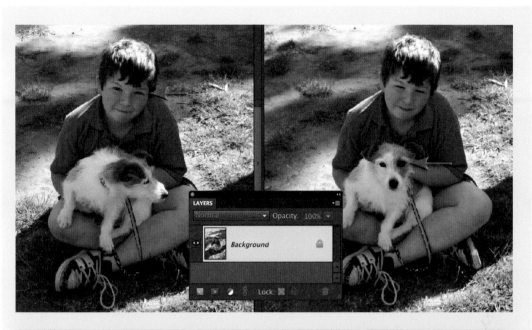

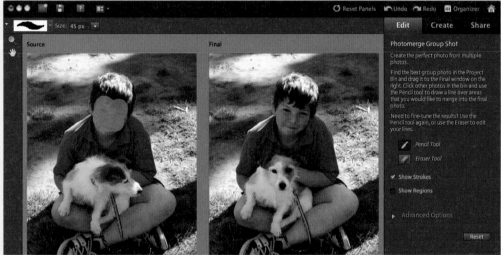

PHOTOMERGE GROUP SHOT

Photomerge also has a Group Shot option. This allows you to merge the best aspects of several images into the same image – especially useful when someone in a group has blinked or looked away. In this group shot (if you can call one boy and his dog a group) it has been decided to combine two images (captured hand-held) so both the boy and his dog are looking at the camera. In the Group Shot dialog box you just scribble over the part of the 'source' image that you would like to merge with the 'final' image. Although Photomerge will align and blend the component images with the same skill as the Panorama option, the user will be presented with an additional flattened file when Group Shot has finished weaving its magic. (see Project 6, Multiplicity; pp. 274–9 for an example application of the Photomerge Group Shot feature.)

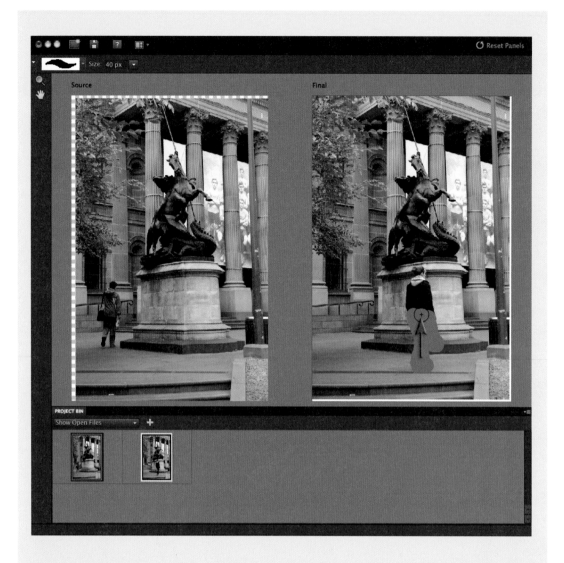

PHOTOMERGE SCENE CLEANER

One of the most useful Photomerge features is the Scene Cleaner. The Scene Cleaner is designed to rid your scenic shots of tourists. You no longer have to wait for the scene to be empty before capturing your shot. Just take multiple shots (no tripod required) as the people move around and you can then clean the scene using Photomerge Scene Cleaner. The process is remarkably simple; just drag one of your images into the Final window and then click on any of the other images in the Project Bin to set it as the Source image. Then paint over any tourist in the Final window or any part of the source file on the left that does not have a tourist (no accuracy is required in the painting action) and the scene in the Final window on the right is cleaned automatically. Move your mouse off the image and the strokes will disappear. The auto-align component of the Photomerge dialog means that the patch is seamless.

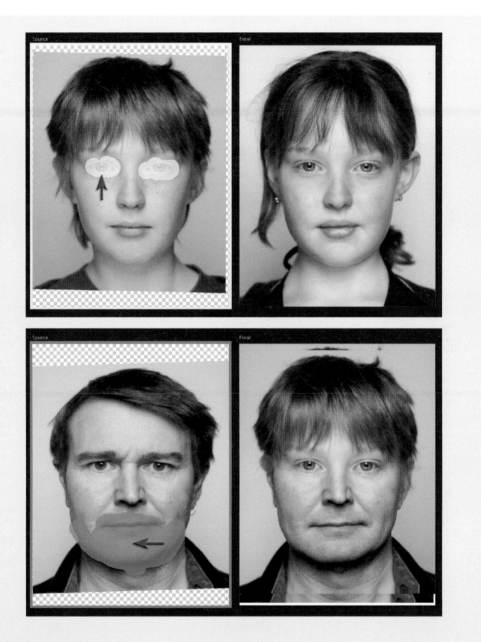

PHOTOMERGE FACES

The strangest of the automated features in the Photomerge bag of tricks is called Photomerge Faces. The results are often delightfully random, even though you are supposed to define the bits you want merged. You must first use the Alignment tool to indicate where the eyes and mouth are in each image and then click the Align Photos button. In the top part of the example above, the boy's eyes have been merged seamlessly into the girl's face, while in the lower examples Photomerge has happily lifted the nose and lower portion of the ears in the source image in order to achieve a seamless stitch. Great fun (if slightly disturbing) – absolutely no commercial value – but will keep the kids amused for hours!

Project 10

Photography by Ed Purnomo

Hair Transplant

One of the most challenging montage or masking jobs in the profession of post-production editing is the hair lift. When the model has long flowing hair and the subject needs to change location many post-production artists call in sick. Get it wrong and, just like a bad wig, it shows. Extract filters, Magic Erasers and Tragic Extractors don't even get us close. The first secret step must be completed before you even press the shutter on the camera. Your number one essential step for success is to first shoot your model against a white backdrop, sufficiently illuminated so that it is captured as white rather than gray.

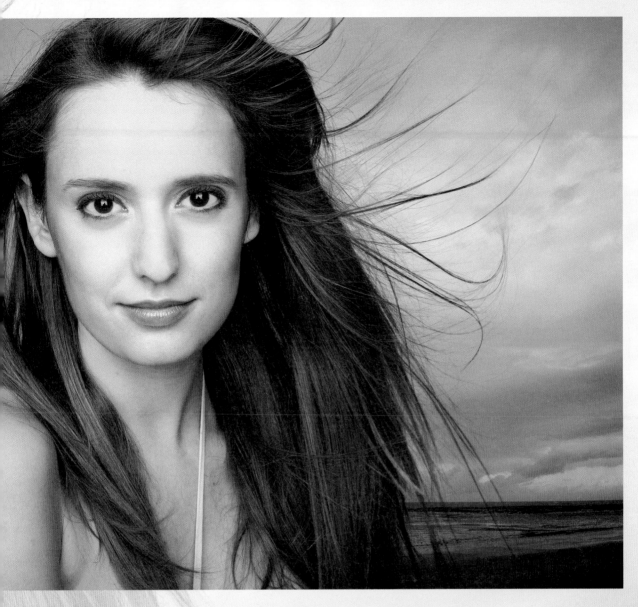

Hair extraction – not as painful as pulling teeth. Image by Ed Purnomo

This important aspect of the initial image capture ensures that the resulting hair transplant is seamless and undetectable. The post-production is the easy bit – simply apply the correct sequence of editing steps and the magic is all yours. This is not brain surgery but follow these simple steps and you will join the elite ranks of image-editing gurus around the world. Celebrity status is just a few clicks away.

Check out the supporting website (www.markgaler.com) to access an extensive stock library of royalty-free skies.

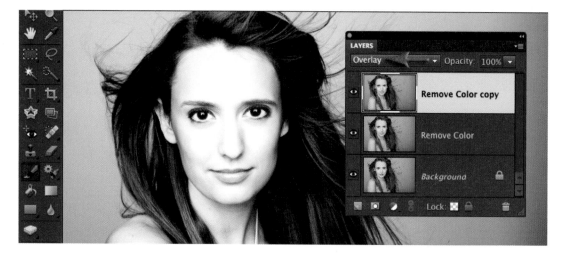

1. The initial steps of this tutorial are concerned with creating a mask that can be used in the final montage. I need to expand the contrast of a copy layer until the girl appears as a silhouette against a bright background. I have started by dragging the background layer to the Create a new layer icon in the Layers panel to duplicate it. I have gone to Enhance > Adjust Color > Remove Color and renamed this layer Remove Color. I have dragged this desaturated/monochrome layer to the Create a new layer icon to duplicate it and have set the blend mode of this new layer (now on top of the layers stack) to Overlay mode.

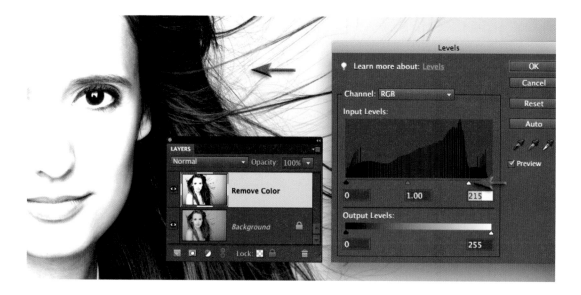

2. From the Layer menu I have chosen Merge Down to create a single high-contrast monochrome layer. I have then gone to Enhance > Adjust Lighting > Levels and adjusted the white Input Levels slider underneath the histogram in the Levels dialog to the left to brighten the background. I have zoomed in to 100% Actual Pixels to determine how far this slider can be moved before I start to lose detail in the fine strands of hair.

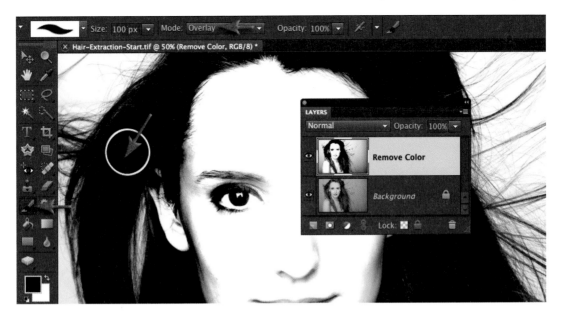

3. To further optimize the mask I have selected black as the foreground color and the Brush tool from the Tools panel. I have chosen a large brush with a Hardness value of 75% and set the Opacity of the brush to 100% in the Options bar. I have set the Mode of the brush to Overlay (also in the Options bar).

Note > Painting in Overlay mode will help to preserve the lighter background while rendering the hair black. It is important to avoid painting over any hair where background is showing through the strands. Painting these individual strands of hair will thicken the hair and may lead to halos appearing later in the montage process.

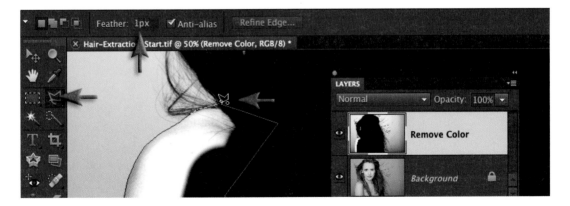

4. In this step I will select some of the low-contrast edges that cannot be painted darker. I have made an accurate selection of the arm using the Lasso or Polygonal Lasso tool with a 1-pixel Feather radius set in the Options bar. I have zoomed in to 100% Actual Pixels so that I can ensure the selection is as accurate as possible. I have gone to Edit > Fill Selection and chosen Black as the contents and then selected OK.

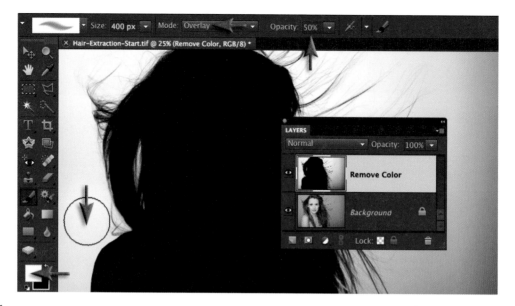

5. To render the background lighter I have switched the blend mode of the brush in the Options bar to Normal and painted over any bright highlights to render the model as a silhouette. This will ensure a speedy conclusion to the mask-making process. To lighten the background I have switched the foreground color to white and set the Mode of the brush in the Options bar to Overlay again. I have reduced the Brush Hardness to 0% and the Opacity to 50%. Brushing the gray background will push it back to white. I have avoided painting over the thin strands of hair.

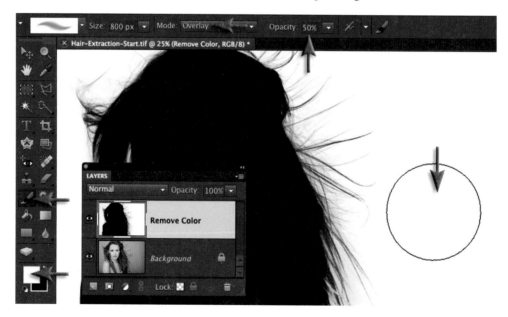

6. It is advisable to leave a small amount of gray in the background between the strands of hair rather than trying to render the background absolute white. Photographing the model against a brighter background (nearly, but not quite, white) would have made this task simpler.

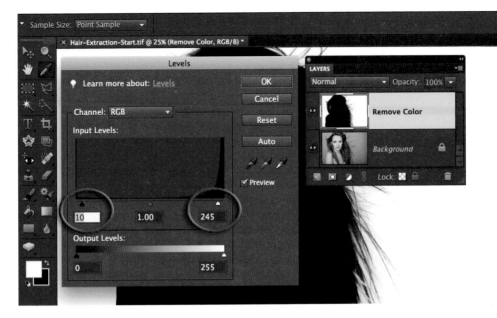

7. To complete the mask-building process I have applied a Levels command once again (Enhance > Adjust Lighting > Levels). This time I have moved the black Input Levels slider to 10 and the white Input Levels slider to 245 as a final contrast boost.

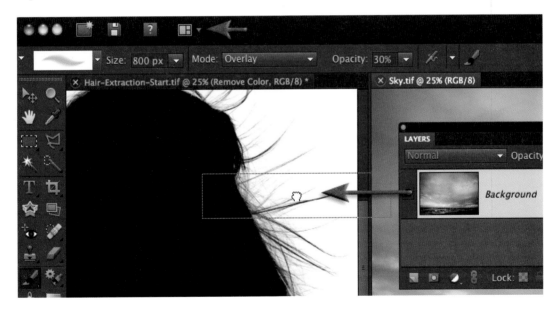

8. The new background is placed on its own layer above the figure and mask layers. I have opened the sky image and gone to the Arrange Documents icon in the Application bar and chosen '2 Up'. I have dragged the layer thumbnail in the Layers panel of this new file into the image window of my project file. I can then use the Free Transform command, Ctrl + T (PC) or Command + T (Mac), to adjust the size if necessary.

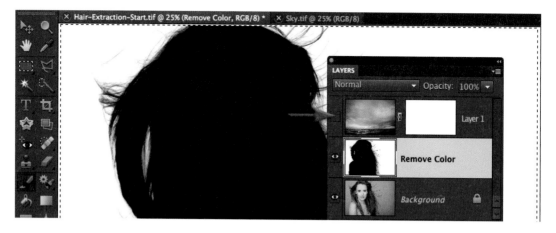

9. Now I need to transfer the silhouette from the Remove Color layer to a layer mask sitting on the layer containing the new background. To do this I need to click on the Add layer mask at the base of the Layers panel to add a mask to the sky layer and then click on the layer Visibility icon, just to the left of the layer thumbnail, to hide the layer. I have selected the Remove Color layer to make this the active layer and from the Select menu chosen 'Select All' (Ctrl/Command + A). From the Edit menu I have chosen Copy (Ctrl/Command + C) to copy the silhouette to the clipboard.

Note > The reason that the new background is placed above, rather than below, the subject will become apparent in Step 13 when we use the Multiply blend mode to restore maximum detail in the hair.

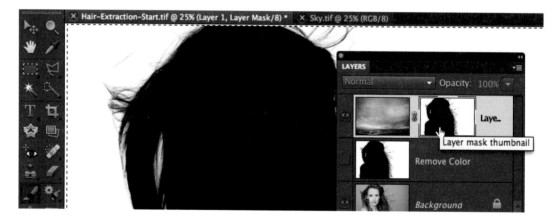

10. After the content of the Remove Color layer has been copied to the clipboard I can switch off the visibility of this layer (this layer has served its purpose). I can then switch the visibility of Layer 1 (the sky) back on and then hold down the Alt/Option key and click on the layer mask thumbnail in the Layers panel. The image window will momentarily appear white as I view the empty contents of the layer mask. From the Edit menu I can then choose Paste to transfer the contents of the clipboard to this layer mask. I have chosen Deselect from the Select menu to lose the active selection and then clicked the layer mask thumbnail, while holding down the Alt/Option key, to return to the normal view.

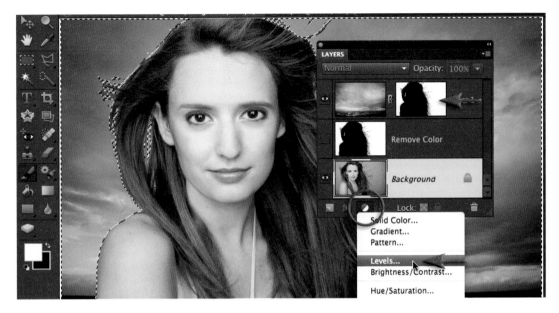

11. At the moment the fine detail of the hair is not perfect. The Multiply mode can restore the fine detail but if it is applied now, the gray background surrounding the model will darken the sky excessively. I can lighten this gray background without affecting the model using the layer mask I have created. If I hold down the Ctrl key (PC) or Command key (Mac) and then click on the layer mask I can load it as a selection. I can then switch off the visibility of the sky layer, select the background layer in the Layers panel and then from the Create new fill or adjustment layer icon select a Levels adjustment layer.

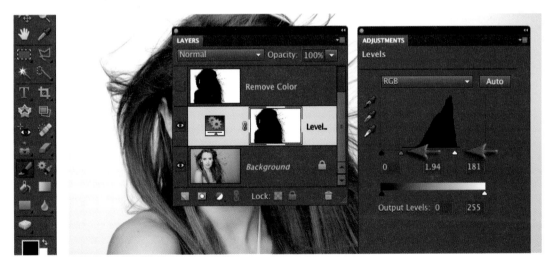

12. I have adjusted the white Input slider to the start of the histogram (any further would have removed fine detail from the hair) and then adjusted the central Gamma slider to the left to brighten the background tones even further. With this technique I should be able to render the gray background nearly white.

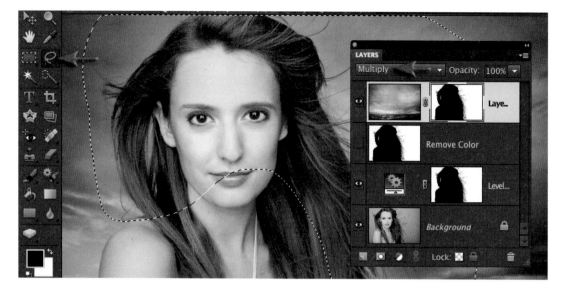

13. I can now switch the visibility of the top layer back on and set the mode to Multiply. This should restore some of the fine detail to the hair. To restore the rest I need to fine-tune the mask. I have selected the Lasso tool from the Tools panel and set the Feather Radius to 20 pixels in the Options bar. This generous Feather Radius will ensure I don't see any 'tide' marks when I adjust the tonality of the mask in the next step. I have made a selection around all of the hair but excluded the arm from this selection. I am about to move the edge of the mask and this would have a negative impact on the arm if it was included in the selection. I cannot use the Refine Edge command for this process as I need to make localized adjustments to the mask.

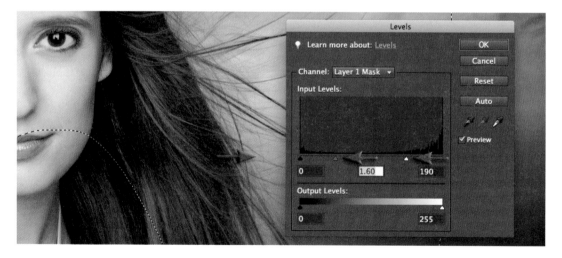

14. I have zoomed in to 100% Actual Pixels and then gone to Enhance > Adjust Lighting > Levels (Ctrl/Command + L). I have moved the white Input slider and the central Gamma slider to the left to remove any traces of the old gray background and to restore all fine detail to the hair. I have selected OK when the hair is looking good and chosen Deselect from the Select menu.

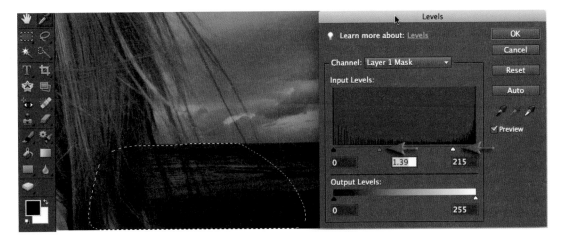

15. I will need to make an additional adjustment to ensure there are no lighter halos around any strands of hair that are positioned over very dark tones in the new background. I have made another selection and then applied another Levels adjustment to this region (Ctrl or Command + L).

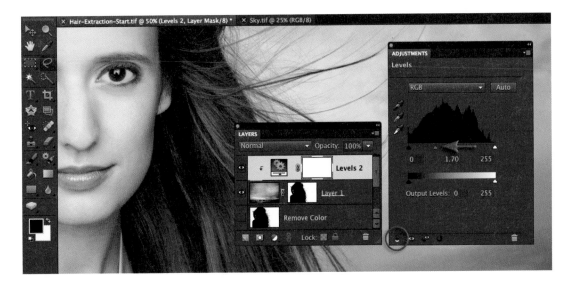

16. The sky is slightly darker after the Multiply blend mode was applied due to the fact that the gray background could not be rendered any lighter without losing fine detail in the hair. We can resolve this problem by clipping an adjustment layer to the sky layer. I have clicked on the Create new fill or adjustment layer icon and can choose either a Levels or a Brightness/Contrast adjustment layer. I have clicked on the Clipping icon in the bottom left-hand corner of the Adjustments panel to ensure the adjustment only affects the sky and not the model.

Note > The secret to success with this technique is to ensure that you have good contrast between the model's hair and the background against which the model is placed. With models with very light hair you can choose to photograph them against a very dark background instead of a light-colored background (see the Performance Tip over the page).

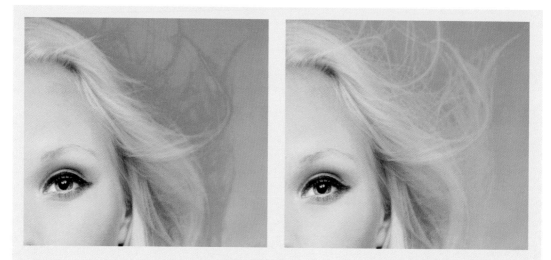

PERFORMANCE TIP

When masking hair that was shot against a black background, setting the layer (the one holding the mask) to the Screen Blend mode is the secret to success. Note the difference between Normal mode (left) and Screen Blend mode (right) in the illustrations above.

You will need to invert the layer mask when using a model shot against a black background (Filter > Adjustments > Invert). Paint in Overlay mode as in Steps 3–5 of the 'Hair Transplant' project. Apply a Levels adjustment to the layer mask and fine-tune the brightness of the hair against the background by moving the Gamma slider.

Jargon Buster

A

ACR: *Adobe Camera Raw. Raw processing utility supplied with Photoshop Elements.*

Adjustment layers: *Non-destructive (always editable) image adjustment placed on a layer.*

Aliasing: *The display of a digital image where a diagonal or curved line appears jagged due to the square pixels.*

Anti-aliasing: *The process of smoothing the appearance of lines in a digital image.*

Artifacts: *Pixels that are significantly incorrect in their brightness or color values.*

B

Bit: *Short for binary digit, the basic unit of the binary language.*

Bit depth: *Number of bits (memory) assigned to recording color or tonal information.*

Blend mode: *The formula used for defining the mixing of a layer with those beneath it.*

Brightness: *The value assigned to a pixel in the HSB model to define the relative lightness of a pixel.*

Byte: *Eight bits. Standard unit of data storage containing a value between 0 and 255.*

C

CCD: *Charge-coupled device. A solid-state sensor used in digital image capture.*

Channel: *A division of color or luminance data.*

Clipboard: *Place for the temporary storage of something that has been cut or copied.*

Clipping group: *Two or more layers that have been linked. The base layer acts as a mask, limiting the effect or visibility of those layers grouped with it.*

Cloning tool: *A tool used for replicating pixels.*

Color fringing: *Bands of color on the edges of lines within an image.*

Color gamut: *The range of colors provided by a hardware device, or a set of pigments.*

Color management: *A system to ensure uniformity of color between the subject, monitor display and final print.*

Color Picker: *Dialog box used for the selection of colors.*

Compression: *A method for reducing the file size of a digital image.*

Constrain proportions: *Retains the proportional dimensions of an image when changing the image size.*

Continuous tone: *The illusion of smooth gradations between highlights and shadows.*

Contrast: *The difference in brightness between the darkest and lightest areas of the image or subject.*

Crash: *The sudden operational failure of a computer.*

Crop: *Reduce image size to enhance composition or limit information.*

Curves: *A control, in the full version of Adobe Photoshop only, for adjusting tonality and color.*

D

Default: A 'normal' or 'start' setting as chosen by the manufacturer or user.

Depth of field: The zone of sharpness variable by aperture, focal length or subject distance.

DNG: Digital Negative (Adobe's Raw file format).

Dpi: Dots per inch. A measurement of resolution.

E

Editable text: Text that has not been rendered into pixels.

Exposure: Combined effect of intensity and duration of light on a light-sensitive material or image sensor.

Exposure compensation: To increase or decrease the exposure from a meter-indicated exposure to obtain an appropriate exposure.

F

Feather: The action of softening the edge of a digital selection.

File format: The code used to store digital data, e.g. TIFF or JPEG.

File size: The memory required to store digital data in a file.

Format: The orientation or shape of an image or the erasure of a memory device.

Freeze: Software that fails to interact with new information.

G

Galleries: A managed collection of images displayed in a conveniently accessible form.

Gaussian Blur: A filter used for defocusing a digital image.

Gigabyte: A unit of measurement for digital files, 1024 megabytes.

Grayscale: An 8-bit image used to describe monochrome (black and white) images.

H

High Dynamic Range (HDR): A subject brightness range that exceeds the ability of the capture medium (film or sensor) to record both the highlight and shadow information simultaneously.

Highlight: Area of subject receiving highest exposure value.

Histogram: A graphical representation of a digital image indicating the pixels allocated to each level.

Hue: The name of a color, e.g. red or green.

I

Image size: The pixel dimensions, output dimensions and resolution used to define a digital image.

Interpolation: Increasing the pixel dimensions of an image by inserting new pixels between existing ones within an image.

ISO: International Standards Organization. A numerical system for rating the speed or relative light sensitivity of a film or sensor.

J

JPEG (.jpg): *Joint Photographic Experts Group. Popular but lossy (i.e. destructive) image compression file format.*

K

Kilobyte: *1024 bytes.*

L

Lasso tool: *Selection tool used in digital editing.*

Latitude: *Ability of the film or device to record the brightness range of the subject.*

Layer mask: *A mask attached to an adjustment layer that is used to define the visibility of the adjustment. It can also be used to limit the visibility of pixels on the layer above.*

Layers: *A feature in digital editing software that allows a composite digital image in which each element is on a separate layer or level.*

Levels: *Shades of lightness or brightness assigned to pixels.*

Luminance adjustment: *The ability to adjust the brightness of a color without affecting either the hue or saturation.*

M

Magic Wand tool: *Selection tool used in digital editing.*

Marching ants: *A moving broken line indicating a digital selection of pixels.*

Marquee tool: *Selection tool used in digital editing.*

Megabyte: *A unit of measurement for digital files, 1024 kilobytes.*

Megapixel: *A million pixels.*

Memory card: *A small removable storage device used in digital cameras to save captured images.*

Minimum aperture: *Smallest lens opening.*

Mode (digital image): *The tonal and color space of the captured or scanned image.*

N

Noise: *Electronic interference producing speckles in the image.*

O

Opacity: *The degree of non-transparency.*

Opaque: *Not transmitting light.*

Optimize: *The process of fine-tuning the file size and display quality of an image.*

Out-of-gamut: *Beyond the scope of colors that a particular device can create, reproduce or display.*

P

Pixel: *The smallest square picture element in a digital image.*

Pixellated: *An image where the pixels are visible to the human eye and curved or diagonal lines appear jagged or stepped.*

Primary colors: *The three colors of light (red, green and blue).*

R

RAM: *Random access memory. The computer's short-term or working memory.*

Reflector: *A surface used to reflect light in order to fill shadows.*

Resample: *To alter the total number of pixels describing a digital image.*

Resolution: *This term can be applied to optical resolution (how sharply the image was captured), screen resolution (the number of pixels being displayed by your monitor, e.g. 1024 x 768), printer resolution (dots per inch or dpi) or **image** resolution (pixels per inch or ppi).*

RGB: *Red, green and blue. The three primary colors used to display images on a color monitor.*

Rubber Stamp: *Another name for the Clone Stamp tool used for replicating pixels.*

S

Sample: *To select a color value for analysis or use.*

Saturation (color): *Intensity or richness of color hue.*

Save As: *An option that allows the user to create a duplicate of a digital file with an alternative name or in a different location.*

Scale: *A ratio of size.*

Scratch disk: *Portion of the hard disk allocated to software such as Elements to be used as a working space.*

Screen redraws: *Time taken to render information being depicted on the monitor as changes are being made through the application software.*

Sharp: *In focus; not blurred.*

Sliders: *A sliding control to adjust settings such as color, tone, opacity, etc.*

Stamp Visible: *The action of copying the visible elements from a number of layers and pasting them onto a new layer.*

System software: *Computer operating program, e.g. Windows or Mac OS.*

T

TIFF: *Tagged Image File Format. Popular image file format for desktop publishing applications.*

Tone: *A tint of color or shade of gray.*

Transparent: *Allowing light to pass through.*

U

Unsharp Mask: *A filter used to sharpen images.*

W

Workflow: *Series of repeatable steps required to achieve a particular result within a digital imaging environment.*

Z

Zoom tool: *A tool used for magnifying a digital image on the monitor.*

Shortcuts (PC)

Action

Keyboard shortcut

Navigate and view

Fit image on screen	Ctrl + 0
View image at 100% (Actual Pixels)	Alt + Ctrl + 0
Zoom tool (magnify)	Ctrl + Spacebar + click image or Ctrl + +
Zoom tool (reduce)	Alt + Spacebar + click image or Ctrl + -
Show/hide rulers	Shift + Ctrl + R
Hide panels	Tab key

File commands

Open	Ctrl + O
Close	Ctrl + W
Save	Ctrl + S
Save As	Ctrl + Shift + S
Undo	Ctrl + Z
Redo	Ctrl + Y

Selections

Add to selection	Hold Shift key and select again
Subtract from selection	Hold Alt key and select again
Copy	Ctrl + C
Cut	Ctrl + X
Paste	Ctrl + V
Paste into selection	Ctrl + Shift + V
Free Transform	Ctrl + T
Distort image in Free Transform	Hold Ctrl key + move handle
Feather	Alt + Ctrl + D
Select All	Ctrl + A
Deselect	Ctrl + D
Reselect	Shift + Ctrl + D
Inverse selection	Shift + Ctrl + I

Painting

Set default foreground and background colors	D
Switch between foreground and background colors	X
Enlarge brush size (with Paint tool selected)]
Reduce brush size (with Paint tool selected)	[
Make brush softer	[+ Shift
Make brush harder] + Shift
Change opacity of brush in 10% increments (with Paint tool selected)	Press number keys 0–9
Fill with foreground color	Alt + Backspace
Fill with background color	Ctrl + Backspace

Image adjustments

Levels	Ctrl + L
Hue/Saturation	Ctrl + U
Group layer	Ctrl + G

Layers and masks

Add new layer	Shift + Ctrl + N
Load selection from layer mask	Ctrl + click thumbnail
Change opacity of active layer in 10% increments	Press number keys 0–9
Add layer mask – Hide All	Alt + click Add layer mask icon
Move layer down/up	Ctrl + [or]
Stamp visible	Ctrl + Alt + Shift + E
Disable/enable layer mask	Shift + click layer mask thumbnail
View layer mask only	Alt + click layer mask thumbnail
View layer mask and image	Alt + Shift + click layer mask thumbnail
Blend modes	Alt + Shift + F, N, S, M, O, Y (Soft Light, Normal, Screen, Multiply, Overlay, Luminosity)

Crop

Commit crop	Enter key
Cancel crop	Esc key
Constrain proportions of crop marquee	Hold Shift key
Turn off magnetic guides when cropping	Hold Alt + Shift keys + drag handle

Shortcuts (Mac)

Action	Keyboard shortcut

Navigate and view

Fit image on screen	Command + 0
View image at 100% (Actual Pixels)	Option + Command + 0
Zoom tool (magnify)	Command + Spacebar + click image or Command + +
Zoom tool (reduce)	Option + Spacebar + click image or Command + -
Show/hide rulers	Shift + Command + R
Hide panels	Tab key

File commands

Open	Command + O
Close	Command + W
Save	Command + S
Save As	Command + Shift + S
Undo	Command + Z
Redo	Command + Y

Selections

Add to selection	Hold Shift key and select again
Subtract from selection	Hold Option key and select again
Copy	Command + C
Cut	Command + X
Paste	Command + V
Paste into selection	Command + Shift + V
Free Transform	Command + T
Distort image in Free Transform	Hold Command key + move handle
Feather	Option + Command + D
Select All	Command + A
Deselect	Command + D
Reselect	Shift + Command + D
Inverse selection	Shift + Command + I

Painting

Set default foreground and background colors	D
Switch between foreground and background colors	X
Enlarge brush size (with Paint tool selected)]
Reduce brush size (with Paint tool selected)	[
Make brush softer	[+ Shift
Make brush harder] + Shift
Change opacity of brush in 10% increments (with Paint tool selected)	Press number keys 0–9
Fill with foreground color	Option + Backspace
Fill with background color	Command + Backspace

Image adjustments

Levels	Command + L
Hue/Saturation	Command + U
Group layer	Command + G

Layers and masks

Add new layer	Shift + Command + N
Load selection from layer mask	Command + click thumbnail
Change opacity of active layer in 10% increments	Press number keys 0–9
Add layer mask – Hide All	Option + click Add layer mask icon
Move layer down/up	Command + [or]
Stamp visible	Command + Option + Shift + E
Disable/enable layer mask	Shift + click layer mask thumbnail
View layer mask only	Option + click layer mask thumbnail
View layer mask and image	Option + Shift + click layer mask thumbnail
Blend modes	Option + Shift + F, N, S, M, O, Y (Soft Light, Normal, Screen, Multiply, Overlay, Luminosity)

Crop

Commit crop	Enter key
Cancel crop	Esc key
Constrain proportions of crop marquee	Hold Shift key
Turn off magnetic guides when cropping	Hold Option + Shift keys + drag handle

Index

342